Roderick Cavaliero is a writer and historian. He is the author of *Admiral Satan: The Life and Campaigns of Suffren*, *Independence of Brazil*, *Strangers in the Land: The Rise and Decline of the British Indian Empire* and *Ottomania: The Romantics and the Myth of the Islamic Orient* (all I.B. Tauris) as well as *The Last of the Crusaders: The Knights of St John and Malta in the Eighteenth Century* and *Romantica: English Romantics and Italian Freedom* (Tauris Parke Paperbacks).

HEURISTICS

*Intelligent Search Strategies
for Computer Problem Solving*

The Addison-Wesley Series in
Artificial Intelligence

Buchanan and Shortliffe (eds.): *Rule-Based Expert Systems: The MYCIN Experiments of the Stanford Heuristic Programming Project*. (In preparation.)

Clancey and Shortliffe (eds.): *Readings in Medical Artificial Intelligence: The First Decade*. (In preparation.)

Pearl: *Heuristics: Intelligent Search Strategies for Computer Problem Solving*. (1984)

Sager: *Natural Language Information Processing: A Computer Grammar of English and Its Applications*. (1981)

Wilensky: *Planning and Understanding: A Computational Approach to Human Reasoning*. (1983)

Winograd: *Language as a Cognitive Process Vol. I: Syntax*. (1983)

Winston: *Artificial Intelligence*, Second Edition. (1984)

Winston and Horn: *LISP*. (1981)

HEURISTICS

Intelligent Search Strategies for Computer Problem Solving

Judea Pearl

Department of Computer Science
University of California
Los Angeles, California

ADDISON-WESLEY PUBLISHING COMPANY
Reading, Massachusetts • Menlo Park, California
London • Amsterdam • Don Mills, Ontario • Sydney

This book is in the Addison-Wesley Series in Artificial Intelligence.

Library of Congress Cataloging in Publication Data

Pearl, Judea.
 Heuristics : intelligent search strategies for
computer problem solving.

 (Artificial intelligence series)
 Bibliography: p.
 Includes index.
 1. Artificial intelligence. 2. Operations research.
3. Problem-solving—Data processing. 4. Heuristic
programming. I. Title. II. Series: Artificial
intelligence series (Addison-Wesley Publishing Company)
Q335.P38 1984 001.53′5 83-12217
ISBN 0-201-05594-5

Reprinted with corrections October, 1985

CDEFGHIJ-MA-898765

To
Ruth, Tammy, Danny, and Michelle

Preface

This book is about *heuristics*, popularly known as rules of thumb, educated guesses, intuitive judgments or simply *common sense*. In more precise terms, heuristics stand for strategies using readily accessible though loosely applicable information to control problem-solving processes in human beings and machine. This book presents an analysis of the nature and the power of typical heuristic methods, primarily those used in artificial intelligence (AI) and operations research (OR) to solve problems of search, reasoning, planning and optimization on digital machines.

The discussions in this book follow a three-phase pattern: Presentation, characterization, and evaluation. We first present a set of general-purpose problem-solving strategies guided by heuristic information (Chapters 1 and 2), then highlight the general principles and properties that characterize this set (Chapters 3 and 8) and, finally, we present mathematical analyses of the performances of these strategies in several well-structured domains (Chapters 5, 6, 7, 9, and 10). Some psychological aspects of how people discover and use heuristics are discussed briefly in Chapters 1 and 4.

The original intention in writing this book was to provide a cohesive and hospitable package for the theoretical results obtained at the UCLA Cognitive Systems Laboratory in the past three years. Some of these results were scattered in various reports, proceedings, and archival journals, and others buried in notebooks awaiting a sufficient incentive for refinement and publication. The compilation of this body of research into a single volume under a consistent notation and a unified logical thread now offers readers easier access to the main results and a better opportunity to assess their range of applicability. These original works are covered in Chapters 5, 6, 7, 9 and 10 and the last sections of Chapters 3 and 8.

Under the persuasive influence of colleagues and students, I later broadened the scope of the book to include some introductory material: an overview of heuristics in typical problem-solving situations (Chapter 1), a description and taxonomy of the basic heuristic search strategies used in AI (Chapters 2 and 8), a formal exposition of their main properties (Chapter 3), and a general discussion on the nature of heuristics (Chapter 4).

As it now stands, the book can fulfill three roles — it can serve as a monograph, as a reference, or as a textbook. The researcher or practitioner familiar

with the standard literature on heuristic search can skip the introductory sections and turn directly to the theoretical topics, which are relatively self-contained. Casual readers, curious enough to gain an understanding of the type of problems and techniques emerging from the AI brewery, are advised to follow the introductory material at their own pace and select the advanced reading which best matches their tastes, backgrounds, and ultimate objectives. Special care was taken to adhere to traditional mathematical notation (avoiding programming-based jargons), thereby ensuring that readers from engineering, operations research, mathematics, or computer science will find the presentation familiar and comfortable. Finally, as a textbook, the book can be used as a reference for an introductory course in AI, and as a full text in a more advanced, graduate-level class on AI control strategies or the analysis of algorithms. At UCLA, for example, we have used Chapters 1, 2, 3 (Section 3.1), and 8 to cover roughly half of the first graduate course in artificial intelligence. The other chapters are used as a text in a graduate course on heuristic algorithms that serves the curriculum of two major fields: machine intelligence and computer science theory. These chapters should also be ideal for an operations research class that focuses on the taxonomy and analysis of combinatorial search techniques.

A large part of the material is presented in the language of mathematics, mainly that of elementary probability theory. It is assumed, therefore, that the reader is familiar with the basic concepts of events, random variables, distribution functions, expectations, and generating functions, which correspond to a first course in probability theory. Chapters 5 and 6 make use of some results from the theory of branching processes. These are described and summarized in Appendix 5-A, which readers are advised to read before proceeding with the text of Sections 5.4 and 6.3. Familiarity with graph theory can be helpful but is not essential because the concepts needed for our purposes are summarized in the introductory sections to Chapters 2 and 3.

The mathematical nature of our analyses should not by any means prevent the less mathematically trained reader from following the basic concepts and techniques, or from appreciating the impact of the main results. A conscious effort was made to introduce each topic in an intuitive—even metaphorical—style so that the presentation as a whole would be both technically correct and easy to follow. The "theorem-proof" structure of some chapters should not automatically suggest dryness. Most theorems either summarize the discussions that precede them, or facilitate valuable shortcuts in the discussions that follow. In all cases, however, I kept in mind that a theorem's primary mission is to resolve some curious dilemma, and it is in the description of these dilemmas that my main effort was invested.

The choice of algorithm description language deserves an explanatory remark. The commitment to make this book accessible to readers from all areas of the applied sciences has resulted in the following guideline: whenever possible algorithms should be as readable by nonprogrammers as the rest of the text. For that reason I have avoided using any of the existing formal

languages.and, moreover, have purposely attempted to give algorithms an *informal*, proselike flavor. Along this line I have avoided an excessive use of recursions, have made repetitive references to the underlying data structures, have emphasized the purpose of steps and the meaning of the variables, and have consistently used *redundant* connecting phrases such as: "else continue," "as soon as," and others. I hope readers will agree that the improved legibility of these descriptions more than makes up for their "impure" appearance; besides, in the not very distant future computers too will be able to accept these natural descriptions and convert them into executable programs.

I take great pleasure in closing this preface by acknowledging those who assisted me with this book. First, I would like to thank the members of the Cognitive Systems Laboratory at UCLA upon whose works and ideas many of the sections are based; Rina Dechter, Nam Huyn, Jin Kim, Scott Kurman, Gerard Michon, Igor Roizen, Michael Tarsi, Chuck Siska, and Rik Verstraete. Acknowledgment is due the National Science Foundation for sponsoring the research that led to many of these results. My academic and professional colleagues have all been very supportive of this endeavor: Nils Nilsson has provided continuous encouragement and Richard Karp is responsible for everything I know about branching processes, especially the ideas of Section 5.4. The comments of John McCarthy, Donald Michie, Allen Newell, and Herbert Simon helped improve the presentation of many sections, especially those relating the historical developments of the key ideas. The largest portion of this book was typed and corrected on a UNIX system by Lorna Freeman, assisted by Tovah Hollander, Terry Peters and Anna Gibbons. Last, I owe a great debt of thanks to my family for their support and understanding: to Danny for insightful suggestions on the first draft, to Michelle for her keen proofreading, and especially to my wife Ruth for tolerating, supporting, and encouraging my longest project since our wedding day.

Tel Aviv, Israel **J.P.**

Prologue

The study of heuristics draws its inspiration from the ever-amazing observation of how much people can accomplish with that simplistic, unreliable information source known as *intuition*. We drive our cars with hardly any thought of how they function and only a vague mental picture of the road conditions ahead. We write complex computer programs while attending to only a fraction of the possibilities and interactions that may take place in the actual execution of these programs. Even more surprisingly, we maneuver our way successfully in intricate social situations having only a guesswork expectation of the behavior of other persons around and even less certainty of their expectations of us. Yet, when these expectations fail we are able to master the great power of humor and recover gracefully. No computer program has yet been designed that exhibits such capabilities. Evidently, the little information we possess is so effectively organized that its poor state of reliability hardly hinders our normal, everyday activities.

Early attempts to equip machines with humanlike intelligence have quickly revealed that machines, too, cannot possibly be expected to operate with only precise and detailed knowledge of their task environment. Rather, this knowledge must, in some way, be summarized or abstracted so as to provide, like human intuition, a steady stream of tentative, unpolished, yet swift and informative *advice* for managing the primitive computational steps that make up a problem-solving process. The information content of this advice came to be known as *heuristic knowledge*. The science of heuristics, then, comprises both empirical and theoretical studies aimed toward understanding the workings of heuristic knowledge; how it is acquired, stored, and used by people, how it can be represented and utilized by machines, and what makes one heuristic succeed where others fail. This book focuses on the latter two topics.

Contents

PART II
Performance Analysis of Heuristic Methods

PART III
Game-Playing Programs

PART
I

Problem-Solving Strategies and the Nature of Heuristic Information

Heuristics! Patient rules of thumb,
So often scorned: Sloppy! Dumb!
Yet, slowly, common sense become.

<div align="right">(ODE TO AI)</div>

By the pricking of my thumbs,
Something wicked this way comes.

<div align="right">(MACBETH)</div>

Chapter 1

Heuristics and Problem Representations

1.1 TYPICAL USES OF HEURISTICS IN PROBLEM SOLVING

Heuristics are criteria, methods, or principles for deciding which among several alternative courses of action promises to be the most effective in order to achieve some goal. They represent compromises between two requirements: the need to make such criteria simple and, at the same time, the desire to see them discriminate correctly between good and bad choices.

A heuristic may be a **rule of thumb** that is used to guide one's actions. For example, a popular method for choosing ripe cantaloupe involves pressing the spot on the candidate cantaloupe where it was attached to the plant, and then smelling the spot. If the spot smells like the inside of a cantaloupe, it is most probably ripe. This rule of thumb does not guarantee choosing only ripe cantaloupe, nor does it guarantee recognizing each ripe cantaloupe judged, but it is effective most of the time.

As an example of a less clear-cut use of heuristics, consider a chess grand master who is faced with a choice of several possible moves. The grand master may decide that a particular move is most effective because that move results in a board position that "appears" stronger than the positions resulting from the other moves. The criterion of "appearing" stronger is much simpler for the grand master to apply than, say, rigorously determining which move or moves forces a checkmate. The fact that grand masters do not always win indicates that their heuristics do not guarantee selecting the most effective move. Finally, when asked to describe their heuristics, grand masters can only give partial and rudimentary descriptions of what they themselves seem to apply so effortlessly.

Even the decision to begin reading this book reflects a tacit use of heuristics—heuristics that have led the reader to expect greater benefit from engaging in this activity rather than doing something else at this point in time.

It is the nature of good heuristics both that they provide a simple means of indicating which among several courses of action is to be preferred, and that they are not necessarily guaranteed to identify the most effective course of action, but do so sufficiently often.

Most complex problems require the evaluation of an immense number of possibilities to determine an exact solution. The time required to find an exact solution is often more than a lifetime. Heuristics play an effective role in such problems by indicating a way to reduce the number of evaluations and to obtain solutions within reasonable time constraints.

To illustrate the role of heuristics in problem solving, we make use of five puzzlelike problems which have served as expository tools in both psychology and artificial intelligence (AI). The expository power of puzzles and games stems from their combined *richness* and *simplicity*. If we were to use examples taken from complex real-life problems, it would take us more than a few pages just to lay the background and specify the situation in sufficient detail so that the reader could appreciate the solution method discussed. Moreover, even after making such an effort we cannot be sure that different readers, having accumulated different experiences, would not obtain diversely different perceptions of the problem situation described. Games and puzzles, on the other hand, can be stated with sufficient precision so as to lay a common ground for discussion using but a few sentences and, yet, their behavior is sufficiently rich and unpredictable to simulate the complexities encountered in real-life situations. This, in fact, is what makes games and puzzles so addictive.

1.1.1 The 8-Queens Problem

To solve this problem, one must place eight queens on a chess board such that no queen can attack another. This is equivalent to placing the queens so that no row, column, or diagonal contains more than one queen.

We can attempt to solve this problem in many ways, from consulting a mystic to looking up the solution in a puzzle book. However, a more constructive method of attack would be to forgo hopes of obtaining the final solution in one step and, instead, to attempt reaching a solution in an **incremental,** step-by-step manner, in much the same way that a treasure hunter "closes in" on a target following a series of local decisions, each based on new information gathered along the way. We can start, for example, with an arbitrary arrangement of eight queens on the board and transform the initial arrangement iteratively, going from one board configuration to another, until the eight queens are adequately dispersed. As with the treasure-hunt, however, we must also make sure that the sequence of transformations is not random but **systematic** so that we do not generate the same configuration over and over and so that we do not miss the opportunity of generating the desired configuration. The former is a requirement of efficiency, whereas the latter is one of utility.

One way to systematize the search is to attempt to **construct** (rather than

transform) board configurations in a step-by-step manner. Starting with the empty board we may attempt to place the queens on the board one at a time, ruling out violations of the problem constraints, until a satisfactory configuration with eight queens is finally achieved. Moreover, because we can easily deduce from the problem specification that there must be exactly one queen in every row, we can assign the first queen to the first row, the second queen to the second row, and so on, thus reducing the number of alternative positions considered for each new queen to less than 8. The feature that allows us to systematize the search in this manner is the fact that we cannot recover from constraint violations by future operations. Once a partial configuration violates any of the problem constraints (i.e., it contains two or more attacking queens), it cannot be rectified by adding more queens to the board, and so many useless configurations can be eliminated at an early stage of the search process.

Assume now that at some stage of the search, the first three queens were positioned in the cells marked by Q's in Figure 1.1 and that we must decide where to position the fourth queen, in cell A, B, or C. The role of heuristics in this context would be to provide rule-of-thumb criteria for deciding, at least tentatively, which of the three positions appears to have the highest chance of leading to a satisfactory solution.

In devising such heuristics, we may reason that to be able to place all the eight queens we need to leave as many options as possible for future additions. That means we need to pay attention to the number of cells in the unfilled rows that remain unattacked by the previously placed queens. A candidate placement is to be preferred if it leaves the highest **number of unattacked cells** in the

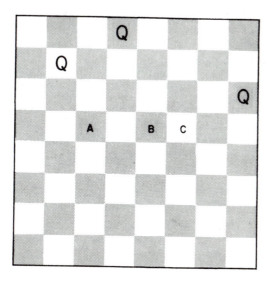

Figure 1.1
A typical decision step in constructing a solution to the 8-Queens problem.

remaining portion of the board. Consequently the number of unattacked cells left by any given alternative constitutes a measure, $f(\cdot)$, of its merit.

If we compute the function $f(\cdot)$ for the alternatives A, B, and C in the preceding example, we obtain

$$f(A) = 8$$

$$f(B) = 9$$

$$f(C) = 10$$

So alternative C should be our preferred choice. Adding credence to the effectiveness of our heuristic is the fact that alternatives B and C both lead to actual eight-queens solutions as shown in Figure 1.2, whereas alternative A leads to no such solution.

A more sophisticated heuristic can be devised by the following consideration. The unfilled rows do not have equal status since those with only few unattacked cells are likely to be "blocked" quicker than rows with many unattacked cells. Consequently, if we wish to minimize the chances of a future blockage, we should focus our attention on the row with the **least number of unattacked cells** and use this number, f', as a figure of merit of each option considered. Performing this computation for the options presented in Figure 1.1, we obtain

$$f'(A) = 1$$

$$f'(B) = 1$$

$$f'(C) = 2$$

which, again, identifies C as the preferred alternative.

Note that if some candidate option makes either f or f' evaluate to 0, there is no sense in pursuing that option any futher; eventually we will come to a **dead end** where no more queens can be added. The function f', however, offers some advantage over f in that it detects all the dead ends predicted by f and many more.

Obviously, for incremental search techniques like the preceding one, there may be cases in which such simplistic heuristic functions would assign the highest value to a futile search avenue. Quite often, however, they would guide the search in the right direction. Moreover, considering the fact that we can recover from bad advice by backtracking to previous decision junctions, the net effect of using such heuristics would be beneficial; they speed up the search without compromising the chances of finding a solution.

The main objective of the studies in this book is to understand and quantify the features of heuristics that make them effective in a given class of problems.

1.1.2 The 8-Puzzle

The objective of the 8-Puzzle is to rearrange a given initial configuration of eight numbered tiles arranged on a 3×3 board into a given final configuration called the **goal state**. The rearrangement is allowed to proceed only by sliding

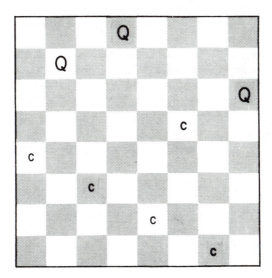

Figure 1.2
Two solutions to the 8-Queens problem extending the options shown in
Figure 1.1.

one of the tiles onto the empty square from an orthogonally adjacent position,
as shown in Figure 1.3

Which of the three alternatives *A, B,* or *C* appears most promising? Of
course, the answer can be obtained by exhaustively searching subsequent
moves in the puzzle to find out which of the three states leads to the shortest
path to the goal. **Exhaustive search**, however, is utterly impractical when the
number of states that must be examined is immense. This "combinatorial ex-

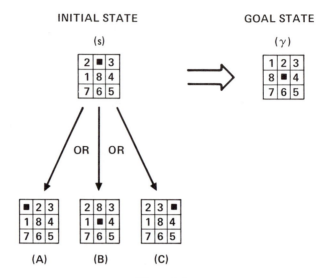

Figure 1.3

A graph description of the first move options in the 8-Puzzle.

plosion" occurs in such puzzles when the path length from the initial state to the goal state is large or when larger boards (e.g., 4×4) are involved. The decision to select the most promising alternative, therefore, cannot rely on exhaustive search, but rather it requires the use of **presearch judgment.**

One of the judgments that we might make in solving a path-finding problem is **estimating how close** a state, or configuration, is to the goal. In the 8-Puzzle there are two very common heuristics, or rules of thumb, that are used for estimating the proximity of one state to another. The first is the **number of mismatched tiles,** those by which the two states differ, which we will call heuristic function h_1. The second is the **sum of the** (horizontal and vertical) **distances** of the mismatched tiles between the two states, which we will call heuristic function h_2. This second heuristic function is also known as the **Manhattan** or **city-block distance.** To see how these heuristic functions work, below are the estimates for the proximities of the states A, B, and C from the goal state in Figure 1.3:

$$h_1(A) = 2 \quad h_1(B) = 3 \quad h_1(C) = 4$$
$$h_2(A) = 2 \quad h_2(B) = 4 \quad h_2(C) = 4$$

Evidently, both heuristics proclaim that state A is the one closest to the goal and that it should, therefore, be explored before B or C.

These heuristic functions are intuitively appealing and readily computable, and may be used to prune the space of possibilities in such a way that only configurations lying close to the solution path will actually be explored. Search strategies that exhibit such pruning through the use of heuristic functions will be discussed in Chapter 2.

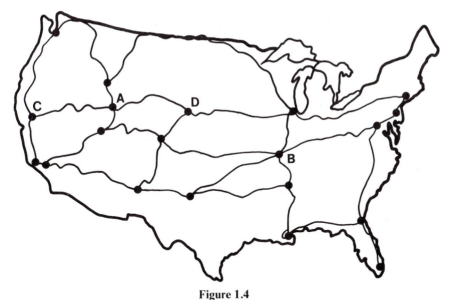

Figure 1.4

A road map, illustrating the use of heuristics in seeking the shortest path from A to B.

1.1.3 The Road Map Problem

Given a road map such as the one shown in Figure 1.4, we want to find the shortest path between city A and city B assuming that the length of each road on the map is specified by a label next to it.

If we are given an actual road map, then in looking for possible paths we would immediately rule out as unpromising those roads that lead away from the general direction of the destination. For example, the fact that city C, unlike city D, lies way out of the natural direction from A to B appears obvious to anyone who glances at the map in Figure 1.4, and so paths going through D will be explored before those containing C. On the other hand, if instead of the map, we are only given a numerical table of the distances $d(i,j)$ between the connected cities, the preference of D over C is not obvious at all; all cities situated at the same distance from A would appear equally meritorious. What extra information does the map provide that is not made explicit in the distance table?

One possible answer is that the human observer exploits vision machinery to estimate the **Euclidean distances** in the map and, since the air distance from D to B is shorter than that between C and B, city D appears as a more promising candidate from which to launch the search. In the absence of a map, we could attempt to simulate these visual computations by supplementing the distance table with extra data of equivalent informational value. For example, because we can easily compute air distances between cities from their coordinates, we can supplement the road-distance table with a heuristic function $h(i)$, which is

the air distance from city i to the goal city B. We can use this extra information to help estimate the merit of pursuing any candidate path from A to some city i, by simply adding $h(i)$ to the distance traversed so far by the candidate path.

For example, starting from city A in Figure 1.4 we find that we have to make a choice between pursuing the search from city C or city D. Since our aim is to minimize the overall path length, our choice should depend on the magnitude of the distance estimate $d(A, C) + h(C)$ relative to the estimate $d(A, D) + h(D)$. Here the respective paths involved are fairly trivial. In general, of course, we might wish to keep track of the shortest distances from the initial city to all the various cities that we have explored in the search.

In contrast to the 8-Queens problem, there is a strong similarity between the Road Map problem and the 8-Puzzle problem. In both the latter two we are asked to find a path from the initial state to some goal state, whereas in the 8-Queens problem we had to construct the goal state itself. However, the 8-Queens problem too was converted into a path-seeking task by our own decision to solve it by incremental search techniques.

1.1.4 The Traveling Salesman Problem (TSP)

Here we must find the cheapest tour, that is, the cheapest path that visits every node once and only once, and returns to the initial node, in a graph of N nodes with each edge assigned a nonnegative cost. The problem is usually stated for a complete graph, that is, one in which every node is linked to each of the other nodes.

The TSP is known to belong to a class of problems called **NP-hard** (Garey and Johnson, 1979) for which all known algorithms require an exponential time in the worst case. However, the use of good **bounding functions** often enables us to find the optimal tour in much less time. What is a bounding function?

Consider the graph in Figure 1.5 where the two paths marked ABC and AED represent two partial tours currently being considered by the search procedure. Which of the two, if properly completed to form a tour, is more likely

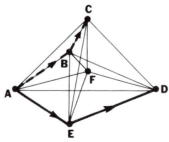

Figure 1.5
Two partial paths as candidates for solving the Traveling Salesman problem.

to be a part of the optimal solution? Clearly the overall solution cost is given by the cost of the initial subtour added to the cost of completing the tour, and so the answer lies in how cheaply we can complete the tour through the remaining nodes. However, since the problem of finding the optimal completion cost is almost as hard as finding the entire optimal tour, we must settle for a *heuristic estimate* of the completion cost. Given such estimates, the decision of which partial tour to extend first should depend on which one of them, after we combine the cost of the explored part with the estimate of its completion, offers a lower *overall* cost estimate.

It can be shown that, if at every stage we select for extension that partial tour with the lowest estimated complete tour cost and if the heuristic function is optimistic (that is, consistently underestimates the actual cost to complete a tour), then the **first** partial tour that is selected for extension and found to already be a complete tour is also a **cheapest** tour. What easily computable function would yield an optimistic, yet not too unrealistic, estimate of the partial tour completion cost?

People, when first asked to "invent" such a function, usually provide very easily computable, but much too simplistic answers. For example, as an estimate of the cost to complete a partial tour, take the cost of the edge from the current end of the partial tour to the initial node. As a marginally more complex example, take the cheapest two-edged path from the current end back to the initial node. These functions, although optimistic, grossly underestimate the completion cost.

Upon deeper thought, more realistic estimates are formed, and the two that have received the greatest attention in the literature are:

1. The cheapest **second degree graph** going through the remaining nodes;
2. The **minimum spanning tree** (MST) through all remaining nodes (Held and Karp, 1971)

The first is obtained by solving the so-called **optimal assignment problem** using on the order of N^3 computational steps, whereas the second requires on the order of N^2 steps.

That these two functions provide optimistic estimates of the completion cost is apparent when we consider that completing the tour requires the choice of a path going through all unvisited cities. A path is both a special case of a graph with degree 2 and also a special case of a spanning tree. Hence, the set of all completion paths is included in the sets of objects over which the optimization takes place, and so the solution found must have a lower cost than that obtained by optimizing over the set of paths only. Figure 1.6(a) shows the shape of a graph that may be found by solving the assignment problem instead of completing subtour AED. The completion part is not a single path but a collection of loops. Figure 1.6(b) shows a minimum-spanning-tree completion of subtour AED. In this case the object found is a tree containing a node with a degree higher than 2.

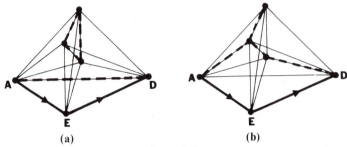

 (a) (b)

Figure 1.6

Two methods of optimistically estimating the completion cost of candidate $A \rightarrow E \rightarrow D$ in the Traveling Salesman problem of Figure 1.5. Part (*a*) The shortest degree-2 graph containing $A \rightarrow E \rightarrow D$. Part (*b*) The minimum spanning tree containing *A*, *D*, and all remaining (unlabeled) cities.

The shapes of the solutions found by these approximations may not resemble the desired tour, but the costs of these solutions may constitute good optimistic estimates of the optimal tour. Therefore they can be used as heuristics for assessing the relative merit of candidate subtours, thus improving the search efficiency. One of the questions addressed later in Chapter 6 is how the accuracy of such estimates affects the complexity of the search.

1.1.5 The Counterfeit Coin Problem

We are given 12 coins, one of which is known to be heavier or lighter than the rest. Using a two-pan scale, we must find the counterfeit coin and determine whether it is light or heavy in no more than three tests.

 To solve this problem we must find a weighing strategy that guarantees that, regardless of the tests' outcomes, the counterfeit coin can be identified and characterized in at most three weighings. By **strategy** is meant a prescription of what to weigh first, what to weigh second for each possible outcome of the first weighing, what to weigh third for each possible outcome of each second weighing, and finally an indication of which coin is counterfeit and whether it is heavy or light for each possible outcome of each of the third weighings. In composing such a strategy we can try to construct it a piece at a time, much as we tackled the 8-Queens problem, by choosing a first weighing, then choosing a second weighing for each outcome, et cetera.

 This problem can be solved by an exhaustive enumeration of all decisions and all possible test outcomes. The role of heuristics, however, is to focus attention on the most promising weighing strategies and to attempt to find a solution *without* exploring all possible strategies.

 Consider the choice between the following two alternatives:

1. Start by weighing a pair of coins (one in each pan).
2. Start by weighing eight coins (four in each pan).

The second alternative appears superior even to a novice problem solver. The reason is that the first alternative has a high probability of ending up with a balanced scale, leaving us with the hard problem of finding a counterfeit coin among ten suspects using only two weighings. The second alternative, on the other hand, leads to more manageable problems: four suspects in case the scale balances and eight suspects each known to be "not-heavy" or "not-light" in case the scale tips.

As in the 8-Puzzle, the decision to defer the exploration of the first alternative in favor of the second can be obtained from a heuristic assessment of the effort required to complete the strategy from the first alternative relative to that of completing it from the second. For example, the base-3 logarithm of the number of remaining possibilities may provide an optimistic estimate for this effort, since every test may result in one of three possible outcomes: scale balances, scale tips to the right, and scale tips to the left.

Note, however, that every action in this problem requires an assessment of not one but three situations, one for each outcome of the balance. The merit of any action, therefore, should be computed by some combination of the merits assigned to the three situations created by that action. The **combination rule** depends on the problem statement. In our example, since the task is to be accomplished in *not more* than three weighings, the appropriate rule would be to assess any action by the effort required to solve the *hardest* of the three problem situations that may result from that action. On the other hand, if we were given an upper limit on the *average* number of weighings, a more appropriate rule would be to take the *expected value* of the effort estimates associated with those three problem situations.

Another difference between the 8-Puzzle and the Counterfeit Coin problem is that in the former we were only concerned with the issue of which action to explore next. In the Counterfeit Coin problem, we also have to address the following question: given that we decide to explore alternative 2 before alternative 1, which **subproblem** deserves our attention next; the easy one, containing four suspected coins, or the hard one, with the eight coins? Moreover, once we shed additional light on the chosen subproblem, should we then attend to its sibling or reevaluate the parent action to test whether it is still more promising than action 1 which we left unexplored? Deciding control issues of this kind is another role heuristics play in computer-based problem solving.

SUMMARY

Each of the five preceding example problems presents us with repetitive choices among a multitude of exploration paths that might be taken to reach a solution. In each case, we have exhibited a heuristic function that serves to indicate which among all those paths seem the most likely to lead to a solution. The heuristics are simple to calculate relative to the complexity of finding a solution and, although they do not necessarily always guide the search in the

correct direction, they quite often do. Moreover, whenever they do not, we can resort to some recovery scheme to resume the search from a different point. The key is that these heuristics save time by avoiding *many* futile explorations.

But how do you find a good heuristic, and when you have found one, how should you use it most effectively and how would you evaluate its merit?

The main objective of this book is to try to answer such questions and to quantify the characteristics of heuristics that produce the most beneficial results.

1.2 SEARCH SPACES AND PROBLEM REPRESENTATIONS

Each of the five examples discussed in the preceding section represents a class of problems with unique characteristics that may require a different representation or a different problem-solving strategy. Some of these characteristics are classified and discussed in the following sections.

1.2.1 Optimizing, Satisficing, and Semi-Optimizing Tasks

The Road Map and the Traveling Salesman problems differ from the other three examples in Section 1.1 in that the former require **optimization;** the path or tour sought had to be at least as cheap as any other feasible path or tour. In all five cases the problem statement delineated a space of candidate objects in which a solution is to be found. The type of objects sought varied from problem to problem; for the 8-Queens problem we were seeking a board configuration with certain properties, for the 8-Puzzle a sequence of moves, a path for the Road Map problem, a tour for the TSP, and a strategy of actions for the Counterfeit Coin problem. In the two optimization problems, however, the objective has been not merely to exhibit a formal object satisfying an established set of criteria but also to ascertain that it possesses qualities unmatched by any other object in the candidate space. By contrast, what was desired in the other three problems was to discover any qualified object with as little search effort as possible, a task we call **satisficing** (originally coined by H. Simon, 1956.)

Most problems can be posed both as constraint-satisfaction and as optimization tasks. For example, the 8-Queens problem can be stated as follows: find the cheapest placement of eight queens on a chess board where each capturable queen introduces a cost of one unit. Posed in this manner, the problem generally becomes harder since we do not know *a priori* whether a zero-cost solution exists. Moreover, even if we prove that such a solution does not exist, the work is not over yet; we still have to search higher cost configurations for the optimal solution. However, heuristic information pertaining to the *quality*

of the solution may also be helpful in reducing the effort of finding one, even in cases in which the quality of the solution is of minor importance. In theorem proving, for example, we would normally be satisfied with the first available proof, however inelegant. Nevertheless, by focusing the search effort toward finding the *shortest* proof, we also install safeguards against aimless explorations in a large space of possibilities, and this normally leads to a smaller search effort in finding a proof. This beneficial principle, which we call **small-is-quick**, plays a major role in heuristic methods for satisficing search. In a later chapter we also demonstrate that algorithms driven by an auxiliary optimization objective (smallness) may exhibit the most efficient (quickest) search even when we know in advance that only one solution exists, or that just any solution will do.

Often the difference in complexity between an optimization task and its satisficing counterpart is very substantial. The TSP is an example of such a case; finding some tour through a set of cities is trivial, but finding an optimal tour is NP-hard. In such cases, one is often forced to relax the optimality requirement and settle for finding a "good" solution using only a reasonable amount of search effort. Whenever the acceptance criterion tolerates a neighborhood about the optimal solution, a **semi-optimization** problem ensues.

Semi-optimization problems fall into one of two categories. If the boundaries of the acceptance neighborhood are sharply defined (e.g., requiring that the cost of the solution found be within a specified factor of the optimal cost), the task is called **near-optimization.** If we further relax the acceptance criterion and insist only that the solution be near optimal with sufficiently high probability, we have an **approximate-optimization** task on our hands.

Most practical problems are of a semi-optimization type, requiring some reasonable balance between the quality of the solution found and the cost of searching for such a solution. Moreover, because the search effort required for many combinatorial optimization problems can easily reach astronomical figures, relaxing optimality is an economic necessity. The basic problem in handling a semi-optimization task is to devise algorithms that guarantee bounds on both the search effort and the extent to which the optimization objective is compromised. A more ambitious task would be to equip such an algorithm with a set of adjustable parameters so that the user can meet changes in emphasis between cost and performance by controlling the tradeoff between the quality of the solution and the amount of search effort.

1.2.2 Systematic Search and the Split-and-Prune Paradigm

Since every problem-solving activity can be regarded as the task of finding or constructing an object with given characteristics, the most rudimentary requirements for computer-based problem solving are:

1. A **symbol structure** or **code** which can represent each candidate object in the space

2. Computational **tools** that are capable of **transforming** the encoding of one object to that of another in order to scan the space of candidate objects systematically
3. An effective method of **scheduling** these transformations so as to produce the desired object as quickly as possible

In the nomenclature common to the artificial intelligence literature, these three components of problem-solving systems are known as

1. The **database**
2. The **operators** or **production rules**
3. The **control strategy**

A control strategy is said to be **systematic** if it complies with the following colloquially stated directives:

1. Do not leave any stone unturned (unless you are sure there is nothing under it).
2. Do not turn any stone more than once.

The first requirement, called **completeness,** guarantees that we do not miss the opportunity to generate an encoding that represents the desired solution if one exists. The second protects us from the inefficiency of repetitious computations.

Let us first examine what kind of objects the code must be capable of **representing.** Obviously we should have the capabilities of representing those objects that we suspect may themselves constitute the desired solutions to the problem at hand, such as board configurations, paths and strategies. But a code limited to expressing only the final objects will severely restrict the flexibility of search strategies. Although we would still be able to comply with the two basic directives of systemization, such an encoding will prevent us from taking advantage of some useful structural properties of the problem domain.

To illustrate this point, imagine the task of searching for the street address of a telephone number in a typical telephone directory. If we are given only the number, we have no alternative but to scan the book exhaustively. By contrast, if the owner's name is also given, the address can be located in just a few operations. In both cases, the book contains a code for every candidate object, but in the latter case we also use **codes for large subsets of objects.** If we open the directory at a page past the name we seek, we immediately recognize that all the names in the following pages could not qualify for a solution and this entire subset of objects is removed from future considerations by turning the pages back or by placing a book marker in the page just opened. The ability to eliminate or prune large chunks of the candidate space does not exist when we are given just the phone number. True, we can still encode large subsets of objects which we may wish to eliminate, e.g., the set of all phone numbers greater than the one sought, but there is no way to guarantee that future transforma-

tions (i.e., page turning operations) will not regenerate elements from the sub-set we wished eliminated.

This simple example illustrates the need to equip our encoding scheme with facilities to express and manipulate not merely individual solution objects but also **subsets of potential solutions.** Moreover, if we are permitted to apply code-transformations that take us from one subset to another, we should also apply the two requirements of systemization to subsets of potential solutions. The first requirement simply states that all individuals must be included in the collection of subsets expressible in our code, and that each individual be reach-able by some operations on the subsets to which it belongs. The second re-quirement, on the other hand, insists that if subset S_1 has been eliminated from consideration, subsequent operations on other subsets will not generate any member of S_1. Putting these two requirements together implies that the only transformation on subsets we should permit is that of **splitting**. Indeed, by sub-jecting a given subset to repeated splitting operations, we may eventually reach any individual member of the subset and, at the same time, we cannot generate a new individual not originally included in the parent subset.

Before elaborating on additional features of this **split-and-prune** method, it is instructive to illustrate its basic building blocks in the context of the problems presented in Section 1.1.

In the **8-Queens** problem the individual objects capable of qualifying as solutions can be taken to include all 8×8 board configurations containing eight queens. Upon further reflection, we may narrow down the candidate space by considering only those configurations containing one queen in every row. A partially filled board, like that shown in Figure 1.1, constitutes a code for a *subset of potential solutions* in that it stands for all board configurations whose top three rows coincide with those filled in the partially specified ar-rangement. Adding a queen to the fourth row further *refines* the parent subset as it constrains the elements represented by the resulting subset to comply with a board of four instead of three specified rows. The three candidate search paths (represented by the letters A, B, and C in Figure 1.1) represent *splitting* of the parent set into a group of three mutually exclusive subsets, each suspect-ed of containing a solution. Note that the subsets corresponding to the remain-ing five cells on the fourth row need not be considered since they could not possibly contain a legitimate solution.

Our ability to detect and eliminate or **prune** such large subsets of objects at such an early stage of the search is what makes the 8-Queens problem easy to solve. This ability was facilitated partly through the splitting method and part-ly by the fortunate choice of code. The splitting method guarantees that subse-quent operations (i.e., adding new queens to the board) will not regenerate any member of subsets rejected earlier and that no potential solution is overlooked in this process. To appreciate the power of the split-and-prune method, the reader may do well to examine an alternative representation for the 8-Queens problem, one that does not allow splitting. Imagine, for example, that someone decides to solve this puzzle by placing eight queens in some random initial po-

sition and then perturb the original position iteratively by moving one queen at a time. In this representation we do have a code for individual objects but not a code for representing subsets of objects. Consequently, as in the case of trying to find an address in a telephone directory without a name, we can reject individual objects but not large chunks of objects.

The availability of an effective code for subset pruning was also significant in facilitating an easy solution to the 8-Queens problem. Choosing a partially filled board as a code for subsets of potential solutions was fortunate because it provided an early detection of some subsets containing no solution (e.g., if two queens in the partially filled board attack each other). The subset code itself, in this case, already possesses qualities of the final solution upon which the final acceptance tests can be performed, and hence early detections of some dead-end subsets are obtained quickly. To appreciate the importance of code-selection, let us now consider an example in which subset splitting is possible, but the code available for representing subsets of potential solutions does not facilitate an early detection of dead ends.

In the **8-Puzzle**, the individual search objects are sequences of legal transformations starting with the initial configuration s. The solution objects are those sequences that lead from s to the goal configuration. A given chain of moves encodes the subset of potential solutions, which includes all those sequences beginning with the chosen chain. Each time we add a new move to a given chain, we narrow the subset of solutions represented by the chain, and since the subsets represented by all legal moves applicable to a given position are mutually exclusive, we are justified in calling the act of listing the consequences of these moves "splitting."

Again, the splitting method theoretically permits us to prune any subset that is proved hopeless, but in the 8-Puzzle no subset is truly hopeless. Subsequent operations can always undo previous operations and place us back on a path to the goal if such a path exists. By contrast, if we change the original problem specifications and require that the goal state be achieved in *no more than K moves*, some subsets of potential solutions do become hopeless. In fact, every sequence of K moves that does not lead to the goal position can simply be discarded because it cannot be turned into a legitimate solution by adding more moves to it. But can we predict this dead-endness early enough simply by looking at an initial segment of such a sequence? Unfortunately we know of no code that would emit early warning signals so vividly as those obtained in the 8-Queens problem. To produce such early warnings, we must, instead, resort to heuristic information that is not explicitly mentioned in the initial problem statement. For example, using heuristic functions such as h_1 and h_2, we can prune away sequences of length shorter than K. Every sequence of $K - h_1(n)$ (or $K - h_2(n)$) moves not leading to the goal can now be discarded, where n is the last position resulting from the sequence.

The use of heuristic functions imposes additional requirements on the **format** of our chosen **code.** We now must make sure that the code we choose for representing candidate subsets not only identifies these subsets unambiguously,

but also facilitates the easy computation of such heuristics. For example, if we choose to codify subsets only by the sequence of splits (or moves) that produced them, such as "up, left, right, down, . . . , " then the computation of h_1 will be very cumbersome. If, on the other hand, we also maintain a (redundant) description of the **state** prevailing after such a sequence, the computation becomes easy. We simply count the number of tiles by which the resulting configuration differs from the goal configuration. And if we also maintain a list of the differing tiles, the computation becomes easier still.

The **Counterfeit Coin** problem introduces a new element. The problem statement requests an identification of a weighing **strategy** that meets certain conditions. A strategy is not simply a sequence of actions but a prescription for choosing an action in response to any possible external event such as an outcome of a test, an action of an adversary, or the output of a complicated computational procedure. Thus, whereas the search objects in the first four examples of Section 1.1 were represented as **paths,** those in the Counterfeit Coin problems are **trees.** A solution to the problem is a tree with depth of at most three which includes all possible outcomes to any of the chosen tests. In addition, each path in the tree must represent a sequence of tests and outcomes that identifies the counterfeit coin unambiguously. To handle such problems, we need, of course, a code for representing subsets of potential solution strategies. A convenient code for such problems is provided by AND/OR graphs, as we will see in Section 1.2.4.

The idea of viewing problem solving as a process of repetitive splitting (also called **branching** or **refinement**) of subsets of potential solutions became popular in operations research and is the basic metaphor behind the celebrated branch-and-bound method (Lawler and Wood, 1966). Artificial intelligence literature rarely mentions this metaphor, preferring to describe problem solving as a "**generate-and-test**" process (Newell and Simon, 1972), **creating** new objects rather than **eliminating** objects from preexisting sets. An artificial intelligence researcher would view a partially developed path, for example, as a building block in the construction of a more elaborate complete solution that will *contain* that path. An operations researcher, on the other hand, views the partial path as (a code for) a huge subset of potential solutions that should eventually be trimmed down to a single element. Note that the use of the word "contain" is reversed in the latter paradigm; the partial path is viewed as an elaborate subset that in itself *contains* complete solutions as structureless points.

The difference between these two approaches is not accidental but reveals a sharp difference of emphasis between the two communities. The split-and-prune paradigm emphasizes the commonality of problem-solving methods over many problems, whereas the object creation paradigm focuses on the unique structure featured by a specific symbolic representation of a given problem. The operations research approach is particularly effective in establishing theoretical guarantees such as completeness and optimality. The artificial intelligence community, on the other hand, has always emphasized the heuristic and implementational aspects of problem solving and its parity with human

style over its mathematical foundations. Indeed, in human terms, the acts of adding a new queen to the board (in the 8-Queens problem), extending a tour to pass through one more city (in the Traveling Salesman problem), or deriving a new lemma in theorem proving are definitely perceived more as acts of *creation* and *construction* than acts of *pruning* or *deletion*.

We will use both paradigms interchangeably. The generate-and-test metaphor will be used to *describe* the various steps used in search procedures, whereas the split-and-prune metaphor will mainly be invoked to *justify* them.

1.2.3 State-Space Representation

Returning to the method of subset splitting, the three basic components needed for the method to work are:

1. A symbol structure called a **code** or a **database** that represents subsets of potential solutions (henceforth called **candidate subsets**)
2. A set of operations or **production rules** that modify the symbols in the database, so as to produce more refined sets of potential solutions
3. A search procedure or **control strategy** that decides at any given time which operation is to be applied to the database

If storage space permits, the database should include codes for several candidate subsets simultaneously. This allows the control strategy to decide which subset would be the most promising to split. When memory space is scarce, the database at any given time may contain a code of only one subset with provisions for backtracking and generating alternate refinements of the parent subset in case a solution cannot be found by a given sequence of refinements.

We may now impose **additional requirements on the format** of the code assigned to a given candidate subset. In principle, since a given sequence of refinement operators corresponds to one and only one candidate subset, that sequence in itself could constitute a sufficient parsimonious code for the resultant subset. We have seen in the 8-Puzzle example, however, that such a code would be very awkward. Although this code is adequate for identifying the candidate subset and for protecting against violations of the two rules of systematic search, it tells us nothing about the nature of the problem which remains to be solved (i.e., finding a solution among the members of the encoded subset). The sequence *s*-up-left-up-right, for example, uniquely specifies one tile-configuration in the 8-Puzzle but contains no explicit information regarding the resultant configuration, its proximity to the goal, whether it has been encountered before in some other candidate subsets, or even which operators are next applicable.

For these reasons we find it convenient to include in the code assigned to each candidate subset additional information that **explicitly defines the remaining subproblem** presented by the subset. The code specifying this additional in-

formation is called a **state**. The set of all subproblems obtainable by executing some sequence of refinement operators from a given position is called a **state-space**. If we connect the elements of this space by arcs labeled by the appropriate refinement operators, we obtain a **state-space graph**.

To illustrate this, a typical candidate subset code for the Traveling Salesman problem might look as follows:

$$A \to B \to C \to D \to \{E, F\} \to A$$

$$\underbrace{\qquad\qquad\qquad}_{\text{candidate}} \underbrace{\qquad\qquad\qquad}_{\text{state}}$$

candidate subset state

The first sequence, $A \to B \to C \to D$, identifies the subset of all tours that begin at city A and then proceed through cities B, C, and D. The part marked "state" specifies the problem of completing the tour: find a path beginning with D, going once through each city in the set $\{E, F\}$ and finally terminating at A. Note that the former is both necessary and sufficient, whereas the latter part is **redundant** and **incomplete**; that is, a solution of the subproblem represented by the state will not identify the entire tour. A subtour description, on the other hand, completely specifies the remaining problem.

The advantages of keeping the state code explicit are apparent. It is this portion of the code that expedites the computation of the heuristic estimates discussed in Section 1.1.4. Moreover, suppose at a certain state of the search, the database also contains the code:

$$A \to C \to B \to D \to \{E, F\} \to A$$

candidate subset state

Although the candidate subset represented by this code is different from the preceding one, their states are identical, so we can determine that one subset of candidates is superior to the other without solving the state subproblem. Simply by comparing the costs of the two paths from A to D, we can prune the inferior subset from future consideration. This type of pruning is called **pruning by dominance** (Ibaraki, 1977) and can be shown to result in substantial savings of search effort.

1.2.4 Problem-Reduction Representations and AND/OR Graphs

We have seen that both constraint-satisfaction problems and sequence-seeking problems can be represented as tasks of finding paths in a state-space graph. Other problems, like the strategy-seeking task in the Counterfeit Coin problem, may be more conveniently represented by a technique called **problem-reduction** representation. The unique feature of this class of problems is that each residual problem posed by some subset of candidates can be viewed as a **conjunction of several subproblems** that may be solved independently of each

other, may require specialized treatments, and should, therefore, be represented as separate entities.

To illustrate this point let us return to the Counterfeit Coin problem of Section 1.1.4 and assume that we have chosen the first alternative, that is, start by weighing a single pair. If we are lucky and the balance tips one way or another, we are left with the easy problem of finding which of the two suspects is the counterfeit coin, knowing that the remaining ten coins are honest. This simple problem can, of course, be solved in a single step, weighing one of the suspects against one of the honest coins. The thing to notice, though, is that this two-suspect problem can be **solved in isolation**, independently of the problems that may ensue in case the balance remains neutral. Moreover, the same simple problem will appear frequently at the end of many elaborate strategies, and so, if we recognize it as an individual entity deserving an individual code, the solution to this subproblem can be found once, remembered, and shared among all strategies that lead to it.

This suggests that we treat **subproblems as individual nodes** in some graph, even though none of these subproblems alone can constitute a complete solution to our original problem. In other words, since every action in our example introduces a triplet of subproblems, all of which must be solved, we prefer to represent the situation resulting from an action not as a single node containing a list of subproblems but rather as a triplet of individual nodes, each residing atop its own specialized set of candidate solution strategies. Figure 1.7 illustrates this problem-reduction representation, contrasting it with the state-space representation of Figure 1.8.

Note that although the individual subproblems are assigned separate nodes, they are still bound by the requirement that *all* must be solved before the parent problem is considered solved. The purpose of the curved arcs in Figure 1.7 is to remind us of this fact. Thus the search-space graph in this representation consists of two types of links:

1. Links that represent alternative approaches in handling the problem node from which they emanate.
2. Links that connect a parent problem node to the individual subproblems of which it is composed.

The former are identical to the links in state-space graphs and are called **OR links**. The latter are unique to problem-reduction and are called **AND links**.

All nodes in an AND/OR graph, like those in a state-space graph, represent subproblems to be solved or subgoals to be achieved, and the start node represents the specification of the original problem. Likewise, each path emanating from the start node identifies a unique candidate subset containing those strategies that comply with the sequence of event-response pairs specified by the path. However, unlike paths in state-space, a solution to the problem represented by the tip node of such a path is no longer sufficient for synthesizing a solution to the original problem. The complete solution is represented by

an AND/OR subgraph, called a **solution graph**, which has the following properties:

1. It contains the start node.
2. All its terminal nodes (nodes with no successors) are primitive problems, known to be solved.
3. If it contains an AND link L, it must also contain the entire group of AND links that are siblings of L.

An AND/OR graph and two of its solution graphs are illustrated in Figure 1.9.

It is sometimes convenient to regard AND/OR graphs as generalizations of ordinary graphs called **hypergraphs**. Instead of links that connect pairs of

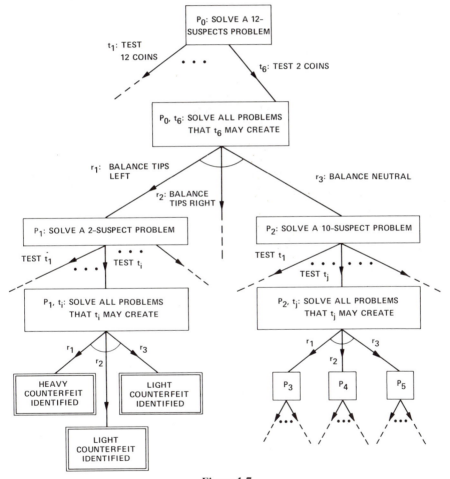

Figure 1.7

Problem-reduction representation for the Counterfeit Coin problem. Each node stands for one subproblem, and the curved arcs indicate which sets of subproblems must be solved conjunctively to make up a complete solution.

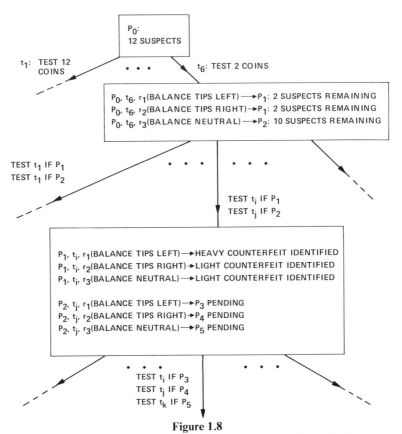

t_1: TEST 12 COINS

• • •

t_6: TEST 2 COINS

P_0:
12 SUSPECTS

P_0, t_6, r_1(BALANCE TIPS LEFT) ⟶ P_1: 2 SUSPECTS REMAINING
P_0, t_6, r_2(BALANCE TIPS RIGHT) ⟶ P_1: 2 SUSPECTS REMAINING
P_0, t_6, r_3(BALANCE NEUTRAL) ⟶ P_2: 10 SUSPECTS REMAINING

TEST t_1 IF P_1
TEST t_1 IF P_2

• • • • • •

TEST t_i IF P_1
TEST t_j IF P_2

P_1, t_i, r_1(BALANCE TIPS LEFT) ⟶ HEAVY COUNTERFEIT IDENTIFIED
P_1, t_i, r_2(BALANCE TIPS RIGHT) ⟶ LIGHT COUNTERFEIT IDENTIFIED
P_1, t_i, r_3(BALANCE NEUTRAL) ⟶ LIGHT COUNTERFEIT IDENTIFIED

P_2, t_j, r_1(BALANCE TIPS LEFT) ⟶ P_3 PENDING
P_2, t_j, r_2(BALANCE TIPS RIGHT) ⟶ P_4 PENDING
P_2, t_j, r_3(BALANCE NEUTRAL) ⟶ P_5 PENDING

• • • • • •

TEST t_i IF P_3
TEST t_j IF P_4
TEST t_k IF P_5

Figure 1.8

State-space representation for the Counterfeit Coin problem. Each node represents the set of all subproblems that may result from the policy (path) leading to that node.

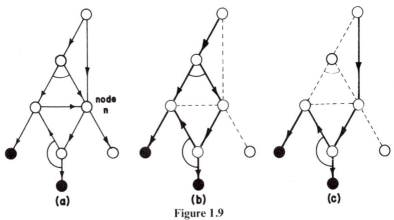

(a) **(b)** **(c)**

node n

Figure 1.9

An AND/OR graph (a) and two of its solution graphs (b) and (c). Terminal nodes are marked as black dots.

nodes, hypergraphs may contain hyperlinks, called **connectors**, connecting a parent node with a *set* of successor nodes. If we regard each group of AND links as a single connector or hyperlink, the task of finding a solution graph amounts to that of finding a **hyperpath** between the start node and the set of primitive terminal nodes. This analogy is helpful in making concepts and techniques developed for path-finding problems applicable to problem-reduction representations.

In general, an AND link and an OR link may simultaneously point to the same node in an AND/OR graph, such as the node marked (n) in Figure 1.9. In this figure, however, each node issues either OR links or AND links, but not both. When this condition holds, it is convenient to label the nodes **OR nodes** and **AND nodes**, depending on the type of links that they issue. In the Counterfeit Coin problem, for example, this separation is natural; OR links represent the strategist's choices of tests, and AND links represent Nature's choice of test outcomes. In cases where a node gives rise to a mixture of OR links and AND links, we can still maintain the purity of node types by imagining that every bundle of AND links emanates from a separate (dummy) AND node and that these dummy AND nodes are OR linked to the parent node. We will assume this node separation scheme throughout our discussion of AND/OR graphs.

In most problems of practical interest, the entire search-space graph will be too large to be explicitly represented in a computer's memory. The problem specifications, however, will contain rules that will allow a computer program to generate the graph incrementally from the start node in any desired direction thus constructing an explicit representation of a portion of the underlying search-space graph, keeping most of it unexplored. The objective of a well-guided search strategy is to find a solution graph by explicating only a small portion of the implicit graph.

At any stage of the search, a test could be conducted to find out if the explicated portion of the searched graph contains a solution graph. That test is best described as an attempt to *label* the start node "solved" through the use of the following **solve-labeling rules:**

A node is "solved" if:

1. It is a terminal node (representing a primitive problem); or
2. It is a nonterminal OR node, and at least one of its OR links points to a "solved" node, or
3. It is a nonterminal AND node, and all of its AND links point to "solved" nodes.

Equivalently, the explicated portion of the search-graph may contain nodes recognizable as "unsolvable," in which case it is worth testing whether the start node still stands a chance of getting solved by attempting to label it "unsolvable." The labeling rules for "unsolvable" status are similar to those of "solve" except that the roles of AND and OR links are interchanged.

1.2.5 Selecting a Representation

The selection of a representation to fit a given problem is sometimes dictated by the problem specifications and sometimes is a matter of choice.

Generally speaking, problem-reduction representations are more suited to problems in which the final solution is conveniently represented as a tree (or graph) structure. State-space representations are more suited to problems in which the final solution can be specified in the form of a path or as a single node.

Strategy-seeking problems are better represented by AND/OR graphs, where the AND links represent changes in the problem situation caused by external, **uncontrolled conditions** and the OR links represent alternative ways of reacting to such changes. In our Counterfeit Coin problem, the uncontrolled condition was Nature's choice of the weighing results. In games, those conditions are created by the legal moves available to the adversary. In program-synthesis, they consist of the set of outcomes that may result from applying certain computations to unspecified data. In general, a strategy-seeking problem can be recognized by the **format required for presenting the solution.** If the solution is a prescription for responding to observations, we have a strategy-seeking problem on our hands, and an AND/OR graph will be most suitable. If, on the other hand, the solution can be expressed as an unconditional sequence of actions or as a single object with a given set of characteristics, we have a path-finding or constraint-satisfaction problem and a state-space representation may be equally or more appropriate.

Another important class of problems suitable for AND/OR graph representations includes cases in which the solution required is a **partially ordered sequence** of actions. This occurs when each available operator replaces a single component of the database by a set of new components. Take, for example, the following **set-splitting** problem:

> Given a set of numbers, find the cheapest way to separate this set into its individual elements using a sequence of partitioning operators. Each operator partitions one subset into two parts, and the cost of each partition is equal to the sum of the elements in the partitioned subset.

It is not hard to show that the solution to this problem is given by the celebrated Huffman-Code algorithm (Horowitz and Sahni, 1978). However, the feature that makes this example worth mentioning here is that the two subsets created by each partitioning operator can later be handled *in any desired order,* without affecting the cost of the solution. Hence, it would be more natural to represent each candidate solution as an **action-tree**, rather than as an action sequence. Thus, although the solution sought is not a strategy in the strict sense of prescribing a policy of reacting to uncontrolled conditions, it is still in tree form, and, therefore, the problem is well suited for AND/OR graph representation.

A similar structure is possessed by **symbolic-integration** problems (Moses, 1971). Several legal transformations are available in this domain (e.g., integration by parts, long division, etc.) which will split the integrand into a sum of expressions to be integrated separately *in any order*. The set of applicable transformations will be represented as OR links emanating from the node representing the integrand, and the AND links represent individual summands within the integrand, all of which must eventually be integrated.

The tasks of **logical reasoning** and **theorem proving** also give rise to AND/OR structures. We begin with a set of axioms and a set of inference rules that allow us, in each step, to deduce a new statement from a subset of axioms and previously deduced statements. The new statement is added to the database, and the process continues until the desired conclusion (e.g., the theorem) is derived. The solution object pursued by the search is a plan specifying in each step which of the inference rules is to be applied to which subset of statements in the database and what the deduced statement is. This plan, again, is best structured as an **unordered tree** because, when a certain conclusion is derived from a given subset of statements, the internal order in which these statements were themselves derived is of no consequence as long as they reside in the database at the appropriate time. Thus, the solution structure is a tree, and hence, the appropriate search-space would be an AND/OR graph.

In certain cases both state-space and problem-reduction formulations appear equally appropriate and the choice of representation requires additional insight. Take, for instance, the 8-Puzzle (Section 1.1.2) and assume that we wish to formulate it in a problem-reduction representation. Whereas in the state-space approach each tile configuration stood for the problem of transforming the configuration into the goal state, we may attempt now to decompose this problem into a set of more elementary problems. We may regard each condition required to meet the goal criterion as a subproblem on its own right (e.g., tile x_1 on cell c_1, tile x_2 on cell c_2, etc.). However, the highly interdependent nature of these subgoals severely weakens the advantages of the problem-reduction approach. As soon as we accomplish some of these subgoals, we find that they must be violated (at least temporarily) in order to achieve the remaining subgoals. Moreover, the solution found for achieving a given subgoal is **context dependent** and can no longer be saved for future use as we have done in the Counterfeit Coin problem. We conclude, therefore, that a problem-reduction formulation is ineffective for the 8-Puzzle and that state-space is its most natural representation.

This conclusion, however, could not have been drawn by a superficial examination of the problem statement without a detailed analysis of the interactions among the goals. In some sequence-seeking problems, like the 8-Puzzle, the goals are interacting with each other, and yet a problem-reduction representation may substantially reduce the search for a solution. A classical example in this category is the **Tower of Hanoi**:

There are n disks $D_1, D_2,...,D_n$, of graduated sizes and three pegs 1, 2, and 3. Initially all the disks are stacked on peg 1, with D_1, the smallest, on top and D_n, the

largest, at the bottom as in Figure 1.10. The problem is to transfer the stack to peg 3 given that only one disk can be moved at a time and that no disk may be placed on top of a smaller one.

The problem can easily be represented in state-space by specifying the operators that are permissible from any given disk configuration. Alternatively, the problem may be represented as a list of goals to be achieved: disk D_1 on peg 3, disk D_2 on peg 3, ..., disk D_n on peg 3. These goals are clearly not independent; placing D_1 initially on peg 3 hinders the transfer of D_2 there. However, this set of goals possesses a unique **linear hierarchy**: once the subset of goals concerning disks D_k, D_{k+1}, ..., D_n are completed, the goals of relocating disks D_1, D_2, ..., D_{k-1} can be accomplished without undoing the former. Whenever a goal set possesses such a linear structure, the key idea is to begin working on the most critical goal (i.e., setting disk D_n on peg 3).

Having decided to begin with this goal, we must first check whether this can be accomplished by solving a primitive problem. In looking up the list of primitive operators available in our problem and their applicability constraints, we should discover that setting disk D_n on peg 3 is indeed a primitive problem if only two conditions are met:

1. Disk D_n must be clear
2. Peg 3 must be empty.

These two conditions are not satisfied in the initial state and, therefore, they are

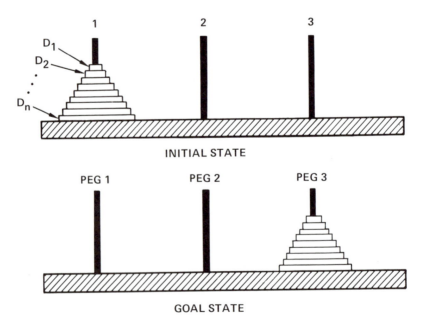

INITIAL STATE

GOAL STATE

Figure 1.10
The Tower of Hanoi problem.

posited as **auxiliary subgoals,** which can also be formulated as the set of conditions: disk D_1 on peg 2, disk D_2 on peg 2, ..., disk D_{n-1} on peg 2.

This auxiliary set of subgoals, together with the primitive problem "move D_n onto peg 3" and the set of unaccomplished goals remaining after the latter, now form a conjunction of three subproblems, which are represented by the first level of the tree in Figure 1.11. At this point the power of the problem-reduction representation can be brought into play; although the conjunction of the three subproblems implies an **ordered execution** of their solutions (from left to right), the **search** for these solutions may be conducted **in any order**. That is, we may begin searching for a solution of the rightmost subproblem prior to knowing the solution to the ones on its left; the latter provides no information that is necessary for the former. This property was not present in the 8-Puzzle and for that reason we could not benefit from the problem-reduction representation. In the Tower of Hanoi puzzle, on the other hand, we were able to reduce the original problem involving n disks to three subproblems, one primitive and two involving $n-1$ disks.

This reduction process can be applied to any nonprimitive subproblem until all the nodes in the tree become primitive and then, reading the leaf nodes left to right, we have a complete detailed sequence of elementary moves that constitutes a solution to the initial problem. The tree will undoubtedly be large (exponential in n) simply because the solution requires a large number of elementary moves. However, if we only wish to communicate a parsimonious description of the solution pattern without worrying about its details, we may take the first level of the tree as an **abstract plan** or a blueprint from which the detailed plan can be generated recursively if desired:

To transfer $S = \{D_1, ..., D_n\}$ from peg i to peg j, do the following:

1. If S contains a single disk, move that disk from i to j; otherwise
2. Transfer $\{D_1, ..., D_{n-1}\}$ from i to k.
3. Move D_n from i to j.
4. Transfer $\{D_1, ..., D_{n-1}\}$ from k to j.

The reasoning behind this problem-reduction method is called **means-end analysis**. It is the basis of a program called GPS, the General Problem Solver (Newell, Shaw, and Simon, 1960), subsequent automatic planning programs such as STRIPS (Fikes and Nilsson, 1971) and ABSTRIPS (Sacerdoti, 1974) and a conversational planning system named GODDESS (Pearl, Leal, and Saleh, 1982). The basic difference between this method and the state-space approach is its purposeful behavior: operators are invoked by virtue of their potential in fulfilling a desirable subgoal, and new subgoals are created in order to enable the activation of a desirable operator.

The success of this method depends, of course, on the availability of an ordered set of subgoals $G_1, G_2, ..., G_n$, such that the problem is solved when all subgoals are achieved and such that the set $G_1, ..., G_k$ can be accomplished

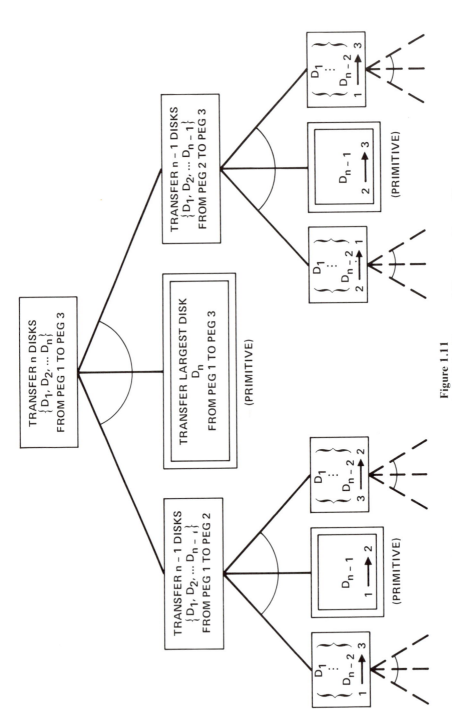

Figure 1.11

Problem-reduction representation of the Tower of Hanoi problem. The problem of transferring n disks is reduced to two subproblems of transferring $n - 1$ disks, and one elementary move.

after G_{k+1}, \ldots, G_n without undoing the latter. The problem of finding such an ordered set mechanically for any given problem is extremely hard but seems to be central to the mechanical discovery of heuristics (see Chapter 4).

1.3 BIBLIOGRAPHICAL AND HISTORICAL REMARKS

Some good general books on puzzles, their structure and their solution methods, are those by Gardner (1959, 1961) and by Averbach and Chein (1980). The books by Conway (1976) and Berlekamp, Conway, and Guy (1982) present formal mathematical treatments of the subject. Computer oriented discussions, including descriptions of programs which solve puzzles and games, can by found in Slagle (1971) and Banerji (1980).

The 8-Queens problem or its general n-Queen version, is typical of a class known as constraint-satisfaction or consistent-labeling problems and is often used to demonstrate ideas connected with backtracking search (Section 2.2.1). For example, see Floyd (1967), Fikes (1970), Mackworth (1977), and Gaschnig (1979a). The method of detecting dead ends such as those predicted by the condition $f' = 0$ is known as "forward checking" (Haralick and Elliot, 1980).

The 8-Puzzle is a small version of the 15-Puzzle (using a 4×4 board) first introduced in the 1870s by the American Problematist Sam Loyd (Loyd, 1959). It has served as an arena for testing heuristic methods by many AI researchers, most notably Doran and Michie (1966) and Gaschnig (1979a).

The Traveling Salesman problem (TSP) is typical of scheduling problems arising in operations research (see Wagner, 1975, and Hillier and Lieberman, 1974) and is surveyed in Bellmore and Nemhauser (1968). The use of optimistic cost estimates for finding optimal solutions is the basis of the branch-and-bound method (Lawler and Wood, 1966). The use of the optimal assignment problem to produce lower bounds for the TSP traces back to Eastman (1958), and was shown to be computable in $O(N^3)$ steps by Edmonds and Karp (1972). The use of the MST as a lower bound for the TSP is due to Held and Karp (1971). Additional bounding functions are discussed by Pohl (1973).

The Counterfeit Coin problem is typically used to demonstrate the applications of coding theory (Massey, 1976). A complete solution for the general N-coin problem has been obtained by Linial and Tarsi (1981).

The relations between the split-and-prune paradigm of operations research and the generate-and-test methods of AI are further analyzed by Ibaraki (1978a), Nau, Kumar and Kanal (1982), and Kumar and Kanal (1983). Simon (1983) compares the search paradigm, where the operations are viewed as transformations on data, with the reasoning paradigm of logic, where the elementary operations are viewed as information gathering steps (e.g., accumulating lemmas in proof procedures).

Our treatment of the state-space and problem-reduction representations follows that of Nilsson (1971). The use of AND/OR graphs for representing problems traces back to Amarel (1967) and Slagle (1963). Kowalski (1972) and vanderBrug and Minker (1975) discuss the relation between AND/OR graphs and theorem proving. Amarel (1968, 1982) gives more general expositions of the problem of finding good representations for problems.

EXERCISES

1.1 *(After D. Nau)* Consider a card game in which two players take turns removing one card from either the right or the left end of a row of cards. Initially the row contains five cards each labeled 1 or 0 as shown:

$$[1] \quad [0] \quad [1] \quad [0] \quad [1]$$

The player who removes the last card wins if that card is marked 1. Otherwise he loses. The problem is to show that the second player wins this game.

 a. Draw an AND/OR graph representing this problem, and identify a solution subgraph.

 b. Draw a section of a state-space graph for this problem and indicate the meaning of each node and each arc.

 c. Can you find a simple criterion for identifying the winner if initially there are *n* cards with arbitrary labels?

1.2 The following puzzle is a variation of the card game in exercise 1.1. The cards are labeled with positive integers (e.g., 7, 5, 1, 2, and 8), and a single player removes a card from either end of the row until all cards are removed. His final score is the sum of the labels removed in odd moves of the game. The problem is to find a strategy that maximizes the final score.

 a. Show the state-space graph of this problem. Interpret the candidate subset and the state code for a typical node in the graph.

 b. Can you think of an optimistic heuristic function that could be of help in the search for an optimal solution?

1.3 *(2-Way Merge Pattern)* Two sorted files containing *n* and *m* records, respectively, can be merged together to obtain one sorted file in approximately $m + n$ operations. When more than two sorted files are to be merged together, the merge can be accomplished by repeatedly merging sorted files in pairs.

 Given five files with sizes 20, 30, 10, 5, and 30, find a sequence of pairwise merges that minimizes the total number of operations.

 a. Illustrate, in the form of a graph section, the state-space representation of this problem; interpret nodes and rules.

 b. Illustrate, as in part (a), a problem-reduction formulation for this problem.

 c. Discuss which representation is more convenient.

1.4 *(Symbolic Integration)* Consider the problem of integrating the expression $x^4/(1-x^2)^{5/2}$. Select problem reduction operators (e.g., substitutions of variables, integration by parts, long division, completing the square) helpful in performing this task, and represent the problem as an AND/OR graph.

1.5 Solve the Counterfeit Coin problem as stated in the text (Section 1.1.5) and find a graph representation of your solution that could be followed by a layman coin-tester. (*Note:* A clear representation of this solution will be helpful in solving related exercises in Chapters 2 and 4.)

Chapter 2

Basic Heuristic-Search
Procedures

In this chapter we describe the basic search strategies used in problem solving
with special attention to the way in which they incorporate heuristic informa-
tion. In Chapter 1, we saw that many types of problems are conveniently
described as tasks of finding some properties of graphs. Our current paradigm
therefore is to find efficient methods of unraveling some properties of graphs
using information from sources outside the graph.

Our discussion will be made easier by compiling some basic nomenclature
regarding graphs and graph searching, although some of the concepts were al-
ready used in Chapter 1.

Basic Graph-Searching Notation

A graph consists of a set of **nodes** (or **vertices**), which in our context represent
encodings of subproblems. Every graph we will consider will have a unique
node s called the **start node**, representing the initial problem at hand. Certain
pairs of nodes are connected by directed **arcs** (or **links**), which represent opera-
tors available to the problem solver. If an arc is directed from node n to node
n', node n' is said to be a **successor** (or a **child** or an **offspring**) of n and node n
is said to be a **parent** (or a **father**) of n'. The number of successors emanating
from a given node is called the **branching degree** (or **degree**) of that node and
normally is denoted as b. We assume that the branching degrees of all nodes
in our graphs are finite, defining a class known as **locally finite graphs**. A pair
of nodes may be successors of each other as in the 8-Puzzle, in which case the
two arcs can be replaced by an undirected **edge**.

A **tree** is a graph in which each node (except one **root** node) has only one
parent. A node in a tree that has no successors is called a **leaf**, a **tip** node, or a
terminal node. A **uniform tree** of depth N is a tree in which every node at
depth smaller than N has the same branching degree whereas all nodes at
depth N are leaves. Often the arcs are assigned **weights** representing either

costs or **rewards** associated with their inclusion in the final solution. We use the notation $c(n, n')$ to denote the cost of the arc from n to n'.

A sequence of nodes n_1, n_2, \ldots, n_k, where each n_i is a successor of n_{i-1}, is called a **path** of length k from node n_1 to node n_k. If a path exists from n_1 to n_k, node n_k is said to be a **descendant** of (or **accessible** from) n_1, and node n_1 is called an **ancestor** of n_k. The cost of a path is normally understood to be the sum of the costs of all the arcs along the path (called the **sum cost**). In special cases other cost measures can be defined, such as the maximum of all the arc costs along the path, or the average cost.

The most elementary step of graph searching that we consider is **node generation**, that is, computing the representation code of a node from that of its parent. The new successor is then said to be **generated** and its parent is said to be **explored**. A coarser computational step of great importance is **node expansion**, which consists of generating *all* successors of a given parent node. The parent is then said to be *expanded*. **Pointers** are normally set up from each generated successor back to its parent node. These pointers form a dynamic network of paths (usually a tree) which facilitates tracing a path from some given node n back to the start node or to some other desired ancestor of n. To distinguish between a pointer-traced path and other paths that may go through a given node, we adopt the following notation: a node n is said to be *along* a **pointer-path** PP at a given time if at that time at least one pointer assigned to n by the search procedure is directed along PP. A node n is said to lie *on* a path P, if the implicit problem graph contains a path P going through n.

A **search procedure**, a **policy**, or a **strategy** is a prescription for determining the order in which nodes are to be generated. We distinguish between a **blind,** or **uninformed,** search and an **informed, guided,** or **directed** search. In the former, the order in which nodes are expanded depends only on information gathered by the search but is unaffected by the character of the unexplored portion of the graph, not even by the goal criterion. The latter uses partial information about the problem domain and about the nature of the goal to help guide the search toward the more promising directions.

Naturally the set of nodes in the graph being searched can at any given time be divided into four disjoint subsets:

1. Nodes that have been expanded,
2. Nodes that have been explored but not yet expanded,
3. Nodes that have been generated but not yet explored,
4. Nodes that are still not generated

Several of the search procedures discussed require a distinction between nodes of the first and third group. Nodes that were expanded (i.e., their successors are available to the search procedure) are called **closed**, whereas nodes that were generated and are awaiting expansion are called **open**. Two separate lists called CLOSED and OPEN are used to keep track of these two sets of nodes.

2.1 HILL-CLIMBING: AN IRREVOCABLE STRATEGY

Hill-climbing, a strategy based on local optimizations, is the simplest and most popular search strategy among human problem solvers. It is called hill-climbing because, like a climber who wishes to reach the mountain peak quickly, it chooses the direction of steepest ascent from its current position. Imagine the task of adjusting the knobs of a television set to obtain a picture of acceptable quality. This task is normally performed by adjusting the knobs one at a time, setting each knob in a position that seems to accomplish the greatest progress toward the desired quality before manipulating the next knob. The procedure is based on continuously monitoring the picture quality against a desired standard and making incremental steps of improvement in a direction that, on the basis of the local information available, seems most promising. The reason this strategy is so popular among human operators is that it requires almost no computational effort; at each setting of the knobs we can begin the adjustment afresh, requiring no memory of past attempts nor of the path that has led us to the current setting.

In terms of our graph-search model, the hill-climbing strategy amounts to repeatedly expanding a node, inspecting its newly generated successors, and choosing and expanding the best among these successors, while retaining no further reference to the father or siblings. Obviously the computational simplicity of this strategy is not without shortcomings. Unless the evaluation function used is extremely informative, we stand a very high chance of violating the first tenet of systematic search, that is, do not leave any stone unturned. Deceptively improving evaluation functions may lure the search into deep, or even infinite, exploration paths that in fact contain no solution. Moreover, as soon as we come to a local maximum (a node more valuable than any of its successors), no further improvement is possible by local perturbations and the process must terminate without reaching a solution. The only way to free ourselves from such a deadlock is to start afresh from what we hope is a completely new node, thus risking violations of the second tenet of systematic search: do not turn any stone more than once. This strategy is called **irrevocable**, because the process does not permit us to shift attention back to previously suspended alternatives, even though they may have offered a greater promise than the alternatives at hand.

Hill-climbing is a useful strategy when we possess a highly informative guiding function to keep us away from local maxima, ridges, and plateaus and to lead us quickly toward the global peak. Hill-climbing is also useful in problems where the state transition operators possess a certain type of independence called **commutativity** (Nilsson, 1980), a condition in which the application of no operator can hinder the future applicability of other operators or alter the state resulting from a sequence of other applicable operators. For example, the operations of expanding nodes in a graph (i.e., generating their successors) are

commutative; the expansion of any one node does not hinder the expansion of other nodes nor alter their descendants. When commutativity holds, irrevocable strategies can be applied without the risk of missing the solution. Applying an inappropriate operator may delay, but never prevent, the eventual discovery of the solution. For that reason, problems that are manageable by a set of commutative operators (e.g., the minimum spanning tree problem) are also blessed with simple optimization algorithms called "greedy." However, the task of fitting such a set of operators to a given problem may be difficult, as is discussed in Chapter 4.

2.2 UNINFORMED SYSTEMATIC SEARCH: TENTATIVE CONTROL STRATEGIES

In contrast to the irrevocable control mechanism employed by hill-climbing, we now discuss a **tentative** scheme to bring our search strategy in line with the requirements of systematization. If for some reason a given search avenue is chosen for exploration, the other candidate alternatives are not discarded but are kept in reserve in case the avenue chosen fails to produce an adequate solution. Naturally this scheme requires more memory space, but it can save time because the memory stores partially developed alternatives which, if discarded, may need to be developed afresh. Many search strategies use this tentative scheme of decision.

The class of strategies described in this section are **uninformed** or "**blind**" in the sense that the order in which the search progresses does not depend on the nature of the solution we seek. In terms of our graph model we usually say that a search strategy is uninformed when the location of the goal node (or nodes) does not alter the order of node expansion, except of course for the termination conditions. Being uninformed, these strategies are rather inefficient and usually are impractical in large problems. They are worth describing, though, as possible standards against which the performances of various informed, heuristically guided, strategies can be compared.

2.2.1 Depth-First and Backtracking: LIFO Search Strategies

In **depth-first** search, as well as in the popular variation called **backtracking**, priority is given to nodes at deeper levels of the search graph. The finest computational step in depth-first search is node expansion, that is, each node chosen for exploration gets all its successors generated before another node is explored.

After each node expansion, one of the newly generated children is again selected for expansion and this forward exploration is pursued until, for some reason, progress is blocked. If blocking occurs, the process resumes from the

deepest of all nodes left behind, namely, from the nearest decision point with unexplored alternatives. This policy works well when solutions are plentiful and equally desirable, or when we have reliable early warning signals to indicate an incorrect candidate direction.

In searching trees the concept of depth is well defined, and a depth-first algorithm should have no difficulty deciding which node in OPEN is the deepest: the deepest node is the one most recently generated. Therefore, if OPEN is structured as a **stack**, a depth-first strategy should put new successors on top of OPEN and select for expansion the topmost node. This last-in-first-out policy guarantees that no node at depth d will be expanded as long as nodes of depths greater than d still reside on OPEN.

It is easy to see that such a policy, if run unchecked, might be dangerous when implemented on large graphs, especially those of infinite depth. It could continue to probe deeper and deeper along some fruitless path and, not having a mechanism to recover from disappointments, would be unable to backup and try a fresh search avenue. For that reason, depth-first algorithms are usually equipped with a **depth-bound**—a stopping rule that, when triggered, returns the algorithm's attention to the deepest alternative not exceeding this bound. Thus the program backtracks under one of two conditions:

1. The depth-bound is exceeded.
2. A node is recognized as a dead end.

The latter event occurs when a node fails to pass a test for some property that must hold true for any node on a path to a solution. For example, requiring that any node explored in the 8-Queens problem should leave at least one unattacked cell in every unfilled row is a legitimate dead-end test.

To summarize, a depth-first policy employs the following sequence of steps:

Depth -First Search
1. Put the start node on OPEN.
2. If OPEN is empty, exit with failure; otherwise continue.
3. Remove the topmost node from OPEN and put it on CLOSED. Call this node n.
4. If the depth of n is equal to the depth bound, clean up CLOSED and go to step 2; otherwise continue.
5. Expand n, generating all of its successors. Put these successors (in no particular order) on top of OPEN and provide for each a pointer back to n.
6. If any of these successors is a goal node, exit with the solution obtained by tracing back through its pointers; otherwise continue.
7. If any of these successors is a dead end, remove it from OPEN and clean up CLOSED.
8. Go to step 2.

The operation "clean up CLOSED" in steps 4 and 7 is performed by purging from CLOSED all those ancestors of the nodes passing the tests in steps 4 and 7

that do not have sons in OPEN. This operation is optional and is designed only to save memory space.

Note that in step 5 placing the successors in an arbitrary order on top of OPEN renders the algorithm totally *uninformed*. An alternative method would be to use heuristics to order these successors, as was discussed in Section 1.1.1. This **partially informed** version of depth-first search will be analyzed in Chapter 6 (Section 6.4).

Figure 2.1 illustrates the sequence of steps taken by a depth-first search of the 4-Queens problem (a 4×4 board version of the 8-Queens problem). Each step is represented by the node being expanded (marked a, b, \ldots, j, k) and the status of the explicit portion of the search graph after each expansion. The order of nodes on OPEN can be seen by traversing the leaf nodes from left to right, skipping the dotted lines which represent portions of the graph deleted from memory. The order of node expansion is further illustrated in Figure 2.2.

Note that at any given time the CLOSED list forms a *single* path from the start node to the currently expanded node. This feature reflects the storage economy of depth-first policies; the maximum storage required cannot exceed the product of the depth-bound and the branching degree. The path of CLOSED nodes maintained by the program appears to be traversing the tree,

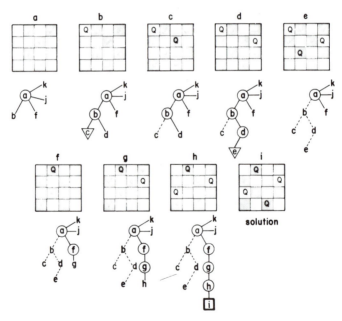

Figure 2.1

Successive steps in a depth-first search of the 4-Queens problem. Circled symbols represent CLOSED nodes, uncircled symbols represent nodes in OPEN, triangles stand for dead ends and boxed nodes are those that satisfy the goal conditions.

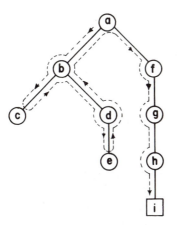

Figure 2.2
Order of node expansion by a depth-first search of the 4-Queens problem.

sweeping across it, from left to right (see Figure 2.2) and is called the **traversal path**.

When implementing depth-first policies on graphs that are not trees, we encounter certain complications. Strictly speaking, the concept of **depth** for a node in a graph is defined recursively as *one plus the depth of its shallowest parent*, with the start node having zero depth. Thus to adhere to a strict depth-first rule the program must first inspect all parents of newly generated nodes, including those parents that were recognized as dead ends and deleted from memory. Such inspection would introduce enormous complications and significantly increase storage requirements. Therefore, in searching graphs we normally compromise the strict depth-first rule (i.e., that no node will be expanded while deeper nodes reside on OPEN) in favor of the last-in-first-out principle, which is much easier to maintain. Thus we still follow the eight-step procedure just outlined, especially step 3, regardless of whether the topmost node is also the deepest node in the strict sense of the word. In step 4, however, where comparison to the depth-bound is required, the depth of a given node is taken as *one plus the depth of the parent designated by its current pointer*. This definition prevents the traversal path from exceeding the depth-bound.

There is still need, however, to check for **node duplications** in order to avoid unnecessary expansions. For example, in the 8-Puzzle, which is an undirected graph, it is important to prevent the search from exploring a repetitive back-and-forth movement of any given tile. This can be done by checking whether any of the newly generated successors already resides on the traversal path and, if a match is found, deleting the matched successor from OPEN. Again, for the sake of maintaining both simplicity and small storage, depth-first strategies normally check for a match only among those nodes residing on the traversal path, allowing duplication of nodes that were generated in the past but since deleted from memory.

Backtracking. Backtracking is a version of depth-first search that applies the last-in-first-out policy to node *generation* instead of node *expansion.* When a node is first selected for exploration, only one of its successors is generated and this newly generated node, unless it is found to be terminal or dead end, is again submitted for exploration. If, however, the generated node meets some stopping criterion, the program backtracks to the closest unexpanded ancestor, that is, an ancestor still having ungenerated successors. This policy can be implemented by modifying the depth-first search procedure as follows:

The Backtracking Procedure

1. Put the start node on OPEN (if it is a goal node, exit immediately).
2. If OPEN is empty, exit with failure, otherwise continue.
3. Examine the topmost node from OPEN and call it *n*.
4. If the depth of *n* is equal to the depth-bound or if all the branches emanating from *n* have already been traversed, remove *n* from OPEN and go to step 2; otherwise continue.
5. Generate a new successor of *n* (along a branch not previously traversed), call it *n'*. Put *n'* on top of OPEN and provide a pointer back to *n*.
6. Mark *n* to indicate that the branch (*n*, *n'*) has been traversed.
7. If *n'* is a goal node, exit with the solution obtained by tracing back through its pointers; otherwise continue.
8. If *n'* is a dead end, remove it from OPEN.
9. Go to step 2.

OPEN is the only list used in backtracking and this time it serves to store the nodes on the traversal path. The marking of nodes in step 6 is usually done by appending to *n* an encoding of the transformation rules that have been applied to *n* in the past. For example, in the 4-Queens puzzle of Figure 2.1, when node *c* is generated, we should mark node *b* to indicate that the branch (*b*, *c*) has already been traversed. Later on, when node *e* is found to be a dead end, we will return to *b* and use this mark to avoid regenerating *c*.

The main advantage of backtracking over depth-first search lies in achieving an even greater storage economy. Instead of retaining in storage all the successors of an expanded node, we only store a single successor at any given time. In addition, backtracking avoids generating nodes that stand to the right of the solution path found, such as nodes *k* and *j* in Figure 2.1. These advantages are marred by the algorithm's inability to use heuristic information for evaluating candidate successors as in the informed version of depth-first search. An informed version of backtracking would have to either temporarily generate all successors of an explored node, or alternatively, to score the available operators on the basis of their own features, without explicating their resultant states.

More sophisticated backtracking strategies also use a technique called **back-marking** with which, after meeting a dead-end condition, they may back up *several levels at once* (Gaschnig, 1979a). This is done by submitting the dead-end condition to a critical analysis to see if the "blame" for that condition can

be placed on one of the earlier ancestors along the traversal path. For example, if a given node at depth 4 of the 8-Queens problem leaves no free cell on the seventh row (see Figure 2.3), and this fact is only discovered at depth 7 (i.e., when trying to place a queen on row 7), backtracking to level 6 or even 5 will not remedy the situation. However, by marking each cell in row 7 with the age of the oldest queen that attacks it, we can detect that the blame really lies with the position of the first four queens and, hence, that we must backtrack directly to level 4 and attempt to change the position of the queen on the fourth row. This situation would not have arisen, of course, were we to insist that each new queen leave at least one unattacked cell in every unfilled row. Meeting this condition, however, would require that we spend extra work on forward testing, whereas backmarking is accomplished with no extra tests.

Backtracking strategies are also useful in **optimization** and semi-optimization problems. If the graph contains many solution paths and our task is to find one with the lowest cost, we can maintain a record of the cheapest solution encountered so far and continue the search until it becomes certain that no cheaper solution may lie ahead of us. For example, if we know that path costs cannot decrease through extension of the path, then finding that the cost of an early portion of a candidate path already exceeds the record we maintain allows us to *prune* that path prior to completion. This pruning is illustrated in Figure 2.4, which describes a backtracking strategy for finding the minimum-sum column in a matrix with nonnegative entries. The search tree, in this case, resembles a curtain where every nonterminal node except the start node is of degree 1. Po-

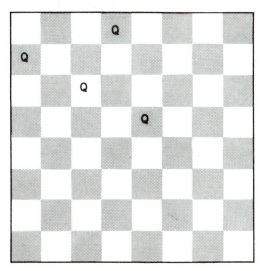

Figure 2.3
A dead-end position in the 8-Queens problem which may not be detected until we try to place a queen on the 7th row.

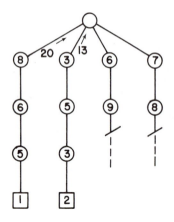

Figure 2.4

Pruning in a backtracking search for the minimum-sum column in a matrix with nonnegative entries.

tential solution paths are pruned as soon as their partial sums exceed the lowest sum encountered on the left. The importance of heuristics for ordering the first group of successors is clearly shown in this example; the amount of pruning increases when we succeed in finding cheap solutions earlier in the search.

2.2.2 Breadth-First: A FIFO Search Strategy

Breadth-first strategies, as opposed to depth-first, assign a higher priority to nodes at the shallower levels of the searched graph, progressively exploring sections of that graph in layers of equal depth. Thus instead of a LIFO policy, breadth-first search is implemented by a first-in-first-out (FIFO) policy, giving first priority to the nodes residing on OPEN for the longest time. The eight-step procedure of the last section can still be followed if in step 5 we place the new successors at the *bottom* of OPEN instead of at the top, thus using OPEN as a queue rather than as a stack.

Figure 2.5 demonstrates the order of node expansions by a breadth-first search on two trees: (*a*) represents the 4-Queens problem including the symmetric half unexplored by backtracking, and (*b*) is a hypothetical tree with a solution node at depth 2. The advantages and weaknesses of breadth-first search can be seen by comparing Figures 2.5(*a*) and 2.1. In the 4-Queens problem, breadth-first is seen to explore almost twice as many nodes as depth-first. This results from having all the solutions situated at depth 5, and no node at depth larger than 5. This property frees depth-first from the danger of following hopeless long paths and, at the same time, commits breadth-first to explore every node of depth smaller than 5. Figure 2.5(*b*), by contrast, represents a situation advantageous to breadth-first search. A solution exists at depth 2 surrounded by paths that may go to a much greater depth. Breadth-first is, again,

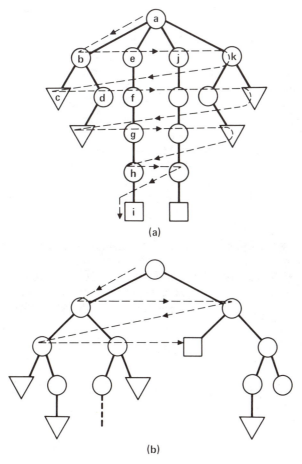

Figure 2.5
Order of node expansion by breadth-first search.

committed to explore every node up to the depth of the shallowest goal, but in this case this commitment is a small price to pay for the safeguard against getting trapped in one of the lengthy paths surrounding the goal.

Unlike depth-first strategies, breadth-first search of locally finite graphs is guaranteed to terminate with a solution if a solution exists. Moreover, it is also guaranteed to find the shallowest possible solution. The price paid for these guarantees is depicted in Figure 2.5. Instead of a single traversal path, breadth-first must retain in storage the entire portion of the graph that it explores. Only by retaining a full copy of the search graph can it shift attention away from newly generated nodes and come back to expand nodes suspended many steps earlier. The need for this abrupt shift of attention, combined with the large storage requirements, is the main reason that breadth-first strategies are rarely adopted by human problem solvers.

The Uniform-Cost Procedure. To exploit the advantages of breadth-first search in optimization problems, an important variation, called the **uniform-cost** or **cheapest-first strategy,** is often employed. Here, instead of progressing in layers of equal depth, we unravel the search space in layers of equal cost. If our task is to find the cheapest path from the start node to a goal and if path costs are nondecreasing with length, we can make sure that no node of cost greater than C is ever expanded while other candidates, promising costs lower than C, are waiting their turn. This guarantees that the first goal node chosen for expansion is also the cheapest solution.

The uniform-cost search procedure is accomplished by selecting for expansion the node in OPEN that has the lowest cost, where the cost of each node is defined as the cost of the path leading to that node from the start node. Figure 2.6 shows the graph explored by the uniform-cost algorithm in searching the minimum-sum-column problem. Note the improved pruning compared to the depth-first search in Figure 2.4.

So far our description has been limited to searches conducted on trees. The modifications required to make these two algorithms suitable for handling graphs will be discussed in Section 2.4.4. as part of the description of the heuristic graph-searching algorithm called $A*$. We will see that both breadth-first and uniform-cost are special cases of $A*$ with its heuristic information suppressed.

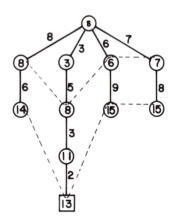

Figure 2.6
Uniform-cost search for the minimum-sum column in the matrix on the left.

2.2.3 Uninformed Search of AND/OR Graphs

Breadth-first and depth-first strategies are easily adaptable to searching AND/OR graphs. The difference lies mainly in the procedures employed for determining the termination conditions. Whereas in state-space searches the

termination test involves the property of a single node, in a problem-reduction formulation we need to ascertain whether a given *set* of solved nodes collectively supports a solution tree. Consequently, the impact of each newly generated group of nodes must be propagated to determine, using the "solved" and "unsolvable" labeling procedures (Section 1.2.3), whether the start node can be labeled. In this propagation process some intermediate nodes are labeled "solved" or "unsolvable," and these can be permanently removed from storage after their impact is transmitted to their parents. Breadth-first transmits the impact of newly generated nodes via the entire AND/OR tree, or graph, that it maintains. Backtracking strategies, on the other hand, transmit that impact through the traversal path that sweeps the graph in a prescribed order.

Both breadth-first and uniform-cost strategies for AND/OR graphs are special cases of a search algorithm called *AO** which will be discussed in Section 2.4.4. We therefore focus our current discussion on backtracking strategies.

Figure 2.7 illustrates the steps taken by backtracking in a left-to-right traversal of a binary AND/OR tree of depth 3. The symbols *S* and *U* stand for the

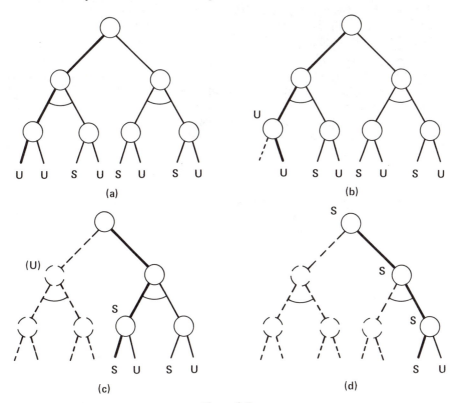

Figure 2.7

Typical steps in the execution of backtracking search of an AND/OR tree. The heavy line represents the traversal path, whereas the broken lines represent portions of the tree that can be purged from memory.

"solve" and "unsolvable" labels that propagate up the traversal path. Note that labeling any intermediate node permits us to remove that node from storage and shift the traversal path one step to the right. This removal, however, although not affecting the correct labeling of the start node, prevents us from reconstructing the actual solution graph once s is labeled as solved. Therefore, if in addition to testing whether a problem can be solved we also wish to exhibit the final solution tree, additional bookkeeping is needed. Prior to its removal, each "solved" node should transmit to its father a code for the solution graph residing below it. These codes are then combined by the various AND nodes and passed upward until the start node, if labeled "solved," receives a code for the entire solution graph beneath it. For example, in Figure 2.7(c) the intermediate node labeled S will transmit to its father the code (1, 1), indicating that a solution can be obtained by going down two levels following the leftmost successors. At stage (d) the AND node assembles the tree code (1, 1) (2, 1), and finally the start node receives the solution tree 2, ((1, 1) (2, 1)).

Since backtracking strategies are committed to maintaining in storage a single traversal path, they cannot take full advantage of the parsimony offered by AND/OR graphs. Identical subproblems encountered along different paths of the graph may need to be solved anew. In Figure 2.8(a), for example, the node labeled A will need to be solved twice, as shown in (b). Cycles can be broken up by discarding any newly generated node that matches those residing in the current traversal path. In so doing we never risk precluding valid, acyclic solutions because the information lost with the node discarded is recoverable from the matching node retained on the traversal path. In Figure 2.8(c), for example, discarding A as a successor of B amounts to breaking up the A-B-A cycle which could not be part of any solution graph. Figure 2.8(d) illustrates how a cycle across siblings is broken after unfolding by a left-to-right backtracking. The legitimate solution tree represented in Figure 2.8(e) is eventually discovered, albeit after some duplicated effort. A breadth-first strategy would have discovered a shallower solution using the terminal nodes at depth 2. However, the extremely low storage required by backtracking strategies normally makes up for this duplicated effort and is the main reason that make them so popular in game-searching (see Part III).

2.3 INFORMED, BEST-FIRST SEARCH: A WAY OF USING HEURISTIC INFORMATION

In Chapter 1 (Section 1.1) we saw examples in which familiarity with the problem domain enabled us to judge certain directions of search more promising than others, thus using knowledge beyond that which is built into the state and operator definitions. In this section, we see how this heuristic knowledge can be used in the formalism of systematic search.

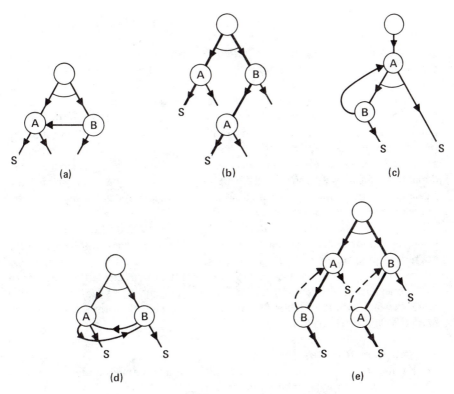

Figure 2.8
Left-to-right backtracking search of AND/OR graphs.

The most natural stage for using heuristic information is in deciding which node to expand next. A somewhat similar decision was also employed by hill-climbing strategies where forward motion was always taken from the last decision through the most promising successor. However, what sets best-first apart from other search strategies is the commitment to select the best from among *all* the nodes encountered so far, no matter where it is in the partially developed tree. To use Winston's (1977) metaphor, "it works like a team of cooperating mountaineers seeking out the highest point in a mountain range: they maintain radio contact, move the highest subteam forward at all times, and divide subteams into sub-subteams at path junctions." To further improve this metaphor we should also add that the mountaineers employ various instruments to estimate the current altitude of the various subteams and the altitude of the paths ahead, and that the readings on these instruments are occasionally corrupted by noise. The noise represents the fact that heuristic information, by its very nature, may occasionally be misleading.

2.3.1 A Basic Best-First (*BF*) Strategy for State-Space Search

The promise of a node can be estimated in various ways. One way is to assess the difficulty of solving the subproblem represented by the node. Another way is to estimate the quality of the set of candidate solutions encoded by the node, that is, those containing the path found leading to that node. A third alternative is to consider the amount of information that we anticipate gaining by expanding a given node and the importance of this information in guiding the overall search strategy. In all these cases, the promise of a node is estimated numerically by a **heuristic evaluation function** $f(n)$ which, in general, may depend on the description of n, the description of the goal, the information gathered by the search up to that point, and most important, on any extra knowledge about the problem domain.

Several best-first strategies differ in the type of evaluation function they employ. The algorithm we describe next is common to all such strategies because no restrictions are placed on the nature of $f(\cdot)$. We assume only that the search space is a general state-space graph, that the node selected for expansion is the one having the *lowest* $f(\cdot)$, and that when two paths lead to the same node, the one with the higher $f(\cdot)$ is discarded. This algorithm is called **best-first** (*BF*) and works as follows:

The Best-First Algorithm BF
1. Put the start node s on a list called OPEN of unexpanded nodes.
2. If OPEN is empty, exit with failure; no solution exists.
3. Remove from OPEN a node n at which f is minimum (break ties arbitrarily), and place it on a list called CLOSED to be used for expanded nodes.
4. Expand node n, generating all its successors with pointers back to n.
5. If any of n's successors is a goal node, exit successfully with the solution obtained by tracing the path along the pointers from the goal back to s.
6. For every successor n' of n:
 a. Calculate $f(n')$.
 b. If n' was neither on OPEN nor on CLOSED, add it to OPEN. Assign the newly computed $f(n')$ to node n'.

 c. If n' already resided on OPEN or CLOSED, compare the newly computed $f(n')$ with the value previously assigned to n'. If the old value is lower, discard the newly generated node. If the new value is lower, substitute it for the old (n' now points back to n instead of to its previous predecessor). If the matching node n' resided on CLOSED, move it back to OPEN.
7. Go to step 2.

In step 6c, the decision to avoid node repetitions amounts to maintaining an explicit tree T, called the **search tree** or **traversal tree**, which is a subtree of the

implicit state-space graph G underlying the problem and whose branches are directed opposite to the pointers assigned by the search procedure at any given time. The leaf nodes of T are either OPEN nodes that are generated and not yet expanded, or nodes on CLOSED that were selected for expansion, generating no successors. All the interior nodes of T are, of course, on CLOSED. At any given time, T designates to every node explored a single distinguished path from the start node defined by tracing the pointers head-to-tail.

The computation required by the test for node repetitions in step 6 can be rather substantial. For this reason, some BF search procedures avoid making this test by eliminating step 6c altogether, with the result of maintaining in storage duplicate descriptions of identical nodes. The tradeoffs between these two methods of handling node identities depend on the particular features of each individual problem domain.

Another variation of BF (Nilsson, 1980), instead of *reopening* previously CLOSED nodes only *redirects* their pointers, propagates new values to their generated descendants and redirects their pointers if necessary. In so doing one must maintain explicitly both a search tree T and a search graph G'. T contains the current pointers system, whereas G' is the explored portion of the underlying state-space graph G (the union of all past traces of T). The advantage of this method is that when pointers are redirected to a node n residing on CLOSED, all successors of n in G' can also adjust their pointers, without waiting for n to be reexpanded. Putting n back on OPEN, as required by step 6c, often invites reexpansion of n and many of its previously generated descendants. Nilsson's variation saves the reexpansion effort at the expense of value propagation and pointer-redirecting effort which may occasionally be superfluous, since some descendants of n in G' may not require regeneration. Most of our discussions in later sections will remain valid for both variations of the BF procedure, since the motion of T through G remains the same in both cases.

2.3.2 A General Best-First Strategy for AND/OR Graphs (*GBF*)

The basic best-first principle, namely the commitment to explore the best among *all* available candidates, can also be applied in searching AND/OR graphs. Here, however, we need to define more carefully what we mean by "best" and what we mean by a "candidate." Like in the state-space formulation we consider candidates to be subsets of potential solutions and, since in problem-reduction formulation the objects of pursuit are solution graphs, we ought to treat *subsets of solution graphs* as candidates awaiting exploration. The AND/OR graph formalism encodes each such subset by a special data structure called a **solution base**.

Assume that at a certain phase of the search the explicated portion of the underlying AND/OR graph G is represented by the subgraph G' of G. Since we can only explore G by repeated node expansions starting from s, G' must

be connected, must contain s, and will have a frontier containing all those nodes generated and not yet expanded. Every subgraph of G' that has the potential of being extended into a solution graph of G represents a subset of potential solutions and ought to be regarded as a candidate for exploration. We can enumerate this set of candidate subgraphs by simply assuming that all the frontier nodes of G' that are not already labeled "unsolvable" are in fact "solved," and then find the set of solution graphs that these frontier nodes can support. Thus a **solution base** is any subgraph G'' of G' for which the following conditions hold:

1. G'' contains the start node s.
2. If an expanded AND node n is in G'', then all n's successors are also in G''.
3. If an expanded OR node n is in G'', then exactly one successor of n is also in G''.
4. None of the nodes in G'' is currently labeled "unsolvable."

We now return to consider which among the frontier nodes of G' should be rated most deserving of the next expansion. While executing BF on OR graphs we maintained a one-to-one correspondence between the candidates for expansion and the candidate solution bases. At any given time the set of solution bases considered by BF were all the (root-to-frontier) paths contained in the traversal tree T, and each one of these paths was represented by a unique node on OPEN. This one-to-one correspondence no longer holds in searching AND/OR graphs; each solution base may contain many nodes that are candidates for expansion, and a given node may participate in several candidate solution bases. Hence the interpretation of what is meant by "best" and the translation of the best-first principle to a working procedure are more complex.

The procedure described in this section applies the best-first principle in two steps. First, it identifies the most promising solution-base graph using a **graph evaluation function** f_1. Then, it expands nodes within that graph using a **node evaluation function** f_2. These two functions, serving in two different roles, provide two different types of estimates: f_1 estimates some properties of the set of solution graphs that may emanate from a given candidate base, whereas f_2 estimates the amount of information that a given node expansion may provide regarding the alleged superiority of its hosting graph. Most works in search theory focus on the computation of f_1, whereas f_2 is usually chosen in an ad hoc manner. The principles underlying the nature of f_1 are discussed later in this section.

Once we select the two guiding functions f_1 and f_2, a best-first search algorithm GBF for an AND/OR graph can be stated as follows:

The GBF Algorithm
1. Put the start node s on OPEN.
2. From the explicit search graph G' constructed so far, (initially, just s),

compute the most promising solution-base graph G_0, using f_1 and the heuristics **h** provided in step 4.

3. Using f_2, select a node n that is both on OPEN and in G_0; remove n from OPEN and place it on CLOSED.

4. Expand node n, generating all its immediate successors, and add them to OPEN and to the search graph G' with pointers back to n (merge duplicate nodes in OPEN and in G'). For each successor n', provide heuristic information **h** (e.g., a list of parameters) that characterizes the set of solution graphs rooted at n' (see the text that follows).

5. If any successor n' is a terminal node, then

 a. Label node n' "solved" if a goal or "unsolvable" if not.

 b. If the label of n' induces a label on any of its ancestors, label these ancestors "solved" or "unsolvable" using the labeling procedure that follows.

 c. If the start node is solved, exit with G_0 as a solution graph.

 d. If the start node is labeled "unsolvable," exit with failure.

 e. Remove from G' any nodes whose label can no longer influence the label of s.

6. Go to step 2.

The **labeling procedure** mentioned in step 5 is defined recursively and can be implemented using either depth-first (see Figure 2.7) or breadth-first policies.

The "Solve" Labeling Procedure

1. A terminal node is labeled "solved" if it is a goal node (representing a primitive subproblem); otherwise it is labeled "unsolvable" (representing a subproblem that cannot be reduced any further).

2. A nonterminal AND node is labeled "unsolvable" as soon as one of its successors is labeled "unsolvable"; it is labeled "solved" if all its successors are "solved."

3. A nonterminal OR node is labeled "solved" as soon as one of its successors is labeled "solved"; it is labeled "unsolvable" if all its successors are "unsolvable."

In step 4 of *GBF* each node n' on the frontier of G' is assumed to be characterized by information regarding the set of *solution graphs rooted at n'*. This set (possibly empty) consists of subgraphs $g(n')$ of G where each $g(n')$ satisfies:

1. n' is the root node of $g(n')$.

2. n' can be labeled "solved" by applying the labeling procedure to $g(n')$.

Of course, since n' is not yet expanded, the subgraphs $g(n')$ are not available explicitly and can only be assessed using heuristic information from outside of G. The role of this information is to assess both the difficulty of finding a solution for the subproblem represented by n' and the quality of the solution when found.

Note that the preceding procedure leaves several computations unspecified. Aside from the graph and node selection functions f_1 and f_2, we also left unspecified the heuristic information provided at step 4, without which f_1 and f_2 cannot be computed. In the next section we will see that restrictions placed on these computations define a natural taxonomy of best-first algorithms. But first it may be instructive to demonstrate the major steps of the *GBF* algorithm by illustrating the sequence of solution bases selected in a simple problem.

An Example of Applying GBF. Let us assume that we wish to find a solution graph in the (implicit) AND/OR graph G of Figure 2.9(a). Expanding s in Figure 2.9(b), we unravel three solution bases (i.e., three disjoint subsets of potential solution graphs represented by the three arcs emanating from s). To apply the best-first principle we need to use some criterion (f_1) for assessing the promise offered by these solution bases. Let us assume that we decide to pursue our search within whichever subset appears to contain the solution graph with the *smallest number of edges*. Although the problem itself is not posed as an optimization task (any solution graph will do), we can reasonably argue that the pursuit of the smallest graph automatically guides us toward an early termination.

Now, to rank our three candidates by this criterion, we need to obtain some information regarding the class of solution graphs stemming from each of the three given arcs. If the entire G graph were accessible, we could have ranked our candidates perfectly; all we would need to know is the size of the smallest

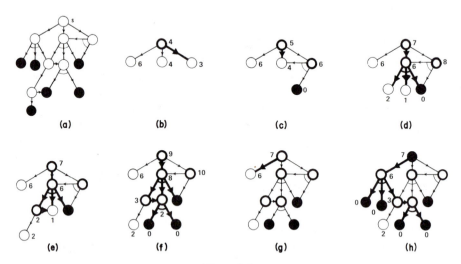

Figure 2.9

Successive steps in the execution of general-best-first (GBF) search on the implicit AND/OR graph of part (a). Solid circles represent solved nodes, heavy hollow circles nodes in CLOSED, and thin circles nodes in OPEN. The heavy lines stand, at each stage, for the current most promising solution base.

solution graph beneath each one of the three nodes currently on OPEN. Not having access to G itself, we must try to estimate the needed information from the descriptions of the nodes themselves, and from our general knowledge of the problem domain.

Assuming that such estimates were computed and gave the values 6, 4, and 3 to the three nodes on OPEN, we now make an additional assumption that these estimates be taken *at face value* for the purpose of computing the merit of each candidate solution base. Recalling that perfect estimates, if available, should be increased by one to give the required size assessment of our candidates, we apply the identical procedure to the imperfect estimates and obtain the values 7, 5, and 4. The best candidate appears to be the rightmost, with an overall estimate of 4, and this estimate can now be stored at s for later use.

This one simple step applied to the three nodes in Figure 2.9 involves two fundamental principles in heuristic programming. The choice of an auxiliary minimization criterion as a means to hasten the search invokes what we call the **small-is-quick** principle. That choice determines the kind of heuristic estimates h that should be provided in step 4 of *GBF*; h *should contain estimates of a set of parameters sufficient for the computation of the minimization criterion chosen*. Substituting these imperfect estimates for the actual values of the parameters constitutes the second principle and would be referred to as the **face-value** principle. Together these two principles determine the graph selection function f_1 in step 2 of *GBF*.

Following step 2, the rightmost candidate solution base is declared most promising, and its (only) OPEN node is expanded (step 3). This allows reevaluation of the candidate using the estimates assigned to its newly generated nodes. In our example (Figure 12.9(c)), the rightmost candidate was reevaluated to 7, rendering it inferior to the middle candidate, valued at 5. Therefore that latter candidate is declared most promising and draws future attention.

The graphs in Figure 2.9 illustrate successive developments of the search graph G' (in thin lines) and the shifting of its most promising solution base G_0 (in heavy lines). Figure 2.9(d) illustrates a situation where the node selection function f_2 is invoked for the first time. The reason for choosing the leftmost tip node of G_0 for expansion stems from the following argument: If the current G_0 is in fact a base of a legitimate solution, all its tip nodes must eventually be expanded, and the order of expansion is immaterial. If it is not, however, the most sensible node to expand would be the one that reveals the error the earliest.

To identify the node most likely to refute G_0's superiority, we need some information regarding the accuracy of each of the estimates. In the absence of such information all we can do is attempt to infer these accuracies from the magnitude of the estimates themselves, assuming, for example, that the errors are proportional to the magnitude of the estimates. In our example we may accordingly argue that the node most likely to prove G_0 inferior is the one with the largest size estimate, since a small percentage error in this estimate may

cause large fluctuations in the value of G_0. More elaborate selection criteria can be applied if additional information is available regarding the candidate tip nodes. For example, it would be appropriate to combine both the likelihood that a node turns unsolvable with the estimate of the effort required to demonstrate it.

Figure 2.9(e) raises another dilemma. One successor (marked 1) of the node expanded at this stage is already on OPEN, with size estimate 1. Should this estimate be also attributed to its second father, or ignored because it has already been counted by its first father? The first alternative compromises our decision to seek the solution graph with the smallest number of edges; we may find ourselves chasing graphs with a different measure of size where each edge is counted several times depending on the number of parents it has. The second alternative, counting each edge only once, severely complicates the computation of f_1, making it impossible to calculate the merit of candidate solution bases from the estimates assigned to their frontier nodes even if these estimates were exact.

Take, for instance, the nodes marked 1 and 2 in Figure 2.9(d) and assume that these estimates are exact. The value of the parent node would be 6 if the optimal solution graphs beneath these two nodes were disjoint. On the other hand, the value of the parent is only 5 if the two solution graphs share an edge as in Figure 2.9(e). This complication implies that the contribution of a given frontier node to the size of a solution base is no longer a constant but may vary depending on the nature of the solution base for which this node is being considered. For example, the node marked 2 in Figure 2.9(e) may contribute only one edge to the size of G_0 but may contribute two full edges to a solution base emerging from its other parent, such as that in Figure 2.9(h). Thus each candidate solution base must be recalculated separately with each node expansion, even if the candidates share a large portion of the graph in common.

In optimization problems we have no choice but to pursue the second alternative, counting each edge once. In satisficing problems, however, because the choice of optimization pursuit was only an auxiliary device for achieving the solution more quickly, we may compromise the optimization purity for the sake of a more efficient computation of f_1.

Provisions for Optimality: GBF.* In Figure 2.9(f) a solution graph is found, the start node is labeled "solved," and the algorithm terminates with the current structure of G_0 whose value is 9. This is not the smallest size solution though; Figure 12.9(h) contains one with only seven edges. To guarantee that the GBF algorithm terminates with an optimal solution graph as defined by the function f_1, all cost estimates must be optimistic (i.e., underestimating costs and overestimating merit) and the termination condition must be modified. Instead of accepting the first solution that induces a "solved" label on the start node (step 5c), we should check for termination only after G_0 is selected (step 2) to see if G_0, in isolation, constitutes a solution graph. Thus, the modified al-

gorithm, which we call *GBF**, would simply discard step 5c, and modify step 2 to read:

2'. Compute the most promising solution-base graph G_0; if all leaf nodes of G_0 are "solved," exit with G_0 as a solution graph.

Applying *GBF** to the situation in Figure 12.9(f) we see that the last expansion has increased the size of G_0 to 9, thus rendering it no longer most promising. Instead, the leftmost branch of Figure 12.9(g) promises a size of 7 and now assumes the G_0 status. In the next step, Figure 2.9(h), a new G_0 is found that retains its most-promising status and simultaneously proves to be a legitimate solution graph; at this point the algorithm terminates.

The fact that **GBF* always finds an optimal solution graph** (if the f_1 estimates are optimistic) can be seen by viewing the solutions as points in some space, the solution bases as subsets of points in that space and the operation of node expansion as the act of splitting those subsets. Since the estimates assigned to the subsets are optimistic (i.e., they exaggerate the merit of the best point in each subset) and the algorithm terminates only when it attempts to split the best subset and finds that it is a point (where the estimate is accurate), the point found could not be inferior to some other point. If it were, the subset containing that other point would have been chosen for splitting on account of its overly optimistic estimate.

This argument is the basis for the branch-and-bound method in operations research and several results in heuristic search theory. It will be proven formally in Chapter 3 in the context of path-seeking problems. The formal proof, however, essentially mirrors the steps of the set-splitting argument but lacks the latter's generality and appeal.

Relations between GBF and BF. If we let *GBF* search a state-space graph G (where all nodes are OR nodes), its operation would resemble that of *BF*. The two differ, however, in one essential feature: whereas *GBF* traverses the implicit graph G using an explicit *subgraph G'*, *BF* traverses G using a *subtree T*. This difference results from step 2 of *BF* where, if a node is found to have two parents, an *irrevocable decision* is made to *discard* the one with the higher f value. That leaves each tip node in T to represent one unique solution base (the path leading to that node) and permits us to characterize the merit of each node with one parameter. Such irrevocable decisions are often justified in state-space search where the relative merits of the two contending solution bases usually will not be altered by new information regarding their common extension and where, more significantly, if one base is solvable, so is the other. These decisions are rarely justified in searching AND/OR graphs though, because one parent can be part of a solution graph, whereas the other parent may not be in one. So, by discarding one parent, we may be removing an edge from the only solution graph possible.

Note, however, that under certain circumstances parent-discarding may not be allowable even in path-seeking problems. For example, if we must find a path containing two edges with equal cost, we run the risk that the discarded subpath will turn out to contain the cost-matching edge needed for a solution. For that reason, *BF* can be guaranteed not to miss a solution only when the criterion qualifying a path as a solution invokes the properties of the *last* node on the path, but not when it depends on global properties of the path as a whole. This condition is assumed throughout our discussions, thus ruling out problems such as: "find the shortest path containing two equal edges."

In the preceding section we saw that if an optimal solution is required, *GBF* should be modified by retarding its termination test, thus leading to algorithm *GBF**. A similar modification can be performed on *BF* if we only delay its termination until a goal node is actually selected for expansion. The resulting procedure would naturally be called *BF**, but its optimality guarantees are more involved than those of *GBF** because of the irrevocable parent-selection step of *BF*. For example, if we seek a path to a goal that has the smallest difference between the most costly and the least costly edges, we cannot discard one parent from future consideration simply because it currently represents a path with a higher difference than a competitor parent. The preference can easily be reversed through extension of the subpath common to the two parents (see exercise 2.4). In the next section and in Chapter 3 we establish conditions that guarantee that *BF** terminates with an optimal solution.

2.4 SPECIALIZED BEST-FIRST ALGORITHMS: Z*, A*, AO, AND AO*

2.4.1 Why Restrict the Evaluation Functions?

In their current general form, the algorithms describing *BF* and *GBF* are merely skeletons of strategies and are far from exhibiting the details necessary for implementation. Since the preference functions, f for *BF* and both f_1 and f_2 for *GBF*, remain arbitrary, the algorithms do not specify how these functions are computed, where the information needed for deciding the "best" choice comes from, or how it propagates through the graph. These issues constitute a major component of the search effort and will, therefore, play an important role in the taxonomy of best-first algorithms.

In large graphs, the computation of f_1 would be a hopeless task if each candidate subgraph had to be evaluated separately or if the entire set of candidates had to be reevaluated afresh with each node expansion. In the example of Figure 2.9, however, the computation of f_1 was facilitated by two main features:

1. *Shared computations* —intermediate computations in the evaluation of some solution candidates could be saved and reused in the evaluation of other candidates.

2. *Selective updating* —only ancestors of newly expanded nodes required updating, whereas all other nodes retained their values unaltered.

These two useful features are results of the **recursive** nature of the cost function chosen as a target of pursuit, that is, because the cost of solving node n could be determined from the costs of solving its successors. Indeed, we saw in Figure 2.9(e) how attempting to minimize the number of graph edges (a non-recursive cost measure) led to computational difficulties, and how these difficulties disappeared as soon as we settled for minimizing a compromised measure, the number of edges in the tree-unfolding of the graph, which can be computed recursively. Much greater complications would have arisen had we chosen a more elaborate minimization measure, such as the median weight of the edges in the graph. (The median of a set of n numbers is the $(n/2)$th smallest number in the set.) This measure is notoriously difficult because it defies recursive formulation; the median of a set cannot be computed from the medians of its subsets but requires the values of every individual element in the set.

Fortunately common cost or merit criteria do not possess these difficulties. They exhibit a certain regularity in the way they combine, which greatly simplifies the implementation of best-first strategies. This regularity is formalized in the next section using the domain of AND/OR graphs.

2.4.2 Recursive Weight Functions

For a given solution graph G, we designate its weight by W_G, where W_G is that property of G chosen as an optimization measure, representing either merit (Q) or cost (C). If we remove from G all nodes but those that are descendants of some given node n, the remaining portion of the graph is a solution graph for n, and its weight is denoted by $W_G(n)$. In general, the weight of any solution graph may be a complex function of all the quantities in the graph: node weights (e.g., representing processing delays), arc weights (e.g., representing transition costs), and terminal node weights (e.g., representing final payoffs).

DEFINITION: *A weight function* $W_G(n)$ *is* **recursive** *if for every node n in the graph*

$$W_G(n) = F[\mathbf{E}(n); W_G(n_1), W_G(n_2), \ldots, W_G(n_b)] \qquad (2.1)$$

where: n_1, n_2, \ldots, n_b *are the immediate successors of n.*
 $\mathbf{E}(n)$ *stands for a set of local properties characterizing the node n.*
 F is an arbitrary combination function, monotonic in its $W_G(\cdot)$ *arguments.*

If such a combining function F exists, it is possible to evaluate the merit of any given solution graph from the bottom up, starting at the payoffs associated with the terminal nodes and working upward until the merit of the entire solu-

tion graph is computed at the root node. The process is similar to the "solve" labeling procedure described in Section 1.2.3 and will henceforth be called the **cost labeling, merit labeling,** or **weight labeling** procedure, as the case requires. *F* is sometimes called the **rollback function.**

Let us demonstrate the weight-labeling procedure on a few typical examples:

1. **The Counterfeit Coin problem with the maximum number of tests as a weight measure.** The solution objects are test-specification graphs where the terminal nodes represent an identified coin and the nonterminal nodes are of two types: *action nodes* (OR nodes with a single successor specifying the type of test to be conducted) and *outcome nodes* (AND nodes whose AND links point at the three possible outcomes of each test). The overall cost of a given solution graph *G* is taken to be the number of tests along the longest path in the graph. Thus the cost combining function can be written:

$$C_G(n) = \begin{cases} 0 & \text{if } n \text{ is terminal} \\ 1 + C_G(n_1) & \text{if } n \text{ is an OR node} \\ \max_{i=1,2,3} [C_G(n_i)] & \text{if } n \text{ is an AND node} \end{cases} \qquad (2.2)$$

2. **The Counterfeit Coin problem with the expected testing cost as a weight measure.** Let $c(n, n')$ be the cost of the test represented by the arc from *n* to *n'*, and let p_1, p_2, and p_3 be the probabilities associated with the three outcomes of any given test. The expected cost of the strategy represented by a solution graph *G* rooted at *n* is given by:

$$C_G(n) = \begin{cases} 0 & \text{if } n \text{ is terminal} \\ c(n, n_1) + C_G(n_1) & \text{if } n \text{ is an OR node} \\ \sum_{i=1,2,3} p_i C_G(n_i) & \text{if } n \text{ is an AND node} \end{cases} \qquad (2.3)$$

3. **Game-playing strategies.** The quality *Q* of a given strategy *S* is determined by the payoff $v(n)$ given to player 1 from the terminal node *n* which is eventually reached. Assuming, however, that player 2 acts in such a way as to minimize this payoff, we have:

$$Q_S(n) = \begin{cases} v(n) & \text{if } n \text{ is terminal} \\ Q_S(n_1) & \text{if } n \text{ admits moves by player } 1 \\ \min_i Q_S(n_i) & \text{if } n \text{ admits moves by player } 2 \end{cases} \qquad (2.4)$$

Thus the quality of any fixed strategy is given by the lowest payoff over all the terminal nodes in the graph representing this strategy.

These three examples represent the use of the two most common cost-combination rules: maximum-cost and (weighted) sum-cost. In these exam-

ples the local properties $\mathbf{E}(n)$ that influence the combination rule are the costs and probabilities associated with the arcs and some characteristics of the node itself, for example, whether it is a terminal node, an OR node, or an AND node.

2.4.3 Identifying G_0, The Most Promising Solution-Base Graph

We will now demonstrate how the recursive nature of the weight measure W simplies the task of rating the candidate solution bases. We assume that the weight signifies the quality or merit of a given solution with the understanding that *cost measures are simply the negative of quality*.

If the entire search space had been explored, an *optimal* solution graph could be constructed and its quality $Q^*(s)$ could be computed by taking the maximum of $Q_G(s)$ over all solution graphs rooted at s. This maximization can be performed recursively by the following **merit-labeling procedure**:

1. If n is a terminal node, then $Q^*(n) = v(n)$, where $v(n)$ is the terminal payoff associated with n.
2. If n is a nongoal node without successors thus representing an unsolvable subproblem, then $Q^*(n)$ is $-\infty$.
3. If n is an AND node with successors n_1, n_2, \ldots, n_b, then
 $Q^*(n) = F[\mathbf{E}(n); Q^*(n_1), Q^*(n_2), \ldots, Q^*(n_b)]$.
4. If n is an OR node with successors n_1, n_2, \ldots, n_b, then
 $Q^*(n) = \max_i F[\mathbf{E}(n), Q^*(n_i)]$.

According to this definition, $Q^*(n)$ is finite if and only if the problem represented by node n is solvable. For each solvable n, $Q^*(n)$ gives the quality of an optimal solution graph rooted at n. If s is the start node, then $Q^*(s)$ is the quality of an optimal solution to the initial problem.

For example, in example 2 of the Counterfeit Coin problem in Section 2.4.2, the optimal cost $C^*(n)$ associated with subproblem n is computed by the cost-labeling procedure:

$$
C^*(n) = \begin{cases} 0 & \text{if } n \text{ is terminal} \\ \min_i[c(n, n_i) + C^*(n_i)] & \text{if } n \text{ is an OR node} \\ \sum_i p_i C^*(n_i) & \text{if } n \text{ is an AND node} \end{cases} \qquad (2.5)
$$

In game-playing (example 3 in Section 2.4.2), the merit-labeling procedure yields the celebrated minimax rule:

$$Q^*(n) = \begin{cases} v(n) & \text{if } n \text{ is terminal} \\ \max_i [Q^*(n_i)] & \text{if } n \text{ admits moves by player 1} \\ \min_i [Q^*(n_i)] & \text{if } n \text{ admits moves by player 2} \end{cases} \quad (2.6)$$

The **optimal solution graph** G^* is likewise defined in terms of Q^*.

DEFINITION OF G^*:
1. *The start node s is in G^*.*
2. *If an AND node is in G^*, all its (AND) successors are in G^*.*
3. *If an OR node n is in G^*, one successor n' of n is in G^* such that*
 $F[\mathbf{E}(n); Q^*(n')] = \max_i F[\mathbf{E}(n); Q^*(n_i)].$

If the search space is only partially explored, there is no way, of course, to compute the optimal solution or even to identify which among the solution bases unraveled leads to an optimal solution. However, if each node n at the search frontier is assigned an *estimate* $h(n)$ of $Q^*(n)$, we may invoke the face-value principle and compute what appears to be the **most promising potential solution**. This solution is computed in two steps:

1. Assign to each tip node n of a solution base an evaluation function $h(n)$ which estimates the quality of the best solution rooted at n.
2. Use the combining function F and the merit-labeling procedure *as if* the estimates $h(n)$ were true terminal payoffs (the face-value principle).

These two steps offer constructive definitions of the function f_1 and the most promising solution base G_0, both of which are used in step 2 of *GBF*. First, we define a **backed-up evaluation function** $e(n)$ which gives an estimate of $Q^*(n)$ for all nodes of the explored graph:

$$e(n) = \begin{cases} h(n) & \text{if } n \text{ is in OPEN} \\ F[\mathbf{E}(n); e(n_1) \cdots e(n_b)] & \text{if } n \text{ is a CLOSED AND node} \\ \max_i F[\mathbf{E}(n); e(n_i)] & \text{if } n \text{ is a CLOSED OR node} \end{cases} \quad (2.7)$$

This evaluation function gives rise to the following top-down definition of G_0.

DEFINITION OF G_0:
1. *The start node s is in G_0.*
2. *If a CLOSED AND node is in G_0, all its (AND) successors are in G_0.*
3. *If a CLOSED OR node n is in G_0, one (OR) successor n' of n is in G_0, such that $e(n) = F[\mathbf{E}(n); e(n')]$.*

In practice, the identification of G_0 can be done bottom-up, together with the computation of $e(n)$, by simply marking the OR successor that has the highest value of e among its siblings.

In this procedure, G_0 is identified without making explicit use of the graph selection function f_1, however, if one wishes to assess the promise $f_1(G')$ of any candidate solution-base graph G', all that is required is to compute e bottom-up along the arcs in G' (each OR node will have only one successor since G' is a solution base). The value finally assigned to the start node $e_{G'}(s)$, is equal to the required promise estimate $f_1(G')$:

$$f_1(G') = e_{G'}(s) \tag{2.8}$$

It is interesting to see how *BF* can use this procedure to compute the node selection function $f(n)$ while traversing an OR graph. Since *BF* explores the graph using a traversal tree T, each node n on OPEN takes part in only one solution base, given by the path $P(n)$ from s to n, currently in T. To decide (in step 3 of *BF*) which node warrants expansion, the evaluation function $e_{P(n)}(s)$ must be assigned to each node on OPEN, where $e_{P(n)}(s)$ is computed bottom-up (using F as in Eq. 2.7) along the unique path connecting s and n. Thus the function $f(n)$, computed in step 6 of *BF*, is merely the negative of $e_{P(n)}(s)$:

$$f(n) = -e_{P(n)}(s) \tag{2.9}$$

(Tradition dictates that f should represent costs and therefore be minimized, whereas e represents merits and is to be maximized.)

Under normal circumstances (e.g., when the solution weight is determined by the sum cost of its edges), we need not traverse the entire path from n to s to compute $e_{P(n)}(s)$. A few auxiliary parameters stored at the parent of n would permit $e_{P(n)}(s)$ to be calculated locally and be transmitted, from father to son, with each node expansion. These parameters correspond to the notion of state description in dynamic programming (Dreyfus and Law, 1977). For example, in the case of the additive cost measure, we need to transmit only one parameter, $g(n)$, which is the overall cost along the path $P(n)$, and this gives rise to the celebrated $A*$ algorithm (Nilsson, 1971) with heuristic function:

$$f(n) = -e_{P(n)}(s) = g(n) + h(n) \tag{2.10}$$

for each node on OPEN.

2.4.4 Specialized Best-First Strategies

If the selection functions f_1 (for *GBF*) and f (for *BF*) are computed recursively by the rollback procedure of Eqs. (2.7) and (2.8), these algorithms assume special names; *BF* becomes what we will call algorithm **Z** and *GBF* becomes

AO. If we further modify these algorithms by delaying the termination test as was done in *GBF**, *Z* becomes **Z*** and *AO* becomes **AO***.

The motivation for delaying the termination test until G_0 is selected lies, of course, in the hope of returning an optimal solution when one is required. This hope will be realized for *AO** if the heuristic estimates *h* of the tip nodes are optimistic (i.e., overestimating merits and underestimating costs), because under such conditions the estimates $f_1(G')$ are also optimistic for all solution bases, and, invoking the same set-splitting argument used for *GBF**, *AO** cannot return a suboptimal solution.

The optimality condition for *Z** is slightly more involved due to the parent-selection step of *BF*. In addition to requiring that the estimates $h(n)$ be optimistic, we still need to ascertain that by discarding the parent with the inferior *f* value we do not in fact throw away the optimal solution path. This would be guaranteed when the rank order of two contending parents remains independent of the path rooted at their common child. Therefore, we need also to require that *F*, the rollback function that defines the cost of any given path, satisfies:

$$F(\mathbf{E}_1, h) \geqslant F(\mathbf{E}_2, h) \implies F(\mathbf{E}_1, h') \geqslant F(\mathbf{E}_2, h') \qquad (2.11)$$

for all $\mathbf{E}_1, \mathbf{E}_2, h$ and h'. If the path-cost definition satisfies the **order-preserving** property of Eq. (2.11) and the estimates $h(n)$ are optimistic, *Z** terminates with an optimal (lowest cost) path. Fortunately the two most commonly used weight measures—the additive cost (where $F = c(n, n') + h(n')$) and the max cost (where $F = \max[c(n, n'), h(n')]$)—do satisfy this property. A more general discussion of the order-preserving restriction is given in Section 3.3, pertaining to the optimality of *BF**.

So far we have encountered eight variations of best-first strategies, four suitable for AND/OR graphs (*GBF*, *GBF**, *AO*, and *AO**) and four limited to searching OR graphs (*BF*, *BF**, *Z*, and *Z**). Before introducing our last strategy, the celebrated specialization of *Z** called *A**, it is instructive to reiterate the relationships between the algorithms defined so far. They are illustrated in the hierarchical diagram of Figure 2.10, where each arrow specifies the restriction placed on the parent algorithm in order to produce the more specialized successor.

Figure 2.10 also shows the position of *A** in this hierarchy; it is a specialization of *Z** where the target of pursuit is the path of minimum sum-cost. *A** may be used both for optimization problems and satisficing problems because the shortest path is the most natural choice for the small-is-quick principle. The reader may wonder why Figure 2.10 does not contain an additive-cost successor of *AO**, which, in fact, was described in the example of Figure 2.9. The reason is simply that the additive-cost condition does not introduce a significant enough change in the algorithm to warrant a new name. *A**, too, is only slightly different from *Z**; however, in order to keep our notation consistent with the

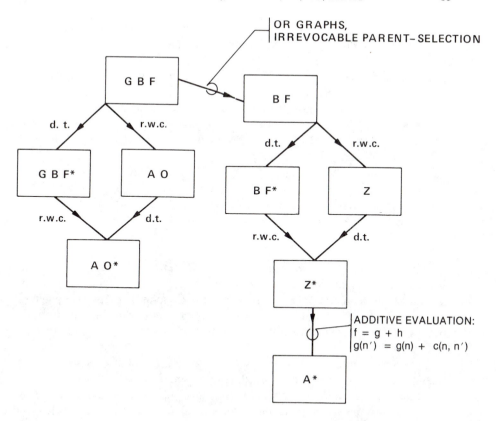

Figure 2.10
Hierarchical diagram showing the relationships between the nine best-first
algorithms discussed in Section 2.4 (d.t. stands for delayed-termination;
r.w.c. stands for recursive-weight-computation).

large body of literature on $A*$ and out of respect for its inventors (Hart, Nilsson, and Raphael, 1968) we prefer to keep its traditional name intact.

Since $AO*$ and $A*$ are the most popular strategies in use, we now give an explicit description of these two algorithms, followed by a few words of explanation. A formal treatment of the properties of $A*$ and $BF*$ is to be found in Chapter 3.

The AO* Algorithm

1. Create a search graph G' initially consisting of the start node s. Put s on OPEN. Let G_0 initially include just s.
2. Trace down the marked connectors of a subgraph G_0 (G_0 stands for the most promising solution-base graph, and its connectors are marked in step 7) and inspect its tip nodes.

3. If OPEN \cap G_0 is empty, exit with G_0 as a solution graph; otherwise
4. Select an OPEN node n in G_0 using a selection function f_2. Remove n from OPEN and place it on CLOSED.
5. Expand n, generating all its successors; put them on OPEN and add them to the search graph G' with pointers back to n.
6. Calculate for each nonterminal successor, n', a heuristic merit estimate $h(n')$. If n' is terminal with payoff $v(n')$, set $h(n') = v(n')$ and move n' from OPEN to CLOSE; if n' is unsolvable, set $h(n') = -\infty$. If n' is already in G', set $h(n') = e(n')$.
7. Revise the evaluation $e(\cdot)$ of n and all its ancestors, using the rollback function F. Mark the best arc from every updated OR node to identify G_0.
8. If $e(s)$ is updated to $-\infty$, exit with failure. Otherwise remove from G' all nodes that can no longer influence the value of s.
9. Go to step 2.

AO^* terminates when the current G_0 has no more OPEN tip nodes, that is, when all its tip nodes are solved terminals (if any of its terminals were unsolvable, s would be marked $-\infty$). If the weight of a solution graph G is given recursively by Eq. (2.1) and the estimates $h(n)$ are optimistic assessments of the weight of the optimal solution to n, then AO^* will exit with the optimal-weight solution.

In step 8 the process of pruning away nodes that cannot provide useful information remains unspecified. Indeed, with a general AND/OR graph and an arbitrary F, not many nodes would meet this pruning criterion, since subsequent expansions may significantly alter the values of all nodes on OPEN and their ancestors. Only unsolvable nodes are truly safe from future alterations and can be pruned away. If, however, F is known to comply with additional restrictions (e.g., that $e(n)$ cannot increase by expansion) or if the graph searched is a tree, this pruning can result in substantial savings. We therefore postpone description of the pruning process until we have discussed some specific types of F functions.

The A* Algorithm

1. Put the start node s on OPEN.
2. If OPEN is empty, exit with failure.
3. Remove from OPEN and place on CLOSED a node n for which f is minimum.
4. If n is a goal node, exit successfully with the solution obtained by tracing back the pointers from n to s.
5. Otherwise expand n, generating all its successors, and attach to them pointers back to n. For every successor n' of n:
 a. If n' is not already on OPEN or CLOSED, estimate $h(n')$ (an estimate of the cost of the best path from n' to some goal node), and calculate $f(n') = g(n') + h(n')$ where $g(n') = g(n) + c(n, n')$ and $g(s) = 0$.

b. If n' is already on OPEN or CLOSED, direct its pointers along the path yielding the lowest $g(n')$.

c. If n' required pointer adjustment and was found on CLOSED, reopen it.

6. Go to step 2.

The more general algorithm Z^* follows essentially the same steps as A^* with one modification. In step 5a the calculation of $f(n')$ may invoke an arbitrary function of the form $f(n') = F[\mathbf{E}(n), f(n), h(n')]$, where $\mathbf{E}(n)$ is a set of local parameters characterizing n (e.g., $c(n, n')$). Similarly, in step 5b Z^* will direct pointers along the path of lowest $f(n')$ (instead of lowest $g(n')$). It is also worth noting that the breadth-first strategy (Section 2.2.2) is a special case of A^* with $h = 0$ and $c(n, n') = 1$ for all successors. Similarly, the uniform-cost strategy (Section 2.2.2) is also a special case of A^* with $h = 0$. Depth-first strategies, on the other hand, can be obtained from Z^* by setting $f(n') = f(n) - 1, f(s) = 0$.

2.5 HYBRID STRATEGIES

The three main search strategies described in the preceding section, that is, **hill-climbing (HC), backtracking (BT), and best-first (BF)**, can be viewed as three extreme points of a continuous spectrum of search strategies. To demonstrate this point, it is convenient to characterize search strategies along the following two dimensions:

1. **Recovery of pursuit (R):** The degree to which a search strategy allows recovery from disappointing search avenues to reaccess previously suspended alternatives.

2. **Scope of evaluation (S):** The number of alternatives considered in each decision.

Along the R dimension we find HC at one extreme, permitting no recovery whatsoever of suspended alternatives, and BT and BF at the other extreme, where all decisions are tentative and all suspensions are revocable. Along the S dimension we find HC and BT focusing narrowly on the set of newly available alternatives, whereas BF examines before each decision the entire set of available alternatives, those newly generated as well as all those suspended in the past.

These extreme cases are illustrated schematically in Figure 2.11. The shaded area represents a continuous spectrum of search strategies that combine some characteristics from each of the three prototypes in order to achieve a better mix of their computational features. To recapitulate, recall that HC spends the minimal amount of computation at the risk of missing the solution. BF

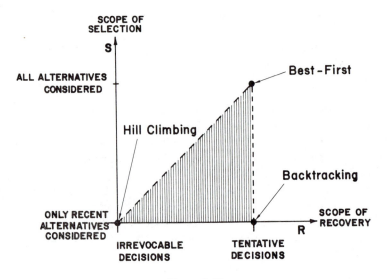

Figure 2.11
Hill-climbing (HC), backtracking (BT), and best-first (BF) strategies as
three extreme points in a 2-dimensional space of hybrid strategies.

proceeds wisely and cautiously; it will find the solution (if one exists) after the
fewest possible decisions but must pay dearly in node storage for these judi-
cious decisions. *BT* is committed to maintaining in storage only a single path
containing the set of alternatives leading to the current decision point. It
proceeds forward heedlessly by considering only a narrow scope of young al-
ternatives, and so it usually pays for its memory economy in increased run-
time.

2.5.1 *BF-BT* Combinations

If one cannot afford the memory space required by a pure *BF* strategy, various
BF-BT combinations can be implemented that cut down the storage require-
ment at the expense of narrowing the evaluation scope. One such combination
is depicted in Figure 2.12(a), where the *BF* strategy is applied at the top of the
search graph (represented by the shaded area with the irregular frontier) and a
BT strategy at the bottom (represented by the left-to-right arrow). As soon as
the memory space allotted to the *BF* strategy is exhausted, the *BT* search takes
over from the best node on OPEN until the entire graph beneath that node is
traversed. If *BT* fails to find a solution, this node is declared unsolvable and
the second best node on OPEN is taken as a new root for a *BT* search, and so
on.

 An opposite approach is shown in Figure 2.12(b). Here *BT* is employed at
the top of the graph, whereas *BF* is used at the bottom. We begin *BT* until a
depth-bound d_0 is reached. At this point, instead of backing up, we employ a

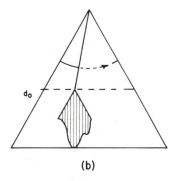

(a) **(b)**

Figure 2.12
Schematic representations of two BF-BT hybrid strategies. Part (a) represents a BF search on top (shaded area) followed by BT ending. Part (b) represents a BT start (left-to-right arrow) followed by BF ending.

BF search from the node at d_0 until it returns a solution or exits with failure. If it fails to find a solution, we return to backtracking and again use BF upon reaching the depth-bound d_0. The parameter d_0 is chosen in such a way that the memory consumed by the BF strategy will not exceed the available allotment. It is harder to control than the strategy in Figure 2.12(a), where memory utilization itself was the mechanism that triggered the transition from BF to BT, but employing BF at the bottom of the graph has an advantage. BF performance is at its best when its guiding heuristic is more informed, and this usually happens at the bottom of the search graph, where the differences between promising nodes and dead-end nodes are more apparent.

A more elaborate scheme is shown in Figure 2.13, where BF is performed locally and BT globally. We begin searching in a best-first manner until a memory allotment M_0 is exhausted. At this point we regard all the nodes on OPEN as direct successors of the root node and submit them to a BT search. BT selects the best among these successors and "expands" it using BF search, that is, it submits the chosen node to a local BF search until a new memory allotment M_0 is consumed and treats the new nodes on OPEN as direct successors of the node "expanded." In summary, this strategy amounts to running an informed depth-first search where each node expansion is accomplished by a memory-limited BF search and the nodes on OPEN are defined as children. The overall memory required for this strategy is equal to M_0 times the maximum length of the global traversal path. It is linear with the depth of the search graph, in contrast to the exponential memory growth required by purely BF strategies.

Ibaraki (1978b) has proposed another scheme of mixing BF and BT strategies. Whereas informed depth-first seach considers for expansion only the newly generated nodes, Ibaraki's scheme expands the scope of selection to include, in addition to the set of new successors, the k best alternatives from the set considered at the previous decision. Thus, at the t^{th} decision, the node ex-

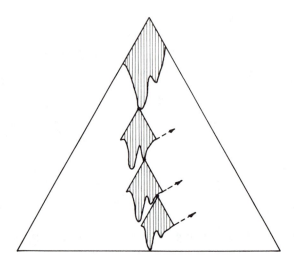

Figure 2.13

Schematic representation of a hybrid BF-BT strategy. Local BF searches (shaded areas) are nested in a global BT traversal.

panded is the best within a subset of OPEN, which we will call FOCAL(t), containing the set of newly generated nodes together with the k best nodes of FOCAL($t - 1$). Clearly, the case $k = 0$ corresponds to pure depth-first while $k = \infty$ amounts to pure *BF*. Although this scheme does not possess an elegant geometrical representation such as those shown in Figures 2.12 and 2.13, Ibaraki was able to show that the storage consumed by this strategy is equal to bN^{k+1} where N is the depth of the search tree and b is its branching degree. One can, therefore, adjust k to meet practical storage limitations.

2.5.2 Introducing Irrevocable Decisions

The need to combine *BF* and *BT* strategies was a result of computational considerations aimed at finding a good storage-time mix when storage space is limited. These combinations retained the purely tentative nature of all decisions. As soon as we introduce irrevocable decisions of the hill-climbing type, permanently discarding alternatives before they are proven fruitless, we also introduce a risk of missing a solution and exiting with failure, or returning a bad solution when an optimal one is required. Occasions may arise in which even the storage required for local best-first search is too large and purely depth-first strategies are too time consuming. In such cases, it may be desirable to take a risk and prune the tree so far generated by the search in order to free needed storage space and allow the search to continue deeper.

A pruning technique that has gained some popularity is called **staged search** (Nilsson, 1971) and proceeds as follows. Instead of maintaining in storage the

entire search tree generated by a *BF* search, only the most promising subtree is retained. At the end of each storage reclamation stage, some subset of nodes on OPEN (e.g., those having the lowest values of f) are marked for retention. The best paths of these nodes are remembered, and the rest of the tree is thrown away. The search then continues in a best-first manner until the storage allotment is again exhausted, thus marking the end of a new storage reclamation stage, and so on. This strategy can be regarded as a hybrid between best-first and hill-climbing; whereas pure hill-climbing discards all but a single best candidate, staged search discards all but a *set* of best candidates. Still, following the best-first philosophy, the scope of selection now includes all candidates available at the decision time.

An important variant of staged search also introduces an element of *BT* search into the *HC-BF* mixture. It is tailored after the hybrid strategy of Figure 2.13, but instead of submitting the entire frontier of the local *BF* search to a global *BT*, only the best subset of these frontier nodes are retained whereas the rest are discarded permanently. Of course, even if *A* * is used in each stage and the whole process does terminate in a solution path, there is now no guarantee that it is an optimal path. In Chapter 5 we analyze a version of this search strategy and show that under certain conditions one can choose the search parameters (e.g., the size of the local search tree and the threshold of pruning) in such a way that the search will run in linear average time and the solution found will almost always fall in an arbitrarily close neighborhood of the optimal solution.

2.6 BIBLIOGRAPHICAL AND HISTORICAL REMARKS

The book by Horowitz and Sahni (1978) contains a thorough discussion of backtracking and other search methods including a more detailed specification of the computational steps involved. Improvements on the basic backtracking algorithm are reported and analyzed by Gaschnig (1979a), Haralick and Elliot (1980), and Nudel (1983). Look-ahead methods of solving satisficing problems, sometimes called "relaxation," "constraint propagation," or "consistency checking," were introduced by Rosenfeld, Hummel, and Zucker (1976), Waltz (1975), Montanari (1974), and Mackworth (1977). These are especially effective in object-recognition tasks where constraints have a local character (e.g., only few lines meet in each vertex of a polyhedran object).

Systematic, uninformed graph-searching procedures are normally discussed under the topic "shortest path problems." Moore's (1959) maze searching algorithm is essentially a breadth-first strategy, while Dijkstra's (1959) two-point shortest path algorithm is what we call uniform-cost (or *A* * with $h = 0$). An up-to-date survey of shortest path methods is given in Deo and Pang (1982). Dynamic programming (Bellman and Dreyfus, 1962) is a recursive formulation of breadth-first search which, for search spaces with regular structures, may yield analytical expressions for the optimal cost or the optimal policy.

The use of heuristic information to increase search efficiency has been studied both in artificial intelligence (*AI*) and in operations research. In operations research the most common representation for this information has been the bounding functions which govern the branch-and-bound search (Lawler and Wood, 1966). In AI, general heuristic search methods applicable to a variety of problem domains were developed by Newell, Shaw, and Simon (1957, 1960). The use of evaluation functions to direct search in graphs was proposed by Lin (1965) who applied it to the Traveling Salesman problem. Doran and Michie (1966) formulated and experimented with a *BF* search algorithm (the Graph Traverser) guided by a distance-to-goal estimate. Hart, Nilsson, and Raphael (1968) recognized the applicability of the algorithm to optimization problems when the estimates are optimistic and have established the basic properties of the A^* algorithm (to be discussed in Section 3.1).

A^* is one of several versions of heuristic shortest-path algorithms introduced by several workers (Michie and Ross, 1970; Slagle and Bursky, 1968; Pohl, 1970; and Nilsson, 1980). Our description of A^* follows that of Nilsson (1971). It differs from that of Nilsson (1980) where the condition $h \leqslant h^*$ is imposed (otherwise the algorithm is called A) and where a search graph (in addition to a search tree) is maintained (see discussion in Section 2.3.1). Bidirectional versions of A^*, which simultaneously explicate the graph from both the start node and from the set of goal nodes, were introduced by Pohl (1971), and further investigated by de Champeaux and Sint (1977).

Techniques for searching AND/OR graphs were first introduced by Amarel (1967), Nilsson (1969), and Chang and Slagle (1971). Our description of AO^*, and to a great extent also GBF and GBF^*, is based on that of Nilsson (1971). More recent versions of AO^*, making use of the monotonic properties of the cost functions, have been introduced by Martelli and Montanari (1973, 1978). Of the nine best-first algorithms mentioned in Section 2.4 (see Figure 2.10), only A^* and AO^* can be found in the general literature under identical acronyms. The names given to the other seven algorithms were contrived so as to best convey their similarities and differences.

EXERCISES

2.1 Consider the 8-Puzzle with start node $s = \begin{bmatrix} 2 & 8 & 3 \\ 1 & 6 & 4 \\ 7 & & 5 \end{bmatrix}$ and goal node $\gamma = \begin{bmatrix} 1 & 2 & 3 \\ 8 & & 4 \\ 7 & 6 & 5 \end{bmatrix}$

Execute the A^* algorithm using the following heuristics:

a. $h = 0$

b. h_1 = number of misplaced tiles

c. h_2 = sum of Manhattan distances

d. $h_3 = 3$ times seq(n) where seq(n) counts 1 for a central tile and counts 2 for each tile on the board perimeter that is not followed (in clockwise order) by its proper successor.

In each of the preceding cases count the number of nodes expanded and display the explicit search tree at termination.

e. Evaluate the performance of hill-climbing strategies using the heuristics in (a), (b), and (c).

2.2 A language L has a four-character vocabulary $V = \{\epsilon, A, B, C\}$ where ϵ is the empty symbol. The probability that character v_i will be followed by v_j is given by the following matrix:

$$P(v_j \,|\, v_i) =$$

v_i \\ v_j	ϵ	A	B	C
ϵ	1/4	1/4	1/4	1/4
A	1/2	0	1/4	1/4
B	1/8	1/2	1/8	1/4
C	1/4	1/8	1/2	1/8

Do parts (a), (b), and (c) using the uniform-cost algorithm.

a. Find the most likely five-symbol string that starts with ϵ.

b. Find the most likely five-symbol string that starts and ends with ϵ.

In transmitting messages from L, some characters may be corrupted by noise and be confused with others. The probability that a transmitted character v_j will be interpreted as v_k is given by the confusion matrix:

$$P_c(v_k \,|\, v_j) =$$

v_j \\ v_k	ϵ	A	B	C
ϵ	.9	.1	0	0
A	.1	.8	.1	0
B	0	.1	.8	.1
C	0	.1	.1	.8

c. Find the message most probably to have been transmitted given that the string ϵ ϵ B C A A ϵ ϵ is received, and knowing that all messages must begin and end with ϵ.

d. Repeat parts (a), (b), and (c) using backtracking. Compare the number of nodes generated and the storage required by the two algorithms.

e. Can you think of a reasonable heuristic function h to be used in A^* on part (c)?

(Remark: You may wish to consult the literature on Viterbi's algorithm, e.g., Forney, 1973; or Bahl, Jelinek, and Mercer, 1983.)

2.3 a. Find a reasonable evaluation function e and execute AO^* to find the solution to the card game of exercise 1.1.

 b. Consider a modified version of the game where the cards are labeled 7, 5, 8, 2, and 1, and the first player wins as many points as the number labeled on the last remaining card. Find an optimistic evaluation function and execute AO^* to find the best first move. Specify a pruning criterion for step 8 of AO^*.

 c. Repeat part (b) for another modification of the game: each player receives a score equal to the sum of the card values that he removed minus those removed by the opponent.

 d. Repeat part (c) assuming that the second player, in his turn, flips a coin to decide his move.

 e. Repeat part (b) assuming that the second player always removes the leftmost card, that the game begins with the set 4, 3, 2, 5, 7, 1, 8, 6, and that the first player receives a score equal to the sum of the card values that he removes.

 f. Solve part (e) using A^*.

2.4 This problem requires the execution of GBF^* on an OR graph. Consider the following variation of the card game, played by a single player. In each move the player removes one element from either end of a given list of numbers. His cost is equal to the difference between the highest and the lowest number removed at odd moves.

 a. Write a detailed description of a GBF^* algorithm that can solve instances of this problem. Determine the set of heuristic parameters h necessary to guarantee optimality, specify the selection functions f_1 and f_2, and devise a convenient code for storing solution bases.

 b. Under what conditions can candidate solution bases be purged from future considerations?

 c. Find the optimal sequence of moves by executing the algorithm in part (a) on the list 8, 3, 9, 7, 2, 6, 1.

2.5 a. Find the expected number of tests required by the solution to the Counterfeit Coin problem (exercise 1.5).

 b. Prove that the value found in part (a) is optimal, i.e., the strategy that minimizes the worst-case number of tests also minimizes its average case value.

 c. Find the expected cost of the solution to exercise 1.6, assuming that the cost of each test is equal to the number of coins weighed in that test.

 d. Assume that the original Counterfeit Coin problem is submitted to an informed depth-first strategy using the evaluation function $f(n) = \log_3 S_n$ where S_n stands for the total number of possible outcomes to subproblem n. Which test will be the first to be explored by this strategy? How many first-level tests will eventually be explored by this strategy?

 e. Repeat part (c) if the objective is to find a strategy with the least expected number of tests.

2.6 Reformulate AO^* to be executed on OR graphs with the objective of finding the lowest (sum) cost path from s to a set Γ of goal nodes, given that h is optimistic. How will it differ from A^*? Discuss the advantages of the way each algorithm handles nodes which are generated and found already on CLOSED.

Chapter 3

Formal Properties of Heuristic Methods

It is often said that heuristic methods are unpredictable; they work wonders *most* of the time, but may fail miserably *some* of the time. Indeed, some heuristics greatly reduce search effort but occasionally fail to find an optimal or even a near-optimal solution. Others work efficiently on most problems in a given domain yet a rare combination of conditions and data may cause the search to continue forever.

In Parts II and III of this book we will use probabilistic analyses to assess how sure we can be that a given heuristic method will perform in accordance with expectations. By contrast, this chapter discusses those properties of heuristic methods that can be guaranteed to hold *all the time*, that is, over all problems in a given class. We will see that, contrary to a common misconception, some desirable properties of heuristics can be *guaranteed in advance*. For instance, a simple test on the type of information used by A^* could guarantee that an optimal path will eventually be found. A second simple test guarantees that A^* will retain all its virtues even without appraising duplicate nodes on CLOSED. Still another test may reveal that one heuristic function is consistently better than another in that it always causes A^* to expand a smaller number of nodes.

Although many of the formal properties discussed in this chapter are shared by several best-first strategies, we will focus our attention on A^* and only mention generalizations when the occasion arises. Thus, unless noted otherwise, we will assume that our search space is an OR graph, that our task is to find a path from s to some goal node, and that a heuristic estimate $h(n)$ is computable for every node in the graph.

More Notations on Graphs. We will be dealing exclusively with graphs in which every node has only a finite number of successors, namely, with **locally finite graphs**. This restriction is natural in problems in which only a finite number of decisions are to be made in every stage of the search process. It

73

excludes the class of problems in which continuous parameters must be chosen, such as in many resource allocation problems. Practically speaking, however, even continuous quantities have finite practical bounds and can be controlled only by a finite degree of precision. Therefore they can be quantized into a finite number of compartments and fit into the locally finite graph formalism.

We will find it useful to condense the verbal phrase "node n_j is a successor of the node n_i" by writing $n_j \in$ SCS (n_i), stating that n_j is a member of the finite set SCS (n_i) of successors to n_i. SCS is also called the **successor operator** because, when applied to n_i, it generates all its successors.

Our graphs will be characterized by having a single start node s. In cases where a set $\{s_i\}$ of multiple starting nodes exists, we can always regard them as successors of a dummy node s with zero-cost links (see Figure 2.4). This dummy node device may not work as well in the case of multiple goal nodes because the addition of a dummy goal node may change the whole character of the search space (e.g., from a tree to a graph). For that reason, we will assume explicitly that the object of the search is to find a cheapest path from s to any **goal node** γ in the **set Γ of goal nodes**. Every arc will be quantified with a positive cost label $c(n_i, n_j) \geqslant \delta > 0$, and the cost of a path will be understood to be the sum-cost of all its arcs.

If node n_j is accessible from node n_i, we will let $\mathbf{P}_{n_i - n_j}$ stand for **the set of all paths going from n_i to n_j** and let $\mathbf{P}_{n - \Gamma}$ denote the set of paths going from n to the set Γ. The symbol $P_{n - \gamma}$ stands for *any path* from n to γ, i.e., $P_{n - \gamma} \in \mathbf{P}_{n - \Gamma}$. The **set of cheapest paths** from n_i to n_j will be denoted by $\mathbf{P}^*_{n_i - n_j}$ and the *cost* of a cheapest path by $k(n_i, n_j)$, (as in Nilsson, 1980).

The costs of paths containing s or an element of Γ will be given special names:

- $g^*(n)$—The cheapest cost of paths going from s to some node n; thus,
$$g^*(n) = k(s, n)$$
- $h^*(n)$—The cheapest cost of paths going from n to Γ, thus,
$$h^*(n) = \min_{\gamma \in \Gamma} k(n, \gamma)$$
- C^*—The cheapest cost of paths going from s to Γ, i.e., $C^* = h^*(s)$
- Γ^*—The set of *optimal* goals, i.e., the subset of goal nodes accessible from s by a path or paths that cost C^*

A^* explores (as does every *BF* strategy) the state-space graph G using a traversal tree T. At any stage of the search, T is defined by the pointers that A^* assigns to the nodes generated, with the branches in T directed opposite to the pointers. Whenever it is desirable to stress the fact that a given path is part of T (at some phase of the search) we will denote this pointer-path by PP, e.g., $PP_{n_1 - n_2} \in T$. Similarly, we will distinguish between a node lying *along* a path P (if P is in T) and a node lying *on* P (when P may not be in T). The union of all the branches in the traversal trees constructed during the search makes up

the **explicated** subgraph of G and will be denoted by G_e. Note that a path P can be in G_e and not in any of the traversal trees that make up G_e.

In the following sections we will examine some basic algorithmic properties of $A *$. These are defined as follows.

- **Completeness**—An algorithm is said to be **complete** if it terminates with a solution when one exists.
- **Admissibility**—An algorithm is **admissible** if it is guaranteed to return an **optimal** solution whenever a solution exists.
- **Dominance**—An algorithm A_1 is said to **dominate** A_2 if every node expanded by A_1 is also expanded by A_2. Similarly, A_1 **strictly dominates** A_2 if A_1 dominates A_2 and A_2 does not dominate A_1. We will also use the phrase "**more efficient than**" interchangeably with **dominates.**
- **Optimality**—An algorithm is said to be **optimal** over a class of algorithms if it dominates all members of that class.

3.1 *A**–OPTIMAL SEARCH FOR AN OPTIMAL SOLUTION

3.1.1 Properties of $f *$

The node-selection function f used by $A *$ consists of adding two parts, $g(n)$ and $h(n)$, where

$g(n) = $ the cost of PP_{s-n}, the *current* path from s to n, with $g(s) = 0$

$h(n) = $ an estimate of $h*(n)$, such that $h(\gamma) = 0$

When we wish to specify the *actual* costs of P_{s-n} and $P_{n-\gamma}$ along a particular path P, we shall write $g_P(n)$ and $h_P(n)$, respectively. Clearly, for every path P we have

$$g_P(n) \geqslant g*(n) \quad \text{and} \quad h_P(n) \geqslant h*(n) \tag{3.1}$$

When g and h coincide with their optimal values, the resulting f assumes a special meaning. Calling

$$f*(n) = g*(n) + h*(n) \tag{3.2}$$

we see that $f *(n)$ measures the **optimal cost over all solution paths constrained to go through n.** In particular, for s and γ we have

$$f*(s) = h*(s) = g*(\gamma) = f*(\gamma) = C* \text{ for all } \gamma \in \Gamma* \tag{3.3}$$

and, moreover, if $n *$ is any node on an optimal path from s to γ, it must satisfy

$$f*(n*) = C* \qquad n* \in P*_{s-\Gamma} \tag{3.4}$$

To show the validity of Eq. (3.4) we reason as follows: $n^* \in P^*_{s-\Gamma}$ implies that there is a solution path P through n costing C^*, that is, along this path $g_P(n) + h_P(n) = C^*$. Using the optimality of g^* and h^* (Eq. 3.1) we have $g^*(n) + h^*(n) \leqslant C^*$, but this inequality cannot be strict or else there would be a path P' along which $g_{P'}(n) + h_{P'}(n) < C^*$, thus contradicting the optimality of C^*.

The importance of $f^*(n)$ stems from its behavior on **off-track** nodes, that is, nodes not lying on any optimal solution path. Let n be any such node, it must satisfy

$$f^*(n) > C^* \qquad n \notin P^*_{s-\Gamma} \qquad (3.5)$$

The reason behind Eq. (3.5) is similar to that for Eq. (3.4); suppose $g^*(n) + h^*(n) \leqslant C^*$, then there should exist a solution path P' through n such that $g_{P'}(n) + h_{P'}(n) \leqslant C^*$, qualifying P' as an optimal solution path and contradicting our assumption that n is an off-track node.

The properties in 3.4 and 3.5 amount to the **principle of optimality** of dynamic programming, stating that a path is optimal if and only if every segment of it is optimal, and is a unique feature of the recursive and order-preserving properties of the additive cost measure. (The reader who wishes to witness a counter-example may examine the problem of finding a minimal median path, mentioned in Section 2.4.1.) These properties single out f^* as a **perfect discriminator**; it could provide perfect early-warning signals $f^*(n) > C^*$ for all off-track nodes encountered along the search and, since we always have some nodes around for which $f^*(n) = C^*$ (e.g., $f^*(s) = C^*$), following the minimum f^* would constitute a perfect search strategy leading straight toward an optimal solution without ever getting sidetracked.

The trouble, of course, is that we normally do not possess the extra information or insight required to compute f^*, especially the h^* part. If we try to compute it by searching the graph itself (as is actually done in dynamic programming), we defeat the main purpose, which is to avoid excessive search, because many off-track nodes need to be explored in the computation of h^*. There still remains the possibility of *approximating* f^* by an easily computable function f, and this is exactly what A^* attempts to achieve via the combination $f = g + h$.

3.1.2 Termination and Completeness

A^* always terminates on finite graphs. The reason is that the number of acyclic paths in each such graph is finite and with every node expansion A^* *adds* new links to its traversal tree. Each newly added link represents a new acyclic path and so the reservoir of paths must eventually be exhausted. Note that even reopened nodes represent new paths because A^* only reopens a node on CLOSED when it finds a *strictly* cheaper path to it. This argument is valid for any best-first strategy that prunes cyclic paths; that is, if the cost of the path without the cycle is not higher than that of the path with the cycle.

$A*$ is also **complete** on finite graphs. A failure is returned only when OPEN is found empty and, if a solution path $P_{s-\gamma}$ exists, OPEN cannot become empty before $P_{s-\gamma}$ is discovered. For if it did there would be a last node $n' \in P_{s-\gamma}$ on OPEN (at least one node, the start node s, from $P_{s-\gamma}$ has surely entered OPEN) which is expanded and found to generate no new successors. This contradicts our assumption that n' lies on a solution path; every such node (except a goal node) has at least one successor also lying on a solution path. This argument is applicable to all best-first strategies.

THEOREM 1. $A*$ *is complete even on infinite graphs.*

Proof: Consider the set of nodes on the solution path $P_{s-\gamma}$; all these nodes are assigned finite f's and at all times at least one of them is on OPEN. If $A*$ does not return a solution, it must be that it does not terminate at all; it cannot exit with failure for the reason invoked in the last paragraph. Now, in any locally finite graph there is only a finite number of paths with finite length; if $A*$ does not terminate, it must be chasing an infinite path. This, however, would be contrary to $A*$ node selection policy; due to the positive, δ-bound nature of the arc costs, every infinite path must have an unbounded cost and, since at all times at least one node on OPEN should be advertising its bounded cost, $A*$ should stop its chase and select that node for expansion.

The proof does not actually require that all arc costs be bounded away from zero; it is enough to demand that the cost of every infinite path is unbounded. This property will be assumed to hold henceforth. A similar condition if imposed on any best-first strategy would render it complete.

3.1.3 Admissibility – A Guarantee for an Optimal Solution

From the set splitting argument of Section 2.3.2, it should be clear that whenever $h(n)$ is an optimistic estimate of $h*(n)$, $A*$ will return an optimal solution. This motivates naming this class of estimates: **Admissible heuristics.**

DEFINITION: *A heuristic function h is said to be **admissible** if*

$$h(n) \leqslant h*(n) \qquad \forall n \tag{3.6}$$

In the following discussion we assume that Eq. (3.6) is satisfied. Our results will be cross-referenced to those found in Nilsson (1980).

LEMMA 1: (Nilsson, Result 2): *At any time before $A*$ terminates, there exists an OPEN node n' on $P*_{s-\gamma}$ with $f(n') \leqslant C*$.*

Proof: Consider any optimal path $P*_{s-\gamma} \in \mathbf{P}*_{s-\Gamma}$

$$P*_{s-\gamma} = s, n_1, n_2, ..., n', ..., \gamma$$

and let n' be the shallowest OPEN node on $P^*_{s-\gamma}$ (there is at least one OPEN node on $P^*_{s-\gamma}$ because γ is not CLOSED until termination). Now, since all ancestors of n' are on CLOSED and since the path $s, n_1, n_2, ..., n'$ is optimal, it must be that the pointers assigned to n' are along $P^*_{s-n'}$, hence, $g(n') = g^*(n')$. Using now the admissibility of h, we obtain:

$$f(n') = g^*(n') + h(n') \leqslant g^*(n') + h^*(n') = f^*(n') \qquad (3.7)$$

and since $n' \in P^*_{s-\gamma}$, we have (see Eq. (3.4)) $f^*(n') = C^*$ and

$$f(n') \leqslant C^* \qquad (3.8)$$

 ■

LEMMA 2: (a Corollary of Lemma 1): *Let n' be the shallowest OPEN node on an optimal path $P^*_{s-n''}$ to any arbitrary node n'', not necessarily in Γ. Then*

$$g(n') = g^*(n') \qquad (3.9)$$

stating that A has already found the optimal pointer-path to n' (i.e., n' is along $P^*_{s-n''}$) and that path will remain unaltered throughout the search.*

Proof: It follows directly from the proof of Lemma 1, where the equality $g(n') = g^*(n')$ was established without using the fact that γ is a goal node.

 ■

THEOREM 2. (Nilsson, Result 4): *A* is admissible.*

Proof: Suppose A^* terminates with a goal node $t \in \Gamma$ for which $f(t) = g(t) > C^*$. A^* inspects nodes for compliance with the termination criterion only after it selects them for expansion. Hence when t was chosen for expansion, it satisfied:

$$f(t) \leqslant f(n) \qquad \forall n \in OPEN$$

This means that, immediately prior to termination, all nodes on OPEN satisfied $f(n) > C^*$. This, however, contradicts Lemma 1 which guarantees the existence of at least one OPEN node (n') with $f(n') \leqslant C^*$. Therefore the terminating t must have $g(t) = C^*$, which means that A^* returns an optimal path.

 ■

Note that this proof is essentially identical to the subset-splitting argument used in Section 2.3.2 to show the admissibility of *GBF** with optimistic estimates. It should still hold, therefore, for any complete best-first strategy with optimistic estimates and order-preserving cost functions (Eq. 2.11).

3.1.4 Comparing the Pruning Power of Several Heuristics

The **power** of the heuristic estimate $h(\cdot)$ is measured by the amount of pruning induced by h and depends, of course, on the **accuracy** of this estimate. If $h(\cdot)$ estimates the completion cost precisely ($h = h^*$), then A^* will only explore nodes lying along optimal paths. On the other hand, if no heuristic at all is used ($h = 0$), a uniform-cost (or breadth-first) search ensues, which amounts to exhaustively expanding all nodes reachable from s by a path costing less than C^*. The more common cases lie somewhere between these two extremes.

In Section 1.1 we saw that a given problem may make use of different types of heuristics. In the 8-Puzzle, for example, we can use h_1, the number of misplaced tiles, or h_2, the sum of the Manhattan distances. In the Traveling Salesman problem (TSP) we had a choice between the minimum-spanning-tree (MST) approximation or the estimate obtained from solving the assignment problem. Clearly, the higher the h, the closer it is to h^* (as long as h remains admissible) and the more powerful it is expected to be. In the 8-Puzzle, for instance, h_2 is generally higher and never lower than h_1; hence it is expected to yield a more efficient search. No such preference can be proclaimed for the two TSP heuristics.

We now wish to cast these considerations into a formal setting.

DEFINITION: *A heuristic function h_2 is said to be **more informed than** h_1 if both are admissible and*

$$h_2(n) > h_1(n) \qquad \text{for every nongoal node } n \qquad (3.10)$$

Similarly, an A^ algorithm using h_2 will be said to be more informed than that using h_1.*

Next we will show that using more-informed heuristics indeed implies more power, but first we need a couple of preliminary results.

THEOREM 3. (a necessary condition for node expansion, Nilsson, Result 5): *Any node expanded by A^* cannot have an f value exceeding C^*, that is,*

$$f(n) \leqslant C^* \qquad \text{for all nodes expanded} \qquad (3.11)$$

Proof: Assume the contrary, i.e., that n is selected for expansion from OPEN while $f(n) > C^*$. This would certainly contradict Lemma 1 which states that OPEN contains a node n' such that $f(n') \leqslant C^*$ and so n' should have been chosen for expansion instead of n. ∎

THEOREM 4. (a sufficient condition for node expansion): *Every node on OPEN for which $f(n) < C^*$ will eventually be expanded by A^*.*

Proof: Suppose, at some stage, n is found on OPEN with $f(n) < C^*$. A^* terminates with $f(t) = C^*$ after selecting t for expansion from

OPEN. The fact that t, not n, was selected means either that n was expanded before t or that $f(n)$ has in the meantime been modified so as to exceed C^*. But f can only be modified downward, thus leaving the former alternative, the expansion of n as the only possibility. ∎

Note that neither Theorem 3 nor 4 individually constitutes both a necessary and sufficient condition. This is so because the fate of OPEN nodes for which strict equality holds $(f(n) = C^*)$ is not determined by either theorem, but remains to be decided by the tie-breaking rule employed in the particular implementation of A^*. We will see later that the set of nodes satisfying this equality is normally of relatively small size, and therefore we can dismiss the equality event from most calculations.

Theorem 3 identifies a set of nodes $S = \{n : f(n) > C^*\}$ that are definitely destined to be *excluded* from expansion. This gives rise to a simple scheme of **cutting down on storage space** without compromising admissibility; any node known to belong to S could be safely removed from OPEN without affecting the performance of A^*. We do not know, of course, the exact value of C^*, but an upper bound on C^* would suffice, for if by some means (e.g., by a depth-first search) we find some path to a goal and it has a cost C', we know for sure that $C^* \leqslant C'$ and so every node satisfying $f(n) > C'$ definitely belongs to S and can be thrown away from storage. If, by chance, n will be regenerated later with a lower f, it will be treated as a new node that may or may not be expanded.

The expansion conditions in Theorems 3 and 4, although useful, do not provide adequate criteria for determining the efficiency of a given A^* algorithm. The reason is that they invoke two local parameters that may vary with the algorithm's state of development and are not, therefore, directly discernible from the external data. The first is the function $g(n)$ which is not truly a property of node n but depends on which path to n it is that A^* happens to have discovered at any given time. The second is the requirement (in Theorem 4) that n resides on OPEN before it is selected for expansion. Whether or not a given node ever enters OPEN depends not on n itself but on the behavior of A^* while exploring the paths leading to n. The next two results rectify these difficulties:

DEFINITION: *We say that a path P is **C-bounded** if every node n along this path satisfies $g_P(n) + h(n) \leqslant C$. Similarly, if a strict inequality holds for every n along P, we say that P is **strictly C-bounded**. When it becomes necessary to identify which heuristic was used in ascertaining the preceding inequality, we will use the notation C(h)-bounded.*

THEOREM 5. *A sufficient condition for A^* to expand a node n is that there exists some strictly C^*-bounded path P from s to n.*

Proof: Assume the contrary, that is, that there exists a strictly C^*-bounded path P from s to n and that at termination its final node n has

not yet been expanded. Let n' be the shallowest OPEN node on P (at termination). Since all ancestors of n' are on CLOSED, the g that $A*$ assigns to n' cannot be more costly than $g_P(n')$; hence,

$$f(n') = g(n') + h(n') \leqslant g_P(n') + h(n') < C*$$

But if $f(n') < C*$ at termination, then n' should have been chosen for expansion instead of the goal node which allegedly terminated the search with $f = C*$. That contradicts our assumption that an OPEN node n' could exist on P and, hence, n must be expanded. ∎

THEOREM 6. *A necessary condition for $A*$ to expand a node n is that there exists a $C*$-bounded path from s to n.*

Proof: If $A*$ expands a node n, then n must be on OPEN, and simultaneously $f(n) \leqslant C*$ (Theorem 3). Now consider the pointer path PP assigned to n at the time of its expansion. Each ancestor n' of n along PP is closed and, hence, was selected for expansion (perhaps more than once) some time in the past at which time (from Theorem 3) it satisfied $g'(n') + h(n') \leqslant C*$. Its current $g(n')$ value along PP cannot be higher than its $g'(n')$ value at the time of expansion. Consequently every node n' along PP currently satisfies $f(n') \leqslant C*$, meaning that PP itself is $C*$-bounded. ∎

Theorems 5 and 6 will play a major role in our analysis of $A*$'s performance. For now we use them only to confirm our intuition regarding the desirability of making h as high as possible.

THEOREM 7. (Nilsson, Result 6): *If A_2* is more informed than A_1*, then A_2* dominates A_1*.*

Proof: Let A_2* use heuristic h_2 and A_1* use heuristic h_1 such that $h_2(n) > h_1(n)$ for every nongoal node n, and assume that A_2* expands some node n. From Theorem 6 we know that there must exist a $C*$-bounded path P from s to n if judged by h_2. Since $h_2(n') > h_1(n')$ for every node n' along P, P is *strictly* $C*$-bounded when judged by h_1. Hence, using Theorem 5, A_1* must also expand n. ∎

The requirement of strict inequality between h_2 and h_1 remains a sore to aesthetics, because it is rarely satisfied, even in situations where h_2 is clearly superior to h_1. In the 8-Puzzle, for example, the number of misplaced tiles (h_1) *exactly* equals the sum of Manhattan distances (h_2) in many configurations, thus disqualifying h_2 as the "more-informed" heuristic of the two. This sore can be alleviated in various ways. First, if the two algorithms compared use the same tie-breaking rule and if the rule is purely structural (i.e., independent of the values of g and h), then the definition of more-informedness can be relaxed to also permit equalities between the corresponding heuristics. Second,

Theorem 12 demonstrates that under reasonable assumptions (satisfied in the 8-Puzzle) equalities between h_1 and h_2 only violate the dominance of A_2 on a small set of nodes for which $f_2(n) = C^*$. Third, in cases where it is required to find *all* the optimal paths, Theorem 6 constitutes both a necessary and sufficient condition and again the definition of more-informedness can permit equalities without affecting Theorem 7. Finally, in Chapter 6, we present a stochastic extension of the concept of more-informedness, to include cases in which one heuristic is known to be greater than another most of the time, but not always.

3.1.5 Monotone (Consistent) Heuristics

In the preceding section we implied that the effectiveness of A^* can be measured by how many nodes it manages to exclude from expansion. In actuality, however, a given node can be expanded many times, and so it is not the number of distinct nodes expanded but rather the number of *expansion operations* that should be our major concern. In this section we show that under certain conditions A^* never reopens nodes from CLOSED, and consequently the labor connected with reexpansion can be saved.

The condition that may enable us to forgo reopenings is a certain property of h that is satisfied by any h^* function, hence, the title **consistent**. In Section 3.1 we saw that every h^* function, aside from correctly estimating the optimal costs to Γ, also conforms to certain relations between $h^*(n)$ and h^* evaluated on n's descendants. In particular, Eq. 3.4 and Eq. 3.5 imply that the cheapest path constrained to pass through n cannot be less costly than the cheapest path available without this constraint, that is:

$$g^*(n) + h^*(n) \geqslant h^*(s) \qquad \forall(n) \tag{3.12}$$

or,

$$k(s,n) + h^*(n) \geqslant h^*(s) \tag{3.13}$$

This form of the **triangle inequality** for geodesics should hold for any pair of nodes not necessarily involving s. Thus, if n' is any descendant of n, we should have:

$$h^*(n) \leqslant k(n,n') + h^*(n') \qquad \forall(n,n') \tag{3.14}$$

which is automatically satisfied for nondescendant n' since $k(n,n') = \infty$.

It is now reasonable to expect that if the process of estimating $h(n)$ is consistent, it should inherit this geodesic property from $h^*(n)$ and satisfy:

$$h(n) \leqslant k(n,n') + h(n') \qquad \forall(n,n') \tag{3.15}$$

DEFINITION: *A heuristic function h(n) is said to be **consistent** if Eq. (3.15) is satisfied for all pairs of nodes n and n'.*

DEFINITION: *A heuristic function h(n) is said to be* **monotone** *if it satisfies:*

$$h(n) \leqslant c(n, n') + h(n') \qquad \forall n, n' \mid n' \in \mathrm{SCS}(n) \qquad (3.16)$$

∎

Monotonicity may seem, at first glance, to be less restrictive than consistency, because it only relates the heuristic of a node to the heuristics of its immediate successors. However, a simple proof (by induction on the depth-k descendants of n, exercise 3.2) should convince the reader that Eq. (3.16) implies Eq. (3.15). We, therefore, state the following theorem.

THEOREM 8. *Monotonicity and consistency are equivalent properties.* ∎

It is also simple to relate consistency to admissibility.

THEOREM 9. *Every consistent heuristic is also admissible.*

Proof: We simply replace n' in Eq. (3.15) by any goal node $\gamma \in \Gamma$, obtaining

$$h(n) \leqslant k(n, \gamma) + h(\gamma) \qquad \forall n$$

Now, since $h(\gamma) = 0$ and $k(n, \gamma) = h^*(n)$ for some goal node $\gamma \in \Gamma^*$, we have the admissibility condition

$$h(n) \leqslant h^*(n)$$

confirmed.

∎

We are now ready to demonstrate the advantages of using consistent or monotone heuristics.

THEOREM 10. (Nilsson, result 7) *An A* algorithm guided by a monotone heuristic finds optimal paths to all expanded nodes, that is,*

$$g(n) = g^*(n) \qquad \forall n \in CLOSED \qquad (3.17)$$

Proof: Assume that A^* selects for expansion a node for which $g(n) > g^*(n)$. Consider an optimal path P^*_{s-n} from s to n; if n is the only OPEN node on P^*_{s-n}, then obviously all n's ancestors along P^*_{s-n} have been expanded and we have $g(n) = g^*(n)$ (Lemma 2). The assumption $g(n) > g^*(n)$ implies that P^*_{s-n} contains at least one additional OPEN node and, as usual, we let n' be the shallowest OPEN node on P^*_{s-n}. We shall now show that n', and not n, should be selected for expansion. Lemma 2 states that $g(n') = g^*(n')$ and therefore, using consistency, we have

$$f(n') = g^*(n') + h(n') \leqslant g^*(n') + k(n', n) + h(n)$$

The sum $g^*(n') + k(n', n)$ is equal to $g^*(n)$ because n' is an ancestor of n along P^*_{s-n}, and so

$$f(n') \leqslant g^*(n) + h(n)$$

We now see that the assumption $g(n) > g^*(n)$ implies

$$f(n') < f(n)$$

which should prohibit the choice of n over n'. Thus we must conclude $g(n) = g^*(n)$. ■

THEOREM 11. (Nilsson, result 8) *Monotonicity implies that the f values of the sequence of nodes expanded by A^* is non-decreasing.*

Proof: Let n_2 be expanded immediately after n_1. If n_2 resided on OPEN while n_1 was expanded, then $f(n_1) \leqslant f(n_2)$ follows immediately from the node selection rule. If it did not reside there, then n_2 must be a newcomer to OPEN, that is, a successor of n_1 for which we have $g(n_2) = g(n_1) + c(n_1, n_2)$ and for which monotonicity dictates:

$$f(n_2) = g(n_1) + c(n_1, n_2) + h(n_2) \geqslant g(n_1) + h(n_1) = f(n_1)$$

Thus the sequence of f values cannot decrease. ■

Monotonicity simplifies significantly the conditions for node expansion.

THEOREM 12. *If h is monotone, then the necessary condition for expanding node n is given by*

$$g^*(n) + h(n) \leqslant C^*$$

and the sufficient condition by the strict inequality

$$g^*(n) + h(n) < C^*$$

Proof: The necessary condition follows by combining Theorems 3 and 10. The sufficient condition is based on the nondecreasing nature of $g^* + h$ along an optimal path from s to any arbitrary node n. This is so because, if n' is the parent of n along any optimal path P^*_{s-n}, it must satisfy

$$g^*(n) = g^*(n') + c(n',n)$$

which, together with the monotonicity of h, yields

$$g^*(n) + h(n) = g^*(n') + c(n',n) + h(n) \geqslant g^*(n') + h(n')$$

This implies that if n satisfies $g^*(n) + h(n) < C^*$, all its ancestors along P^*_{s-n} must also satisfy this inequality. Thus P^*_{s-n} is strictly C^*-bounded and, according to Theorem 5, n will be expanded by A^*. ■

This result has an interesting implication on the significance of the tie-breaking rule. Suppose two versions of A^*, A_1^* and A_2^*, employ two different tie-breaking rules and both are guided by the same monotone heuristic h. A_2^* may, in general, expand more nodes than A_1^*, but Theorem 12 demonstrates that the difference cannot exceed the number of nodes actually satisfying the equality $f(n) = C^*$.

In Chapter 4 we will argue that monotonicity is not an exceptional property but rather a common occurrence among admissible heuristics (e.g., all the heuristics discussed in the example of section 1.1 are monotone). Theorem 12 helps explain why the difference between the relation $f(n) \leqslant C^*$ and $f(n) < C^*$ is so often insignificant and why it is permissible, in certain analyses, to treat them both as equivalent. The equivalence would be further strengthened if $f(n)$ can be modeled as a continuous random variable, in which case the equality $f(n) = C^*$ is a rare event indeed.

An important corollary of Theorem 12 is that in guaranteeing the advantage of one monotone heuristic over another we no longer need to insist on strict inequality between the two, as in Eq. (3.10).

DEFINITION: *An algorithm A_2^* is said to **largely dominate** A_1^* if every node expanded by A_2^* is also expanded by A_1^* except, perhaps, some nodes for which $h_1(n) = h_2(n) = C^* - g^*(n)$.*

COROLLARY TO THEOREM 12. *If $h_2(n) \geqslant h_1(n)$ for all n and both are monotone, then A_2^* (using h_2) largely dominates A_1^* (using h_1).*

Proof: Let n be a node expanded by A_2^* and not by A_1^* then, from Theorem 12, $g^*(n) + h_2(n) \leqslant C^*$ and $g^*(n) + h_1(n) \geqslant C^*$. These, together with $h_2(n) \geqslant h_1(n)$, imply $h_1(n) = h_2(n) = C^* - g^*(n)$ ∎

Note that in the absence of monotonicity, the advantage of A_2^* over A_1^* would be much less certain; every descendant of n that is reachable from n by a strictly $C^*(h_2)$-bounded path will also be expanded by A_2^* and possibly not by A_1^*. (See exercise 3.1.)

Consistency also plays an important role in establishing the **optimality** of A^* over other types of search algorithms that are provided with the same heuristic information. It is possible to show (Dechter and Pearl, 1983) that if h is consistent, then A^* **largely dominates every admissible algorithm** having access to that same h (see exercise 3.7b). On the other hand, if h is admissible but not consistent, then there are admissible algorithms that, using the same h, will grossly outperform A^* in some problem instances, regardless of what tie-breaking rule A^* invokes (see Section 3.4 and exercise 3.7a).

3.2 RELAXING THE OPTIMALITY REQUIREMENT

In the previous section, we have seen that A^* possesses some useful properties that make good use of the heuristics provided. In particular, if the available heuristic is admissible (i.e., an optimistic estimate of h^*), then A^* is guaranteed to find an optimal solution path if one exists.

Experience shows, however, that in many problems A^* spends a large amount of time discriminating among paths whose costs do not vary significantly from each other. In such cases, the admissibility property becomes a curse rather than a virtue. It forces A^* to spend a disproportionately long time in selecting the best among roughly equal candidates and prevents A^* from completing the search with a suboptimal but otherwise acceptable solution path. These observations cast doubt on the appropriateness of the small-is-quick paradigm in satisficing problems and raise the question as to whether a more direct estimate of the "promise" of a node would do better.

In this section we describe attempts to solve three basic questions, quoted here from *The Handbook of Artificial Intelligence* (Barr and Feigenbaum, 1981, vol.1):

1. One may be more concerned with minimizing search effort than with minimizing solution cost. Is $f = g + h$ an appropriate evaluation function in this case?
2. Even if solution cost is important, the combinatorics of the problem may be such that an admissible A^* cannot run to termination. Can speed be gained at the cost of a bounded decrease in solution quality?
3. It may be hard to find a good heuristic function h that satisfies the admissibility condition; with a poor but admissible heuristic function, A^* deteriorates into blind search. How is the search affected by an inadmissible heuristic function?

3.2.1 Adjusting the Weights of g and h

To find alternatives to the rule $f = g + h$, it may be instructive to recap the way this rule originated to govern satisficing problems. We started with the small-is-quick paradigm, arguing that if we persistently pursue the shortest path, we will be safe from being trapped into searching along fruitless directions. We then saw that to identify unmistakenly the node belonging to the shortest path we need to add to $g(n)$ a second term, the remaining shortest distance $h^*(n)$. In the absence of an exact value for $h^*(n)$, we applied the face-value principle; we took its estimate $h(n)$ and added it to $g(n)$ as if it was $h^*(n)$ itself. The result of all this is an algorithm that goes about the optimiza-

tion mission too seriously, contrary to our original intention of getting a quick, though perhaps suboptimal, solution.

One approach to rectify this predicament is to examine the effects of g and h separately. The effect of g is to add a breadth-first component to the search. Without h, A^* reduces to a purely breadth-first (or uniform cost) search, whereas without g, A^* ignores completely the distance already covered and bases its decisions purely on h, the estimate of the remaining proximity to the goal. The latter strategy looks ideal for cases where solutions are plentiful, equally desirable, and the heuristic function is trustworthy. However, if h is unreliable, it can lead to a disaster; h may assign misleadingly low values to hopelessly long blind alleys, and we would not have g around any more to remind us that we have been led astray.

To adjust the balance between these two tendencies, Pohl (1970) has suggested using a weighted evaluation function:

$$f_w(n) = (1-w)g(n) + w\,h(n) \qquad (3.18)$$

Obviously, $w = 0, \frac{1}{2}$, and 1 correspond to uniform-cost, A^* and BF^* (with $f = h$) strategies, respectively. By varying w continuously between 0 and 1, one can achieve any desired mixture between conservatism and radicalism, to match the degree of reliability one attributes to h.

If h is admissible, it is easy to show that f_w is admissible in the range $0 \leqslant w \leqslant \frac{1}{2}$ but may lose its admissibility in the remaining interval $\frac{1}{2} < w \leqslant 1$, depending on how far h is from h^*. Empirical results obtained for the 15-Puzzle (15 tiles in a 4×4 array) indicate (Pohl, 1970) that f_w achieves its best performance in the range $\frac{1}{2} < w < 1$. More extensive simulations by Gaschnig (1979a) on the 8-Puzzle revealed that in most cases f_w achieves its optimal performance (minimum average number of nodes expanded) in the vicinity of $w = \frac{1}{2}$ and increasing w beyond $\frac{1}{2}$ may cause the expected number of nodes expanded to increase rather than decrease.

Pohl has provided some analytical explanation for the advantages of using g by analyzing a uniform tree with one goal node and assuming that the absolute error between h and h^* is bounded by a fixed integer e. If one now analyzes the worst-case performance of f_w, that is, assuming that a clever adversary distributes the error in such a way that the search exhibits its worst performance, one finds that the number of nodes expanded with $f = h$ is greater than that expanded using $f = g + h$. In Chapter 7, we present an average-case analysis of this phenomena and demonstrate that, in the model chosen, f_w indeed achieves its best performance at the admissibility limit $w = \frac{1}{2}$, as was observed in Gaschnig's experiments.

These empirical and analytical findings strengthen the soundness of the small-is-quick paradigm. In the cases examined, the auxiliary optimization task represented by the $f = g + h$ rule seems to be producing its expected by-product: speed.

3.2.2 Two ε-Admissible Speedup Versions of A *

The deterioration of the performance of $f_w = (1-w)g + wh$ for $w > \frac{1}{2}$, coupled with the ever present risk of termination with a much costlier solution than is acceptable, prompted attempts to answer the second question: can speed be gained at the cost of a *bounded* decrease in solution quality? Two approaches will be described, **dynamic weighting** and A_ϵ*. Both endow A * with a stronger depth-first component while still guaranteeing that the solution found at termination will not be worse than the optimal one by a factor greater than $1 + \epsilon$, $(\epsilon \geqslant 0)$.

Dynamic Weighting (Pohl, 1973). Rather than keeping w constant throughout the search, it is natural to dynamically change w so as to weigh h less heavily as the search goes deeper. The approach devised by Pohl uses the evaluation function:

$$f(n) = g(n) + h(n) + \epsilon \left[1 - \frac{d(n)}{N} \right] h(n) \qquad (3.19)$$

where $d(n)$ is the depth of node n and N is the (anticipated) depth of the desired goal node. At shallow levels of the search tree ($d \ll N$), h is given a supportive weight equal to $(1 + \epsilon)$, encouraging depth-first excursions. At deep levels, however, where termination is likely to occur, the search assumes an admissible, equal weight, character protected against premature termination.

It is not hard to see that if $h(n)$ is admissible, the algorithm is ε-admissible, that is, it finds a path with cost at most $(1 + \epsilon)C$*. This follows by noting that before termination the shallowest OPEN node n' along any optimal solution path still has $g(n') = g^*(n')$ (see Lemma 2) and so,

$$f(n') \leqslant g^*(n') + h^*(n') + \epsilon \left[1 - \frac{d(n')}{N} \right] h^*(n')$$

$$\leqslant C^* + \epsilon h^*(n')$$

$$\leqslant (1 + \epsilon)C^*$$

Therefore, the algorithm cannot terminate with any goal node whose cost is greater than $(1 + \epsilon)C$*.

A_ϵ* — An Algorithm Using Search Effort Estimates[†]. A_ϵ* uses two lists: OPEN and FOCAL. FOCAL is a sublist of OPEN containing only those nodes that

† © 1982 IEEE. Reprinted with permission, from *IEEE Transactions on Pattern Analysis and Machine Intelligence*, Vol. 4, No. 4, pp. 392–399, July 1982.

do not deviate from the lowest f node by a factor greater than $1 + \epsilon$, that is,

$$FOCAL = \{n : f(n) \leqslant (1 + \epsilon) \min_{n' \in OPEN} f(n')\}.$$

The operation of $A_\epsilon{}^*$ is identical to that of A^* except that $A_\epsilon{}^*$ selects the node from FOCAL with the lowest h_F value, where $h_F(n)$ is a second heuristic function estimating the computational effort required to complete the search starting from n.

The rationale for this variation is simple. According to the estimates $f(\cdot)$ at hand, all nodes on FOCAL have roughly equal solution paths. Therefore, rather than spending time on deciding which among them is the best, it makes more sense to use the time to compute the remaining portion of the solution, and the node that promises to offer the easiest completion job is the one with the lowest h_F. Clearly, for $\epsilon = 0$, $A_\epsilon{}^*$ reduces to A^*.

The heuristic h used in *forming* FOCAL is of an entirely different nature than the FOCAL-heuristic h_F used for *selecting* nodes from within FOCAL. The former anticipates the reduction in *solution quality* due to the remaining part of the solution once it is found; the latter estimates the *computational effort* required to complete the search.

In certain cases, it makes sense to surmise that the search would be completed faster from nodes with lower h values and hence choose $h_F = h$. In other cases, additional information may be available regarding the structure of the search graph emanating from any given node (e.g., the height of the graph or its approximate branching degree) and could be incorporated into h_F.

THEOREM 13. $A_\epsilon{}^*$ *is ϵ-admissible, that is, it always finds a solution whose cost does not exceed the optimal cost by more than a factor $1 + \epsilon$.*

Proof: Adopting the following notation:

$n_0 = $ a node in OPEN having the smallest f value

$t = $ termination node (chosen for expansion and found to be a goal)

$n_1 = $ shallowest OPEN node on an optimal solution path

$C(t) = f(t) = g(t) = $ cost of solution found

we have:

$$
\begin{array}{ll}
f(n_1) \leqslant C^* & \textit{since h is admissible} \\
f(n_0) \leqslant f(n_1) & \textit{because OPEN is f-ordered} \\
f(t) \leqslant f(n_0)(1+\epsilon) & \textit{since t is chosen from FOCAL}
\end{array}
$$

Therefore:

$$C(t) = f(t) \leqslant f(n_1)(1+\epsilon) \leqslant C^*(1+\epsilon) \qquad \blacksquare$$

We still have to prove that $A_\epsilon{}^*$ terminates, but the proof of this fact is identical to the proof that A^* terminates if all arc costs are positive and bounded away from zero.

Note that, unlike h, h_F is not required to be optimistic, that is, it may overestimate the actual computational effort required without affecting the ϵ-admissibility of A_ϵ^*.

Comparing the Two Algorithms. Dynamic weighting is a simpler algorithm to implement; it maintains only one list and employs only one heuristic function. A_ϵ^*, on the other hand, offers several other advantages. Whereas dynamic weighting is limited to problems where the depth of the optimal solution (N), or at least a good upper bound to it, is known *a priori*, A_ϵ^* will maintain its ϵ-admissibility even when N is completely unknown. In addition, the complete separation of the two heuristics used by A_ϵ^* renders it a more flexible mechanism for incorporating sophisticated estimations of the computational cost required for completing the search. These may, in general, involve elaborate functions of the path from s to n, not always capturable by g and h. For example, if the Traveling Salesman problem is applied to a sparsely connected road map, the number of edges in the unexplored portion of the graph would usually constitute a more valid estimation of the remaining computational effort than the proportion of unexplored cities $1 - \text{depth}(n)/N$, which guides the dynamic weighting algorithm.

Figure 3.1 represents an empirical comparison between the performances of A_ϵ^* and dynamic weighting. Each coordinate represents the ratio of the number of nodes expanded by the corresponding algorithm to that expanded by A^* (with the same heuristic). The open circles represent Traveling Salesman problems generated by a random distribution of nine cities in the unit square. The solid circles represent "hard" problems where intercity distances were independently chosen from a uniform distribution over the interval (0.75, 1.25). The heuristic function in all cases was computed by

$$ h = \max \left[\sum_j \min_i d_{ij}, \sum_i \min_j d_{ij} \right] $$

where d_{ij} stands for the distance between city i and city j, and where both the summation and the min operation range over the set of unvisited cities. The focal-heuristic employed by A_ϵ^* was simply the number of unvisited cities.

The chart indicates comparable performances for the two algorithms with a slight edge in favor of A_ϵ^*. Both algorithms exhibit their highest utility on "hard" problems with saving ranging between 60% and 90%.

3.2.3 R_δ^* – A Limited Risk Algorithm Using Information about the Uncertainty of h

Harris (1974) has convincingly argued that the condition of admissibility is too restrictive. Although it may be impractical to find a good estimate of h^* that never violates the admissibility conditions, "it is often easier to find a heuristic

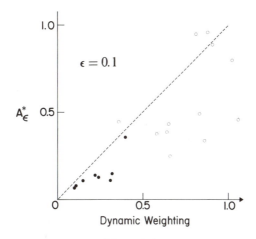

Figure 3.1

Comparison of the performances of A_ϵ^* and dynamic weighting, for $\epsilon = 0.1$.

that estimates the future cost well, but occasionally overestimates it." In these cases Harris shows that the extra cost of the resulting solution cannot exceed the amount by which h^* is overestimated, that is, if e bounds the overestimation, $h(n) - h^*(n) \leqslant e$, then A^* is e-admissible, $C(t) - C^* \leqslant e$. This property enabled Harris to devise an algorithm called **band-width search** which was permitted to accept a wider variety of heuristic functions as long as they are known to be e-admissible.

We now wish to make the notion of e-admissibility even less restrictive. Harris' e-admissibility condition requires that a heuristic estimate be found that *never* overestimates h^* by more than e (to express this more precisely, $h(n) - h^*(n) \leqslant e$ should hold for all nodes found on OPEN at termination). This requirement, however, may rule out the use of very precise estimators that only *occasionally* overestimate h by more than any reasonable e.

Consider, for example, the case where all arc costs are known to be drawn independently from a common distribution function, uniform between 0 and 1. If N stands for the number of arcs between n and the goal (assuming a single solution path from each n on OPEN), then, for large N, it is known that $h^*(n)$ is most likely to fall in the neighborhood of $N/2$. However, the only *admissible* estimate that one can produce is $h = 0$, whereas the most *reasonable* heuristic, $h = N/2$, is not admissible and will not be permitted even by e-admissibility standards because it may, in the worst case, lead to an extra cost of $N/2$. Nevertheless, the likelihood of this event is extremely small and thus may be tolerated.

R_δ^* provides a generalized admissible search procedure for cases in which we wish to invoke likelihood considerations in the admissibility guarantee. We assume that in addition to estimating the value of h^*, we also have information regarding the uncertainty of the estimation process, and that this uncertainty

information is expressed in the form of a probability density function $\rho_{h*}(x)$, which measures the relative likelihood that $h*$ will be found in the neighborhood of x. In cases where $g*$ is known (e.g., in tree searching where $g* = g$), $\rho_{h*}(x)$ also induces a density function on $f* = g* + h*$:

$$\rho_{f*}(y) = \rho_{h*}(y - g*) \tag{3.20}$$

Similarly, if $g(n) \neq g*(n)$ and P_{s-n} is the best path found so far between s and some node n on OPEN, the cost of an optimal solution path constrained to continue P_{s-n} is given by the random variable:

$$f^+(n) = g(n) + h*(n) \tag{3.21}$$

with density:

$$\rho_{f^+}(y) = \rho_{h*}(y - g) \tag{3.22}$$

Note that OPEN always contains some node n for which $f^+(n) = f*(n) = C*$ (see Lemma 2).

Our task now is to devise a rule for scheduling nodes for expansion based on the information contained in the density function $\rho_{f^+}(y)$ attached to each node on OPEN. If these density functions were nonoverlapping (Figure 3.2(a)), we would simply select for expansion the node for which the density $\rho_{f^+}(y)$ signifies the lowest f^+ value, thus complying with the best-first principle. When overlaps exist, the decision is more involved, as can be seen in Figure 3.2(b). Which of the two nodes shown, n_1 or n_2, is the more promising (i.e., the "best") one? $f^+(n_1)$ has a lower mean, but n_2 advertises some possibility that its actual cost $f^+(n_2)$ is, in fact, appreciably lower than that of node n_1. An admissible algorithm, or even an ϵ-admissible one, would insist on expanding n_2, whereas intuition urges us to prefer n_1 because the density functions indicate that the event $f^+(n_1) > f^+(n_2)$ is rather unlikely.

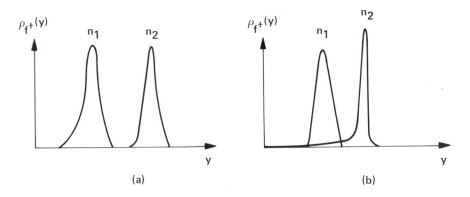

Figure 3.2
Probability density functions of $f^+ = g + h*$ for two typical nodes in OPEN.

$R_\delta{}^*$ resolves this conflict by the following argument. Imagine that some algorithm has found a solution path with cost C, and that node n still resides on OPEN unexpanded. What is the basis of our *regrets* for not having explored n? We should have expanded n if it had exhibited a high potential for reducing the resultant cost C by a significant amount or, alternatively, if the **risk** of terminating the algorithm at cost C (without exploring the possibilities latent in n) had been above a given acceptable level. Otherwise we should be satisfied with the solution found. If our knowledge about the costs of solutions continuing P_{s-n} is represented by $\rho_{f+}(y)$, the risk of missing a further cost reduction ought to be characterized by a risk-measure $R(C)$, associated with each node, which is a nondecreasing function of C, and can be computed from $\rho_{h^*}(y)$. Every node competing for expansion could then be characterized by a function $R(C)$ measuring the **risk associated with leaving that node unexplored,** and we can impose the requirement that the search will continue until the risk associated with every (unexplored) node on OPEN becomes lower than some acceptable level δ.

This is precisely what $R_\delta{}^*$ sets out to do, except that it pursues this objective in a best-first manner. It associates with every node on OPEN a **cost threshold** parameter $C_\delta(n)$, given by the solution to the equation:

$$R(C) = \delta \qquad\qquad (3.23)$$

and chooses for expansion that node n from OPEN with the lowest $C_\delta(n)$. $C_\delta(n)$ represents the largest solution cost allowable before the risk associated with missing a potentially better solution emanating from n exceeds δ.

Figure 3.3 illustrates typical $R(C)$ curves for three nodes n_1, n_2, and n_3 and can serve to explain the rationale for expanding the node with the lowest

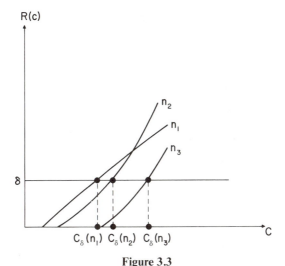

Figure 3.3
Typical $R(C)$ functions for three nodes in OPEN.

$C_\delta(n)$. If we choose n_1 for expansion and discover that it is a goal node (with $h(n_1) = 0$), then its cost $g(n_1)$ must be at most $C_\delta(n_1)$ (see Eq. 3.28). Hence, leaving n_2 and n_3 unexpanded is permissible because their associated risk measures $R_{n_2}[g(n_1)]$ and $R_{n_3}[g(n_1)]$ are both guaranteed to be below δ. This guarantee does not hold if we choose for expansion n_2 or n_3, which have higher cost thresholds than n_1 at the given level of δ. Note that because of possible crossings of the $R(C)$ curves, the order of node expansion should vary depending on the risk tolerance δ.

> DEFINITION: *An algorithm is said to be* **δ-risk-admissible** *if it always terminates with a solution cost C such that $R(C) \leqslant \delta$ for every node left on OPEN.*

An alternative way of stating the δ-risk-admissible condition is that at termination, the cost of the solution found is not greater than $C_\delta(n)$ for each n on OPEN.

> DEFINITION OF R_δ^*: *R_δ^* is an ordered search algorithm which is identical to A^* except that it chooses for expansion that node from OPEN with the lowest cost-threshold $C_\delta(n)$.*

Note that with $\delta = 0$, R_δ^* is identical to A^* since it is guided by the solution to $R(C) = 0$ which is the lowest point on the tail of the density of f^+, that is, a lower bound to $g + h^*$. For $\delta > h^*$, R_δ^* selects nodes by a criterion combining both the mean and the tail of the distribution.

Before demonstrating that R_δ^* is indeed δ-risk-admissible, the reader may find it useful to examine some typical risk measures. Three common measures are defined as follows:

1. R_1—*The worst case risk:*

$$R_1(C) = \sup_{y : \rho_{f^+}(y) > 0} (C - y) = C - g - h_a \tag{3.24}$$

 where h_a is the lowest imaginable value of h^* (i.e., the lowest h^* with positive density)

2. R_2—*The probability of suboptimal termination:*

$$R_2(C) = P(C - f^+ > 0)$$

$$= \int_{y = -\infty}^{C} \rho_{f^+}(y)\, dy \tag{3.25}$$

3. R_3—*The expected risk:*

$$R_3(C) = E[\max(C - f^+; 0)]$$

$$= \int_{y = -\infty}^{C} (C - y)\rho_{f^+}(y)\, dy \tag{3.26}$$

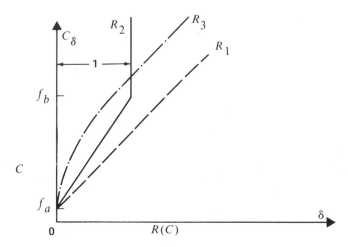

Figure 3.4
The horizontal axis represents the functions $R(C)$ for the three risk measures considered, when f^+ is uniformly distributed between f_a and f_b. Conversely, if the risk tolerance is fixed at δ, the vertical axis represents the cost threshold C_δ.

Figure 3.4 depicts the shape of these risk measures for the case where f^+ is uniformly distributed between f_a (an optimistic estimate) and f_b (a pessimistic estimate):

$$\rho_{f^+}(y) = \begin{cases} \dfrac{1}{f_b - f_a} & f_a \leqslant y \leqslant f_b \\ \\ 0 & \text{elsewhere} \end{cases}$$

Symbolically, $R_3(C)$ is given by:

$$R_3(C) = \begin{cases} 0 & C \leqslant f_a \\ \\ \dfrac{(C - f_a)^2}{2(f_b - f_a)} & f_a \leqslant C \leqslant f_b \\ \\ C - \dfrac{(f_a + f_b)}{2} & f_b \leqslant C \end{cases}$$

The cost threshold C_δ associated with the expected risk measure R_3 is given by:

$$C_\delta = \begin{cases} f_a + \sqrt{2\,(f_b - f_a)} & 0 \leqslant \delta \leqslant \dfrac{f_b - f_a}{2} \\ \\ \delta + \dfrac{f_b + f_a}{2} & \dfrac{f_b - f_a}{2} \leqslant \delta \end{cases} \tag{3.27}$$

which clearly demonstrates its role in rating nodes for expansion; if the risk-tolerance δ is higher than half the uncertainty range $f_b - f_a$, $R_\delta{}^*$ will rate nodes according to the mean values $(f_a + f_b)/2$. Under a lower tolerance for risk (i.e., $\delta < (f_b - f_a)/2$) $R_\delta{}^*$ will pay a greater attention to the optimistic estimate f_a until, when no risk at all can be tolerated ($\delta = 0$), the optimistic estimate f_a will become the sole criterion for node selection.

The exact shape of $\rho_h{}^*(n)$ can be computed only in those cases where the arc costs are generated by a well-defined probabilistic model and where the graph searched is of relatively simple structure. This should not prevent us, however, from computing good estimates for $C_\delta(n)$. Optimistic and pessimistic bounds to h^* are normally easy to compute for each node n, and moreover we often have a fairly good idea of where, between these bounds, h^* is most likely to concentrate. Using this information, the value of $C_\delta(n)$ can be estimated by making simplifying assumptions regarding the shape of $\rho_{h*}(x)$, for example, uniform, triangular, or exponential. Since $R_\delta{}^*$'s performance is only guaranteed in probabilistic terms, these simplifications, being one additional level removed from exactitude, will have only second order effect on the performance guarantees.

We are now ready to prove some of the stated properties of $R_\delta{}^*$, assuming that $\rho_h{}^*(x)$ is known exactly.

THEOREM 14. $R_\delta{}^*$ *is δ-risk-admissible with respect to risk measures R_1, R_2, or R_3.*

Proof: Let $\delta > 0$ and assume $R_\delta{}^*$ terminates at node t with cost $g(t)$. Since $h(t) = h^*(t) = 0$, there remains no uncertainty regarding $f^+(t)$, and $C_\delta(t)$ is given by:

$$C_\delta(t) = \begin{cases} g(t) + \delta & \text{for } R_1 \text{ and } R_3 \\ g(t) & \text{for } R_2 \end{cases}. \tag{3.28}$$

(The reader may wish to verify Eq. (3.28) by inspecting the behavior of the cost threshold functions in Figure 3.4 in the limit $f_b = f_a = g$.) Thus we conclude that for all three risk measures

$$g(t) \leqslant C_\delta(t).$$

At the same time the goal node t, having just been selected for expansion, must have the lowest $C_\delta(\cdot)$ on OPEN. Therefore, for each node n on OPEN we have:

$$C_\delta(n) \geqslant g(t)$$

which is the condition defining δ-risk-admissibility. ∎

It remains to show that $R_\delta{}^*$ terminates for all graphs with positive branch costs for which a solution path exists. This will be demonstrated at the end of the section.

Note that for the R_1 and R_3 measures, $R_\delta{}^*$ guarantees a termination risk that is even lower than δ. For these measures we, in fact, showed that:

$$g(t) \leqslant C_\delta(n) - \delta \qquad \forall \, n \text{ on OPEN} \qquad (3.29)$$

or, that the cost found at termination would always be at least δ lower than the cost threshold of every node on OPEN. In particular, for R_1 we always have:

$$C_\delta(n) = \delta + g(n) + h_a(n)$$

where h_a is the lowest feasible value of h^*, and therefore:

$$g(t) \leqslant g(n) + h_a(n)$$

implying that the solution cost $g(t)$ is optimal or, equivalently, that $R_\delta{}^*$ is strictly admissible for all values of δ. This is to be expected since the node-rating criterion $C_\delta(n) = \delta + g + h_a$ is equivalent to that of A^* using the admissible heuristic $h = h_a$.

Note that the guarantees provided by $R_\delta{}^*$ are only as reliable as the density function describing the uncertainty of h^*. If this density function represents the user's subjective estimate of the magnitude of h^*, then $R_\delta{}^*$ only provides protection against the *subjectively* assessed risks associated with a premature termination. Alternatively, if $\rho_{h^*}(y)$ is obtained from a large statistical sample of problem instances, the risk protection of $R_\delta{}^*$ assumes statistical meaning with respect to the same problem ensemble.

The preceding discussion centered around the requirement of keeping the termination risk below a *fixed* tolerable level δ. For the risk measures, R_1 and R_3, it may be desirable to limit the termination risk by a fixed *percentage* of the solution cost. The results can easily be generalized to the case of proportional risk tolerance if instead of $C_\delta(n)$ we use the cost threshold $C'_\delta(n)$, where $C'_\delta(n)$ is the solution of

$$\frac{R(C')}{C'} = \delta \qquad (3.30)$$

All the conditions necessary for proving Theorem 14 remain valid when $C'_\delta(n)$ is used as a node selection criterion and $0 \leqslant \delta \leqslant 1$.

3.2.4 $R_{\delta,\epsilon}^*$ – A Speedup Version of $R_\delta{}^*$

The search of $R_\delta{}^*$, like that of A^*, is guided solely by the safeguards installed to keep the solution cost within an acceptable range. It uses no information regarding the computational effort required to reach a solution and therefore, like A^*, will suffer from the same deficiency that induced us to devise the $A_\epsilon{}^*$ algorithm: spending an unwarrantedly long time selecting the best among roughly equal solution paths.

To remedy this deficiency, the scheme employed by $A_\epsilon{}^*$ can be applied directly to $R_\delta{}^*$ at the price of risking only a slight deterioration in solution cost.

Algorithm $R_{\delta,\epsilon}^*$

1. Select a risk measure and a risk tolerance δ.
2. Order nodes on OPEN by increasing values of the cost threshold $C_\delta(n)$, given by the solution to Eq. (3.23).
3. Form a sublist FOCAL of all nodes whose $C_\delta(n)$ deviates by at most ϵ from that of the leading node on OPEN, n_0:

$$\text{FOCAL} = \{n: \ C_\delta(n) - C_\delta(n_0) \leqslant \epsilon\}$$

4. Select (for expansion) a node from FOCAL that promises to facilitate the quickest search for the (optimal) completion part of the solution.
5. Halt when a node chosen for expansion is found to satisfy the goal conditions.

THEOREM 15. *Algorithm $R_{\delta,\epsilon}^*$ always finds a solution that does not exceed the cost threshold of all nodes in OPEN by more than ϵ.*

Proof: If $R_{\delta,\epsilon}^*$ terminates at node t, we have:

$$g(t) \leqslant C_\delta(t)$$

and since $t \in$ FOCAL;

$$C_\delta(t) \leqslant C_\delta(n_0) + \epsilon \leqslant C_\delta(n) + \epsilon \qquad \forall \ n \text{ on OPEN} \qquad \blacksquare$$

Exceeding the cost threshold $C_\delta(n)$ by ϵ results in only a small increase in the overall termination risk. Additionally, we will show that for R_1 and R_3 the choice $\epsilon = \delta$ would lead to a termination risk of at most δ. Thus the speedup feature is obtained for free, without deteriorating the termination risk.

THEOREM 16. *For risk measures R_1 and R_3, algorithm $R_{\delta,\delta}^*$ is δ-risk-admissible.*

Proof: Assume first that $R_{\delta,\delta}^*$ terminates at node t. In Eq. (3.29) we obtained, for R_1 and R_3,

$$g(t) \leqslant C_\delta(t) - \delta.$$

t being in FOCAL implies

$$C_\delta(t) \leqslant C_\delta(n_0) + \epsilon \leqslant C_\delta(n) + \epsilon \qquad \forall \ n \text{ on OPEN}$$

and therefore

$$g(t) \leqslant C_\delta(n) + \epsilon - \delta \qquad \forall \ n \text{ on OPEN}.$$

The choice $\epsilon = \delta$ leads to

$$g(t) \leqslant C_\delta(n) \qquad \forall \ n \text{ on OPEN}$$

which is the condition for δ-risk-admissibility. \blacksquare

Proof of R_δ* Termination with Risk Measures R_1, R_2, or R_3. The proof consists of two steps. The first step shows that if a solution path exists, then at all times OPEN contains a node on this path for which $R_\delta(n)$ is bounded. The second step shows that any such node cannot remain unexpanded for all but a finite number of steps. The two steps of the proof are:

1. From the definition of $R_1(C) = C - g - h_a$, it is clear that the equation $R_1(C) = \delta$ has a finite solution $C_\delta = \delta + g + h_a$, and therefore, $C_\delta(n)$ is finite for all nodes on OPEN. Likewise, the equation $R_2(C) = \delta$ has a solution $C_\delta \leqslant 1$ for all $0 \leqslant \delta \leqslant 1$. The finiteness of C_δ for the expected risk $R_3(C)$ is based on the assumption that the density $\rho_h(x)$ possesses a finite expectation $E(h) < \infty$ for every node on a solution path. With this assumption, we can write

$$R_3(C) \geqslant C[1 - P(f^+ > C)] - E(f^+)$$

and, using Tchebycheff's inequality

$$R_3(C) \geqslant C - 2E(f^+) = C - 2g - 2E(h)$$

Clearly the equation $R_3(C) = \delta$ also possesses a finite solution C_δ.

2. The inequality $C_\delta(n) \geqslant g(n)$ holds for each node on OPEN since the decision to abandon n after finding a solution with cost $C < g(n)$ carries no risk at all. Now, since $g(\cdot)$ was assumed to increase beyond bounds along any infinite path (see proof of Theorem 1), R_δ* must return after a finite number of expansions to those nodes on OPEN that, by virtue of their belonging to some solution path, possess bounded C_δ.

3.3 SOME EXTENSIONS TO NONADDITIVE EVALUATION FUNCTIONS (*BF** AND *GBF**)

Our discussions in this chapter have so far been limited to the additive cost measure $g(n') = g(n) + c(n, n')$ and to additive evaluation functions such as $f = (1 - w)g + wh$. In this section, our aim is to examine how the results established in Section 3.1 will change if we remove both restrictions. The minimization objective is generalized to include nonadditive cost measures of solution paths such as **multiplicative** costs, the **max-cost** (i.e., the highest branch cost along the path), the **mode** (i.e., the most frequent branch cost along the path), the **range** (i.e., the difference between the highest and lowest branch cost along the path), the cost of the **last** node, and many others. Additionally, even in the usual case where the minimization objective is the additive cost measure, we now permit $f(n)$ to take on a more general form and to employ more elaborate evaluations of the promise featured by a given path from s to n. For

example, one may wish to consult the evaluation function $f(n) = \max_{n'}\{g(n')$ $+ h(n')\}$ where n' ranges along the path from s to n. Alternatively, the class of evaluation functions may now include nonlinear combinations of g and h in $f = f(g, h)$ and, as another example, the additive evaluation $f = g + h$ with h an arbitrary nonadmissible estimate of h^*.

3.3.1 Notation and Preliminaries

The computations required by some of these generalizations may no longer be executable by A^* and we may have to employ more elaborate best-first algorithms (see Figure 2.10) such as BF^* (in case of nonrecursive cost measures) or even GBF^* (in case of cost measures that are not order-preserving as in Figure 3.5). In the following discussion, we use the terminology of the BF^* algorithm (i.e., delayed termination with irrevocable parent selection) and hope that the reader can infer the modifications needed if GBF^* is employed. For comparison purposes, we assign to each new result an asterisk number (e.g., Theorem 1*, Theorem 2*) pointing to the corresponding topics in Section 3.1.

The objective of BF^* is to find an optimal or a near-optimal solution path in a directed locally finite graph, where each solution path $P^s = s, n_1, n_2, \ldots, \gamma, \gamma \in \Gamma$, is assigned a cost measure $C(P^s)$ which may be a complex function of all the nodes and the arcs along P^s. In principle, the cost measure $C(P^s)$ need only be defined on complete solution paths in $\mathbf{P}_{s-\Gamma}$, as only these paths are returned by the search algorithm at termination. However, since every node may be proclaimed a goal node in some conceivable problem instance, the domain of $C(\cdot)$ essentially spans all path-segments in G which begin at s.

To each node n_i along a given path $P = s, n_1, n_2, \ldots, n_i, \ldots$ we assign a nonnegative evaluation function $f_P(n_i)$ that *depends only on the portion of the path leading to that node*. Thus, $f_P(n_i)$ is a shorthand notation for $f(s, n_1, n_2, \ldots, n_i)$. As the search progresses, a given node n may be assigned to different paths depending on the pointers used by BF^* to trace back the path from s to n. However, at any given time the computation of $f_P(n)$ is uniquely determined by the pointer-path assigned to n at that time, and so $f(n)$ will denote an arbitrary element in the set $\{f_P(n): P \in \mathbf{PP}\}$ where \mathbf{PP} is the set of all pointer-paths constructed during the execution of the search. Moreover, BF^* adjusts pointers along the path of lowest f. Hence, if P_1 and P_2 are two paths leading to n from two distinct parents of n, we can write $f_{P_1}(n) \leqslant f_{P_2}(n)$ if path P_1 was explicated after P_2. In particular, $f_{P_i}(n) \leqslant f(n)$ if P_i is known to be the path assigned to n at termination.

This is a convenient point to demonstrate why an adequate analysis of BF^* on graphs that are not trees requires that f be **order-preserving**. Relations such as $f_{P_i}(n) \leqslant f(n)$ would be very helpful if $f(n)$ stood, not merely for the set of values attached to n during the execution of the search algorithm, but also for

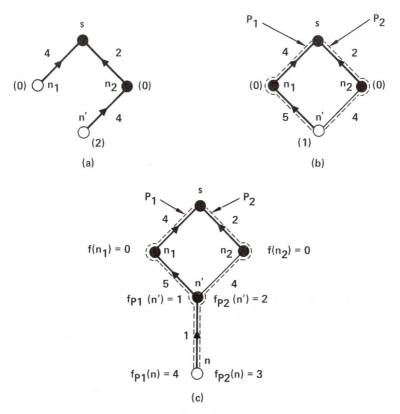

Figure 3.5

An order-reversal produced by using the range as the cost measure, i.e.,
$f_P(n)$ stands for the difference between the highest and lowest edge values
along the path P leading to n.

the entire set of values n *may receive* along each one of the paths leading to n in
the graph G_e explicated by the algorithm. Figure 3.5 exemplifies the difference
between the two sets using the cost-range measure as an f function that is not
order-preserving.

In Figure 3.5(b) a new path, P_1 is discovered to n' and, since
$f_{P_1}(n') = 1 < f_{P_2}(n') = 2$, BF^* redirects the pointer of n' along P_1. Next,
when n is generated, BF^* assigns to it a pointer back to n', that is, along
$P_1 = s, n_1, n', n$, while $P_2 = s, n_2, n', n$ is no longer considered. However,
the value of $f_{P_1}(n)$ at this point is 4, whereas the f value along P_2 would have
been lower since $f_{P_2}(n) = 3$. Thus, even though the two paths to n are part of
the subgraph G_e explicated by BF^* with $f_{P_1}(n) > f_{P_2}(n)$, we find that n is
currently directed along the inferior path P_1. Such an order reversal in the
ranking of P_1 and P_2 would not have occurred if f was an order-preserving
function such as the additive, multiplicative, or maximum-cost measures.

Likewise, the relation $f_{P_1}(n) > f_{P_2}(n)$ would be recognized by GBF^* which would have maintained both $P_1 = s, n_1, n', n$ and $P_2 = s, n_1, n', n$ in the list of candidate solution bases and, as soon as n was generated, would have computed $f_{P_1}(n) = 4$ and and $f_{P_2}(n) = 3$ and would have reassigned the pointer of n' back along P_2.

> **DEFINITION:** *Let $P_i P_j$ denote the concatenation of two paths in a graph, i.e., P_j is an extension of P_i. An evaluation function f is said to be **order-preserving** if for any two paths P_1 and P_2 leading from s to n, and for any extension P_3 of those paths, the following holds:*
>
> $$f(P_1) \geqslant f(P_2) \implies f(P_1 P_3) \geqslant f(P_2 P_3)$$

In terms of our $f_P(n)$ notation, order-preservation can be written

$$f_{P_1}(n) \geqslant f_{P_2}(n) \implies f_{P_1 P_3}(n') \geqslant f_{P_2 P_3}(n') \qquad n' \in P_3$$

Order-preservation is a version of the **principle of optimality** in dynamic programming (Dreyfus and Law, 1977), and it simply states that if a path P_1 from s to n is judged to be more meritorious than another path P_2, also from s to n, then no common extension of P_1 and P_2 may later reverse this judgment. In other words, the information that may be gathered by exploring node n has no bearing on the relative merit of candidate path-segments from s to n and hence BF^*'s decision to irrevocably discard the less meritorious parent as soon as n is generated in duplicate is justified. The discarded parent cannot possibly offer a better path to any of n's descendants. Based on this property, we may state the following lemma.

> **LEMMA 0*:** *If f is order-preserving and P_1 and P_2 are any two paths from s to n such that n is currently directed along P_1 and P_2 has been explicated in the past (i.e., all arcs along P_2 have been generated), then*
>
> $$f_{P_1}(n) \leqslant f_{P_2}(n)$$
>
> *In particular, if P_t is known to be the path assigned to n at termination, then*
>
> $$f_{P_t}(n) \leqslant f_P(n) \qquad \forall P \in G_c \qquad \blacksquare$$

Note that for GBF^* the lemma holds true even without the requirement that f be order-preserving.

Relations between C and f. So far we have not specified any relation between the cost function C, defined on solution paths, and the evaluation function f, defined on partial paths or solution bases. Since the role of f is to guide the search toward the lowest cost solution path, we now impose the restriction that f be *monotonic* with C when evaluated on complete solution paths, that is,

$$f(s, n_1, n_2, \ldots, \gamma) = \psi[C(s, n_1, n_2, \ldots, \gamma)] \qquad \gamma \in \Gamma \qquad (3.31)$$

where ψ is an increasing function of its argument. No restriction, however, is imposed on the relation between C and f on nongoal nodes, that is, we may allow evaluation functions that treat goal nodes preferentially, for example:

$$f(s, n_1, n_2, \ldots, n) = \begin{cases} \psi[C(s, n_1, n_2, \ldots, n)] & \text{if } n \in \Gamma \\ F(s, n_1, n_2, \ldots, n) & \text{if } n \notin \Gamma \end{cases}$$

where $F(\cdot)$ is an arbitrary function of the path $P = s, n_1, n_2, \ldots, n$. The additive evaluation function $f = g + h$ used by $A*$ is, in fact, an example of such goal-preferring types of functions. The condition $h(\gamma) = 0$ guaranteed the identity $f = C$ on solution paths, whereas on other paths f was not governed by C since, in general, h could take on arbitrary values.

3.3.2 Algorithmic Properties of Best-First Search *BF* *

In locally finite graphs the set of solution paths is countable, so they can be enumerated:

$$P_1^s, P_2^s, \ldots, P_j^s, \ldots$$

and correspondingly, we shall use the notation $f_j(n)$ to represent $f_{P_j^s}(n)$. Let M_j be the maximum of f on the solution path P_j^s, that is,

$$M_j = \max_{n \in P_j^s} \{ f_j(n) \} \tag{3.32}$$

and let M be the minimum of M_j:

$$M = \min_j \{ M_j \} \tag{3.33}$$

Henceforth we will assume that both the max and the min functions are well defined.

Termination and *Completeness*

LEMMA 1*: *At any time before BF* terminates, there exists on OPEN a node n' that is on some solution path and for which $f(n') \leqslant M$.*

Proof: Let $M = M_j$, i.e., the min-max is obtained on solution path P_j^s. Then at some time before termination, let n' be the shallowest OPEN node on P_j^s, having pointers directed along P_i^s (possibly $i = j$). From the definition of M_j:

$$M_j = \max_{n_i \in P_j^s} \{ f_j(n_i) \}$$

therefore,

$$f_j(n') \leqslant M_j = M$$

Moreover, since all ancestors of n' on P_j^s are on CLOSED and BF^* has decided to assign its pointers along P_i^s, Lemma 0* states

$$f_i(n') \leqslant f_j(n')$$

This implies

$$f_i(n') \leqslant M$$

which proves Lemma 1*. ∎

LEMMA 2*: *Let P be any pointer path established by BF^* at termination time. Then any time before termination there is an OPEN node n on P for which $f(n) = f_P(n)$.*

Proof: Let n be the shallowest OPEN node on P at some arbitrary time t before termination. Since all n's ancestors on P are closed at time t, P was explicated and, hence (Lemma 0*), n must be assigned an f at least as cheap as $f_P(n)$. Thus $f_P(n) \geqslant f(n)$ with strict inequality holding only if, at time t, n is found directed along a path different than P. However, since BF^* eventually terminates with pointers along P, it must be that BF^* has never encountered another path to n with cost lower than $f_P(n)$. Thus $f(n) = f_P(n)$. ∎

THEOREM 1*. *If there is a solution path and f is such that $f_P(n_i)$ is unbounded along any infinite path P, then BF^* terminates with a solution, i.e., BF^* is complete.*

Proof: The proof is similar to that of Theorem 1 in Section 3.1.2, using the boundness of $f(n') \leqslant M$, $n' \in$ OPEN. ∎

The importance of M lies not only in guaranteeing the termination of BF^* on infinite graphs, but mainly in identifying and appraising the solution path eventually found by BF^*.

Properties of the Final Solution Path

THEOREM 2*. *BF^* is $\psi^{-1}(M)$-admissible, that is, the cost of the solution path found by BF^* is at most $\psi^{-1}(M)$.*

Proof: Let BF^* terminate with solution path $P_j^s = s, \ldots, t$ where $t \in \Gamma$. From Lemma 1* we learn that BF^* cannot select for expansion any node n having $f(n) > M$. This includes the node $t \in \Gamma$ and, hence, $f_j(t) \leqslant M$. But Eq. (3.31) implies that $f_j(t) = \psi[C(P_j^s)]$ and so, since ψ and ψ^{-1} are monotonic,

$$C(P_j^s) \leqslant \psi^{-1}(M)$$

which proves the theorem. ∎

Theorem 2* can be useful in appraising the degree of suboptimality exhibited by nonadmissible algorithms. For example, Pohl's dynamic weighting scheme (Section 3.2.2, Eq. (3.19)) can be easily shown to be ϵ-admissible. Indeed, for the evaluation function

$$f(n) = g(n) + h(n) + \epsilon[1 - \frac{d(n)}{N}]h(n)$$

$h(\gamma) = 0$ and Eq. (3.31) dictate $\psi(C) = C$ and we can bound M by considering $\max\limits_{n} f_{P*}(n)$ along any optimal path $P*$. Thus

$$M \leqslant \max_{n \in P*} f_{P*}(n)$$

$$\leqslant \max_{n \in P*} \left[g*(n) + h*(n) + \epsilon h*(n)\left[1 - \frac{d(n)}{N}\right]\right]$$

$$= C* + \epsilon h*(s)$$

$$= C*(1 + \epsilon)$$

On the other hand, Theorem 2* states that the search terminates with cost $C_t \leqslant M$. Hence

$$C_t \leqslant C*(1 + \epsilon)$$

This example demonstrates that any evaluation function of the form

$$f(n) = g(n) + h(n)[1 + \epsilon \rho_p(n)]$$

will also be ϵ-admissible, as long as $\rho_p(n) \leqslant 1$ for all n along some optimal path $P*$. In more elaborate cases where it is impossible to guarantee an upperbound to M, the statistical properties of M may be used to assess the average degree of suboptimality, $E(C_t - C*)$; see exercise 5.4.

Theorem 2* can also be used to check for ordinary admissibility, i.e., $C_t = C*$; all we need to do is to verify the equality $\psi^{-1}(M) = C*$. This, however, is more conveniently accomplished with the help of the next corollary. It makes direct use of the facts that

1. An upperbound on f along *any* solution path constitutes an upperbound on M.
2. The relation between $f_P(n)$ and $C*$ is more transparent along an *optimal path*. (For example, in the case of $A*$ with $h \leqslant h*$, the relation $f_{P*}(n) \leqslant C*$ is self-evident.)

COROLLARY 1: *If in every graph searched by BF* there exists at least one optimal solution path along which f attains its maximal value on the goal node, then BF* is admissible.*

Proof: Let BF^* terminate with solution path $P_j^s = s, ..., t$ and let $P^* = s, ..., \gamma$ be an optimal solution path such that

$$\max_{n \in P^*} f_{P^*}(n) = f_{P^*}(\gamma).$$

By Theorem 2* we know that $f_j(t) \leqslant M$. Moreover, from the definition of M we have

$$M \leqslant \max_{n \in P_i^s} f_i(n)$$

for every solution path P_i^s. In particular, taking $P_i^s = P^*$, we obtain

$$f_j(t) \leqslant M \leqslant \max_{n \in P^*} f_{P^*}(n) = f_{P^*}(\gamma)$$

However, from Eq. (3.31) we know that f is monotonic in C when evaluated on complete solution paths, thus

$$C(P_j^s) \leqslant C^*$$

which means that BF^* terminates with an optimal-cost path. ∎

The admissibility condition for Pohl's weighted heuristic $f_w = (1 - w)g + wh$ (Section 3.2.1) can be obtained directly from Corollary 1. Here $\psi(C) = (1 - w)C$ which complies with Eq. (3.31) for $w < 1$. It remains to examine what values of $w < 1$ will force f_w to attain its maximum at the end of some optimal path $P^* = s, ..., \gamma$. Writing

$$f_{P^*}(n) \leqslant f_{P^*}(\gamma)$$

we obtain

$$(1 - w)g^*(n) + wh(n) \leqslant (1 - w)g^*(\gamma) = (1 - w)[g^*(n) + h^*(n)]$$

or

$$\frac{1 - w}{w} \geqslant \frac{h(n)}{h^*(n)}$$

Clearly, if the ratio $h(n)/h^*(n)$ is known to be bounded from above by a constant β, then setting $1 - w/w \geqslant \beta$ will satisfy this inequality. Therefore, the condition

$$w \leqslant \frac{1}{1 + \beta}$$

delineates the range of admissibility of A^* and, for $h(n) \leqslant h^*(n)$ ($\beta = 1$), it simply becomes $w \leqslant \frac{1}{2}$. Note, however, that the use of $w > \frac{1}{2}$ may also be admissible if h is known to consistently underestimate h^* such that $h(n)/h^*(n) \leqslant \beta < 1$. Conversely, if h is known to be nonadmissible with $\beta > 1$, the use of $w = 1/(1+\beta)$ will turn A^* admissible. This technique is called **debiasing** and its effect on the average run-time of A^* is analyzed in Chapter 7.

Another useful application of Corollary 1 is to check whether a given combination of g and h, $f = f(g, h)$, would constitute an admissible heuristic in the usual task of minimizing an additive cost measure. If $h \leqslant h^*$ and f is monotonic in both arguments, then Corollary 1 states that $f(g, h)$ is guaranteed to be admissible as long as

$$f(g, C - g) \leqslant f(C, 0) \qquad \text{for } 0 \leqslant g \leqslant C$$

Thus, for example, $f = \sqrt{g^2 + h^2}$ is admissible while $f = (g^{1/2} + h^{1/2})^2$ is not. In general, any combination of the form $f = \Phi[\Phi^{-1}(g) + \Phi^{-1}(h)]$ will be admissible if Φ is monotonic nondecreasing and concave.

It can be shown, however, that of all functions $f(g, h)$, $f = g + h$ results in the least number of nodes expanded (Dechter and Pearl, 1983) and, in this sense, A^* can be termed **optimal**. If, in addition, h is consistent, then A^* largely dominates *every* admissible algorithm (see exercise 3.7), even those outside the best-first class.

Conditions for Node Expansion

LEMMA 3*: *Let P_j^s be the solution path with which BF* terminates, then M is obtained on P_j^s, i.e., $M = M_j$.*

Proof: Suppose BF^* terminates on P_j^s, but $M_j > M$, and let $n^* \in P_j^s$ be such that $f_j(n^*) = M_j$. At the time that n^* is last chosen for expansion its pointer must already be directed along P_j^s and, therefore, n^* is assigned the value $f(n^*) = f_j(n^*) > M$. At that very time there exists an OPEN node n' having $f(n') \leqslant M$ (Lemma 1*), and so

$$f(n') < f(n^*)$$

Accordingly, n' should be expanded before n^*, which contradicts our supposition. ∎

COROLLARY 2: *BF* chooses for expansion at least one node n such that at the time of this choice, $f(n) = M$.*

Proof: Let BF^* terminate with P_j^s and let $n^* \in P_j^s$ such that $f_j(n^*) = M_j$. From Lemma 3*, $M_j = M$. Moreover, at the time that n^* is last expanded, it is pointed along P_j^s. Hence,

$$f(n^*) = f_j(n^*) = M_j = M \qquad\qquad ∎$$

THEOREM 3*. *Any node expanded by BF* has $f(n) \leqslant M$ immediately before its expansion.*

Proof: Follows directly from Lemma 1*. ∎

THEOREM 4*. *Let n^* be the first node with $f(n^*) = M$ which is expanded*

by BF (there is at least one). Any node which prior to the expansion of n^*
resides in OPEN with $f(n) < M$ will be selected for expansion before n^*.*

Proof: $f(n)$ can only decrease through the redirection of pointers.
Therefore, once n satisfies $f(n) < M$, it will continue to satisfy this ine-
quality as long as it is in OPEN. Clearly, then, it should be expanded be-
fore n^*. ■

Note the difference between Theorems 3* and 4* and Theorems 3 and 4 in
Section 3.1. First, M plays the role of C^* on the right-hand side of the inequal-
ities. Second, the sufficient condition for expansion in Theorem 4* must also
include the provision that n enters OPEN before the expansion of n^*. This
provision was not necessary in Theorem 4 because C^* is always obtained on
the terminal node t and so, if a node n ever resides on OPEN, it automatically
enters OPEN before t's expansion. When f is nonadditive (or even additive
with nonadmissible h), it is quite possible that M will be obtained on a non-
terminal node n^* and then, a descendant n of n^* may enter OPEN satisfying
$f(n) < f(n^*) = M$ and still will not be expanded.

We will now show that such an event can *only* occur to descendants of nodes
n^* for which $f(n^*) = M$, i.e., it can only happen to a node n reachable by an
M-bounded path but not by a strictly M-bounded path.

THEOREM 5*. *Any node reachable from s by a strictly M-bounded path will
be expanded by BF**

Proof: Consider a strictly M-bounded path P from s to n (M cannot be
obtained on s). We can prove by induction from s to n that every node
along P enters OPEN before n^* is expanded and hence, using Theorem
4*, n will be expanded before n^*. ■

The final results we wish to establish are necessary and sufficient conditions
for node expansion which are superior to Theorems 4* and 5* in that they also
determine the fate of the descendants of n^*.

THEOREM 6*. *Let P_j^s be the solution path eventually found by BF* and let
n_i be the depth-i node along $P_j^s, i = 0, 1, \ldots$. A necessary condition for
expanding an arbitrary node n in the graph is that for some $n_i \in P_j^s$ there
exists an L_i-bounded path $P_{n_i - n}$ where*

$$L_i = \max_{k > i} f_j(n_k).$$

In other words, there should exist a path $P_{n_i - n}$ along which

$$f(n') \leqslant \max_{k > i} f_j(n_k) \qquad \forall n' \in P_{n_i - n} \tag{3.34}$$

*Moreover, a sufficient condition for expanding n is that (3.34) be satisfied
with strict inequality.*

Proof: Assume that n is expanded by BF^* and let n_k be the shallowest OPEN node on P_j^s at time t_n when n is selected for expansion (see Figure 3.6). Since P_j^s is the solution path eventually found by BF^* we know (see proof of Lemma 2*) that at time t_n n_k is *along* P_j^s and, therefore,

$$f(n) \leqslant f(n_k) = f_j(n_k)$$

We are now ready to identify the node n_i on P_j^s that satisfies (3.34). Let P_{s-n} be the path along which n's pointers are directed at time t_n, and let n_i be the deepest common ancestor of n and n_k along their respective pointer-paths P_{s-n} and P_j^s. Since n_i is an ancestor of n_k we have $i < k$ and so, $f(n) \leqslant f_j(n_k)$ implies

$$f(n) \leqslant \max_{k > i} f_j(n_k)$$

We now repeat this argument for every ancestor n' of n along the P_{n_i-n} segment of P_{s-n}. At the time it was last expanded, each such ancestor n'

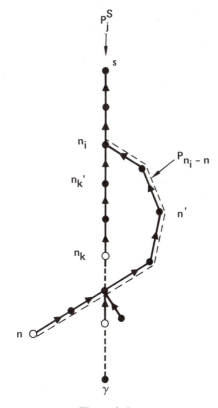

Figure 3.6

The condition for expanding n given that path P_j^s is eventually found by the search. n will be expanded if all the f values along path P_{n_i-n} are lower than the maximal f value between n_i and γ (along P_j^s).

may have encountered a different $n_{k'}$ on OPEN, but each such $n_{k'}$ must have been a descendant of n_i along P_j^s satisfying $f(n') \leqslant f_j(n_{k'})$. Hence, Eq. (3.34) must be satisfied for all nodes n' along the $P_{n_i - n}$ segment of P_{s-n} which proves the necessary part of Theorem 6*.

Sufficiency is proven by assuming that $\max\limits_{k > i} f_j(n_k)$ occurs at some node $n_{k'} \in P_j^s$, $k' > i$. Both n_i and $n_{k'}$ are eventually expanded by BF^* and so, if n is not already expanded at the time t' when $n_{k'}$ is last selected for expansion, then $P_{n_i - n}$ should contain at least one OPEN node. We now identify n' as the shallowest OPEN node on $P_{n_i - n}$ at time t', for which we know that

$$f(n') \leqslant f_{P_{n_i - n}}(n')$$

However, since Eq. (3.34) is assumed to hold with strict inequality for any n' along $P_{n_i - n}$, we must conclude

$$f(n') \leqslant f_{P_{n_i - n}}(n') < f(n_k)$$

implying that n', not n_k, should have been chosen for expansion at time t', thus contradicting our supposition that n remains unexpanded at time t'. ∎

The expansion condition of Theorem 6* plays a major role in Chapter 7 where we analyze the average complexity of nonadmissible algorithms, treating f as a random variable.

This condition is rather complex for general graphs since many paths may stem from P_j^s toward a given node n, all of which must be tested according to Theorem 6*. The test is simplified somewhat in the case of trees since Eq. (3.34) need only be tested for one node, $n_i \epsilon P_j^s$, which is the deepest common ancestor of n and γ. Still, the condition stated in Theorem 6* requires that we know which path will eventually be found by the search algorithm and this, in general, may be a hard task to determine *a priori*. An alternative condition, involving only the behavior of f across the tree, is given by Dechter and Pearl (1983), but it is of a rather complex form when f is nonmonotonic. Fortunately the model we analyze in Chapter 7 is a tree having only one solution path and so, since the identity of P_j^s is given, the expansion condition of Theorem 6* becomes extremely simple (see Figure 7.1).

3.4 BIBLIOGRAPHICAL AND HISTORICAL REMARKS

A formal description of A^* and many of its properties were presented in a paper by Hart, Nilsson, and Raphael (1968). The fact that the performance of A^* cannot improve by making h lower (Theorem 7) was originally thought to depend on the con-

sistency property of h. This error was corrected in Hart, Nilsson and Raphael (1972) and in Nilsson (1980). Our treatment, using the concept of c-bounded paths, renders the proof of Theorem 7 simpler than in earlier works. The property of monotonicity was introduced by Pohl (1977) to replace that of consistency. Surprisingly, the equivalence of the two (Theorem 8), as well as Theorem 9 (that consistency implies admissibility), have not previously been noted in the literature.

The **optimality** of A^*, in the sense of expanding the least number of distinct nodes, has been a subject of some confusion. Theorem 7 has often been interpreted to reflect some supremacy of \mathbf{A}^* over other search algorithms of equal information, and, consequently, several authors have assumed that A^*'s optimality is an established fact (e.g., Nilsson 1971, Méro 1981, Barr and Feigenbaum, 1981). In fact, all Theorem 7 says is that some A^* algorithms are better than other \mathbf{A}^* algorithms. It does not indicate whether the additive rule $f = g + h$ is the best way of combining g and h, neither does it assure us that expansion policies based *only* on g and h can do as well as more sophisticated policies using the entire information gathered along each path. These two conjectures have been examined by Gelperin (1977) and Dechter and Pearl (1983) and were finally given a qualified confirmation using the results of Section 3.3.

Gelperin (1977) has correctly pointed out that in any discussion of the optimality of A^* one should consider a wider class of equally informed algorithms, not merely those guided by $f = g + h$, and that the comparison class should include, for example, algorithms which *adjust* their h in accordance with the information gathered during the search. His analysis, unfortunately, falls short of considering the entirety of this extended class, having to follow an over-restrictive definition of *equally informed*. Gelperin's interpretation of "an algorithm B is *never more informed* than A" not only restricts B from using information unavailable to A, but also forbids B from processing common information in a better way than A does. For example, if B is a best-first algorithm guided by f_B, then in order to qualify for Gelperin's definition of "never more informed than A" B is restricted from ever assigning to a node n a value $f_B(n)$ higher than $g(n) + h(n)$, even if the information gathered along the path to n justifies such an assignment.

Dechter and Pearl (1983) used the more natural interpretation of "equally informed," allowing the algorithms compared to have access to the same heuristic information while placing no restriction on the way they use it. They considered the class of all search algorithms seeking a lowest (additive) cost path in a graph where the nodes are assigned an arbitrary heuristic function h, and assumed that $h(n)$ is made available to any algorithm that generates node n. Within this class, they first showed that A^* is optimal over all those algorithms which, for all h's, are guaranteed to find a solution at least as good as A^*. Second, they considered the wider class of algorithms which like A^* are only admissible whenever $h \leqslant h^*$ and showed that on this class A^* is not optimal and that **no optimal algorithm exists** unless h is also restricted to be consistent (exercise 3.7a and 3.7b). Finally, they showed that A^* is optimal over the subclass of *best-first* algorithms (i.e., BF^*) which are admissible when $h \leqslant h^*$.

Section 3.2 is based on Pearl and Kim (1982); other methods of relaxing the admissibility requirement to gain speed are reported by Harris (1974), Pohl (1973), and Ghallab (1982). Section 3.3 is based on Dechter and Pearl (1983), although some of the results were also reported by Bagchi and Mahanti (1983). Improvements in A^* which reduce the number of node reopenings in the case of nonmonotone h were introduced by Martelli (1977), Méro (1981), and Bagchi, et al. (1983); see exercise 3.4.

EXERCISES

3.1 a. Give an example of two heuristic functions and a simple search tree where for every node n we have $h_2(n) \leqslant h_1(n) \leqslant h^*(n)$ and, yet, there exists a node n' having $f_2(n') < f_1(n') < C^*$ which is expanded by A_1^* and is not expanded by A_2^*. A_1^* and A_2^* use the same tie-breaking rule.

b. Prove that a situation like the one described in part (a) cannot occur if the tie-breaking rule used by the two algorithms is purely structural, e.g., leftmost first.

3.2 Prove Theorem 8 by induction on the depth-k descendants of n.

3.3 Prove that, if h_1 and h_2 are both monotone, so also is $h = \max(h_1, h_2)$.

3.4 (Martelli, 1977) Suppose, during the execution of A^* with $h \leqslant h^*$, we maintain a global variable F equal to the highest f value of all nodes so far expanded.

a. What is known about the set of nodes n that enter OPEN and satisfy $f(n) < F$?

b. Discuss the possible advantages of the following modification of A^*: whenever one or more nodes from the set above is present in OPEN, we interrupt the lowest-f-first policy and choose for expansion a node from this set having the lowest g value. Is this modified strategy admissible?

c. Give an example in which the modified strategy will shorten the search time by a factor of at least 2.

3.5 For risk measures R_1 and R_3, show that R_δ^* is δ-risk-admissible if C_δ' is used as a node selection criterion, where C_δ' is the solution of

$$\frac{R(C')}{C'} = \delta \qquad 0 \leqslant \delta \leqslant 1.$$

3.6 a. Use Theorem 2* Section 3.3 (or Corollary 1) to prove that BF^* guided by $f = f(g, h)$ is admissible if:

1. $h \leqslant h^*$,
2. $f(g, h)$ is monotonic in both arguments, and
3. $f(x, y - x) \leqslant f(y, 0)$ for $0 \leqslant x \leqslant y$.

b. Accordingly, check whether the following combinations are admissible:

1. $f(g, h) = \dfrac{g + h}{c^2 - gh} \qquad c > g \qquad c > h$
2. $f(g, h) = g \cdot h$
3. $f(g, h) = \sqrt{g^2 + h^2}$
4. $f(g, h) = g + h + a(g \cdot h)$
5. $f(g, h) = g + h^2/(g + h)$

3.7 a. Invent a search algorithm that is admissible whenever provided with a heuristic $h \leqslant h^*$ and yet, unlike A^*, it sometimes avoids expanding nodes reachable by strictly C^*-bounded paths.

b. Show that such node avoidance will never occur if h is consistent, i.e., A^* largely dominates every algorithm that is admissible under a consistent h.

c. Show that node avoidance as in part (a) cannot be accomplished by any admissible best-f-first algorithm (i.e., using a path-dependent f, and halting as soon as the first goal node is selected for expansion).

Chapter 4

Heuristics Viewed as Information Provided by Simplified Models

In Chapter 1 we saw a few examples of heuristic functions that were devised by clever individuals to assist in the solution of combinatorial problems. We now focus our attention on the mental process by which these heuristics are "discovered," with a view toward emulating the process mechanically.

4.1 THE USE OF RELAXED MODELS

4.1.1 Where Do These Heuristics Come From?

The word *discovery* carries with it an aura of mystery, because it is normally attached to mental processes that leave no memory trace of their intermediate steps. It is an appropriate term for the process of generating heuristics, since tracing back the intermediate steps evoked in this process is usually a difficult task. For example, although we can argue convincingly that h_2, the sum of the distances in the 8-Puzzle, is an optimistic estimate of the number of moves required to achieve the goal, it is hard to articulate the mechanism by which this function was discovered or to invent additional heuristics of similar merit.

Articulating the rationale for one's conviction in certain properties of human-devised heuristics may, however, provide clues as to the nature of the discovery process itself. Examining again the h_2 heuristic for the 8-Puzzle, note how surprisingly easy it is to convince people that h_2 is admissible. After all, the formal definition of admissibility contains a universal quantifier ($\forall n$) that, at least in principle, requires the inequality $h(n) \leqslant h^*(n)$ to be verified for *every* node in the graph. Such exhaustive verification is, of course, not only im-

113

practical but also inconceivable. Evidently the mental process we employ in verifying such propositions is similar to that of symbolic proofs in mathematics, where the truth of universally quantified statements (say, that there are infinitely many prime numbers) is established by a sequence of inference rules applied to a finite number of axioms without exhaustive enumeration.

An even more surprising aspect of our conviction in the truth of $h_2(n) \leqslant h^*(n)$ is the fact that $h^*(n)$, by its very nature, is an unknown quantity for almost every node in the graph; not knowing $h^*(n)$ was the very reason for seeking its estimate $h(n)$. How can we, then, become so absolutely convinced of the validity of the assertion $h_2(n) \leqslant h^*(n)$? Clearly, the verification of this assertion is performed in a code where $h^*(n)$ does not possess an explicit representation.

In the case of the Road Map problem our conviction in the admissibility of the air distance heuristic is explainable. Here, based on our deeply entrenched knowledge of the properties of Euclidean spaces, we may argue that a straight line between any two points is shorter than any alternative connection between these points and hence that the air distance to the goal constitutes an admissible heuristic for the problem. In the 8-Puzzle and the Traveling Salesman problem, however, such a universal assertion cannot be drawn directly from our culture or experience, and must be defended therefore by more elaborate arguments based on more fundamental principles.

If we try to articulate the rationale for our confidence in the admissibility of h_2 for the 8-Puzzle, we may encounter arguments such as the following:

1. Consider any solution to the goal, not necessarily an optimal one. To satisfy the goal conditions, each tile must trace some trajectory from its original location to its destination, and the overall cost (number of steps) of the solution is the sum of the costs of the individual trajectories. Every trajectory must consist of at least as many steps as that given by the Manhattan-distance between the tile's origin and its destination, and hence the sum of the distances cannot exceed the overall cost of the solution.

2. If I were able to move each tile independently of the others, I would pick up tile 1 and move it, in steps, along the shortest path to its destination, do the same with tile 2, and so on until all tiles reach their goal locations. On the whole, I will have to spend at least as many steps as that given by the sum of the distances. The fact that in the actual game tiles tend to interfere with each other can only make things worse. Hence, . . .

The first argument is analytical. It selects one property that must be satisfied by every solution, such as in providing a homeward-trajectory for every tile, and asks for the minimum cost required for maintaining just that property. The second argument is operational. It describes a procedure for solving a similar, auxiliary problem where the rules of the game have been *relaxed*. Instead of the conventional 8-Puzzle whose tiles are kept confined in a 2-dimensional plane, we now imagine a relaxed puzzle whose tiles are permitted to climb on

top of each other. Instead of seeking a mathematical *function* $h(n)$ to approximate $h^*(n)$, we can actually complete the solution using the relaxed version of the puzzle, *count* the number of steps required, and use this count as an estimate of $h^*(n)$.

This last scheme leads to the general paradigm expounded in this chapter: **Heuristics are discovered by consulting simplified models of the problem domain**. Later we will explicate what is meant by a *simplified* model and how to go about finding such a one. The preceding example, however, specifically demonstrates the use of one important class of simplified models; that generated by *removing constraints* which forbid or penalize certain moves in the original problem. We call models obtained by such constraint-deletion processes **relaxed models**.

Let us examine first how the constraint-deletion scheme may work in the Traveling Salesman problem, such as that of Figure 1.5. We are required to find an estimate for the cheapest completion path that starts at city D, ends at city A, and goes through every city in the set S of the unvisited cities. A path is a connected graph of degree 2, except for the end-points, which are of degree 1, a definition that we can express as a conjunction of three conditions:

1. Being a graph.
2. Being connected.
3. Being of degree 2.

If we delete the requirement that the completion graph be connected, we get the optimal assignment heuristic of Figure 1.6(a). Similarly, if we delete the constraint that the graph be of degree 2, we get the minimum-spanning-tree (MST) heuristic depicted in Figure 1.6(b). An even richer set of heuristics evolves by relaxing the condition that the task be completed by a graph (Pohl, 1973 and 1977).

An alternative way of leading toward the MST heuristic is to imagine a salesman employed under the following cost arrangement. He has to pay from his own pocket for any trip in which he visits a city for the first time, but can get a free ride back to any city that he visited before. It is not hard to see that under such relaxed cost conditions the salesman would benefit from visiting some cities more than once and that the optimal tour strategy is to pay only for those trips that are part of the minimum spanning tree. If instead of this cost arrangement the salesman gets one free ride *from* any city visited twice, the optimal tour may be made up of smaller loops, and the assignment problem ensues. Thus, by adding free rides to the original cost structure, we create relaxed problems whose solutions can be taken as admissible heuristics for the original problem.

4.1.2 Consistency of Relaxation-Based Heuristics

It is interesting to note that heuristics generated by optimizations over relaxed models are guaranteed to be *consistent* (or monotone). This is easily verified by

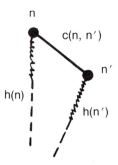

Figure 4.1

The consistency of relaxation-based heuristics, that is,
$h(n) \leqslant c(n, n') + h(n')$.

inspecting Figure 4.1, where $h(n)$ and $h(n')$ are the heuristics assigned to
nodes n and n', respectively. These heuristics stand for the minimum cost of
completing the solution from the corresponding nodes in some relaxed model
common to both nodes. $h(n)$, representing an optimal solution (geodesic),
must satisfy $h(n) \leqslant c'(n, n') + h(n')$, where $c'(n, n')$ is the relaxed cost of
the edge (n, n'). Otherwise $c'(n, n') + h(n')$, instead of $h(n)$, would consti-
tute the optimal cost from n.) The relaxed edge-cost $c'(n, n')$ cannot, by
definition, exceed the original cost $c(n, n')$. Thus:

$$h(n) \leqslant c(n, n') + h(n')$$

which, together with the technical condition $h(\text{goal}) = 0$, completes the re-
quirements for consistency (see Section 3.1.5).

This feature has both computational and psychological implications. Com-
putationally it guarantees that A^*, guided by any heuristic evolving from a re-
laxed model, would be spared the effort of reopening CLOSED nodes and
redirecting their pointers. The pointers assigned to any node expanded by such
algorithms are already directed along the optimal path to that node.

Psychologically, if we assume that people discover heuristics by consulting
relaxed models, we can explain now why most man-made heuristics are both
admissible *and* consistent. The reader may wish to test this point by attempting
to generate heuristics for the 8-Puzzle or the TSP that are admissible but not
consistent. The difficulties encountered in such attempts should strengthen the
reader's conviction that the most natural process for generating heuristics is by
relaxation, where consistency surfaces as an automatic bonus.

4.1.3 Overconstrained, Analogical, and Other Types of Auxiliary Models

Before proceeding to outline how systematic relaxations can be used to gen-
erate heuristics mechanically, it is important to note that not every relaxed
model is automatically simpler than the original. Assume, for example, that in

the 8-Puzzle, in addition to the conventional moves, we also allow a checker-like jumping of tiles across the main diagonals. The puzzle thus created is obviously more relaxed than the original, but it is not at all clear that the complexity of searching for an optimal solution in the relaxed puzzle is lower than that associated with the original problem. True, adding shortcuts makes the search graph of the relaxed model somewhat shallower, yet it also becomes bushier; a search strategy must now examine the extra moves available at every decision junction, even if they lead nowhere.

Moreover, relaxation is not the only scheme that may simplify problems. In fact, simplified models can easily be obtained by a process opposite that of relaxation, such as loading the original model with **additional constraints.** Of course, the solutions to overconstrained models would no longer be admissible. However, in satisficing problems where one settles for finding any path to a goal, not necessarily the optimal, simplified overconstrained models may be very helpful. The most straightforward way of constraining models is to assume that a certain portion of the solution is given *a priori.* This assumption cuts down on the number of remaining variables which, of course, results in a speedy search for the completion portion. For example, if one arbitrarily selects an initial subtour through M cities in the TSP, an overconstrained problem ensues which is simpler than the original because it involves only $N - M$ cities. The cost associated with the solution to such a problem constitutes an upper bound to h^* and can be used to cut down the storage requirement of A^*. Every node in OPEN whose admissible evaluation $f(n) = g(n) + h(n)$ exceeds that upper bound can be permanently removed from memory without endangering the optimality of the resulting solution.

A third important class of simplified models can be obtained by **probabilistic** considerations. In certain cases we may possess sufficient knowledge about the problem domain to permit an estimate of the *most probable* cost of the completion path, and we may use this cost as a heuristic to guide the search. Alternatively, probability-based models can be used to determine when irrevocable pruning of nodes is "safe." The use of such models is discussed in Section 4.3.

Another class of auxiliary models used in heuristic reasoning is **analogical** or **metaphorical** models. Here the auxiliary model draws its power not from the simplicity of the *problem structure,* but rather from matching the machinery or expertise available to the *problem solver.* For example, the popular game of tic-tac-toe appears simpler to us than its isomorphic number-scrabble game (where the aim is to select three numbers that sum to fifteen, Newell and Simon, 1972), even though the two games are merely different representations of the same underlying graph. The former appears *simpler* because it evokes an expertise available to our visual machinery (e.g., the ability to swiftly detect rows, columns, and diagonals) that has not yet been acquired by our arithmetic reasoner (e.g., to quickly identify sets of number-triplets which sum to fifteen).

Human expertise, because it consumes a fair amount of computational resources, remains narrowly bound to one notational system, usually that in which the expertise was initially acquired. Tic-tac-toe experts were found to

play a rather mediocre game of number scrabble (if forbidden the use of pencil and paper) even when shown the equivalence of the two games. The only players who benefited from their tic-tac-toe expertise were those gifted with the power of visual imagery who were able to visualize the array of dots and crosses which corresponded to each numerical configuration encountered in the number-scrabble game. Evidently, the game-playing expertise was not easily transferable from the notation of square arrays to that of numerical symbols, causing the players to miss threats and opportunites that would otherwise be evoked by imagining the equivalent 3×3 array configurations.

This example demonstrates the essence of the computational benefits drawn from analogical reasoning, namely, that it is often easier to transform the notational system to fit the evoking mechanism of a preexisting expertise than to organize a duplicate body of expertise around a new notational system. The prevailing use of visual imagery in solving complex problems in mathematics, physics, economics, and programming further attests to the power and generality of this computational principle, even in cases where the analogical transformations are only partially valid. Imagery capitalizes both on the vast amount of common-sense knowledge we have acquired regarding the physical world surrounding us and on the special-purpose machinery evolution has bestowed upon us for processing motor-visual information. Clearly, the use of analogical models by computers would likewise be beneficial only when we learn to build efficient data-driven expert systems for at least one problem domain of sufficient richness, e.g., the manipulation of physical objects. (See Kling, 1971; Funt, 1977; Pearl, 1977b; Lenat, 1977; and Carbonell, 1983.)

4.2 MECHANICAL GENERATION OF ADMISSIBLE HEURISTICS

4.2.1 Systematic Relaxation

We return now to the relaxation scheme and to show how the deletion of constraints can be systematized to the point that natural heuristics, such as those demonstrated in Chapter 1, can be generated by mechanical means. The constraint-relaxation scheme is particularly suitable for this purpose because it is often convenient to represent problem domains by specifying the constraints that govern the applicability and impact of the various transformations in that domain. Take, for instance, the 8-Puzzle problem. It is utterly impractical to specify the set of legal moves by an exhaustive list of pairs, describing the states before and after the application of each move. A more natural representation of the puzzle would specify the available moves by two sets of conditions, one that must hold true before a given move is applicable and one that must prevail

after the move is applied. In the robot-planning program STRIPS (Fikes and Nilsson, 1971), for example, actions are represented by three lists:

1. A *precondition list*—a conjunction of predicates that must hold true before the action can be applied
2. An *add list*—a list of predicates that are to be added to the description of the world-state as a result of applying the action
3. A *delete list*—a list of predicates that are no longer true once the action is applied and should, therefore, be deleted from the state description.

We will use this representation in formalizing the relaxation scheme for the 8-Puzzle.

We start with a set of three primitive predicates:

$$ON(x,y) \quad : \quad \text{tile } x \text{ is on cell } y$$
$$CLEAR(y) \quad : \quad \text{cell } y \text{ is clear of tiles}$$
$$ADJ(y,z) \quad : \quad \text{cell } y \text{ is adjacent to cell } z,$$

where the variable x is understood to stand for the tiles X_1, X_2, \ldots, X_8 and where the variables y and z range over the set of cells C_1, C_2, \ldots, C_9. Although the predicate CLEAR can be defined in terms of ON:

$$CLEAR(y) \iff \forall(x) \sim ON(x,y)$$

it is convenient to carry CLEAR explicitly as if it were an independent predicate. Using these primitives, each state is described by a list of nine predicates, such as:

$$ON(X_1, C_1), ON(X_2, C_2), \ldots, ON(X_8, C_8), CLEAR(C_9)$$

together with the board description:

$$ADJ(C_1, C_2), ADJ(C_1, C_4), \ldots,$$

The move corresponding to transferring tile x from location y to location z will be described by the three lists:

$MOVE(x,y,z)$:

precondition list	:	$ON(x,y), CLEAR(z), ADJ(y,z)$
add list	:	$ON(x,z), CLEAR(y)$
delete list	:	$ON(x,y), CLEAR(z)$

The problem is defined as finding a sequence of applicable instantiations for the basic operator $MOVE(x,y,z)$ that will transform the initial state into a state satisfying the goal criteria.

Let us now examine the effect of relaxing the problem by deleting the two conditions, CLEAR (z) and ADJ (y, z), from the precondition list. The resultant puzzle permits each tile to be taken from its current position and be placed on any desired cell with one move. The problem can be readily solved using a straightforward control scheme: at any state find any tile that is not located on the required cell. Let this tile be X_1, its current location Y_1, and its required location Z_1. Apply the operator MOVE (X_1, Y_1, Z_1), and repeat the procedure on the prevailing state until all tiles are properly located.

Clearly the number of moves required to solve any such problem is exactly the number of tiles that are misplaced in the initial state. If one submits this relaxed problem to a mechanical problem-solver and counts the number of moves required, the heuristic $h_1(\cdot)$ ensues.

Imagine now that instead of deleting the two conditions, only CLEAR (z) is deleted, whereas ADJ (y, z) remains. The resultant model permits each tile to be moved into an adjacent location regardless of its being occupied by another tile. This obviously leads to the $h_2(\cdot)$ heuristic: the sum of the Manhattan-distances.

The next deletion follows naturally. Let us retain the condition CLEAR (z) and delete ADJ (y, z). The resultant model permits transferring any tile to the empty spot, even when the two cells are not adjacent. The problem of reconfiguring the initial state with such operators is equivalent to that of sorting a list of elements by *swapping* the locations of two elements at a time, where every swap must exchange one marked element (the blank) with some other element. The optimal solution to this swap-sort problem can be obtained using the following "greedy" algorithm:

> If the current empty cell y is to be covered by tile x, move x into y. Otherwise (if y is to remain empty in the goal state), move into y any arbitrary misplaced tile. Repeat.

The resulting cost of solving problems in this model, h_3, is mentioned neither in Chapter 1 nor in text books on heuristic search (e.g., Nilsson, 1971). It is not the kind of heuristic that is likely to be discovered by the novice, and it was first introduced by Gaschnig (1979b) 13 years after A^* was tested using h_1 and h_2 (Doran and Michie, 1966). Although h_3 turns out to be only slightly better than h_1, its late discovery, coupled with the fact that it evolves so naturally from the constraint-deletion scheme, illustrates that the method of systematic deletions is capable of generating nontrivial heuristics.

The reader may presume that the space of deletions is now exhausted; deleting ON (x, y) leads again to h_1, whereas retaining all three conditions brings us back to the original problem. Fortunately the space of deletions can be further refined by enriching the set of elementary predicates. There is no reason, for instance, why the relation ADJ (y, z) need be taken as elementary—we may wish to express this relation as a conjunction of two other relations:

$$\text{ADJ } (y, z) \iff \text{NEIGHBOR } (y, z) \wedge \text{SAME-LINE } (y, z)$$

Deleting any one of these new relations results in a new model, closer to the original than that created by deleting the entire ADJ predicate.

Thus, if we equip our program with a large set of predicates or with facilities to generate additional predicates, the space of deletions can be refined progressively, each refinement creating new problems closer and closer to the original. The resulting problems, however, may not lend themselves to easy solutions and may turn out to be even harder than the original problem. Therefore the search for a model in the space of deletions cannot proceed blindly but must be directed toward finding a model that is both easy to solve and not too far from the original.

This begs the following question: Can a program tell an easy problem from a hard one without actually trying to solve them? We discuss this question in the next section.

4.2.2 Can a Program Tell an Easy Problem When It Sees One?

We now come to the key issue in our heuristic-generation scheme. We have seen how problem models can be relaxed with various degrees of refinements. We have also seen that relaxation without simplification is a futile excursion. Ideally, we would like to have a program that evaluates the degree of simplification provided by any candidate relaxation and uses this evaluation to direct the search in model-space toward a model that is both simple and close to the original. This, however, may be asking for too much. The most we may be able to obtain is a program that recognizes a simple model when such a one happens to be generated by some relaxation. Of course, we do not expect to be able to prove mechanically propositions such as "this class of problems cannot be solved in polynomial-time." Instead, we should be able to recognize a *subclass* of easy problems, those possessing salient features advertising their simplicity.

Most of the preceding examples possess such features. They can be solved by "greedy," hill-climbing methods without backtracking, and the feature that makes them amenable to such methods is their **decomposability**. Take, for instance, the most relaxed model for the 8-Puzzle, where each tile can be lifted and placed on any cell with no restrictions. We know that this problem is simple, without actually solving it, because all the goal conditions, $ON(X_1, C_1)$, $ON(X_2, C_2), \ldots$, can be satisfied *independently* of each other. Each element in this list of subgoals can be satisfied by one operator without undoing the effect of previous operators and without affecting the applicability of future operators.

Similar conditions prevail in the model corresponding to h_2, with the exception that a *sequence* of operators is now required to satisfy each of the goal conditions. The sequences, however, are again independent in both applicability and effects, a fact that is discernible mechanically from the formal specification of the model, since the subgoals themselves define the desired partition of the

operators. Any operator whose add list contains the predicate $ON(X_i, y)$ will be directed only toward satisfying the subgoal $ON(X_i, C_i)$ and can be *proven* to be noninterfering with any operator containing the predicate $ON(X_j, y)$ in its add list.

Most automatic problem-solvers are driven by mechanisms that attempt to break down a given problem into its constituent subproblems as dictated by the goal description. For example, the General Problem Solver (Ernst and Newell, 1969) is controlled by "differences," a set of features that make the goal different from the current state. The programmer has to specify, though, along what dimensions these differences are measured, which differences are easier to remove, what operators have the potential of reducing each of the differences, and under what conditions each reduction operator is applicable. In STRIPS, most of these decisions are made mechanically on the basis of the three-list description of operators. Actions are brought up for consideration because their add list contains predicates that can bridge the gap between the desired goal and the current state. If the current state does not possess the conditions necessary for enacting a useful difference-reducing transformation, a new subgoal is created to satisfy the missing conditions. Thus the complexity of this "end-means" strategy increases sharply when subgoals begin to interact with each other.

The simplicity of decomposable problems, on the other hand, stems from the fact that each of the subgoals can be satisfied independently of each other; thus the overall goal can be achieved in a time equal to the number of conjuncts in the goal description multiplied by the time required for satisfying a single conjunct in isolation. It is a version of the celebrated "divide-and-conquer" principle, where the division is dictated by the primitive conjuncts defining the goal conditions. For example, in an $N \times N$ Puzzle we have N^2 conjuncts defining the goal state configuration, and the solution of each subproblem, namely finding the shortest path for one tile using a relaxed model with single-cell moves, can be obtained in $O(N^2)$ steps even by an uninformed, breadth-first, algorithm. Thus the optimal solution for the overall relaxed $N \times N$ Puzzle can be obtained in $O(N^4)$ steps, which is substantially better than the exponential complexity normally encountered in the nonrelaxed version of the $N \times N$ Puzzle.

The relaxed $N \times N$ Puzzle is an example of a complete independence between the subgoals, where an operator leading toward a given subgoal is neither hindered nor assisted by any operator leading toward another subgoal. Such complete independence is a rare case in practice and can only be achieved after deleting a large fraction of the applicability constraints. It turns out, however, that simplicity can also be achieved in much weaker forms of independence which we call **semi-decomposable** models.

Take, for example, the minimum-spanning-tree problem. If the goal is defined as a conjunction of $N - 1$ conditions:

$$\text{CONNECTED (city } i, \text{ city } 1) \qquad i = 2, 3, \ldots, N$$

and each elementary operator consists of adding an edge between a connected and an unconnected city, we have a semi-decomposable structure. Even though no operator may undo the labor of previous operators or hinder the applicability of future operators, some degree of coupling remains since each operator *enables* a different set of applicable operators. This form of coupling, which was not present in the relaxed 8-Puzzle, may make the cost of the solution depend on the order in which the operators are applied. Fortunately, the MST problem possesses another feature, **commutativity**, which renders the greedy algorithm "cheapest-subgoal-first" optimal. *Commutativity* implies that the internal order at which a given set of operators is applied does not alter the set of operators applicable in the future (Nilsson, 1980). This property, too, should be discernible from the formal specification of the domain model and, once verified, would identify the "greedy" strategy which yields an optimal solution.

Another type of semi-decomposable problem is exemplified by the swap-sort model of the 8-Puzzle where the subgoals interact with respect to both applicability and effects. Moving a given tile into the empty cell clearly disqualifies the applicability of all operators that move other tiles into that particular cell. Additionally, if at a certain stage the predicate specifying the correct position of the empty cell is already satisfied, it would be impossible to satisfy additional subgoals without first falsifying this predicate, hopefully on a temporary basis only.

In spite of these couplings, the feature that renders this puzzle simple, admitting a greedy algorithm, is the existence of a **partial order** on the subgoals and their associated operators such that the operators designated for any subgoal g may influence only subgoals of higher order than g, leaving all other subgoals unaffected. In our simple example, establishing the correct position of the blank is a subgoal of a higher order than all the other subgoals and should, therefore, be attempted last. A similar hierarchy of subgoals was also encountered in the Tower of Hanoi problem (Section 1.2.5). To find such a partial order of subgoals from the problem specification is similar to finding a triangular connection matrix in GPS; programs for computing this task have been reported in the literature (Ernst and Goldstein, 1982).

4.2.3 Summary

This section outlined a natural scheme for devising heuristics for combinatorial problems. First, the problem domain is formulated in terms of the three-list operators that transform the states in the domain and the conditions that define the goal states. Next, the preconditions that limit the applicability of the operators are refined and partially deleted, and the resulting model submitted to an evaluator that determines whether it is semi-decomposable. The space of all such deletions constitutes a meta-search-space of relaxed models from which the most restrictive semi-decomposable element is to be selected. The search

starts either at the original model from which precondition conjuncts are delet-ed one at a time, or at the trivial model containing no preconditions to which restrictions are added sequentially until decomposability is destroyed. The model selected, together with the "greedy" strategy that exploits its decompo-sability, constitutes the heuristic for the original domain.

Although the effort invested in searching for an appropriate relaxed model may seem heavy, the payoffs expected are rather rewarding. Once a simplified model is found, it can be used to generate heuristics for **all instances** of the ori-ginal problem domain. For example, if our scheme is applied successfully to the TSP model, it may discover a $O(N^2)$ heuristic superior to (more con-strained than) the MST heuristic. Such a heuristic should be applicable to every instance of the TSP problem and, when incorporated into A^*, would yield optimal TSP solutions in shorter times than the MST. We currently do not know if such heuristics exist. Equally challenging are routing problems en-countered in communication networks and VLSI designs which, unlike the TSP, have not been the focus of a long theoretical research, but where the problem of devising effective heuristics remains, nonetheless, a practical neces-sity.

4.3 PROBABILITY-BASED HEURISTICS

Probability is a language for **quantifying the unpredictability** of our environ-ment. Probabilistic models specify a set of possible instances of the environ-ment together with their associated degree of likelihood. In the Traveling Salesman problem, for example, the intercity distance table specifies one in-stance of the environment that the salesman may actually encounter. If, instead of specific distances, the table gives lower and upper bounds between which the actual distances may fall, that table delineates a *set* of possible problem in-stances. Finally, by specifying the *distribution* of the intercity distances, we are also able to determine whether one instance is more credible than another and by how much. In other words, the distribution quantifies the relative likelihood at which problem instances are expected to be encountered.

Although probability and statistics have developed in the past century into intricate mathematical specialties, probabilistic considerations are not less per-vasive in our common, daily activities than other simplification heuristics. We choose one route over another because the former is *more likely* to be shorter, even though it has occasionally turned out longer. We say that a certain situa-tion is *more desirable* than others mostly because similar situations in the past turned out disappointing *less often* (Pearl, 1977a).

Clearly people do tend to retain and invoke likelihood considerations as part of their mental encoding of past experiences. The acquisition and use of these likelihood relationships are governed by heuristic strategies of their own, such as those based on **similarity** and **ease of recall** (Tversky and Kahaneman, 1973,

1974). Normally an event is judged to be likely or probable if it possesses features considered *prototypical* of a large population. Thus we regard a white-skinned African to be a rare event by virtue of the disparity between the skin color observed and that expected from a normally protrayed African. In certain cases, the tendency to attribute to a single instance properties characterizing the population as a whole may even reach paradoxical proportions. For example, uniform sequences of coin-tossing outcomes are normally judged to be "less likely" than sequences with no apparent pattern (Tversky and Kahneman, 1974) simply because a "typical" sequence is expected to appear unorderly. Nevertheless, these mental heuristics perform relatively well in most cases and only highlight the importance of probabilistic estimates in everyday problem-solving activity.

Because the ultimate test for the success of heuristic methods is that they work well "most of the time," and because probability theory is our principal formalism for quantifying concepts such as "most of the time," it is only natural that probabilistic models should provide a formal ground for quantitatively evaluating the performance of heuristic methods. Moreover, it is equally natural that probabilistic models, whenever available, be consulted in the process of devising heuristic methods, or in selecting the parameters that govern these methods, so as to guarantee that only a small fraction of problem instances will escape an adequate treatment.

The following sections represent a brief overview of some probability-based heuristics. Some examples of these heuristics were already encountered in Section 3.2 where both the rating of nodes for expansion and the termination conditions were determined by probabilistic considerations based on the distribution of the random variable h^*. Additional examples are presented in subsequent chapters.

4.3.1 Heuristics Based on the Most Likely Outcome

Heuristic methods are often based on estimates of some unknown variables of the problem instance. For example, A^* is driven by the function h which estimates the unknown value of h^* (the minimal cost required for completing the solution path). If the problem domain is characterized by a probabilistic model, it is sometimes possible to *calculate* the most-likely value of the unknown variable and use this value in constructing the heuristic function.

Probability calculus provides a machinery for performing such calculations. Consider, for example, the problem of finding the cheapest path in a graph where all arc costs are known to be drawn independently from a common distribution function with mean μ. If N stands for the number of arcs remaining between a node n and the goal, then for large N the law of large numbers (Feller, 1968) asserts that the cost of any path to the goal is likely to fall in the neighborhood of μN. Therefore, if we are sure that only one path leads from n to the goal, we can take the value μN as an estimate of h^* and use $f = g + \mu N$ as a node-rating function in A^*.

If several paths lead from n to the goal set, μN may no longer be the best cost estimate for the cheapest path. However, if the structure of these solution paths is fairly regular, probability calculus can still be invoked to obtain that best cost estimate. Section 5.4 contains an example of such a computation. It will be shown there that in a tall uniform binary tree where every branch assumes the cost 1 or 0 with probabilities p and $1 - p$, respectively, the cost of the cheapest path converges to $\alpha^*(p)N$, if $p > \frac{1}{2}$, where α^* is a predetermined function of p (see Figure 5.8). Hence, if the value of p summarizes all the information available regarding costs in the unexplored portion of the tree, then $f = g + \alpha^*N$ would be the natural criterion for rating nodes in A^*.

By their very nature, such probability-based estimates are not guaranteed to be admissible. Occasionally these estimates may grossly overestimate the completion cost h^* and, in turn, may cause A^* to terminate prematurely with a suboptimal solution. On the other hand, if one does not insist on finding an exact optimal solution *all* the time, but settles for finding a "good" solution *most* of the time, probability-based heuristics may be perfectly acceptable (see exercise 5.4). They can also be incorporated into various hybrid strategies to determine the appropriate pruning criteria (see Section 5.4) and lead to dramatic reductions in the expected search time.

4.3.2 Heuristics Based on Sampling

Sampling is perhaps the oldest and the most widely practiced of all heuristic methods. Generally speaking, it involves inferring some property of a large set of elements from the properties of a small, randomly selected, subset of elements.

The economical benefits of sampling are widely studied in text books on statistics (e.g., Winkler and Hays, 1975). For example, if a manufacturer wishes to test whether a batch of 1 million nails contains no more than 1,000 defective units, he need not test the entire batch; a random sample of a few hundred nails may suffice to reflect the quality of the entire batch with an acceptable level of confidence. Significantly, the number of samples required for reaching a given level of confidence is fairly independent of the size of the batch and so, the larger the batch, the greater the economical savings achieved by sampling over that of exhaustive testing.

The implications to problems in **computational complexity** and algorithm design are straightforward. Assume, for instance, that we are given a huge database containing N binary digits and we are asked to compute the *proportion* of digits that are 1. Clearly, there is no way of computing the exact value of the proportion without inspecting all N digits, thus spending N computational steps. However, if we are willing to tolerate a small error, a constant number of computations may suffice. We need only choose a random sample of n digits and compute the proportion of 1's among the n samples. For large values of N, the celebrated Bernoulli Theorem (Uspensky, 1937) guarantees that if the

underlying proportion is π and the sample proportion is ν, then the deviation between the two is bounded by the following relation

$$P(\,|\,\pi - \nu\,| \,\geqslant\, \epsilon) \,\leqslant\, 2e^{-n\epsilon^2/2}$$

Hence, the number of observations necessary to guarantee with sufficiently high probability (η) that the error $|\,\pi - \nu\,|$ will remain below ϵ is given by

$$n \,=\, \frac{2}{\epsilon^2} \,\log\frac{2}{1-\eta}$$

This number depends only on the precision and confidence parameters, ϵ and η, but remains constant with increasing N. Thus the computational savings produced by our willingness to tolerate some degree of imprecision can be enormous; a reduction of complexity from linear time to constant time.

Moreover, if N increases indefinitely, we can choose the sample size to be any divergent function of N, say $n = g(N)$, and guarantee that as $N \to \infty$ the deviation between ν and π will vanish with probability approaching 1; that is,

$$P(\,|\,\pi - \nu\,| \,<\,\epsilon) \to 1 \qquad \vee\,\epsilon > 0$$

Colloquially, we can say that our willingness to tolerate some small errors, guaranteed to "vanish almost surely," causes a complexity reduction from N to $g(N)$. The function $g(N)$ can, of course, be made to diverge very slowly, e.g., like $\log N$, $\log\log N$, or even slower.

This technique is not limited to the task of computing proportions but is applicable to the computation of every statistical property of the database population: the mean, the variance, the median, the mode, etc., Weide (1978) has extended the applications of sampling methods to problems of sorting, searching, and selection.

In Section 4.3.3 we describe heuristic methods that are based on the assumption that problem instances are generated by known distribution functions; the search parameters are tailored to fit the distribution functions so as to solve *almost* all problem instances and, simultaneously, exhibit limited *average* search times as computed by the assumed distributions. In the event that these distributions are not known, sampling techniques can again be resorted to for **estimating the shape** of these distributions or their main parameters. In some cases, however, sampling-based estimates of certain input properties can be used to guide **probabilistic search algorithms** that achieve much stronger guarantees:

1. Every problem instance will be solved *exactly*.
2. The average search time will be limited for *every problem instance*, irrespective of any assumed distribution.

Using such estimates, Rabin (1976) has shown that the closest-pair among any set of N points in a Euclidean space can be found in linear expected time; a

substantial improvement over the quadratic time required by an exhaustive examination of all pairs.

4.3.3 Probability-Based Heuristics in the Service of Semi-Optimization Problems

Assume that we are given an unsorted list of N distinct real numbers and we are asked to find the largest element in the list. There is no way that we can perform this task without first inspecting all N elements and, if each inspection counts as one computational step, it is clear that finding the maximal element requires N steps.

Let us now assume that we are also permitted to consult an **oracle** who, for reasons of his own, reveals to us the true value of the maximal element in the list but not its position. With this added information we can inspect the elements sequentially and stop as soon as we find an element that matches the value given by the oracle. In the worst case, we will still need to inspect all N elements but, if we are lucky, the search may terminate after the first inspection. On the average, assuming that the elements are arranged at random (or that our inspection proceeds at random), the time required for identifying the maximal element is $N/2$. A speedup factor of 2, then, is the utility of consulting an oracle, which turns the optimization problem into a satisficing one.

Let us further assume that, instead of finding the exact maximal element, we are willing to settle for any element in the **ε-neighborhood** of the maximal, that is, if X_m is the actual value of the maximal element, then any number in the set $\{X: X_m - X \leqslant \epsilon\}$ would qualify for a solution. What is now the benefit associated with knowing the value of X_m?

Clearly the answer depends on how early we can find an element falling above $X_m - \epsilon$. A well-known result in probability theory states that if we are conducting a series of independent trials to be terminated upon the first success and if the probability of success in each trial is p, then the expected number of trials performed is $1/p$. Consequently, if $p(X_m, \epsilon)$ stands for the probability that a typical element in the list falls in the range $X_m - \epsilon \leqslant X \leqslant X_m$ given that $X \leqslant X_m$, then the expected number of tests conducted is at most $[p(X_m, \epsilon)]^{-1}$. If the X's are continuous bounded random variables independently drawn from a common distribution $F_X(x)$ and if ϵ is very small, then $p(X_m, \epsilon)$ is easily calculated to give

$$p(X_m, \epsilon) = P[X_m - \epsilon \leqslant X \leqslant X_m \mid X \leqslant X_m]$$

$$= \frac{F_X(X_m) - F_X(X_m - \epsilon)}{F_X(X_m)}$$

$$\approx \frac{F'_X(X_m)}{F_X(X_m)} \epsilon$$

and the expected number of tests $E(Z_N)$ is bounded by

$$E(Z_N \mid X_m) \leqslant [P(X_m, \epsilon)]^{-1} \approx \frac{F_X(X_m)}{F'_X(X_m)} \, 1/\epsilon$$

which is a constant value, inversely proportional to ϵ, but independent of N. Thus the benefits of knowing X_m have been amplified significantly by tolerating an ϵ worth of suboptimality; instead of $N/2$, we can now find a solution in constant expected time.

Assume now that an oracle is not available, but instead we have a **probabilistic model** from which we may infer an estimate K for X_m. We can still conduct a sequential inspection of the items on the list but with a modified stopping criterion. Instead of stopping at the interval $X_m - \epsilon \leqslant X \leqslant X_m$ which now is unknown, we can stop as soon as we get a number X exceeding $K - \epsilon$, where K is our guess for the value of X_m. A simple analysis, similar to the preceding one, shows that the expected number of inspections under this new stopping criterion is bounded by

$$E(Z_N) \leqslant \frac{F_X(X_m)}{F'_X(K)} \, 1/\epsilon$$

As in the case of the oracle, this bound is also a constant. However, the number finally found is no longer guaranteed to lie in the ϵ-neighborhood of X_m unless we make sure that X_m does not exceed the guess K. In case X is a bounded random variable with a known distribution, we can easily meet this guarantee by choosing $K = x_o$, where x_o is the highest possible value that X may attain; that is,

$$x_o = \sup\{x : F_X(x) < 1\}$$

Moreover, if $F'(x_o)$ is too small, we still have the option of choosing $K = x_o - \epsilon'$ $(\epsilon' < \epsilon)$ and modifying the stopping rule to the interval $X \geqslant K - \epsilon + \epsilon'$, again guaranteeing the ϵ-admissibility of the solution found together with the boundness of $E(Z_N)$.

However, if X is an unbounded random variable, there is no way to guarantee that the actual maximal value X_m will not exceed any fixed stopping limit K and, therefore, we must abandon absolute guarantees of near optimality in every scheme short of exhaustive search. One may be tempted, at this point, to replace the near-optimality requirement with the requirement of *approximate-optimality;* accepting occasional solutions outside the ϵ-neighborhood of X_m but insisting that these occasions not occur too often. This can be accomplished by choosing a stopping bound $K(N)$ sufficiently large so that $P[X_m - K(N) < \epsilon]$ be made smaller than some $\delta > 0$. However, this will usually work against our second objective of keeping $E(Z_N)$ bounded or, at least, growing at a rate slower than N. The value of $K(N)$ will often be so high that the expected number of inspections needed until finding a sample exceeding $K(N)$ would be proportional to N (see exercises 4.4a and 4.5a). Permitting

the error ϵ to grow proportionally to X_m may sometimes alleviate this problem (see exercises 4.4b and 4.5b).

The purpose of the preceding discussion was to demonstrate how the willingness to tolerate some degree of suboptimality coupled with knowledge regarding the distribution of the input data can sometimes result in dramatic reduction of search complexity. The demonstration was made simple and feasible by three major assumptions:

1. That the items on the list are independent and identically distributed (i.i.d.) random variables.
2. That testing each candidate requires the same amount of computation.
3. That these random variables are bounded.

In more elaborate search problems, the values associated with each candidate solution (e.g., the costs of solution paths in a tree) will not be i.i.d.; each candidate may have a different probability of leading to a solution and may require a different amount of exploration effort. The expected search time then depends on the *order* in which tests are applied and optimizing this order may not be simple (see exercise 4.5 for a simple ordering optimization and Simon and Kadane (1975) for more elaborate cases). Search problems are further complicated by the fact that the exploration of any given candidate solution usually sheds light on the qualities of related solutions and may be performed incrementally, that is, we have the option of abandoning a partially explored candidate to attend another. Finally, the distribution of the solution weights very often varies with the problem size N and so, one may not be able to find a stopping bound $K(N)$ that falls in the ϵ-neighborhood of the optimal solution while, at the same time, guaranteeing that a solution meeting this bound will be found in a reasonable time.

Despite these complications, however, the essential steps of our exercise point to a general method of devising heuristics, applicable to a large class of optimization problems. We first use probabilistic considerations to estimate in what neighborhood the optimal solution is most likely to fall, and then devise an efficient search for identifying a solution within that neighborhood. This method succeeds if the following two conditions prevail:

1. The density of X_m becomes highly concentrated about some predetermined quantity $K(N)$. In other words,

$$P[(1 - \epsilon)K(N) \leqslant X_m \leqslant (1 + \epsilon)K(N)] \to 1$$

2. In almost every problem instance, the target ϵ-neighborhood around $K(N)$ should contain at least one solution that is discoverable by an easy search algorithm.

In Section 5.4 we analyze in detail a problem environment where these two conditions hold. More specifically, we show there that the costs along many

solution paths in the neighborhood of $K(N)$ are likely to increase gradually at a predetermining rate α^* and hence, an irrevocable search strategy can be employed which prunes away any path found to be at variance with this expectation. This probability-based pruning strategy reduces the average complexity from exponential to linear.

4.4 BIBLIOGRAPHICAL AND HISTORICAL REMARKS

The idea of connecting heuristics with the use of simplified models was first communicated to me by Stan Rosenschein. Relaxation methods of obtaining lower bounds to optimization problems have been practiced extensively in operations research in conjunction with the branch-and-bound techniques (Lawler and Wood (1966), and Held and Karp (1970)). A simple way of obtaining relaxed problems is to enlarge the region over which a function is minimized until the boundaries become mathematically more tractable, e.g., piece-wise linear or totally unbounded. However, the most popular use of relaxation lies in **integer programming** problems (Shapiro, 1979) where we exploit the fact that it is often easier to minimize a function over a continuous domain (using the tools of calculus or linear programming) than the domain of integers. The solution to the relaxed problem can then be used as a lower bound in a branch and bound algorithm for the original problem (see exercise 4.1).

Rather than ignoring constraints altogether, an alternative way of relaxing problems by mathematical manipulations is to penalize the cost function for some constraint violations and reward it when some constraints are satisfied. This can be done most conveniently whenever the constraints are represented in the form of numerical inequalities (or equalities) where one may add to the cost function a penalty term proportional to the amounts by which the inequalities are violated. This technique was coined **"Lagrange relaxation"** by Geoffrion (1974) and is surveyed by Fisher (1981).

The auxiliary-problem approach was formally introduced to nonnumeric, AI-type problems by Gaschnig (1979b), Guida and Somalvico (1979), and Banerji (1980). Gaschnig described the space of auxiliary problems as "subgraphs" and "supergraphs," obtained by deleting or adding edges to the original problem graph. The swap-sorting problem was contrived by Gaschnig to exemplify supergraphs of the 8-Puzzle. Guida and Somalvico use propositional representation of constraints similar to that of Section 5.1.2 and propose the use of relaxed models for generating admissible heuristics. A slightly different formulation is also given in Kibler (1982).

Valtorta's thesis (1981) contains a proof of the consistency of relaxation-based heuristics, and an analysis of the overall complexity of searching both the original and the auxiliary problems. It shows that if the auxiliary problem is searched by a breadth-first strategy, then the overall complexity will be worse than simply executing a breadth-first search on the original problem. The use of systematic deletions in search of decomposable problems was proposed by Pearl (1982a). Other approaches to automatic generation of heuristics are reported by Ernst and Goldstein (1982); Korf (1982); and Lenat (1983).

An effective planning system (named ABSTRIPS) using constraints relaxation was implemented by Sacerdoti (1974). ABSTRIPS first synthesizes a global abstract plan

and then searches for a detailed mode of its implementation. The abstract plan differs from a fully detailed one in that the operators invoked by the former are lacking some of the preconditions spelled out in the latter. Although the program does not make an explicit use of a numerical evaluation function, the search schedule is determined by progress achieved in the abstract planning phase and so, in effect, it can be thought of as being guided by the advise of a relaxed model.

EXERCISES

4.1 a. An optimistic estimate of the number of tests required (in the worst case) for resolving a given subproblem in the Counterfeit Coin problem (Section 1) is given by $\lceil \log_3 S \rceil$ where S stands for the number of possible solution outcomes to that subproblem. Find a relaxed version to the Counterfeit Coin problem for which $\lceil \log_3 S \rceil$ represents the *exact* minimal number of tests required to reach a solution.

 b. Find an optimistic estimate and a relaxed model supporting that estimate for the task of solving the Counterfeit Coin problem using the minimum average number of tests.

 c. Verify whether the heuristic estimates devised in parts (a) and (b) lead to the correct choice of the first weighing in the 12-coin instance of the Counterfeit Coin problem.

 d. Repeat part (b) assuming that the 12 coins are labeled C_1, C_2, \ldots, C_{12} and that the i^{th} coin initially has a probability of P_i of being the counterfeit. (*Hint:* Consult the literature on Huffman Code; e.g., Horowitz and Sahni, 1978.)

4.2 Identify the relaxed models which have assisted you in devising heuristics for exercises 1.2(b), 2.2(e), 2.3(a), (b), (c), (d), (e), and 2.4(a). Formulate these models using STRIPS-like operators.

4.3 (Relaxation in Integer Programming.) Apply a best-first search strategy to find a pair of integers (x, y) in the range $1 \leqslant x \leqslant 10$, $1 \leqslant y \leqslant 10$ which minimizes the function: $T(x, y) = y^2 - y^3 x e^{-yx/3}$. The evaluation function is to be computed by minimizing $T(x, y)$ under the relaxed condition of allowing one of the variables to take on continuous values. How many functional evaluations are performed? (Ans. 18)

4.4 We are given an unsorted list of N positive numbers, independently drawn from a common distribution function $F_X(x) = 1 - e^{-\alpha x}, x \geqslant 0, \alpha > 0$. In order to find an element near the maximal number X_m in the list, the following procedure is implemented: the list is searched sequentially until we find an element X_f exceeding a predetermined bound $K(N)$ and that element is then issued as a solution.

 a. Show that in order to guarantee that $P[X_m - X_f > \epsilon] \leqslant \delta$, the average number of elements inspected must be proportional to N, as $N \to \infty$.

 b. Show that the condition $P[X_f < (1 - \epsilon)X_m] \leqslant \delta$ can be guaranteed using $0(N^{1-\epsilon})$ expected time.

4.5 Repeat exercise 4.4 assuming that $F_X(x) = 1 - (x)^{-n}, n \geqslant 1$.

 a. Show that the condition $P[X_m - X_f > \epsilon] \leqslant \delta$ again requires linear expected time.

 b. Show that even the more relaxed condition $P[X_f < (1 - \epsilon)X_m] \leqslant \delta$ now requires linear expected time.

4.6 Suppose, in exercise 4.4, we wish to find a *near-minimal* element.

 a. Show that $X_f - X_m < \epsilon$ can be guaranteed in constant expected time, whereas $X_f < (1 + \epsilon)X_m$ requires N inspections.

 b. Show that the relaxed condition $P[X_f > (1 + \epsilon)X_m] \leqslant \delta$ still requires linear expected time.

4.7 (Optimal Search Ordering, after Simon and Kadane (1975)). An unknown number of chests of Spanish treasure have been buried on a random basis at some of n sites, at a known depth of 3 feet. For each site there is a known unconditional probability $p(i), i = 1, \ldots, n$, that a chest was buried there, and the cost of excavating site i is $q(i)$.

 a. Prove that the optimal search strategy (i.e., that which minimizes the expected cost required for finding a single treasure) is to excavate sites in descending order of the ratio $p(i)/q(i)$.

 b. Suppose the excavation costs are not known precisely but are estimated to have the conditional means $q^+(i)$ (if site i contains a treasure) and $q^-(i)$ (if site i contains no treasure). Find the optimal search strategy. (*Hint:* You may wish to consult Section 9.5.)

PART
II

Performance Analysis of Heuristic Methods

When you can measure what you are speaking about, and express it in numbers, you know something about it.

(LORD KELVIN)

Chapter 5

Abstract Models for Quantitative Performance Analysis

5.1 MATHEMATICAL PERFORMANCE ANALYSIS, OR TEST TUBES VERSUS FRUIT FLIES IN THE DESIGN OF GOTHIC CATHEDRALS

In his dissertation entitled "Performance Measurement and Analysis of Certain Search Algorithms," John Gaschnig (1979a) quotes the following passage from Bronowski (*The Ascent of Man*).

> One has the sense that the men who conceived these high buildings [Gothic Cathedrals] were intoxicated by their new-found command of the forces in the stone. How else could they have proposed to build vaults of 125 feet and 150 feet at a time when they could not calculate any of the stresses?

Gaschnig compares the task of building cathedrals to that of designing speech-understanding or program-synthesis systems, and draws a parallel between our failure to predict the performances of these systems and the inability of the medieval architects to calculate the stresses. Take, for example, some of the questions often raised by people who build complex AI systems. How much is gained by improving a given heuristic? How should one adjust the weights of g and h? Can some heuristic beat the exponential explosion? How much speed can be gained at the cost of lowering the solution quality? Design choices that depend on answers to such questions are normally made by educated guesses combined with trial and error. Like the twelfth century cathedral builders, the

system designers of today find they lack a mathematical theory of stresses, are unable to conduct meaningful experiments on scaled-down models, and have to rely primarily on craftmanship taught by apprenticeship.

But craftmansip has its limitations. It is based on expertise gathered by repetitive patterns of experiences and it lacks, therefore, the ability to leap forward and respond to novel requirements; would a larger column be able to support a cathedral 50 feet higher than those built before? Would our speech understanding system be able to handle an increased vocabulary, say from 1,000 words to 2,000 words?

Gaining access to a miniature workbench model of the system under design would certainly help answer such questions. It would enable us to compare performances of various design options under identical conditions and might reveal the existence of previously unsuspected phenomena.

Gaschnig, for example, selected the 8-Puzzle as a workbench model for measuring the performance of A*. Justifying this choice, he writes:

> The 8-Puzzle is to this work as the **fruit fly** is to the geneticist: simple, convenient to manipulate, yet exhibiting interesting phenomena that hypothetically hold for a broader class of subjects.

These simulations have, indeed, revealed several interesting phenomena and have evoked conjectures regarding search behavior in general. For example, for mid-size problems the mean run time of A* with $f_w = (1 - w)g + wh$ was found to attain its minimum at $w = \frac{1}{2}$, whereas for hard problems the minimum was found at $w = 1$. Why? Also, Gaschnig's observation that for $w > \frac{1}{2}$ the mean search time tends to level off from its normal exponential growth curve led him to conjecture that "some heuristics beat the exponential explosion and others do not. But the latter can be made to do so simply by giving more weight to h."

The trouble with fruit flies is that, despite their accelerated mutation rate, they represent just one species—a unique and rigid genetic system. They do not give the experimenters the freedom to selectively modify the system's parameters one at a time so that they can decisively confirm or refute a general law of genetics. Such are also the drawbacks of the 8-Puzzle, or any other specific problem domain, when used as a prototypical model for general search issues. Even when we discover an interesting phenomena, we can never tell for sure whether it reflects a universal pattern of behavior, common to all problems, or merely a by-product of the idiosyncratic features of the puzzle under study. It is impossible, for example, to confirm or refute conjectures about general ways of beating the exponential explosion merely by observing instances of 8-Puzzle searches.

In its quest to make workbench models more flexible, modern science has resorted to mathematical analysis of **ideal** or **abstract models** of reality. Galileo's invention (1638) of using symbolic mathematics to calculate the stresses in ideal beams, perfectly uniform in shape and properties, marks the

beginning of this development (together with his treatment of dynamics). It offered definite advantages over experimenting with miniature replicas of cathedrals, even though the ideal beams considered could not possibly represent realizable physical objects.

One advantage lies, of course, in the ease of obtaining an answer to a "what if" type question. Rather than subjecting an expensive replica model to destructive endurance tests, the Renaissance engineer was now able to come up with ball park predictions, consuming but a few drops of ink. The significance of this advantage has not diminished in the age of electronic computers. Computer simulations of search performance are both lengthy and expensive, especially when average-case behavior is required and large-size problems simulated. By contrast, predictions based on tractable probabilistic models can often be obtained with only a few steps of computation and can lead to a quicker identification of the conditions responsible for some desirable or undesirable phenomena.

But perhaps an even greater advantage of Galileo's invention lies in the ease and flexibility it offered for altering the model parameters. The abstract model in its mathematical representation now stood for not one but an infinite variety of conceptual realizations, each corresponding to a different combination of the model parameters. Pictorially, it simulated not one experiment but a vast laboratory with an infinite variety of **test tubes,** each subjected to a different set of conditions and all monitored simultaneously. For the first time the designer was able to interrogate his model with "how" queries: How wide should the beam be? How best to shape it? This added flexibility not only shortened the design time, but also evoked new conjectures, which in turn swayed the focus of attention to new types of experiments. After all, it was a theory sprouting from a mathematical equation that made the prudent citizens of Pisa suddenly so curious of falling bodies.

Chapters 5 to 10 of this book consist of mathematical performance analyses using abstract models of various problem domains. These can be likened to experiments in Galilean-type laboratories with the test-tubes being: simplified graph structures, tractable probabilistic models, synthetic games, and so on. The applicability of these investigations is limited, of course, to those problems that are similar in structure to the mathematical models analyzed but, like all conclusions drawn from the laboratory, they help identify the factors that have decisive influence on the phenomenon under study.

Probabilistic models constitute the dominant portion of the analysis presented in this book. The reason is that in many practical problems we are interested in optimizing some performance measure involving a combination of solution quality and search effort *averaged* over all problems *likely* to be encountered. Probability theory is today our primary (if not the only) language for formalizing concepts such as "average" and "likely," and therefore it is the most natural language for describing those aspects of performance that we seek to improve.

In practice, the average value of this performance measure is seldom actually computed, primarily because it is difficult to define and analyze a probability distribution that adequately represents the set of problems to be encountered. Nevertheless, to understand what attributes make a candidate search method suitable or unsuitable for a given class of problems, some analysis must be conducted. Toward this goal we start with a simplified abstract model, containing the smallest number of parameters required for representing the salient features of the problem domain, and then we analyze the performance of various search algorithms on this model as a function of the model's parameters. If, as a result of such an exercise, it becomes apparent that the value of a certain parameter has a dramatic influence over the relative performances of the candidate search methods, that parameter becomes a focus of attention in empirical efforts to characterize the problem environment. Alternatively, if a given search method appears to exhibit superior performance over a wide range of model parameters, that method then becomes the first candidate to be tried on actual problem instances.

This chapter presents three tractable abstract models for path optimization problems, and analyzes the performances of several search methods on these models. Satisficing problems are modeled in Chapters 6 and 7, and game searching is treated in Chapters 8, 9, and 10.

5.2 EXAMPLE 1: FINDING A SHORTEST PATH IN A REGULAR LATTICE WITH AIR-DISTANCE HEURISTICS

The Problem. Consider the infinite lattice graph of Figure 5.1, where each node is identified by a pair of integer coordinates (x, y) and each edge represents a unit distance. A shortest path must be found between the start node $s = (0, 0)$ and the goal node $\gamma = (m, n)$ using the air distance

$$h(x, y) = \sqrt{(x - m)^2 + (y - n)^2}$$

as a guiding heuristic. We wish to estimate, for large m and n, the number of nodes Z expanded by A^* using the following evaluation functions:

(a) $f = g$

(b) $f = g + h$

(c) $f = h$

Solution.

h is an admissible and consistent heuristic since it is a geodesic in a relaxed model where movement is permitted in any direction. Hence, all nodes ex-

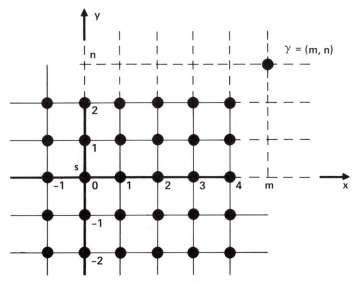

Figure 5.1

A square lattice representing the graph of example 1.

panded will have $g = g^*$. In addition, we have exact expressions for g^* and h^*:

$$g^*(x,y) = |x| + |y|$$
$$h^*(x,y) = |m - x| + |n - y| \quad .$$

Hence, assuming $m \geqslant 0, n \geqslant 0$:

$$f^*(s) = f^*(0,0) = m + n$$

Case (a): $f = g$.

Setting $f = g$ turns A^* into a breadth-first algorithm, where each node satisfying the inequality

$$g^*(x,y) < f^*(s)$$

or

$$|x| + |y| < m + n \tag{5.1}$$

will be expanded. This set of nodes is circumscribed by the diamond-shaped boundary of Figure 5.2, whose area is given by

$$I_a = 2(m + n)^2 \tag{5.2}$$

Since the density of nodes is unity, and the boundary may contain at most $O(m + n)$ nodes, the number of nodes Z_a expanded without heuristic information is:

$$Z_a = 2(m + n)^2 + O(m + n) \tag{5.3}$$

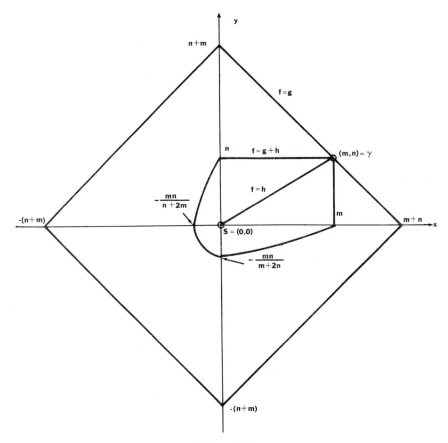

Figure 5.2

The diamond shape region contains the nodes that will be expanded by
the use of $f = g$. The smaller region (marked $f = g + h$) contains the
nodes expanded by A^* using the air-distance heuristic. The line marked
$f = h$ is a schematic representation of the $m + n$ nodes expanded under
$f = h$.

Case (b): $f = g + h$.
The set of nodes expanded is enclosed by a boundary satisfying the equation:

$$g(x, y) + h(x, y) = m + n$$

or

$$|x| + |y| + \sqrt{(m - x)^2 + (n - y)^2} = m + n \qquad (5.4)$$

The shape of this boundary is represented by the inner contour of Figure 5.2.
Its area can be determined by combining the contributions of the following
four quadrants.

- b. 1: $x \geqslant 0, y \geqslant 0$

Eq. 5.4 becomes: \qquad $2(m - x)(n - y) = 0$ $\qquad\qquad$ (5.5)

which circumscribes the rectangle $0 \leqslant x \leqslant m, 0 \leqslant y \leqslant n$, with area:

$$I_1 = mn \qquad\qquad (5.6)$$

- b. 2: $x > 0, y < 0$

Eq. 5.4 becomes:

$$4ny + 2(m - x)(n + y) = 0$$

or

$$y = \frac{2n^2}{m + 2n - x} - n$$

It encloses an area given by the integral:

$$I_2 = -\int_0^m \left[\frac{2n^2}{m + 2n - x} - n \right] dx = mn - 2n^2 \ln\left[1 + \frac{m}{2n} \right] \quad (5.7)$$

- b. 3: $x < 0, y > 0$

This case is symmetrical to $b.2$ with the roles of m and n interchanged. Thus

$$I_3 = mn - 2m^2 \ln\left[1 + \frac{n}{2m} \right] \qquad\qquad (5.8)$$

- b. 4: $x < 0, y < 0$

Here $|x| = -x$, $|y| = -y$ and Eq. 5.4 becomes:

$$4mx + 4ny + 2(m + x)(n + y) = 0$$

or:

$$y = \frac{2(m + n)^2}{m + 2n + x} - (n + 2m)$$

Thus,

$$I_4 = -\int_{-\frac{mn}{n + 2m}}^{0} \left[\frac{2(m + n)^2}{m + 2n + x} - (n + 2m) \right] dx$$

$$= mn - 2(m + n)^2 \ln\left[1 + \frac{mn}{2(n + m)^2} \right] \qquad\qquad (5.9)$$

Summing up the four areas, we obtain:

$$Z_b = 4mn - 2n^2\ln\left[1 + \frac{m}{2n}\right] - 2m^2\ln\left[1 + \frac{n}{2m}\right] -$$

$$2(m + n)^2\ln\left[1 + \frac{mn}{2(m + n)^2}\right] \qquad (5.10)$$

For the special case $m = n$ Eq.(510) reads:

$$Z_b \approx 1.436m^2$$

representing 18% of the number of nodes expanded by breadth-first search (Eq. (5.3)). For $n = 0$, the enclosed area shrinks to zero and $Z_b = m$. Figure 5.3 shows the relative performance Z_b/Z_a as a function of the ratio n/m. An

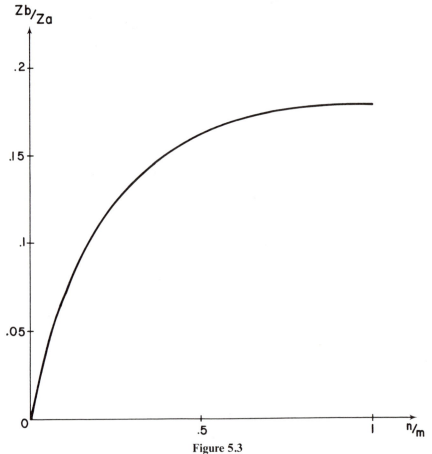

Figure 5.3
The number of nodes expanded by A^* relative to that of breadth-first as a function of the ratio n/m.

identical curve, if plotted against m/n, would characterize the range $n/m > 1$. This curve demonstrates that the air-distance heuristic achieves its highest pruning power when either $m \ll n$ or $n \ll m$. This is to be expected since the lowest relative error between the optimal distance h^* and the air-distance estimate h is achieved when the goal is near one of the axes.

Case (c): $f = h$.
In general, a best-first search algorithm guided by $f = (1 - w)g + wh$ is only admissible if $w \leqslant \frac{1}{2}$. However, the special structure of our graph permits the $w = 1$ search to find an optimal path with the minimum possible effort, expanding only the $m + n$ nodes lying on one optimal path. The reason for this efficiency is that every node has one son along an optimal path to the goal having h strictly smaller than that of the father. Thus, since the father has had the lowest h in OPEN, that son too will have the lowest h; it will immediately be selected for expansion and the algorithm will never backtrack.

Summary

This example demonstrates several features typical of best-first search.

1. In planar graphs with constant node density, the savings induced by the use of heuristics is a constant factor of the overall computational effort. In Chapter 6 we demonstrate that, in search spaces involving exponentially growing trees, the percentage savings approaches unity as the distance to the goal increases.
2. A large fraction of the nodes expanded actually lies on optimal paths. In our preceding example, all the mn nodes situated within the rectangle $0 \leqslant x \leqslant m, 0 \leqslant y \leqslant n$ lie on optimal paths to the goal and will be expanded by A^* even if the heuristic function becomes close to perfect. Typically, if the graph possesses many paths of near optimal costs, A^* explores them all prior to termination. Methods for overcoming this weakness of A^*, albeit at the expense of sacrificing optimality, were described in Chapter 3 (Section 3.2.2).
3. Setting $f = h$ may occasionally yield a more efficient search than $f = g + h$. In general, however, this may lead to suboptimal solutions and, more significantly, if h is grossly misinformed, it may actually *increase* the search effort or even prevent A^* from terminating. For instance, if in our example we were to use the following heuristic:

$$
h_1 = \begin{cases} \sqrt{(m - x)^2 + (n - y)^2} & \text{for } y \neq y_0 \\ 0 & \text{for } y = y_0, \ y_0 < n \end{cases}
$$

then A^* with $f = h_1$ will never terminate. It will continue forever to expand nodes along the path $y = y_0$. Adding g to h_1, on the other hand, and

using $f = g + h_1$ would restore A^* to the proper search domain as soon as g increases above $f^*(s)$, that is, as soon as we reach the diamond-shaped boundary of Figure 5.2.

5.3 EXAMPLE 2: FINDING A SHORTEST PATH IN A ROAD MAP WITH RANDOMLY DISTRIBUTED CITIES

The Problem. Assume that a typical road map is characterized by a tightly interconnected network of randomly scattered cities with a uniform density of ρ cities per unit area. It is required to estimate the complexity of finding the shortest path between the start city s, situated at the origin $(0, 0)$, and a goal city γ at $(0, c)$, using the A^* algorithm guided by the air-distance heuristic.

Solution.
Let the length of the shortest path between city n_1 and city n_2 be denoted by $k(n_1, n_2)$ and the air distance between them by $d(n_1, n_2)$. In particular, let

$$d(s, \gamma) = h(s) = c \tag{5.11}$$

$$k(s, \gamma) = h^*(s) = a \tag{5.12}$$

The ratio c/a measures the accuracy of the start-to-goal distance estimate, and may, in general, be a function of both ρ and c. The size of the problem also depends on c and ρ. A breadth-first search is likely to expand all the $M = \rho \pi c^2$ nodes located within a radius c of s, and therefore we take that number as a standard in assessing the heuristic power of the air-distance estimator. More specifically, we define the pruning power η_h of $h(\cdot)$ as the ratio of the number of nodes expanded with and without the use of $h(\cdot)$, that is,

$$\eta_h = M/Z_h = \rho \pi c^2/Z_h \tag{5.13}$$

where Z_h is the number of nodes expanded by A^* using h. Our task is to compute η_h as a function of the problem size M and the accuracy parameter c/a.

The necessary condition for A^* to expand a node n dictates (Chapter 3, Theorem 4) that only nodes satisfying:

$$g^*(n) + h(n) \leqslant f^*(s) = a \tag{5.14}$$

are candidates for expansion. Since $h(n)$ is equal to the distance $d(n, \gamma)$ and since $g^*(n)$ upperbounds the distance $d(s, n)$, every node satisfying (5.14) must also satisfy:

$$d(s, n) + d(n, \gamma) \leqslant a \tag{5.15}$$

The inequality in Eq. (5.15) delineates an **ellipse** with foci s and γ, and major axes a and $\sqrt{a^2 - c^2}$. The area of this ellipse is given by $\pi a \sqrt{a^2 - c^2}/4$ and, since every node outside this ellipse is known to be excluded from expansion, we obtain an upper bound to the number of nodes expanded:

$$Z_h \leqslant \rho \pi a \, \frac{\sqrt{a^2 - c^2}}{4} \tag{5.16}$$

When the accuracy of the air distance improves, the estimation error $a - c$ diminishes, the eccentricity of the ellipse increases, and a larger fraction of nodes escapes expansion. The ratio between the areas of the ellipse and the circle (see Figure 5.4) determines the pruning power of h.

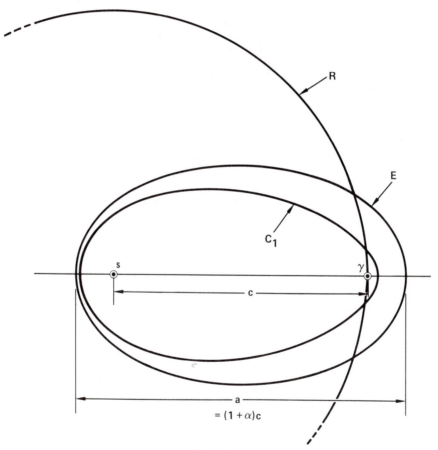

Figure 5.4

The circle (R) delineates the region where nodes would definitely be expanded under breadth-first search. Every node outside the ellipse (E) is known to escape expansion under A^*. The contour C_1 contains those nodes that are sure to be expanded by A^*.

Defining:

$$\alpha = (a/c) - 1 \qquad (5.17)$$

we obtain, from Eqs. (5.13) and (5.16)

$$\eta_h \geqslant \frac{4}{(1 + \alpha)\alpha^{1/2}(2 + \alpha)^{1/2}} \qquad (5.18)$$

and, assuming $\alpha \ll 1$, we see that **a fraction of at most $(\alpha/8)^{1/2}$ of the nodes expanded under breadth-first search will also be expanded by A^*.**

Since the road map was assumed to be homogeneous, it is also reasonable to assume that the ratio a/c will remain constant for large distances. Hence, the lower bound in (5.18) remains a constant factor regardless of how far apart γ is from s.

To show that η_h is also bounded from above, we need to make further assumptions about the regularity of the interconnections in the road map. First, let us assume that except for a set of nodes with zero measure, the relative estimation error X is bounded away from zero, or:

$$X(n) = \frac{k(s,n)}{d(s,n)} - 1 \geqslant \beta > 0 \qquad (5.19)$$

With this assumption we can use the sufficient condition for node expansion (Theorem 12, Chapter 3):

$$g^*(n) + h(n) < a \qquad (5.20)$$

and conclude that all nodes satisfying:

$$(1 + \beta)d(s,n) + d(n,\gamma) < (1 + \alpha)d(s,\gamma) \qquad (5.21)$$

will be expanded. Use was also made of the consistency of h, which renders Eq. (5.20) applicable to all nodes, not necessarily those on OPEN. The inequality in Eq. (5.21) circumscribes a contour C_1 such as that shown in Figure 5.4, containing those nodes that are sure to be expanded.

More generally, the probability P that node n situated outside C_1 will be expanded by A^* is given by the probability that $X(n)$ satisfies the inequality:

$$[1 + X(n)]d(s,n) + d(n,\gamma) < (1 + \alpha)d(s,\gamma) \qquad (5.22)$$

Therefore, if $X(n)$ is characterized by a single distribution function $F_X(x)$, the isoprobability contour connecting all points with expansion probability P is given by the equation:

$$[1 + F_X^{-1}(P)]d(s,n) + d(n,\gamma) = (1 + \alpha)d(s,\gamma)$$

Some of these contours are shown in Figure 5.5. Note that the "search beams" become somewhat more focused in the vicinity of the goal node, indicating that

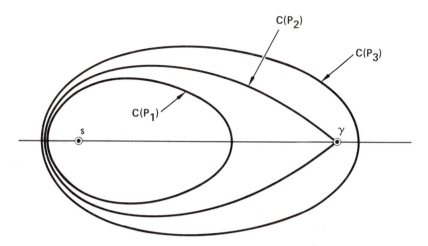

Figure 5.5
Three iso-probability contours connecting all points with the same expansion probability.

$A*$ spends most of its effort around the start node, where the accuracy of $h(\cdot)$ relative to the magnitude of g is at its worse.

Nodes inside C_1 are guaranteed to be expanded and, since the area enclosed by C_1 is proportional to a^2, we conclude that the pruning power η_h achieved by the use of the air-distance heuristic is at most a multiplicative constant. In other words, if N is the number of nodes along the optimal path ($N \approx \rho^{1/2} a$), then for fixed ρ the complexity of $A*$ remains $\Theta(N^2)$. One may also argue that even when the city density ρ increases, the accuracy of h is not guaranteed an improvement unless additional assumptions are made regarding the statistics that relate distances to road connections.

These results are readily generalizable to a higher-dimensional space. In a D-dimensional space the fraction of nodes escaping expansion is given by the volume ratio between a hyper-sphere of radius c and an ellipsoid-of-revolution with one major axis of size a and $D-1$ minor axes of size $\sqrt{a^2 - c^2}$. This ratio is equal to

$$2a \left[\frac{2c}{\sqrt{a^2 - c^2}} \right]^{D-1}$$

and consequently:

$$\eta_h \geqslant \frac{2}{1 + \alpha} \left[\frac{2}{(2 + \alpha)\alpha} \right]^{\frac{D-1}{2}} \approx 2 \left[\frac{2}{\alpha} \right]^{\frac{D-1}{2}}$$

which shows a marked improvement in pruning power with increasing dimensionality.

Using an argument similar to the preceding one, we can show that η_h remains bounded with increasing problem size. The complexity remains $\Theta(N^D)$ and only improves by a constant factor proportional to α^D. This behavior is a direct consequence of the uniform density assumption, implying that the number of nodes situated within a distance d from s grows polynomially with d. By contrast, typical combinatorial problems are represented by graphs where that number grows exponentially with d. The next example demonstrates that in such graphs heuristics exhibit a more decisive pruning power.

5.4 EXAMPLE 3: SEARCHING FOR AN OPTIMAL PATH IN A TREE WITH RANDOM COSTS[†]

The Problem: Find a cheapest path leading from the root of a tree to any of its leaves. The tree is known to be uniform, binary, and of height N. Each branch independently may have a cost of 1 or 0 with probability p and $1 - p$, respectively.

We will analyze the expected performance of two search methods within this model. The first consists of the uniform-cost algorithm (Section 2.2.2), which, of course, makes no use of heuristics regarding the unexplored portion of the search tree. The second method is a version of staged-search (Section 2.5.2), which periodically uses heuristic information to prune away those "bad" nodes that do not perform in accordance with expectations.

The analysis shows that the uniform-cost algorithm can be remarkably efficient when the branch costs are more likely to assume the value zero ($p < \frac{1}{2}$). By contrast, when the branch costs are more likely to have a unity cost ($p > \frac{1}{2}$), the uniform-cost algorithm requires exponential time, whereas the pruning algorithm almost always finds a near optimal solution in linear average time.

5.4.1 Notation and Preliminaries

The problem statement defines a task to be executed over an **ensemble** of problem instances. In each problem instance we have to find the cheapest root-leaf path in a tree T drawn from the sample space $\mathbf{T}(N, p)$, containing uniform binary trees of height N with 0-1 edge costs. The probability that a tree T with a specified assignment of edge costs is drawn from $\mathbf{T}(N, p)$ is given by

† The author thanks North Holland Publishing Company for permission to reprint the portion of the article "Searching for an Optimal Path in a Tree with Random Costs" by Richard M. Karp and Judea Pearl which appeared in *Artificial Intelligence* 21(1–2), 99–117, March 1983.

$p^{N_1}(1-p)^{N_0}$ where N_1 and N_0 are, respectively, the number of edges in T with cost 1 and 0 ($N_1 + N_0 = 2^{N+1} - 2$).

We say that a node J in the tree has **cost** c if c is the sum of the costs of the edges along the path from the root to J. Of particular interest to us are the costs of leaves and especially the cost of the cheapest leaf, which is our target of pursuit. Let the random variable $C(N, p)$ be the **minimum number of 1's** on a root-leaf path in a tree T drawn from $\mathbf{T}(N, p)$. We will see later that the distribution of $C(N, p)$ varies significantly with p and assumes a different character in the following three regions: $p < \frac{1}{2}, p = \frac{1}{2}$, and $p > \frac{1}{2}$. Moreover, the nature of this distribution dictates which algorithm is most suitable for search. Therefore we will discuss these three regions separately.

We say that a node J' is a (α, L)-**son** of node J if the following two conditions hold:

1. J' is situated L levels below J.
2. The cost of the path connecting J and J' does not exceed αL.

A family line of t successive (α, L)-sons represents a path in T consisting of t consecutive segments each with cost at most αL. We call such a path a (α, L)-**regular path,** and families generated by this process (α, L)-**regular families.** To keep our notation simple, we still call a path terminating at a leaf node (α, L)-regular even when its last segment contains fewer than L nodes as long as the cost of that last segment is at most αL. Clearly, any root-leaf path that is (α, L)-regular may not cost more than $\alpha(N + L)$.

We analyze the performance of two search algorithms which we call A_1 and A_2. A_1 is a **uniform-cost** algorithm and is analyzed for the cases: $p < \frac{1}{2}$ and $p = \frac{1}{2}$. A_2 is a **hybrid of local and global depth-first** search strategies and is analyzed for $p > \frac{1}{2}$.

Both algorithms start with a subtree containing the root of T and, at a general step, expand some node on the frontier of the subtree. Expanding a node J means creating its two children and the edges from J to these children.

Algorithm A_1:
At each step, expand the leftmost node among those frontier nodes of minimum cost. The algorithm halts when it tries to expand a leaf of T. That leaf then represents an optimal solution.

Algorithm A_2:
A_2 conducts a depth-first search to find a (α, L)-regular path from a level-d node to a leaf where d, α, and L are three externally chosen parameters. In other words, A_2 is a depth-first strategy that stops at regular intervals of L levels to appraise its progress. If the cost increase from the last appraisal is at most αL, the search continues; if that cost increase is above αL, the current node is irrevocably pruned, the program backtracks to a higher level, and the search resumes. If it succeeds in finding a (α, L)-regular path, A_2 returns that path as

a solution; its cost is at most $d + \alpha(N - d + L)$. If it fails, the search is repeated from another d-level node. If all the 2^d nodes at level d fail to root a (α, L)-regular path to a leaf, A_2 terminates with failure. The probability of such an event, however, is made vanishingly small by an appropriate choice of the parameters d, α, and L.

This search is shown schematically in Figure 5.6. It consists of two components:

1. Local depth-first search (with depth-bound L) to find (α, L)-sons.
2. Global depth-first search on members of the (α, L)-family, seeking a family line extending to level N.

The rationale for algorithm A_2 is as follows. Probabilistic analysis reveals (Theorem 3) that for $p > \frac{1}{2}$ and large N the optimal cost $C(N, p)$ lies very near $\alpha^* N$ where α^* is a constant dictated by p. If we settle for finding a near-optimal solution, we may stop the search as soon as we find any leaf node with cost below αN ($\alpha > \alpha^*$) where α is chosen sufficiently close to α^*. Fortunately there are many leaves with costs between $\alpha^* N$ and αN and so we are at liberty to confine our search to a special subset of these leaves that are **easy search targets**. A convenient choice would be the set of leaves reachable by (α, L)-regular paths, along which the cost increases by not more than a fixed increment αL in every successive path segment of length L. Such paths are convenient search targets because violations of the requirement for a gradual

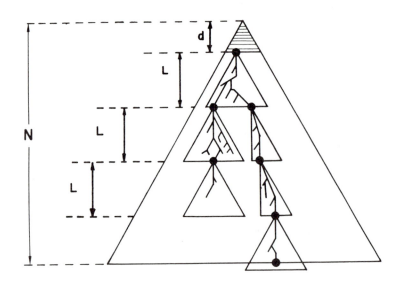

Figure 5.6

Schematic representation of the search algorithm A_2. The triangles represent local depth-first searches for (α, L)-sons (solid circles).

cost increase (unlike violations of requirements posed on the overall cost of a path) are detectable by **local analysis**. Indeed, we will see later (Theorem 6) that A_2 runs in linear expected time and, if the parameters d and L are chosen appropriately, A_2 is guaranteed to find a near-optimal solution with probability approaching one.

5.4.2 Summary of Results

The results of our analysis are summarized in the following six theorems. The first three theorems determine the asymptotic distribution of the optimal cost $C(N,p)$, whereas the later three quantify the expected complexities of algorithms A_1 and A_2 in the three regions of p.

THEOREM 1. *If* $p < \frac{1}{2}$*, then*

$$P[C(N,p) > k] \leqslant (2p)^{2^{k+1}-2} \qquad k = -1, 0, 1, \ldots$$

Thus **the optimal cost is almost certain to remain bounded** *as* $N \rightarrow \infty$*.*

THEOREM 2. *If* $p = \frac{1}{2}$*, then, for every unbounded monotone function* H*,*

$$P[\,|\,C(N,\frac{1}{2}) - \log_2 \log_2 N\,| \, > H(N)] \rightarrow 0$$

This implies that **the optimal cost tends to** $\log_2 \log_2 N$*.*

THEOREM 3. *Let* $p > \frac{1}{2}$ *and* $G(\alpha,p) = \left[\dfrac{p}{\alpha}\right]^{\alpha} \left[\dfrac{1-p}{1-\alpha}\right]^{1-\alpha}$*. Define* α^* *by the equation* $G(\alpha^*,p) = \frac{1}{2}$*.*
For $\alpha < \alpha^*$*:*

$$P[C(N,p) \leqslant \alpha N] = O(c_\alpha^{-N}) \qquad c_\alpha > 1$$

For $\alpha > \alpha^*$*:*

$$P[C(N,p) \geqslant \alpha N] = O(d_\alpha^{-N}) \qquad d_\alpha > 1$$

This theorem states that **the optimal cost grows proportionally to** N *and that the proportionality factor is very likely to be near* α^**.*

Let the random variables $t_1(N,p)$ and $t_2(N,p)$ be the number of nodes expanded in the execution of algorithm A_1 and A_2, respectively, on a tree T drawn from $\mathbf{T}(N,p)$.

THEOREM 4. *If* $p < \frac{1}{2}$*, then* $E[t_1(N,p)] = O(N)$*, that is,* A_1 *finds an optimal cost leaf in linear expected time.*

THEOREM 5. *If $p = \frac{1}{2}$, then $E[t_1(N, \frac{1}{2})] = O(N^2)$, that is, A_1 finds an optimal cost leaf in quadratic expected time.*

THEOREM 6. *If $p > \frac{1}{2}$, then every algorithm that guarantees finding a path cheaper than $(1 + \epsilon)C(N, p)$ must run in exponential time. However, for every $\epsilon > 0$ the parameters d and L can be chosen in such a way that algorithm A_2 will find a solution costing at most $(1 + \epsilon)C(N, p)$ with probability approaching 1 and will run in linear expected time, that is, $E[t_2(N, p)] = O(N)$.*

5.4.3 Branching Processes and the Proofs of Theorems 1-6

The proofs of Theorems 1-6 depend on some results from the theory of branching processes (Harris, 1963).

Branching processes describe phenomena in which objects generate additional objects of the same kind and in which different objects reproduce independently of one another. Search strategies are related to branching processes in that the operation of node expansion can be viewed as a reproduction process; the node expanded gives rise to a certain number of children nodes, a random number of which will eventually be expanded.

A branching process is characterized by a set $\{p_k\}$ of probabilities, where:

$$p_k = P(\text{a typical father has } k \text{ sons})$$

A **run** of the process generates a family tree where the root node corresponds to the 0^{th} generation containing a single member. This member gives birth to a random number of sons which constitute the first generation, each member of the first generation gives birth to a random number of sons of the second generation, and so on. The theory of branching processes is concerned with the statistical properties of the random variables $Z_n, n = 0, 1, \ldots,$ which stand for the number of objects in the n^{th} generation. (*Note:* $Z_0 = 1$ and $P(Z_1 = k) = p_k$.) The basic notation and properties of branching processes are summarized in Appendix 5-A, and additional results are contained in the next two lemmas.

LEMMA 1: *Let Z_n stand for the size of the n^{th} generation in a branching process for which $m = E(Z_1) \neq 1$, then*

$$E\left[\sum_n Z_n \mid \text{extinction}\right] = Q < \infty$$

The lemma states that the **expected size of an extinct family is bounded** for both $m < 1$ and $m > 1$ even though the generation for which we can certify that extinction has occurred may be arbitrarily deep. The proof is given in Appendix 5-B.

LEMMA 2: *Let $\{p_k\}$ determine a branching process such that only finitely many of the p_k's are nonzero. Define the random variable $D(N)$ as follows: let T_o be the family tree created in a run of this process, and let $D(N)$ be the number of nodes encountered in a depth-first search of T_o which terminates as soon as a node at depth N is reached. Then*

$$E[D(N)] = O(N)$$

Proof: If $m \leqslant 1$, then for each k, $E(Z_k) = m^k \leqslant 1$ (Harris, 1963, Theorem 5.1, p. 6), so

$$E[D(N)] \leqslant \sum_{k=0}^{N} E(Z_k) = \sum_{k=0}^{N} m^k \leqslant N + 1$$

Suppose that $m > 1$. From Lemma 1 we remember that $E[D(N) \mid T_o \text{ finite}] \leqslant Q$, so it is only necessary to show that

$$I_N = E[D(N) \mid T_o \text{ infinite}] = O(N)$$

Call a node J in T_o **immortal** if the subtree rooted at J is infinite; otherwise, call J **mortal**. Assume J is immortal, and that J' is leftmost among the immortal sons of J. Then in searching the subtree rooted at J, J' is the only immortal son of J that is encountered. In addition to J', the search may also encounter all the mortal sons of J situated to the left of J'. The expected number of nodes encountered in searching the subtree rooted at J' is I_{N-1}, whereas that encountered in searching each of its mortal siblings is at most Q. Consequently, letting M stand for the average number of mortal sons of an immortal father ($M < \infty$), we have:

$$I_N \leqslant 1 + I_{N-1} + MQ$$

from which it follows that

$$I_N \leqslant N + (N-1)MQ \qquad \blacksquare$$

More precise expressions for $E[D(N)]$ are given in exercise 5.4.

Proof of Theorem 1: Let

$$F_k^N = P[C(N, p) > k] \qquad k = -1, 0, 1, \ldots, N-1 \qquad (5.24)$$

To establish a recurrence relation for F_k^N we condition the event $C(N, p) > k$ on the four possible events of the first generation, as shown in the following table:

Cost of left arc	0	1	0	1
Cost of right arc	0	0	1	1
Probability	$(1-p)^2$	$p(1-p)$	$(1-p)p$	p^2
$P[C(N,p) > k]$	$(F_k^{N-1})^2$	$F_{k-1}^{N-1} \cdot F_k^{N-1}$	$F_k^{N-1} \cdot F_{k-1}^{N-1}$	$(F_{k-1}^{N-1})^2$

and obtain the recursion:

$$F_k^N = [(1-p)\,F_k^{N-1} + p\,F_{k-1}^{N-1}]^2, \qquad F_{-1}^N = 1 \tag{5.25}$$

We now take the limit as $N \to \infty$:

$$F_k = \lim_{N \to \infty} F_k^N = [(1-p)F_k + pF_{k-1}]^2 \tag{5.26}$$

which, for $p < \frac{1}{2}$, has the nontrivial solution:

$$F_k = \frac{1}{2(1-p)^2}[1 - 2F_{k-1}\,p(1-p) - \sqrt{1 - 4F_{k-1}\,p(1-p)}] \tag{5.27}$$

Using the inequality

$$\sqrt{1-x} \geqslant (1-x)\left[1 + x/2\right] \qquad \text{for } 0 \leqslant x \leqslant 1 \tag{5.28}$$

we obtain a bound on F_k in Eq. (5.27):

$$F_k \leqslant 4p^2(F_{k-1})^2 \tag{5.29}$$

The boundary condition $F_{-1} = 1$, together with Eq. (5.29) leads to the desired inequality:

$$F_k \leqslant \frac{1}{4p^2}\,(4p^2)^{2^k} = (2p)^{(2^{k+1}-2)} \tag{5.30}$$

∎

Note that for $p \geqslant \frac{1}{2}$, the only meaningful solution of Eq. (5.26) is $F_k = 1$ for all k, implying that as $N \to \infty$ the cost of the cheapest path is almost surely unbounded.

Proof of Theorem 2: See Appendix 5-C. ∎

Proof of Theorem 3: Let $Z(\alpha, N)$ stand for the number of leaves in a tree of height N with costs not exceeding αN, $0 < \alpha < 1$. We first wish to show that the average number of such leaves undergoes a critical jump at $\alpha = \alpha^*$ as $N \to \infty$.

There are a total of 2^N root-leaf paths in the tree. The probability that the cost of any one path does not exceed αN is given by the binomial distribution:

$$P(\text{path cost} \leqslant \alpha N) = B_{p,N}(\alpha N) \triangleq \sum_{i=0}^{\alpha N} \binom{N}{i} p^i (1-p)^{N-i} \tag{5.31}$$

and therefore:

$$E[Z(\alpha, N)] = 2^N B_{p,N}(\alpha N) \tag{5.32}$$

The binomial distribution can be bounded (Peterson, 1961) between two entropy related functions, provided $\alpha < p$:

$$\frac{1}{\sqrt{8N\alpha(1-\alpha)}}\,G^N(\alpha, p) \leqslant B_{p,N}(\alpha N) \leqslant G^N(\alpha, p) \tag{5.33}$$

where

$$G(\alpha, p) = \left[\frac{p}{\alpha}\right]^\alpha \left[\frac{1-p}{1-\alpha}\right]^{1-\alpha} \tag{5.34}$$

or:

$$\log G(\alpha, p) = (1 - \alpha) \log(1 - p) + \alpha \log p + H(\alpha) \tag{5.35}$$

where $H(\alpha)$ is the entropy function

$$H(\alpha) = -[\alpha \log \alpha + (1 - \alpha) \log(1 - \alpha)] \tag{5.36}$$

Figure 5.7 depicts the dependence of $\log_2 G$ on α and p. For $p > \frac{1}{2}$, $\log_2 G$ crosses the level of -1 at $\alpha = \alpha^* < p$ and at this point $E[Z(\alpha, N)]$ undergoes an abrupt jump:

$$\lim_{N \to \infty} E[Z(\alpha, N)] = \lim_{N \to \infty} [2G(\alpha, p)]^N = \begin{cases} \infty & \alpha > \alpha^* \\ 0 & \alpha < \alpha^* \end{cases} \tag{5.37}$$

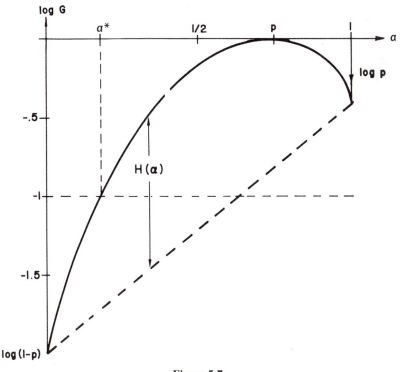

Figure 5.7
The dependence of $\log_2 G$ on α and p.

The critical value α^* is defined by the equation:

$$G(\alpha^*, p) = \tfrac{1}{2} \qquad (5.38)$$

and it varies with p in the manner shown in Figure 5.8.

The fact that $E[Z(\alpha, N)]$ vanishes for $\alpha < \alpha^*$ implies that the cheapest path has only vanishingly small probability of costing less than αN. In fact, from

$$E[Z(\alpha, N)] \geqslant P[C(N, p) \leqslant \alpha N]$$

together with Eqs. (5.32) and (5.33), we have:

$$P[C(N, p) \leqslant \alpha N] \leqslant [2G(\alpha, p)]^{N} \qquad (5.39)$$

and, since $2G(\alpha, p) < 1$ for $\alpha < \alpha^*$, the first part of Theorem 3 is established.

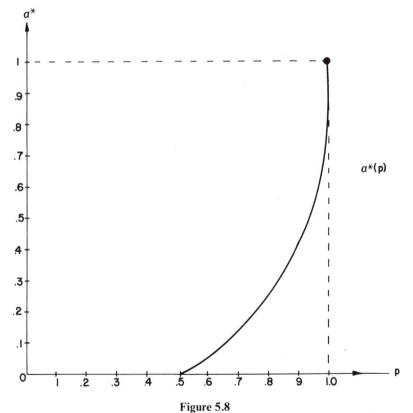

Figure 5.8

The dependence of α^* on p. $\alpha^* N$ is the most likely cost of the cheapest path in the tree.

The behavior of $P[C(N,p) \leqslant \alpha N]$ for $\alpha > \alpha^*$ is not implied by Eq. (5.37), but can be derived using a branching process argument on subtrees with depth L.

From Eqs. (5.32) and (5.33) we can write:

$$E[Z(\alpha, L)] \geqslant \frac{1}{\sqrt{8L \; \alpha(1-\alpha)}} [2G(\alpha, p)]^L \qquad (5.40)$$

implying that if $\alpha > \alpha^*$, one can always find an L large enough (but independent of N) such that the expected number of (α, L)-sons of the root node is greater than unity. For each α, let us define the lowest possible value of L that satisfies this condition:

$$L_\alpha = \min\{L \mid E[Z(\alpha, L)] > 1\} \qquad (5.41)$$

that is, L_α is the lowest value of L such that the expected number of leaf nodes costing at most αL in a tree drawn from $T(L, p)$ exceeds unity.

The family of (α, L_α)-sons reproduces like a branching process for which $m > 1$. Such a family has a nonzero probability $1 - q_\alpha$ of lasting forever and, therefore, the probability of finding an (α, L_α)-regular path of length N (and cost at most αN) is at least equal to $1 - q_\alpha$.

We will now show that the probability of finding a path costing at most αN approaches unity if $\alpha > \alpha^*$ and $N \to \infty$. Choose a value β between α^* and α, $\alpha^* < \beta < \alpha$, and a depth L_β such that the expected number of (β, L_β)-sons of each node is larger than unity. Any node at depth d of the tree has a probability of at least $1 - q_\beta$ of nucleating a (β, L_β)-regular path reaching level N and costing at most $\beta(N - d + L_\beta)$. Since there are 2^d such nodes at depth d, the probability that at least one of them resides on top of a (β, L_β)-regular path to a leaf node is higher than $1 - (q_\beta)^{2^d}$. The total cost of such a path including the portion from the root to depth d is at most $\beta(N + L_\beta) + d(1 - \beta)$. Thus, we can write

$$P[C(N,p) > \beta(N + L_\beta) + d(1 - \beta)] \leqslant (q_\beta)^{2^d} \qquad (5.42)$$

Choosing d to vary slowly with N, for example, $d = \lceil \log_2 N \rceil$, yields:

$$P[C(N,p) > \beta(N + L_\beta) + (1 - \beta)(1 + \log N)] \leqslant (q_\beta)^N$$

Now, β was chosen strictly smaller than α, and so for sufficiently large N we have

$$P[C(N,p) > \alpha N] \leqslant (q_\beta)^N \qquad (5.43)$$

which establishes the second part of Theorem 3. ∎

The arguments used in this proof will dictate the appropriate choice of the parameters d, α, and L for the A_2 algorithm (see Theorem 6).

Proof of Theorem 4: The execution of Algorithm A_1 involves a series of trials, each of which consists of a depth-first search in the subtree of T rooted at some vertex J, and containing those vertices reachable from J at cost zero. The algorithm terminates as soon as some trial reaches a leaf of T.

Consider the branching process π in which the birth of a son corresponds to the discovery of a zero cost edge. For this process we have: $p_o = p^2$, $p_1 = 2p(1-p)$, and $p_2 = (1-p)^2$. Since $p < \frac{1}{2}$, $m = 2(1-p) > 1$, and so the extinction probability q is less than 1. Each trial, starting at a node of depth d, corresponds to a depth-first search in a family tree associated with a run of the process π. The search terminates when an $(N-d)^{th}$ generation node is reached as in the conditions set for Lemma 2. The expected time for such a search is $E[D(N-d)] \leqslant E[D(N)]$ and the expected number of trials cannot exceed $1/(1-q)$, which is the expected number of trials until encountering the first immortal node. Hence, the expected number of nodes expanded by the algorithm is at most $E[D(N)]/(1-q)$ and, using Lemma 2,

$$E[t_1(N,p)] = O(N) \qquad \blacksquare$$

Proof of Theorem 5: The proof is similar to that of Theorem 4. The time spent in each trial is still at most $D(N)$, and the probability that a trial succeeds is at least $P[Z_N > 0]$ for the process π. This process now has $m = 1$ and so (see Appendix 5-A)

$$P[Z_N > 0] \sim \frac{2}{N\sigma^2}$$

Hence, the expected number of trials is at most

$$\frac{N\sigma^2}{2} + o(N),$$

and the expected number of nodes expanded satisfies:

$$E[t_1(N,p)] \leqslant E[D(N)] \left\lceil \frac{N\sigma^2}{2} + o(N) \right\rceil = O(N^2) \qquad \blacksquare$$

Proof of Theorem 6: If a tree $T \in T(N,p)$ has a minimal cost $C(T)$, then every algorithm A which is guaranteed to return a path costing $C_R(T) \leqslant (1+\epsilon)C(T)$ must examine every node at level $\lfloor C(T)/(1+\epsilon') \rfloor$ of T, if $\epsilon' > \epsilon$. This is so because if A skips a node n at that level, it will return the same solution, costing $C_R(T') = C_R(T) \geqslant C(T)$, on another tree T' which is identical to T in all respects but has an all zero's extension to n. This would violate the

stated guarantee for A because the cheapest path of T' can cost at most $\lfloor C(T)/(1+\epsilon')\rfloor < C(T)/(1+\epsilon)$ whereas A would return $C_R(T') = C_R(T) \geqslant C(T) > (1+\epsilon)C(T')$. At the same time, Theorem 3 states that trees with $C(T) > (1-\delta)\alpha^*N$, $\alpha > 0$, occur with probability $P_\delta > 0$, hence the expected number of nodes examined by A must be at least

$$P_\delta 2^{\left|\frac{(1-\delta)}{(1+\epsilon')}\alpha^*N\right|}$$

which is exponential in N.

The second part of Theorem 6 is proven by the following construction. Given N, p, and ϵ, calculate α^* from Eq. (5.38) and let $d(N)$ be any unbounded monotone function of N such that $d(N) = o(N)$. For N sufficiently large it is possible to find an α between α^* and $(1+\epsilon)\alpha^*$ satisfying

$$N\alpha + (1-\alpha)d(N) + \alpha L_\alpha \leqslant (1+\epsilon)\alpha^*N$$

Choose this alpha together with its associated L_α (Eq. (5.41)) and with $d(N)$ as the three input parameters for algorithm A_2.

From the proof of Theorem 3 we know that algorithm A_2, when governed by these three parameters, will fail to reach a leaf of T with probability at most $(q_\alpha)^{2^{d(N)}}$. Moreover, when the search succeeds, it returns a path costing at most $N\alpha + (1-\alpha)d(N) + \alpha L_\alpha \leqslant (1+\epsilon)\alpha^*N$ (see Eq. (5.42)). Thus the probability that A_2 would fail to return a solution within a cost factor $(1+2\epsilon)$ of the optimal is at most

$$P[A_2 \text{ fails to reach a leaf}] + P[C(N,p) < (1-\epsilon)\alpha^*N]$$

and, since both terms tend to zero, the second part of Theorem 6 is established.

To show that A_2 runs in linear expected time, we consider the depth-first search on an (α, L_α)-regular family. Let the existence of an (α, L_α)-son for some node J be regarded as a reproduction event in a branching process π'; i.e., $p_k = P[Z(\alpha, L_\alpha) = k]$. Our choice of L_α (Eq. (5.18)) guarantees that for this process $m > 1$ and $q < 1$. For simplicity we will assume that d is chosen so that $N - d$ is a multiple of L_α, which makes the $[(N-d)/L_\alpha]^{th}$ generation of π' coincide with the leaf nodes of T. A **trial** in the execution of A_2 is a depth-first search through a family tree from π', terminating as soon as a node at depth $(N-d)/L_\alpha$ is reached. The expected number of nodes in a family tree of π' expanded in each trial is $E[D((N-d)/L_\alpha)] = O(N)$. Each such node expansion involves creating at most $2^{L_\alpha} - 1$ nodes of T by the local search of A_2. The expected number of trials until algorithm A_2 terminates is at most $1/(1-q)$, and so the expected number of nodes expanded by algorithm A_2 is:

$$E[t_2(N,p)] \leqslant E\left[D\left\lceil\frac{N-d}{L_\alpha}\right\rceil\right](2^{L_\alpha}-1)\left[\frac{1}{1-q}\right] = O(N) \quad \blacksquare$$

5.4.4 Conclusions

Finding a cheapest path in a tree, or even a path within a fixed cost ratio of the cheapest, requires exponential time in the worst case. It is remarkable, therefore, that subject to our probabilistic assumptions, both algorithms are executed in linear or quadratic expected times.

The blind search uniform-cost algorithm (A_1) derives its efficiency from the smallness of the optimal cost in the range $0 \leqslant p \leqslant \frac{1}{2}$. The solution path normally contains only a few 1's. As a result, A_1 reaches a leaf node after "peeling" only a few cost layers. Moreover, backtracking from off-track excursions is extremely cheap; Lemma 1 asserts that the average effort spent in failing to find a zero-cost extension to any node is bounded (for $p < \frac{1}{2}$) or $O(N)$ (for $p = \frac{1}{2}$).

In the range $p > \frac{1}{2}$, A_1 becomes exponential. The optimal cost now grows linearly with N, and so disappointing excursions are abandoned only after searching through a large number of cost layers. We have shown, in fact, that in the range $p > \frac{1}{2}$ any admissible algorithm (i.e., one that is guaranteed to find an exact optimal solution) must run in exponential average time. Therefore the transition from $p \leqslant \frac{1}{2}$ to $p > \frac{1}{2}$ should serve as an indicator to abandon admissible search strategies altogether.

The success of the pruning algorithm A_2 can be attributed to two factors:

1. Our willingness to accept a near optimal solution *almost* always.
2. The availability of probabilistic, domain-specific knowledge for determining the appropriate pruning criterion (i.e., determining α and L_α).

A_2 is another example in the class of "bounded look-ahead plus partial backtrack" search strategies which have been proposed for the determination of near-optimal solutions (almost everywhere) to certain NP-hard problems (Karp, 1976). The common idea in this class of strategies is to examine nodes to determine their likelihood of yielding a near-optimal solution and to prune away (irrevocably) unpromising nodes. Probabilistic knowledge is required to fine-tune the pruning criterion in such a way that the number of nodes generated grows linearly instead of exponentially with problem size and, at the same time, near-optimal solutions are obtained almost everywhere.

Although it is hard to circumscribe exactly the types of problems that lend themselves to such a delicate tuning of the pruning criterion, the model analyzed here highlights three conditions that essentially guarantee the success of this pruned depth-first method:

1. The density of the optimal cost becomes highly concentrated about some predetermined function $K(N)$ of the problem size N.
2. There exists a pruning criterion based on local information (i.e., each test can be completed in constant time) that will detect and prune away every solution that lies outside a specified neighborhood of $K(N)$.

3. In almost every problem instance, the neighborhood about $K(N)$ should contain at least one solution that will survive the pruning axe.

In our model (and for $p > \frac{1}{2}$) condition 1 is satisfied by virtue of $C(N, p)$ concentrating about $\alpha^* N$ (Theorem 3). Condition 2 holds because by discarding all but (α, L)-sons we guarantee that for any arbitrary L, each surviving path would cost at most $\alpha(N + L)$. Hence, choosing $\alpha \leqslant (1 + \epsilon)\alpha^*$ assures the $\alpha^* N$ neighborhood of all survivors. Finally, condition 3 is satisfied by our ability to always find an L_α such that $E[Z(\alpha, L_\alpha)] > 1$, thus guaranteeing a nonzero probability of survival which is further amplified to almost unity by the option of repeating the search from all nodes at depth $d(N)$.

A pruning strategy similar to A_2 is employed in the HARPY speech recognition system (Lowerre, 1976; Newell, 1978) where it is called "beam search." Related strategies based on local pruning have become popular in application areas such as speech processing (Lea, 1980) and scene analysis (Rubin, 1978]. The preceding analysis helps explain the secrets of their success.

5.5 BIBLIOGRAPHICAL AND HISTORICAL REMARKS

Section 5.1 comprises excerpts from my preface to a special issue of the *AI Journal* in memory of John Gaschnig 1950-1982 (Pearl, 1983c).

Golden and Ball (1978) analyzed the pruning power of the air-distance heuristic on a regular lattice network with diagonal arcs, that is, where each node is connected to its eight nearest neighbors. On this lattice A^* expands less than 10.7% of the area expanded by a breadth-first search, compared with the 18% (see Figure 5.3) attainable on our square lattice.

The first use of ellipsoidal contours to estimate the size of the search region is found in Munyer (1976) and independently in DeWitt (1977).

Section 5.4 is taken, almost verbatim, from Karp and Pearl (1983). Richard Arratia has pointed out the proof of the first part of Thereom 6 and the connection between Theorem 2 and the result of Bramson (1978).

EXERCISES

5.1 Explore how the results of Section 5.1 will change if, instead of the air distance, we were to use

$$h(x,y) = \max(\,|\,m - x\,|,\,|\,n - y\,|\,)$$

5.2 Consider the $N \times N$-board generalization of the 8-Puzzle. The region circumscribed by the inequality $g(n) + h_1(n) \leqslant K$ (h_1 = number of misplaced tiles) can be regarded as an ellipsoid in an N^2 dimensional space. Assessing the volume of this region, estimate the pruning power of h_1 for $N \to \infty$ and bounded C^*.

5.3 Show that for $m = 1$ the expected size of an extinct family is linear with the extinction horizon, that is,

$$E\left[\sum_{i=0}^{n-1} Z_i \mid Z_n = 0\right] \sim n/3$$

5.4 a. Improve Lemma 2 to read:

$$E[D(N)] \sim \begin{cases} (1 - m)^{-1} & m < 1 \\ N/2 & m = 1 \\ N & m > 1 \end{cases}$$

b. For all three cases, find the expected number of mortal sons older than the first immortal son of a typical (immortal) father.

5.5 Use the claims of exercises 5.3 and 5.4 to show that Theorems 4 and 5 can be made stronger:

a. $E[t_1(n,p)] \leqslant N\dfrac{(1-p)^2}{1 - 2p} + (N),\, p < 1/2,$

b. $E[t_1(n, 1/2)] \leqslant \dfrac{N^2}{8} + (N^2)$

5.6 Assume that trees drawn from $\mathbf{T}(N,p),\, p > 1/2$, are searched by A^* ($f = g + h$) using the heuristic function $h(n) = \alpha^*[N - d(n)]$ where $d(n)$ is the depth of node n. Use Theorem 2* (section 3.3) to show that the relative difference between C_t, the cost found by A^* and the optimal cost $C(N,p)$ vanishes almost everywhere, i.e., as N tends to infinity

$$P[C_t \geqslant (1 + \epsilon)\, C(N,p)] \to 0$$

for every $\epsilon > 0$.

APPENDIX 5-A
BASIC PROPERTIES OF BRANCHING PROCESSES

Branching processes describe phenomena in which objects generate additional objects of the same kind and where different objects reproduce independently of one another.

Notation: A branching process is characterized by a set $\{p_k\}$ of probabilities, where:

$$p_k = P(\text{a typical father has } k \text{ sons})$$

or equivalently, by the associated generating function

$$f(s) = \sum_k p_k s^k$$

Two important parameters dictated by $\{p_k\}$ are:

$$m = \text{mean number of sons (of a typical father)} = f'(1)$$

$$\sigma^2 = \text{variance of the number of sons} = f''(1) + m - m^2$$

Let Z_n be the size of the n^{th} generation ($Z_0 = 1$). We define the generating function $f_{(n)}(s)$ for Z_n by:

$$f_{(n)}(s) = \sum_n P(Z_n = k)s^k$$

Basic Facts (Harris, 1963): The generating function for Z_n is given by the n^{th} iterate of $f(s)$, that is,

$$f_{(n)}(s) = f_n(s)$$

where

$$f_n(s) = f[f_{n-1}(s)] \quad \text{and} \quad f_1(s) = f(s)$$

If $0 < p_o < 1$, then $f(s)$ is strictly convex on the unit interval and the sequence $\{f_n(0)\}$ is strictly increasing.

Each branching process is characterized by a parameter q called the **extinction probability** given by the least nonnegative root of the equation $f(s) = s$. q stands for the probability that after some finite number of generations the family will cease to reproduce, that is, $Z_n \to 0$. Naturally, $1 - q$ is called the probability of **immortality.**

The influence of m on q is illustrated in Figure 5.9. It is shown that:

If	then	and
$m < 1$	$q = 1$	$f'(q) < 1$
$m = 1$ and $p_1 \neq 1$	$q = 1$	$f'(q) = 1$
$m > 1$	$q < 1$	$f'(q) < 1$

Moreover, it can be shown that, if $m = 1$ and $\sigma^2 < \infty$, then $P[Z_n > 0] \sim \dfrac{2}{\sigma^2 n}$.

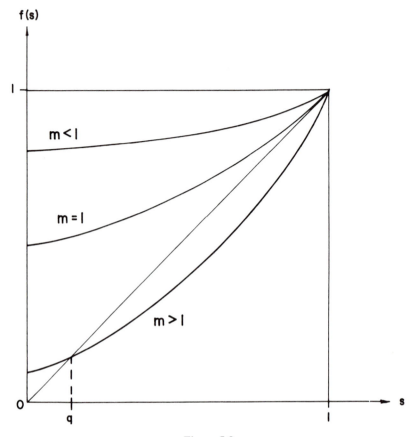

Figure 5.9

The effect of the reproduction rate m on the shape of the generating function $f(s)$ and on the probability of extinction q.

APPENDIX 5-B
THE EXPECTED SIZE OF AN EXTINCT FAMILY

We show that the expected size of an extinct family is finite iff $m \neq 1$. By extinction we mean the event that some generation is empty, that is,

$$\bigcup_{i=1}^{\infty} (Z_i = 0)$$

LEMMA:

$$E[\sum_{i=0}^{\infty} Z_i \mid \bigcup_{i=1}^{\infty} (Z_i = 0)] = \frac{1}{1 - f'(q)}$$

Proof:

By Bayes Thereom:

$$P[Z_1 = k \mid \bigcup_{i=1}^{\infty}(Z_i = 0)] = P[Z_1 = k] \frac{P[\bigcup_{i=1}^{\infty}(Z_i = 0) \mid Z_1 = k]}{P[\bigcup_{i=0}^{\infty}(Z_i = 0)]}$$

$$= \frac{p_k q^k}{q} = p_k q^{k-1}$$

Thus

$$E[Z_1 \mid \bigcup_{i=1}^{\infty}(Z_i = 0)] = \sum_{k=0}^{\infty} k p_k q^{k-1} = f'(q)$$

Similarly,

$$E[Z_n \mid \bigcup_{i=1}^{\infty}(Z_i = 0)] = (f'(q))^n$$

and

$$E[\sum_{i=0}^{\infty} Z_i \mid \bigcup_{i=1}^{\infty}(Z_i = 0)] = \frac{1}{1 - f'(q)} \qquad \blacksquare$$

The result now follows since

$$f'(q) < 1 \qquad \text{iff } m \neq 1$$

Obviously the lemma does not hold for the case $m = 1$, where $f'(1) = 1$, so the expected size of an extinct family becomes infinite. However, it is possible to show that in this case the expected family size tends to one-third the depth of the shallowest generation for which extinction is known to have occurred (see exercise 5.3), that is,

$$E(\sum_{i=0}^{N-1} Z_i \mid Z_N = 0) \sim \frac{N}{3}$$

APPENDIX 5-C
PROOF OF THEOREM 2

Theorem 2 follows from a result by Bramson (1978) concerning branching random walks. We present here a short proof, in the terminology of Section 5.4, by reformulating the theorem in terms of infinite trees. Consider an infinite uniform binary tree in which each edge has cost 0 with probability ½ and cost 1 with probability ½. Let $C(N, \frac{1}{2})$ be the minimum cost of a path from the root to a node at level N. Call a node an i^{th} *generation frontier node* if its cost is i and its father's cost is $i - 1$, and let Z_i be the number of i^{th} generation frontier nodes. Note that the level of each i^{th} generation frontier node is at most Z_i.

We will prove that the number of i^{th} generation frontier nodes tends to be approximately 2^{2^i}. More precisely,

(∗) $P[Z_i + 1 \leqslant (2^{2^i})x]$ approaches a limit $v(x)$, where $v(x) \to 1$ as $x \to \infty$.

Assuming this result, we proceed as follows. Observe that the event $C(N, \frac{1}{2}) \leqslant i$ implies $Z_i \geqslant N$ because the former means that there exists an i^{th} generation frontier node at level at least N. But, by the preceding claim

$$P[Z_{\log_2 \log_2 N - H(N)} \geqslant N] \to 0$$

and hence,

$$P[C(N, \frac{1}{2}) \leqslant \log_2 \log_2 N - H(N)] \to 0$$

On the other hand, the existence of a zero-cost path of length N starting at an i^{th}-generation frontier node is sufficient to ensure that $C(N, \frac{1}{2}) \leqslant i$. The probability that a particular i^{th}-generation frontier node is the origin of such a path is $(2/\sigma^2 N) + o(1/N)$, and thus, the probability that such a path fails to exist from any of the Z_i frontier nodes is

$$\left[1 - \frac{2}{\sigma^2 N} - o\left[\frac{1}{N} \right] \right]^{Z_i}$$

In the case

$$i = \log_2 \log_2 N + H(N), P[Z_i > N^2] \underset{N \to \infty}{\to} 1$$

and hence, the probability that such a path fails to exist goes to zero as $N \to \infty$. Hence,

$$P[C(N, \frac{1}{2}) > \log_2 \log N + H(N)] \underset{N \to \infty}{\to} 0$$

It remains to prove the claim (∗). The random variables Z_i are determined by a branching process $\{p_k\}$ where $p_0 = p_1 = 0$, $p_2 = \frac{1}{4}$ and

$$p_k = \frac{1}{2} p_{k-1} + \frac{1}{4} \sum_{j=0}^{k} p_j p_{k-j}, \qquad k \geqslant 3$$

The generating function $f(s)$ for this process satisfies

$$f(s) - \frac{s^2}{4} = \frac{1}{2} s f(s) + \frac{1}{4} f^2(s)$$

whence $f(s) = 2 - s - 2\sqrt{1-s}$ and $m = \infty$.

We now invoke the following lemma.

LEMMA (Darling, 1970): Consider a branching process with $m = \infty$ and $f(s) = \Sigma p_k s^k$. If $g(x)$, the inverse function of $1 - f(1-s)$ satisfies $g'(x) = ax^{b-1}(1 + O(x^\delta))$ as $x \to 0$, for some $a > 0$, $b > 1$, $\delta > 0$, then, for every x, $P[b^{-n} \log(Z_n + 1) \leqslant x]$ approaches a limit $v(x)$ as $n \to \infty$.

In the present case, $g(x) = 2 - x - 2\sqrt{1-x}$ and $g'(x) = \frac{1}{2} x(1 + O(x))$ as $x \to 0$. The conditions of the preceding lemma are satisfied with $a = \frac{1}{2}$ and $b = 2$, hence the claim is proven. ∎

Chapter 6

Complexity versus Precision of Admissible Heuristics

Whereas in Chapter 5 we analyzed the performances of some specific heuristics, Chapter 6 relates performance to an operational property relevant to all heuristics, namely their **informedness** or **accuracy**.

In Section 6.1 we construct a probabilistic model for assessing quantitatively the accuracy provided by a given heuristic and its effect on the complexity of A^*. In Section 6.2 we use the model to refine the concept of dominance and show that a heuristic h_2 can be proclaimed "more effective" than h_1 even when the condition $h_1(n) < h_2(n)$ is violated occasionally. Section 6.3 analyzes the average complexity of A^* within the probabilistic model of Section 6.1 and delineates the boundary between exponential and polynomial performances. In Section 6.4 we compare A^* to informed backtracking under identical conditions and identical heuristics. We show that A^* is more effective in converting its heuristic information into computational savings.

6.1 HEURISTICS VIEWED AS NOISY INFORMATION SOURCES

6.1.1 Simplified Models as Sources of Noisy Signals

In Chapter 4 it was argued that heuristic methods usually derive their knowledge from simplified models of the problem environment. It is natural to expect, therefore, that the utility of the heuristic used should depend on the proximity between its underlying model and the reality of the problem at hand. The more faithful the model, the more efficient the search. The A^* search algorithm is a convenient model for studying this relationship in quantitative

terms since both its mission (i.e., cost minimization) and its heuristics can be expressed quantitatively. Thus, rather than dealing with the proximity between the model and reality, a relation that is hard to quantify, we can characterize the quality of information provided by a given heuristic *operationally* by specifying the accuracy of its cost estimates. The better the model, the more accurate the estimation.

Indeed, the pruning power of A^* is directly tied to the accuracy of the estimates provided by h. If h estimates the optimal completion cost h^* precisely, then A^* only explores nodes lying along optimal paths. Otherwise A^* expands every OPEN node satisfying the inequality:

$$g(n) + h(n) < C^*$$

(see Chapter 3, Theorem 4). Clearly, the higher the value of h, the fewer nodes will be expanded by A^*, as long as h remains admissible. In the 8-Puzzle example, for instance, since h_2 is generally larger and never lower than h_1, it is a more accurate heuristic and gives rise to a more efficient search. This suggests that we regard heuristics as **noisy signal sources** which, at each node in the graph, produce the distorted signal $h(n)$, instead of the perfect signal $h^*(n)$. Thus, the difference between the two signals, $h - h^*$, is regarded as an **error** (also **noise** or **inaccuracy**) associated with the heuristic function h.

The first analysis of the effect of errors on the performance of A^* was conducted by Pohl (1970) and the topic has been pursued since by Munyer (1976), vanderBrug (1976), Pohl (1977), and Gaschnig (1979a). The basic motivation for these studies has been the following enigma. When A^* employs a perfectly informed heuristic ($h = h^*$) it is propelled directly toward the closest goal (assuming it is unique) without ever getting sidetracked, spending only N computational steps where N is the distance of the closest goal. At the other extreme, when no heuristic at all is available ($h = 0$), the search becomes exhaustive, normally yielding an exponentially growing complexity. Between these two extremes there lies an unknown relationship between the accuracy of the heuristic estimates and the complexity of the search they help control.

The designer of a problem-solving system often has some control over the quality of the heuristics employed, usually by resorting to more sophisticated models or by permitting lengthier computations. The question then arises: "Is it worth it?" Having a predictive model for the accuracy-complexity dependency would help the designer decide whether the added computation invested in improving accuracy would pay for itself in reduced search complexity. Some initial results along this line were obtained by Pohl (1977) and Gaschnig (1979a). For instance, they found that if the relative error remains constant, the search complexity may be exponential, but that if the absolute error is constant, the search complexity is linear.

These results, however, were derived for a **worst case** model, assuming that a clever adversary distributes the errors in such a way that A^* exhibits its poorest performance. This chapter contains **probabilistic** extensions of these analyses

(originally reported by Huyn, Dechter, and Pearl, 1980) which are warranted for two main reasons. First, worst-case results are often found to be too conservative, and we wonder whether the *average* performance of A^* would be significantly better. Second, it is often hard to guarantee precise bounds on the magnitude of errors produced by a given heuristic, whereas probabilistic characterization of these magnitudes may be both more natural to conceptualize and easier to obtain by empirical means.

6.1.2 A Probabilistic Model for Performance Analysis

In Section 5.3 we were able to analyze the average performance of the air-distance heuristic function by assuming that the nodes were randomly and uniformly distributed in some Euclidean space defined by the heuristic function h. In other words, we let h and g define a fixed set of coordinates and assumed that the graph topology varied randomly in accordance with the regularity found in typical road maps. In most cases we will not be able to give such a vivid physical interpretation to the heuristic h. As a result, it may be more convenient to construct a probabilistic model from an opposite viewpoint: taking the graph topology as a fixed entity and **treating $h(n)$ as random variables** that are distributed to the nodes in the graph by chance, but correlate to some degree with the actual remaining distances, $h^*(n)$.

Following Pohl (1977), and Gaschnig (1979a), we shall model the search space by a uniform undirected b-ary tree T with a unique start state s and a unique goal state γ, situated at a distance N from s. The tree may be either finite (with depth \geqslant N) or infinite, and each arc is assumed to have a symmetric unary cost. A typical search tree is depicted in Figure 6.1 where (without loss of generality) the solution path $(s, n^s_{N-1}, \ldots, n^s_j, \ldots, n^s_1, \gamma)$ is represented on the extreme right. The trees $T_1, \ldots, T_j, \ldots, T_N$ are subtrees of T, stemming from the solution path; each "off-course" subtree T_j is identified by its root node n^s_j on the solution path, (n^s_j is the only node in T_j having $b - 1$ sons).

A^* searches for the goal state not knowing its location nor the distance N but is guided by a heuristic function $h(n)$ which estimates the distance of each node to the goal. Since all edges are assumed to be of unit cost, f is given by:

$$f(n) = g(n) + h(n)$$

where: $g(n)$ is the depth of n

$h(n)$ is a heuristic estimate of $h^*(n)$, the number of edges that separate n from γ.

Although the presence of only one solution path renders our problem a satisficing type, we will assume that $h(n)$ is admissible, thus guaranteeing that nodes at depths greater than N will not be expanded. Non-admissible heuristics are analyzed in Chapter 7.

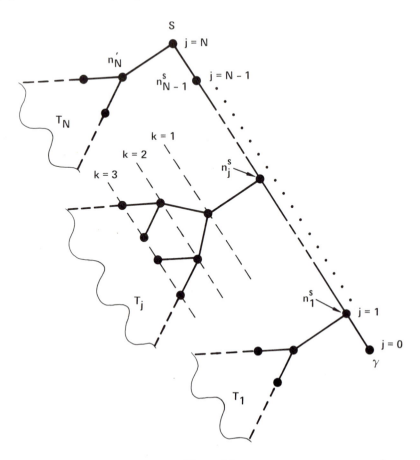

Figure 6.1

Uniform tree model ($b = 2$) for analyzing the pruning power of A^*. The solution path is shown on the extreme right, and the "off course" subtrees T_1, \ldots, T_N stem to the left.

Our probabilistic model assumes that each $h(n)$ can be treated as a random variable ranging over $[0, h^*(n)]$ and characterized by a distribution function $F_{h(n)}(x) = P[h(n) \leqslant x]$. We further assume that, for any two nodes n_1 and n_2, $h(n_1)$ and $h(n_2)$ are conditionally independent given their corresponding depths and distances to the goal. That amounts to assuming that the **error** $h - h^*$ occurring at node n may depend only on $h^*(n)$ and $g(n)$ but **is independent of the errors at other nodes in the graph**.

Given a characterization of the distribution functions $F_{h(n)}(x)$, our task is to explore how they influence the relationship between $E(Z)$, the expected number of nodes expanded by A^*, and the length N of the solution path which we treat as the parameter defining the problem size.

6.1.3 A Formula for the Mean Complexity of A *

Since $h(n)$ is admissible, a necessary condition for the expansion of a node n is $n \in$ OPEN and $f(n) \leqslant C^*$, and a sufficient condition for its expansion is $n \in$ OPEN and $f(n) < C^*$ (Chapter 3, Theorems 3 and 4). Consequently we can write:

$$P(n \text{ expanded}) \leqslant P(n\text{'s parent expanded and } f(n) \leqslant N) \qquad (6.1)$$

$$P(n \text{ expanded}) \geqslant P(n\text{'s parent expanded and } f(n) < N) \qquad (6.2)$$

The gap between the bounds in Eqs. (6.1) and (6.2) is created by the eventuality that some node n_j^s on the solution path together with a node n off the solution path could both be in OPEN having $f(n_j^s) = f(n) = N$. In such a case the expansion of n would be determined by the tie-breaking rule and not by the character of n. However, if $h(n)$ is a continuous random variable, the likelihood of such eventuality is essentially zero, and the bounds in Eqs. (6.1) and (6.2) become equalities. Moreover, since we are primarily interested in establishing bounds to $E(Z)$, we may, in case $h(n)$ is a discrete random variable, use Eq. (6.1) for deriving upper bounds and Eq. (6.2) for deriving lower bounds.

The process by which algorithm A * expands nodes in a search tree is analogous to a **reproduction process** where, for any node n off the solution path, the condition that it survives to reproduce is $f(n) < N$ and the condition that it dies prior to reproduction is $f(n) \geqslant N$. At the top level, we have the 0^{th} generation consisting of one member residing on the solution path. This member gives birth to a random number of sons of the first generation (or equivalently, the father gives birth to a fixed number b of infants, a random number of which will survive to reproduce). Then, each surviving member of the first generation gives birth to a random number of reproducing sons of the second generation, and so on. The number of reproducing sons of any member may also be 0 (i.e., all the sons may die), thus raising the possibility that the whole family be extinct after a certain number of generations.

The expansion process is tree-structured as shown in Figure 6.2. It is similar to the branching process studied in Chapter 5 with the exception of being **nonhomogeneous**, the survival rate may now vary from generation to generation.

Analytically, the i^{th} member of generation $d(1 \leqslant i \leqslant w_d)$ gives birth to a random number $X_{i,d}$ of fertile sons which are members of generation $d + 1$. Therefore, the size w_{d+1} of the $(d+1)^{th}$ generation is the sum of a random number (w_d) of random variables:

$$\begin{cases} w_{d+1} = X_{1,d} + \cdots + X_{i,d} + \cdots + X_{w_d,d} & \text{if } w_d \geqslant 1 \\ w_{d+1} = 0 & \text{if } w_d = 0 \end{cases}$$

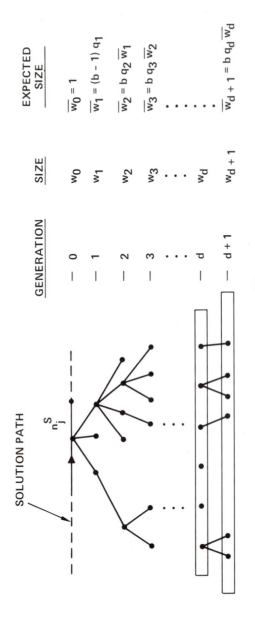

Figure 6.2

Branching model of node expansion in a typical "off-course" tree T_j.

174

In accordance with our previous assumption that $F_{h(n)}(x)$ depends only on $h^*(n)$ and $g(n)$, w_d and $X_{i,d}$ are mutually independent and the variables $\{X_{i,d}\}$, $i = 1, 2, ..., w_d$, are identically distributed (i.e., the fertility of each member of generation d may depend on d but is independent of both the size of the generation and the member's serial number). These conditions further imply (Feller, 1968) that the expectation of w_{d+1} is given by the product:

$$E(w_{d+1}) = E(w_d)E(X_{i,d})$$

Noting that the root n_j^s gives birth to exactly $b - 1$ infants and that exactly b infants are subsequently born to each parent of generation $d \geqslant 1$, $X_{i,d}$ is a binomial random variable with mean

$$E(X_{i,d}) = \begin{cases} (b - 1)q_d & d = 1 \\ b\,q_d & d \geqslant 2 \end{cases}$$

where q_d denotes the probability of infant survival for a typical member of generation d. Consequently $E(w_{d+1})$ becomes:

$$E(w_{d+1}) = E(w_d)b\,q_d \qquad d \geqslant 1$$

and, by induction over $d = 0, 1, 2, \cdots$ (with $E(w_0) = 1$), we finally obtain:

$$E(w_d) = (b - 1)b^{d-1}q_d\,q_{d-1} \cdots q_1$$
$$= \frac{b-1}{b}b^d \prod_{k=1}^{d} q_k \qquad (6.3)$$

The expected number of nodes expanded by A^* could be calculated by applying this analysis to each of the off-course subtrees in Figure 6.1. The expected number of nodes expanded at depth $d \geqslant 1$ of T_j is given by the product $(b - 1)b^{d-1}q_{j,d} \cdot q_{j,d-1} \cdots q_{j,1}$, where $q_{j,k}$ represents the probability that a node $n_{j,k}$ at depth k of T_j is expanded once it enters OPEN (infant survival), that is,

$$P[f(n_{j,k}) \leqslant N] \geqslant q_{j,k} \geqslant P[f(n_{j,k}) \leqslant N - 1] \qquad (6.4)$$

Summing this product over all levels d and over all off-course subtrees and adding the N nodes expanded along the solution path, we obtain a **formula for the expected number of nodes expanded** (Huyn et al., 1980):

$$E(Z) = N + \frac{b-1}{b} \sum_{j=1}^{N} \sum_{d=1}^{\infty} b^d \prod_{k=1}^{d} q_{j,k} \qquad (6.5)$$

where $q_{j,k}$ is bounded in (6.4). The summation over d need only span the range $1 \leqslant d \leqslant j$, because the requirement $h(n) \geqslant 0$ guarantees that no node at depth greater than N will ever be expanded. Thus, an alternative formula for $E(Z)$ is:

$$E(Z) = N + \frac{b-1}{b} \sum_{j=1}^{N} \sum_{d=1}^{j} b^d \prod_{k=1}^{d} q_{j,k} \qquad (6.6)$$

Note, for comparison, that the expected number of nodes expanded by a breadth-first search ($h = 0$) is roughly $\dfrac{1}{2} \dfrac{(b+1)}{(b-1)} b^N$.

In Sections 6.4 and 6.5 we use Eq. (6.5) to study how the distribution of errors influences the average complexity $E(Z)$. However, prior to this analysis we wish to examine a wider sense in which one heuristic can be said to be "superior" to another.

6.2 STOCHASTIC DOMINANCE FOR RANDOM ADMISSIBLE HEURISTICS

The problem of deciding whether one heuristic is better than another arises often. Clearly, if one heuristic consistently provides a more accurate estimate of h^*, it ought to be preferred. This is indeed the essence of Theorem 7 in Chapter 3 stating that, if for each nongoal node of the search graph $h_1(n) < h_2(n)$ and both are admissible, then every node expanded by A_2^* is also expanded by A_1^*, that is, $h_2(n)$ is to be preferred. However, we seldom possess sufficient *a priori* knowledge to guarantee that the inequality $h_1(n) < h_2(n)$ holds for every node in the graph. Even when the improved accuracy of h_2 is a product of invoking more sophisticated computation procedures than h_1, the improvement is seldom guaranteed to take place at every node of the problem space. Generally, when $h(n)$ is made more accurate for some nodes, it may become less accurate for others. For example, in one state of the Traveling Salesman problem the solution to the assignment problem may produce a higher cost estimate than the cost of the minimum spanning tree and in another state, having a different distribution of remaining cities, the opposite may be true. It is natural then to ask whether a statement of preference can be made in the case where the inequality $h_1 < h_2$ is only known to be a reasonably probable but occasionally violated event. The formalization and affirmation of such a statement is carried out in this section.[†]

DEFINITION: *Given two random variables X_1 and X_2, we say that X_2 is* **stochastically greater** *than X_1 (denoted by $X_1 \gtrsim X_2$) iff:*

$$P(X_2 > x) \geqslant P(X_1 > x) \qquad \forall\, x \in R$$

or equivalently,

$$F_{X_1}(x) \geqslant F_{X_2}(x) \qquad \forall\, x \in R$$

† The author thanks North Holland Publishing Company for permission to reprint the portion of the article "Probabilistic Analysis of the Complexity of A^*" by N. Huyn, R. Dechter, and J. Pearl which first appeared in *Artificial Intelligence* 15–3: 241–254, December 1980.

DEFINITION: *Let A_1^* and A_2^* employ the heuristic functions h_1 and h_2, respectively. A_2^* is said to be* **stochastically more informed** *than A_1^* iff $h_1(n) \gtrsim h_2(n)$, $\forall n \in T$. Similarly, A_2^* is said to be* **stochastically more efficient** *than A_1^* iff $Z_2 \gtrsim Z_1$, where Z_1 and Z_2 are the number of nodes expanded by A_1^* and A_2^*, respectively.*

An inspection of Eqs. (6.5) and (6.4) reveals that if, for every node n, $h_2(n)$ is stochastically greater than $h_1(n)$, then h_2 would induce a lower $E(Z)$. This is so because every $q_{j,k}$ in the case of h_2 will be smaller than or equal to the corresponding factor for h_1. However, a much stronger statement can be made; $h_1(n) \gtrsim h_2(n)$ implies not merely preference in the mean, but also *stochastic preference*.

THEOREM 1 *(Huyn et al, 1980): For any error distribution, if A_2^* is stochastically more informed than A_1^*, then A_2^* is stochastically more efficient than A_1^*.*

Proof: The theorem can be obtained directly using "coupling" methods in stochastic processes (Durrett, 1981) but an explicit proof, using our previous notation, may be instructive.

Given a set of mutually independent random variables, the order \gtrsim is preserved under addition within the set. In other words if X_1, Y_1, X_2, and Y_2 are mutually independent, then $X_1 \gtrsim X_2$ and $Y_1 \gtrsim Y_2$ imply $X_1 + Y_1 \gtrsim X_2 + Y_2$. Denote by $Z_1(n)$ and $Z_2(n)$ the number of nodes expanded by A_1^* and A_2^*, respectively, within the subtree rooted at n. We want to prove that $Z_2(s) \gtrsim Z_1(s)$. Equivalently, since the number of nodes expanded in the off-course trees T_j (see Figure 6.1) are independent, using the order-preserving property of addition for independent random variables, we only need to show that $Z_2(n_j{}') \gtrsim Z_1(n_j{}')$ for one arbitrary T_j. Let n be any node at depth d of that tree; it is sufficient to prove that $Z_2(n) \gtrsim Z_1(n)$ for each such n. We plan to prove this by a bottom-up induction on d.

For d sufficiently large the statement is trivially true since $Z_2(n) = Z_1(n) = 0$ for all n at level d. Assume $Z_2(n) \gtrsim Z_1(n)$ for all n at level d; we wish to show that $Z_2(n) \gtrsim Z_1(n)$ for all nodes n at level $d - 1$. Let nodes $n_1 \cdots n_k \cdots n_b$ be the direct descendants of a node n at level $d - 1$ as in Figure 6.3. For all integers $x \geqslant 0$ we have:

$$
P(Z(n) \leqslant x) =
\begin{cases}
1 & \text{if } A^* \text{ does not expand } n \\[2mm]
P\left(\sum_k Z(n_k) \leqslant x - 1\right) & \text{if } A^* \text{ expands } n
\end{cases}
$$

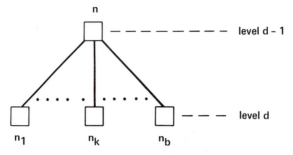

Figure 6.3
Notation used in the proof of Theorem 1.

or:

$$F_{Z(n)}(x) = P(Z(n) \leqslant x)$$
$$= [1 - P(n \text{ exp.})] + P(n \text{ exp.}) \, P\left[\left[\sum_k Z(n_k) \right] \leqslant x - 1 \mid n \text{ exp.} \right] \quad (6.7)$$

Since $h_1(n) \gtrsim h_2(n) \; \forall n$, and the path from s to n is unique, it is clear that (see Eq. (6.4)):

$$P(A_1{}^* \text{ expands } n) \geqslant P(A_2{}^* \text{ expands } n) \quad (6.8)$$

By induction hypothesis:

$$Z_2(n_k) \gtrsim Z_1(n_k) \qquad \text{for all } k$$

but, since $Z(n_1) \cdots Z(n_k) \cdots Z(n_b)$ are conditionally independent.

$$\sum_k Z_2(n_k) \gtrsim \sum_k Z_1(n_k)$$

or:

$$P\left[\sum_k Z_1(n_k) \leqslant x - 1 \right] \leqslant P\left[\sum_k Z_2(n_k) \leqslant x - 1 \right] \quad (6.9)$$

Thus, using Eqs. (6.8) and (6.9) in Eq. (6.7), we wish to show that $F_{Z_1(n)}(x) \leqslant F_{Z_2(n)}(x)$ or that:

$$\left. \begin{array}{c} u_1 \geqslant u_2 \\ v_1 \leqslant v_2 \end{array} \right\} \Longrightarrow 1 - u_1 + u_1 v_1 \leqslant 1 - u_2 + u_2 v_2 \quad (6.10)$$

where: $\quad u_j = P(A_j{}^* \text{ expands } n) \qquad\qquad j = 1, 2$
$\qquad\qquad v_j = P\left[\sum_k Z_j(n_k) \leqslant x - 1 \right] \qquad j = 1, 2$

The implication in (6.10) can be reduced to:

$$\left.\begin{array}{c} u_1 \geqslant u_2 \\ v_1 \leqslant v_2 \end{array}\right\} \Rightarrow (u_1 - u_2)(1 - v_1) + (v_2 - v_1)u_2 \geqslant 0$$

which is easily validated using the fact that u_2 and v_1 stand for probabilities and so, $v_1 \leqslant 1$ and $u_2 \geqslant 0$.

We conclude, therefore, that $F_{Z_1(n)}(x) \leqslant F_{Z_2(n)}(x)$ for all nodes and all levels of a given off-course subtree of T. Consequently, $Z_1(s) \gtrsim Z_2(s)$ which proves Theorem 1. ∎

6.3 THE MEAN COMPLEXITY OF $A*$ UNDER DISTANCE-DEPENDENT ERRORS

6.3.1 The Average Complexity under Proportional Errors

The quality of the heuristic estimates $h(n)$ often improves with proximity to the goal state or, equivalently, their precision deteriorates with increasing distances to the goal. In certain cases it may be appropriate to model this deterioration by assuming that the typical magnitude of the errors $h(n) - h*(n)$ increases proportionally to the distance $h*(n)$, or that for every node n in the tree the relative error

$$Y(n) = \frac{h(n) - h*(n)}{h*(n)} \tag{6.11}$$

is likely to remain bounded away from zero no matter how far n is from the goal.

Gaschnig (1979a) has analyzed proportional errors under worst case conditions namely where $Y(n)$ takes on a fixed negative value $-\epsilon$, $1 \geqslant \epsilon > 0$, for each off-track node n. Under such assumption the number of nodes expanded by $A*$ is exponential in N. This is evident from Figure 6.1 where for every node $n_{N,k}$ at depth k of the top off-course subtree T_N we can write

$$g(n_{N,k}) = k \tag{6.12}$$

$$h*(n_{N,k}) = N + k \tag{6.13}$$

$$h(n_{N,k}) = (1 - \epsilon)h*(n_{N,k}) = (1 - \epsilon)(N + k) \tag{6.14}$$

Now, from Eq. (6.2), we conclude that every node satisfying the inequality

$$k + (1 - \epsilon)(N + k) < N \tag{6.15}$$

will be expanded by A^*, once it enters OPEN. That means that every node down to depth

$$k = \left\lfloor \frac{N\epsilon}{2 - \epsilon} \right\rfloor - 1 \qquad (6.16)$$

of T_N will definitely be expanded, which brings the total number of nodes expanded in T_N to at least

$$b^{\left\lfloor \frac{N\epsilon}{2-\epsilon} \right\rfloor - 2}$$

Clearly, then, the total number of nodes expanded by A^* is exponential in N;

$$Z = \Omega(c_\epsilon^N) \qquad (6.17)$$

where $c_\epsilon > 1$ if $1 \geqslant \epsilon > 0$.

We now generalize this result to the average case. Instead of assuming that all errors take on their largest possible values, we allow the relative errors $Y(n)$ to take on any value between -1 and zero in accordance with some arbitrary distribution functions

$$F_{Y(n)}(y) = P[Y(n) \leqslant y] \qquad (6.18)$$

Assuming further that the relative errors $Y(n)$ are independent and nonpositive random variables $(-1 \leqslant Y(n) \leqslant 0)$ we wish to examine the conditions under which the set of distributions $\{F_{Y(n)}(y)\}$ leads to an exponential growth of $E(Z)$ (Eq. (6.5)).

One way of accomplishing this objective is to begin with the case where $Y_n(y)$ are *identically* distributed over all nodes with a well-behaved distribution function $F_Y(y)$, determine under what conditions $F_Y(y)$ would give rise to an exponential $E(Z)$, and then identify those sets $\{F_{Y(n)}(y)\}$ which could be bounded from below by $F_Y(y)$. Clearly, every heuristic h' whose error distributions are bounded from below by $F_Y(y)$ is stochastically less informed than h and so, if h gives rise to exponential mean complexity so will h'.

This approach was pursued by Huyn, Dechter, and Pearl (1980), who chose for analysis the piecewise linear distribution:

$$F_Y(y) = \begin{cases} 1 & y \geqslant 0 \\ (1 - \beta)(1 + y/\epsilon) & -\epsilon \leqslant y < 0 \\ 0 & y < -\epsilon \end{cases} \qquad (6.19)$$

with parameters $0 \leqslant \beta \leqslant 1$ and $0 < \epsilon \leqslant 1$. This distribution characterizes a mixed random variable whose continuous part is uniformly distributed between $-\epsilon$ and 0, having a probability β of being identically equal to zero, that is, $\beta = P(h = h^*)$.

After substituting Eq. (6.19) in Eqs. (6.4) and (6.5), the expected number of nodes expanded was shown to assume the following asymptotic behavior:

$$E(Z) = \begin{cases} \Omega(c^{\,v}), c > 1 & \text{if } P(h = h^*) < 1 - 1/b \\ O(N^2) & \text{if } P(h = h^*) = 1 - 1/b \\ O(N) & \text{if } P(h = h^*) > 1 - 1/b \end{cases} \qquad (6.20)$$

thus generalizing the result of Eq. (6.17) from the worst case to the average case analysis. This result implies that the average complexity is exponential in N when the relative errors are uniformly distributed over the interval $[-\epsilon, 0]$. Evidently, not much is gained by diffusing the errors smoothly over the interval. The only time the complexity of A^* reduces to a polynomial is when the likelihood that h *literally coincides* with h^* is sufficiently high at all nodes, that is, $\beta \geqslant 1 - 1/b$. Under this condition the expansion of nodes is governed by a nonhomogeneous branching process with reproduction rate $m \leqslant 1$ and, in light of Lemma 2, Chapter 5, the result is not surprising.

Using the uniform distribution of Eq. (6.19) to bound other distribution functions, Huyn et al. (1980) also showed that the behavior exhibited in Eq. (6.20) is not unique to the uniform distribution, but generalizes to distributions of arbitrary shape as long as they represent errors that grow proportionally to the distance from the goal, that is, $(h - h^*)/h^*$ possess a limiting distribution as $h^* \to \infty$. We will not pursue this approach here but will analyze, instead, the behavior of $E(Z)$ directly from the essential parameters of the distributions $F_{Y(n)}(y)$. This method sheds a better light on the mechanism responsible for the exponential character of $E(Z)$.

THEOREM 2: *If, for every node in the tree, the probability that the magnitude of the relative error exceeds some fixed positive quantity ϵ is bounded above $1/b$, then the average complexity of A^* is exponential in N.*

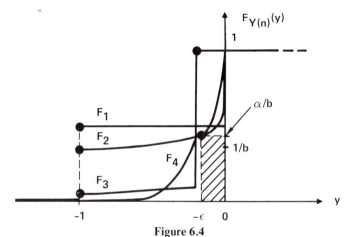

Figure 6.4
A set of error-distributions satisfying the condition of Theorem 2.

Proof: Consider the set of random variables $\{Y(n)\}$ where $Y(n)$ stands for the relative error $(h - h^*)/h^*$ at node n, and n ranges over all nodes of the tree. The condition of Theorem 2 translates to

$$F_{Y(n)}(-\epsilon) \geqslant \alpha/b \qquad \text{for some } \alpha > 1, \epsilon > 0 \qquad (6.21)$$

as shown in Figure 6.4. Now consider node $n_{j,k}$ at depth k of off-course subtree T_j for which we have:

$$g(n_{j,k}) = N - j + k \qquad (6.22)$$

$$h^*(n_{j,k}) = j + k \qquad (6.23)$$

and

$$
\begin{aligned}
q_{j,k} &\geqslant P[g(n_{j,k}) + h(n_{j,k}) \leqslant N - 1] \\
&\geqslant P\left[\frac{h(n_{j,k}) - (j + k)}{j + k} \leqslant -\frac{2k + 1}{j + k} \right] \\
&= F_{Y(n_{j,k})}\left[\frac{-2k - 1}{j + k} \right] \qquad (6.24)
\end{aligned}
$$

Clearly, Eq. (6.21) implies

$$bq_{j,k} \geqslant \alpha > 1 \qquad \text{for all } k < D(j, \epsilon) = \frac{j\epsilon - 1}{2 - \epsilon}$$

since $D(j, \epsilon)$ is the solution of

$$\frac{-2x - 1}{j + x} = -\epsilon$$

and so, substituting in Eq. (6.5) and taking the single term $j = N$, gives:

$$
\begin{aligned}
E(Z) &\geqslant \frac{b - 1}{b} \sum_{d=1}^{\infty} b^d \prod_{k=1}^{d} q_{N,k} \\
&\geqslant \frac{b - 1}{b} \sum_{d=1}^{D(N,\epsilon)} \alpha^d \\
&\geqslant \frac{b - 1}{b} \alpha^{D(N,\epsilon)} \\
&= \frac{b - 1}{b}(C_\alpha)^N \qquad (6.26)
\end{aligned}
$$

where:

$$C_\alpha = (\alpha)^{\frac{\epsilon}{2 - \epsilon}} > 1$$

which proves Theorem 2. ■

The essence of the proof lies in two basic observations:

1. In reproduction processes where all members down to some extinction depth $D(j, \epsilon)$ have a reproduction rate $m = bq$ greater than unity, the average family size is exponential in $D(j, \epsilon)$.
2. The format of the argument of F in Eq. (6.24) is such that the depth k required to lower the argument below some given level $-\epsilon$ is linear in j.

In most practical situations we will not possess the detailed information required for assigning each node $n_{j,k}$ a separate error distribution $F_{Y(n_{j,k})}(y)$ which is a function of both j and k. Instead, the only reasonable assumption we would be able to make about the relative errors $Y(n_{j,k})$ is that they are identically distributed over all nodes in the tree, with distribution function $F_Y(y)$. Under such an assumption, the condition of Theorem 2 assumes an especially simple form; it is satisfied whenever $F_Y(0^-) > 1/b$. We can, therefore, state:

COROLLARY 1: *If the relative errors in a uniform b-ary tree are independently drawn from a common distribution $F_Y(y)$ such that $F_Y(0^-) > 1/b$, then the average complexity of $A*$ is exponential in N.*

Theorem 2 implies that in order to avoid an exponential growth of $E(Z)$, the magnitude of the typical errors in the tree should increase more slowly than linearly with the distance from the goal. For example, if the absolute errors $h*(n) - h(n)$ are bounded by a fixed quantity δ, the condition of Theorem 2 would not be satisfied. For every $\epsilon > 0$, we could then find nodes sufficiently remote from the goal for which the error $| h(n) - h*(n) |$ is below $\epsilon h*(n)$. This, indeed, is the type of error for which both Pohl (1977) and Gaschnig (1979a) have established a linear worst-case complexity (ensuring, of course, linear mean complexity).

In light of these results, a natural question to ask is how accurate the estimates must be in order to guarantee a *polynomial complexity*. The following section answers this question.

6.3.2 The Average Complexity under General Distance-Dependent Errors

The results of the preceding section delineate the spectrum of the precision-complexity exchange by two extreme points. On one extreme we have Pohl (1977) and Gaschnig's (1979a) results stating that if the absolute errors $| h(n) - h*(n) |$ are bounded by a fixed quantity, then $A*$ is guaranteed a linear complexity. On the other extreme, if these errors grow linearly with $h*(n)$, then $A*$ exhibits an exponential complexity. In this section we quantify the precision-complexity exchange over the *interior* of its spectrum and show

that the **precision-complexity exchange has an exponential character**, that is, if the typical error grows like $\phi(h^*)$, then the mean complexity of A^* grows approximately like $N \exp[c\,\phi(N)]$, where c is a positive constant (Pearl, 1983a). Thus, a necessary and sufficient condition for maintaining polynomial search complexity is that A^* be guided by heuristics with logarithmic precision, for example, $\phi(N) = (\log N)^k$.

To demonstrate this result we need a more precise definition of what is meant by the **growth of the typical error**. When, in the preceding section, we wished to represent random errors whose magnitude grows linearly with the distance $h^*(n)$ we had to insist that for every node n:

$$P[\,|h(n) - h^*(n)| \;>\; \epsilon h^*(n)] > 0 \qquad \text{for some } \epsilon > 0 \qquad (6.27)$$

regardless of how far n is from the goal. Simultaneously, in order to rule out errors growing faster than linear one should also require:

$$P[\,|h(n) - h^*(n)| \;\geqslant\; \lambda h^*(n)] < 1 \qquad (6.28)$$

for some $\lambda > 0$ and for all n. This requirement was not stated explicitly in Theorem 2 because it is always satisfied with $\lambda = 1$, due to our restriction that h be nonnegative, yielding $|h - h^*| \leqslant h^*$.

To represent errors growing at an arbitrary rate $\phi(h^*)$, slower than linear, we define $Y(n)$, the **ϕ-normalized error** at node n, by the ratio:

$$Y(n) = \frac{h(n) - h^*(n)}{\phi[h^*(n)]} \qquad (6.29)$$

where $\phi(\cdot)$ is an arbitrary normalization function monotonically increasing with its argument and satisfying:

$$\lim_{x \to \infty} \phi(x) = \infty$$

$$\lim_{x \to \infty} \phi(x)/x = 0 \qquad (6.30)$$

Paralleling Eqs. (6.27) and (6.28) we now define the **order** of the typical errors induced by h:

DEFINITION: *A heuristic estimate is said to induce a **typical error of order** $\phi(N)$ if for all nodes in a b-ary tree there exist two fixed positive quantities ϵ and λ and a normalizing function $\phi(\cdot)$, such that:*

$$P\left[\left|\frac{h(n) - h^*(n)}{\phi[h^*(n)]}\right| \geqslant \epsilon\right] \geqslant \alpha/b, \qquad \text{for some } \alpha > 1 \qquad (6.31)$$

and simultaneously:

$$P\left[\left|\frac{h(n) - h^*(n)}{\phi[h^*(n)]}\right| \geqslant \lambda\right] \leqslant \beta/b, \qquad \text{for some } \beta < 1 \qquad (6.32)$$

The first condition insists that the magnitudes of the ϕ-normalized errors remain bounded away from zero with sufficiently high probability, as in Theorem 2. The second condition limits the likelihood that the ϕ-normalized errors will grow beyond bounds when the distance to the goal increases indefinitely. Figure 6.5 depicts a family of distribution functions that satisfy these two conditions. The reason for the factors α/b and β/b in Eqs. (6.31) and (6.32) will become clear later on when we see that the value of b, as in the case of proportional errors, has a decisive influence on the rate of growth of $E(Z)$. Note that if both Eqs. (6.31) and (6.32) are satisfied simultaneously by two normalizing functions, ϕ_1 and ϕ_2, then $\phi_1(N) = \Theta[\phi_2(N)]$.

The proportional errors treated in Section 6.3.1 are represented by the special case $\phi(N) = N$, whereas the absolute errors analyzed by Pohl (1970) correspond to $\phi(N) = $ constant. These two extreme cases are excluded by the requirements of Eq. (6.30) in order to facilitate the mathematical analysis that follows.

A convenient special case that produces typical errors of order $\phi(N)$ occurs when the ϕ-normalized errors are identically distributed with distribution $F_Y(y)$. In this case, Eq. (6.31) is equivalent to $F_Y(0^-) > 1/b$, whereas Eq. (6.32) is automatically satisfied since $F_Y(-\infty) = 0$. We may, therefore, state the following lemma.

LEMMA 1: *If the ϕ-normalized errors $Y(n) = [h(n) - h^*(n)]/\phi[h^*(n)]$ in a uniform b-ary tree are independently drawn from a common distribution $F_Y(y)$ such that $F_Y(0^-) > 1/b$, then h induces a typical error of order $\phi(N)$.*

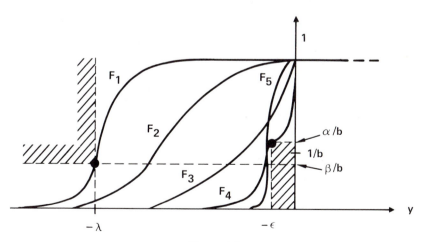

Figure 6.5

A heuristic h induces a typical error of order $\phi(N)$ if the distributions of the ϕ-normalized errors $(h - h^*)/\phi(h^*)$ at all nodes of the tree avoid the two shaded areas shown.

Paralleling our treatment of the proportional errors in the proof of Theorem 2, we now derive the asymptotic behavior of $E(Z)$ for subproportional errors, i.e., $\phi(N) = o(N)$. First, we establish a lower bound to $E(Z)$ using Eq. (6.31) and then an upper bound, of identical form, using Eq. (6.32).

THEOREM 3. *If for all nodes in a b-ary tree there exist two fixed quantities $\epsilon >$ and $\alpha > 1$, and a normalizing function $\phi(\cdot)$, such that:*

$$P\left[\left|\frac{h(n) - h^*(n)}{\phi[h^*(n)]}\right| \geq \epsilon\right] \geq \frac{\alpha}{b}, \tag{6.33}$$

then the mean complexity of A^ is lower bounded by:*

$$E(Z) \geq N \exp\left\{c_1\phi(N)\left[1 + O\left[\frac{\phi(\phi(N))}{\phi(N)}\right]\right]\right\} \tag{6.34}$$

where c_1 is a constant.

Proof: Using Eqs. (6.4), (6.22), and (6.23) we now write

$$q_{j,k} \geq P[g(n_{j,k}) + h(n_{j,k}) \leq N - 1]$$

$$= P\left[\frac{h(n_{j,k}) - (j + k)}{\phi(j + k)} \leq -\frac{2k + 1}{\phi(j + k)}\right]$$

$$= F_{Y(n_{j,k})}\left[-\frac{2k + 1}{\phi(j + k)}\right] \tag{6.35}$$

whereas Eq. (6.33) states that, for every node n,

$$F_{Y(n)}(-\epsilon) \geq \alpha/b \qquad \text{for some } \alpha > 1 \text{ and } \epsilon > 0 \tag{6.36}$$

Clearly, Eqs. (6.35) and (6.36) imply that

$$bq_{j,k} \geq \alpha > 1 \qquad \text{for all } k < D(j, \epsilon) \tag{6.37}$$

where, now, $D(j, \epsilon)$ is the solution of

$$\frac{2x + 1}{\phi(j + x)} = \epsilon \tag{6.38}$$

The asymptotic behavior of $D(j, \epsilon)$ for large j can be obtained by bootstrapping Eq. (6.38) iteratively:

$$D(j, \epsilon) = \frac{\epsilon}{2}\phi[j + \frac{\epsilon}{2}\phi(j + \frac{\epsilon}{2}(...))]$$

resulting in:

$$D(j, \epsilon) = \frac{\epsilon}{2}\phi(j)\left[1 + O\left[\frac{\phi(\phi(j))}{\phi(j)}\right]\right] \tag{6.40}$$

We now substitute Eq. (6.37) in the j^{th} term of the summation in Eq. (6.5), and obtain a lower bound to $E(Z_j)$, the expected number of nodes expanded in subtree T_j:

$$E(Z_j) \geqslant \frac{b-1}{b} \sum_{d=1}^{\infty} \left[b\, q_{j,k} \right]^d$$

$$\geqslant \frac{b-1}{b} \sum_{d=1}^{D(j,\epsilon)} \alpha^d$$

$$\geqslant \frac{b-1}{b} \alpha^{D(j,\epsilon)}$$

Since there are a total of N off-course trees, $j = 1, 2, ..., N$, we can lower bound $E(Z)$ by:

$$E(Z) \geqslant \sum_{j \geqslant N/2}^{N} E(Z_j) \geqslant \frac{N}{2} E(Z_{N/2}) \geqslant \frac{N}{2} \frac{b-1}{b} \alpha^{D(N/2,\epsilon)}$$

This, together with Eq. (6.40) and $\phi(N/2) \geqslant \frac{1}{2}\phi(N)$, establishes Eq. (6.34). ∎

If $\phi(x)$ is a fractional power of N, that is, $\phi(N) = N^{\mu}$, $\mu < 1$, then the factor N in Eq. (6.34) is not essential because it can be absorbed into the exponent. It is significant, however, in case $\phi(N)$ is logarithmic; for example, $\phi(N) = (\log N)^k$, because it will then increase the degree of the resulting polynomial by one.

THEOREM 4. *If for all nodes in a b-ary tree there exist two fixed quantities, $\lambda > 0$ and $\beta < 1$, and a normalizing function $\phi(\cdot)$ such that:*

$$P\left[\left| \frac{h(n) - h*(n)}{\phi[h*(n)]} \right| \geqslant \lambda \right] \leqslant \frac{\beta}{b} \qquad (6.41)$$

then the mean complexity of A is upper bounded by:*

$$E(Z) \leqslant N \exp\left\{ c_2\phi(N) \left[1 + O\left(\frac{\phi(\phi(N))}{\phi(N)} \right) \right] \right\} \qquad (6.42)$$

where c_2 is a positive constant.

Proof: Eq. (6.41) implies that there exist λ and β such that, for every node,

$$F_{Y(n)}(-\lambda) \leqslant \frac{\beta}{b} \qquad \beta < 1, \lambda > 0$$

Moreover, from Eqs. (6.4), (6.22), and (6.23) we obtain

$$q_{j,k} \leqslant P[g(n_{j,k}) + h(n_{j,k}) \leqslant N]$$

$$= F_{Y(n)} \left[-\frac{2k}{\phi(j+k)} \right]$$

Hence, we see that

$$bq_{j,k} \leqslant \beta < 1 \qquad \text{for all } k < D(j, \lambda) \tag{6.43}$$

where $D(j, \lambda)$ is the solution of

$$\frac{2x+1}{\phi(j+x)} = \lambda$$

having the asymptotic expression:

$$D(j, \lambda) = \frac{\lambda}{2} \phi(j) \left[1 + O\left[\frac{\phi(\phi(j))}{\phi(j)} \right] \right]$$

Focusing now on the $j = N$ term in Eq. (6.5) we write:

$$E(Z_N) = \frac{b-1}{b} \sum_{d=1}^{\infty} b^d \prod_{k=1}^{d} q_{j,k}$$

$$\leqslant \frac{b-1}{b} \left[\sum_{d \leqslant D} b^d + b^D \sum_{d > D}^{\infty} \beta^d \right]$$

$$\leqslant b^D \left[1 + \frac{\beta^D}{1 - \beta} \right]$$

But, since $\beta < 1$ and $D(N, \lambda) = O[\phi(N)]$, we have:

$$\beta^D \to 0$$

Moreover, since $q_{j,k}$ is increasing in j, we can upper bound $E(Z)$ by:

$$E(Z) \leqslant N + N E(Z_N)$$

$$= N + N b^{D(N, \lambda)}$$

which proves Eq. (6.42). ∎

This proof highlights the significance of the depth $D(j, \lambda)$; every node at depth greater than D will have reproduction rate $m = bq$ lower than unity and hence can only nucleate a family with bounded expected size. Thus, $D(j, \lambda)$ should be regarded as the **effective search depth** of subtree T_j. The fact that $D(j, \lambda) = O[\phi(j)]$ provides a simple intuitive explanation for the bound in Theorem 4.

Note that the extreme cases, $\phi(x) = $ constant and $\phi(x) = x$, which were excluded from Theorems 3 and 4 by virtue of the requirements in Eq. (6.30), are also covered by Eq. (6.44).

COROLLARY 2: *A sufficient condition for Theorems 3 and 4 to be valid is that $\phi(\cdot)$ satisfies* $\lim\limits_{x \to \infty} \dfrac{\phi(x)}{x} < \infty.$

Theorems 2, 3, and 4 can all be summarized in one statement using the term **typical errors** as defined earlier in this section. This definition requires that Eqs. (6.33) and (6.41) be satisfied simultaneously, and so we are led to:

COROLLARY 3 (Pearl, 1983a): *If the typical error induced by $h(\cdot)$ is of order $\phi(N)$ and* $\lim\limits_{N \to \infty} \dfrac{\phi(N)}{N} < \infty$, *then the mean complexity of A *is given by:*

$$E(Z) = N \, \exp\{c\,\phi(N)[1 + o(1)]\} \qquad (6.44)$$

where c is a positive constant.

The exponential relationship established in this section implies that the precision-complexity exchange for A * is fairly "inelastic," that is, highly precise heuristics must be devised if the search complexity is to be contained within reasonable growth rate. For example, Theorem 3 implies that if the typical distance-estimation error increases as a fractional power of the actual distance to the goal (e.g., $\phi(N) = \sqrt{N}$), then the mean complexity of A * grows faster than N^k for any positive k regardless of the shapes of the distribution functions. A necessary (and sufficient) condition for maintaining a polynomial search complexity is that A * be guided by heuristics with logarithmic precision (e.g., $\phi(N) = (\log N)^k$). Such heuristics are hard to come by. Most physical measurements are subject to a constant relative error, and statistical inferences are usually characterized by $O(N^{1/2})$ error law (where N stands for the number of random elements). Logarithmic precision, by contrast, is a rare commodity.

6.4 COMPARISON TO BACKTRACKING AND THE EFFECT OF MULTIPLE GOALS

Naturally, the results of the last section are influenced by the assumptions governing our workbench model, that is, uniform infinite trees with unary costs, a single goal state, independent estimation errors, and so on. Other models would undoubtedly exhibit different precision-complexity tradeoffs, and it is still unclear how these assumptions shape the character of the exchange mechanism. The model analyzed in the preceding section captures some essential aspects of heuristic search with only a few parameters and, due

to its mathematical simplicity, can be considered a starting point for more elaborate models. Its more practical usage, though, is in obtaining an analytical comparison of the performances of several search algorithms operating under identical conditions, and in determining how the model parameters influence their effectiveness.

6.4.1 The Mean Complexity of Informed Backtracking [†]

It is interesting, for example, to compare the precision-complexity exchange of A^* with that of partially informed backtracking (Section 2.2.1). The latter also employs an element of the best-first principle but, unlike A^*, the "best" (i.e., lowest f) node is chosen only among the set of newly generated nodes, not from among all the nodes on the search frontier. Consequently, once a decision is made to expand a node not lying on a solution path, the entire tree beneath that node must be irrevocably expanded (down to a given depth-bound) before another path is tried. Thus, assuming that successor ordering in backtracking is governed by the same heuristic function $f(n) = g(n) + h(n)$ that guides A^*, the complexity Z_B depends on how often each node n on the solution path is assigned an estimate $f(n)$ higher than its off-course siblings. In Figure 6.1, for example, if $f(n^s_{N-1})$ is higher than $f(n'_N)$, the entire "off-course" subtree rooted at n'_N with all its $(b^N - 1)/(b - 1)$ nodes would be expanded (assuming a depth-bound of N) before n^s_{N-1} is reexamined. In a b-ary tree the expected number of siblings expanded prior to n^s_{N-1} is equal to $(b - 1)q_{N-1}$, where:

$$q_{N-1} = P[f(n'_N) < f(n^s_{N-1})] \qquad (6.45)$$

and hence, discounting errors at lower levels:

$$E(Z_B) \geqslant q_{N-1}(b^{N-1} - 1) \qquad (6.46)$$

Assume now that the ϕ-normalized errors $Y = (h - h^*)/\phi(h^*)$ are identically distributed over all nodes with $P(Y = 0) = \beta$ and that $\phi(\cdot)$ is constrained by Eq. (6.30). Nodes n'_N and n^s_{N-1} are equally distant from s (i.e., $g(n_N') = g(n^s_{N-1}) = 1$) and their distances to the goal differ by only 2 units, i.e., $h^*(n_N') = h^*(n^s_{N-1}) + 2 = N + 1$. Hence, Eq. (6.45) can be written:

$$q_{N-1} = P[Y(n'_N) < \frac{\phi(N-1)}{\phi(N+1)}(Y(n^s_{N-1}) - 2/\phi(N-1))] \qquad (6.47)$$

However, since $Y(n'_N)$ and $Y(n^s_{N-1})$ are identically distributed and (using Eq. (6.30)) $\frac{\phi(N-1)}{\phi(N+1)} = 1 + o(\frac{1}{\phi(N)})$, the asymptotic behavior of Eq. (6.47) becomes:

$$q_{N-1} = \frac{1}{2}(1 - \beta^2) + O(\frac{1}{\phi(N)}) \qquad (6.48)$$

[†] The author thanks North Holland Publishing Company for permission to reprint the portion of the article "Knowledge versus Search: A Quantitative Analysis Using A^*" by Judea Pearl which first appeared in *Artificial Intelligence* 20, 1–13, January 1983.

Thus, the two-units distance-difference between n_N' and n_{N-1}^s is insufficient to produce a consistent preference in favor of the right branch. When the distance estimates $h(n_N')$ and $h(n_{N-1}^s)$ are not literally exact, the superiority of the right branch is masked by the ever-increasing errors $h^* - h$, which lead to an equal chance of selecting any of the b branches stemming from s.

Substituting in Eq. (6.46), the mean complexity of backtracking becomes:

$$E(Z_B) \geqslant \frac{1}{2}(1 - \beta^2)b^{N-1}\left[1 + O\left[\frac{1}{\phi(N)}\right]\right] \qquad (6.49)$$

implying that backtracking's complexity would retain its exponential character despite any improvement in the heuristic precision. Whereas $\phi(\cdot)$ and the error distribution $F_Y(\cdot)$ have a direct impact on the *growth-rate* of the complexity of A^* (see Corollary 2), they have only tenuous influence on the complexity of backtracking strategies via the multiplication constant $(1 - \beta^2)$. Thus, if an admissible distance-estimating heuristic is available, A^* is a more effective instrument for converting this information into appreciable savings in search time.

6.4.2 The Effect of Multiple Goals

One may wonder whether A^* would retain this effectiveness when the search tree contains multiple goal states. Clearly the presence of suboptimal solutions should cause off-track nodes to obtain deceptively low h and would therefore increase the number of nodes expanded by A^*. To obtain an idea of the magnitude of this effect, we can analyze an extreme model whereby all nodes at depth $N + 1$ are goal nodes, whereas only one goal exists at depth N. Under this condition the h^* for every off-track node $n_{j,k}$ is determined by its distance to the suboptimal goal beneath it, that is,

$$h^*(n_{j,k}) = j - k + 1 \qquad (6.50)$$

Letting Eq. (6.50) modify Eq. (6.23) and following the proof of Theorem 3, we obtain:

$$E(Z) \geqslant N[b(1 - \beta)]^N e^{-c\psi(N)} \qquad (6.51)$$

where

$$\psi(N) = \sum_{k=0}^{N} 1/\phi(k)$$

and c is a positive constant. Hence, A^* would retain its exponential complexity regardless of the order ϕ of the typical errors. Its growth rate, though, would still be affected by ϕ. For example, for $\phi = $ constant (i.e., bounded absolute errors) $E(Z)$ becomes $O[(b')^N]$ where $b' = bP(h^* - h > 1)$, and for $\phi(x) = x$ we obtain $E(Z) = N^{1-\alpha}[b(1 - \beta)]^N$, $\alpha > 0$. Thus, although the

presence of multiple solutions may significantly deteriorate A^*'s ability to benefit from improved precision, the complexity of A^* remains more sensitive to error reduction than that of backtracking (i.e., Eq. (6.49)).

Backtracking control strategies, on the other hand, have several advantages over A^* (see Chapter 2). They are typically simpler to implement and, more significantly, require much less storage. Eq. (6.49) reveals the price paid for this storage economy—an exponential time-complexity coupled with ineffective utilization of heuristic knowledge. These drawbacks are only significant in optimization problems or satisficing problems in which the depth-bounded search tree contains a small number of solutions. When solutions are plentiful and equally desirable, backtracking is a very effective strategy. Hybrid search strategies combining the storage economy of backtracking with the time savings of A^* also warrant empirical and theoretical investigations.

EXERCISES

6.1 A knight on an infinite chess board must be transferred from an initial position $s = (0, 0)$ to a goal position $\gamma = (m, n)$ using the minimum number of legal knight moves.

 a. Find an admissible heuristic function h having a bounded absolute error $|h - h^*|$.

 b. Determine the maximum value of the error.

6.2 Consider the relaxed versions of the 8-Puzzle where it is permissible to move any tile into the blank space. Assume this version is played on an $N \times N$ board and that h_1, the number of misplaced tiles, is used as a guiding heuristic. What is the order of the typical error induced by h_1?

6.3 Find approximations for the constants c_1, and c_2 in Eqs. (6.34) and (6.42)) if the ϕ-normalized errors are exponentially distributed, that is,

$$F_{Y(n)}(y) = \exp[\alpha \, y] \qquad \alpha > 0, \, y \leqslant 0$$

6.4 Derive Eq. (6.51).

Chapter 7

Searching with Nonadmissible Heuristics

Admissible search strategies are cursed with two basic defects: they spend a disproportionate amount of time investigating *all* equally meritorious alternative solutions, and they limit the selection of heuristic functions to only those that *never* overestimate the optimal completion cost. The literature on heuristic search contains many examples of nonadmissible heuristics that empirically out-perform any known admissible heuristic and yet very frequently discover an optimal path.

The aims of theoretical investigations in this area are to answer questions that would otherwise require a lengthy simulation exercise in each specific domain. When are nonadmissible heuristics safe from a catastrophic overcomputation? How often are they likely to miss the optimal solution? When is one heuristic better than another? Is admissibility a virtue in cases where just any solution will do? How should one "debias" a given heuristic? How should one aggregate the estimates provided by several heuristic functions?

The results reported in the following sections provide answers to some of these questions in the context of the probabilistic model of Chapter 6. Their applicability is limited, of course, to problems that are similar in structure to our probabilistic search-tree model but they help identify the major factors that influence the behavior of the search under the guidance of overestimating heuristics. The only complexity measure considered in this chapter is the number of distinct nodes expanded by A^*. We should keep in mind, though, that in practice other computational works, such as sorting OPEN and reopening closed nodes, should also be considered (see Martelli, 1977, and Bagchi et al., 1983).

7.1 CONDITIONS FOR NODE EXPANSION

The analysis of the mean run-time of admissible best-first algorithms is facilitated by the simplicity of the condition for node expansion. We know that every node n in OPEN whose evaluation satisfies $f(n) < C^*$ must eventually

be expanded and conversely, that every node satisfying $f(n) > C^*$ will not be expanded. In our standard model of a b-ary tree with one goal at depth N, these conditions amount to deciding whether $f(n)$ is larger or smaller than N.

The expansion condition for nonadmissible heuristics is complicated by the fact that $f(n)$ may exceed N at several places along the solution path. The expansion condition under such circumstances can be deduced from Theorem 6* Chapter 3 (Section 3.3) and the fact that our search space is a tree with a single goal γ, giving:

LEMMA 1: *A* expands every node in OPEN for which*

$$f(n) < L_j \qquad (7.1)$$

and excludes every node for which

$$f(n) > L_j$$

where

$$L_j \triangleq \max_{0 \leqslant i < j} f(n_i^s) \qquad (7.2)$$

$n_0^s, n_1^s, n_2^s, ..., n_N^s$ *are nodes along the solution path and* n_i^s *is the deepest common ancestor of* γ *and* n *(see Figure 7.1). In other words, node* n *will be expanded iff the path* P_A *is bounded by the max of* f *along the path* P_B.

The right-hand side of (7.1) is a random variable L_j whose distribution determines the probability of expanding any node in subtree T_j. Since for any node along the solution path, we have

$$g(n_i^s) = N - i \qquad h^*(n_i^s) = i$$

L_j can be written:

$$L_j = \max_{0 \leqslant i < j} \{N + [h(n_i^s) - h^*(n_i^s)]\}$$
$$= N + \max_{0 \leqslant i < j} \epsilon_i \qquad (7.3)$$

where

$$\epsilon_i = \max[0, h(n_i^s) - h^*(n_i^s)] \qquad (7.4)$$

is the magnitude of the overestimation error at node n_i^s.

If the absolute errors are bounded, overestimations have only a minor influence on the expansion probability. However, if overestimation increases with the distance to the goal, L_j may be significantly higher than N, which may cause many more nodes in T_j to be expanded, especially higher up the tree ($j \approx N$).

We can now calculate upper and lower bounds on the expansion probability $q_{j,k}$. The lower bound is obtained simply by discarding the second term from the right-hand side of Eq. (7.3):

$$q_{j,k} \geqslant P[f(n_{j,k}) < N] \qquad (7.5)$$

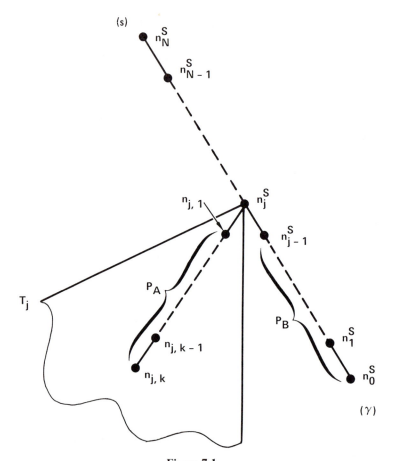

Figure 7.1

Node $n_{j,k}$ is expanded if the maximal f value along path P_A is lower than the maximal f value along P_B.

The upper bound can be obtained if we assume that each ϵ_i in Eq. (7.3) attains its highest possible value. Assuming that the overestimation error ϵ_i is bounded by r_i, and that r_i is nondecreasing with i, we can write

$$L_j \leqslant N + r_{j-1} \tag{7.6}$$

which yields:

$$q_{j,k} \leqslant P[f(n_{j,k}) \leqslant N + r_{j-1}] \tag{7.7}$$

If we calculate the average complexity assuming equality in (7.5), we will get an optimistic estimate, whereas substituting equality in (7.7) would yield a pessimistic estimate. The following two results demonstrate that the pessimistic estimate is more valid and, moreover, that calculations based on the equality $L_j = N + r_{j+1}$ yield the correct asymptotic behavior of the expected com-

plexity. This would permit us to simplify the analysis of the mean complexity by replacing the *random variable* L_j with the *deterministic* quantity $N + r_{j-1}$.

> **LEMMA 2:** Let $\phi(x)$ be a positive nondecreasing function of x such that $\lim \phi(\gamma x)/\phi(x) < \infty$ for all $\gamma < \infty$, and let the ϕ-normalized overestimation errors, $\epsilon_i /\phi(i)$, along the solution path be independent random variables all having nonzero probabilities of exceeding some positive quantity t (i.e., there exists a $t > 0$ such that for all i $P[\epsilon_i > t\phi(i)] > 0$). For sufficiently large j, the random variable $L_j = \max_{0 \leqslant i < j} f(n_i^s)$ is almost sure to exceed the quantity $N + t\phi(j)$.

Lemma 2 will be proven at the end of the chapter (Appendix 7-A) where it is also demonstrated that the ratio

$$t_j = \frac{L_{j+1} - N}{\phi(j)}$$

has a geometrically decreasing probability $\rho^j, \rho < 1$ of remaining below t. The implications of this lemma can be highlighted by assuming that the errors ϵ_i have limited ranges of fluctuations (called **upper supports**) proportional to $\phi(i)$.

> **DEFINITION:** A random variable X is said to have an **upper support** r if $X \leqslant r$ and $P(X \leqslant x) < 1$ for all $x < r$. To avoid confusion, we denote the upper support of X by $r(X)$.

Let the upper supports $r(\epsilon_i)$ of the errors ϵ_i be proportional to $\phi(i)$, where $\phi(i)$ satisfies the conditions of Lemma 2. The random variables $\epsilon_i /\phi(i)$ then share a common upper support r, and for every $t < r$ we have:

$$P[\epsilon_i > t\phi(i)] > 0 \tag{7.8}$$

as required by the second condition of Lemma 2. The lemma states that, for large j, the random variable

$$t_j = \max_{0 \leqslant i < j} \epsilon_i /\phi(j) \tag{7.9}$$

is almost sure to exceed any $t < r$, while, at the same time, $t_j \leqslant r$. This means that t_j **converges (in probability) to the upper support** r. Moreover, since $L_{j+1} = N + \phi(j)t_j$ (see Eq. (7.3)) we conclude that the pessimistic estimate of Eq. (7.7), obtained by using

$$L_j \approx N + r(\epsilon_{j-1}) = N + r\phi(j-1) \tag{7.10}$$

is very likely to materialize.

To put it bluntly, if anything can go wrong on the solution path, it almost surely will. L_j will most likely take on a value close to its upper limit of variations, as if the highest possible overestimation error $r(\epsilon_{j-1})$ indeed took place at node n_{j-1}^s.

Our ability to perform an average case analysis as well as our understanding of the mechanisms that govern the search complexity would be greatly facilitated if we could substitute the deterministic quantity $N + r(\epsilon_{j-1})$ for the random variable L_j in the expansion condition (7.1). We now wish to show that this is indeed permissible, that is, that the rate of growth of the mean complexity of A^* remains unaltered when we substitute for the random variable $t_j = (L_{j+1} - N)/\phi(j)$ the value r toward which it converges.

THEOREM 1 (The Pessimistic Substitution Principle). *Let $Z_j(t)$ denote the conditional expected number of nodes expanded in off-track tree T_j given that $t_{j-1} = t$, and let the ϕ-normalized errors $Y = (h - h^*)/\phi(h^*)$ be independent identically distributed random variables over all nodes in the search tree with distribution function $F_Y(y)$ and upper support $r > 0$. Then, for sufficiently large j,*

$$\log E_t[Z_j(t)] \sim \log Z_j(r) \sim C_F \phi(j) \qquad (7.11)$$

where C_F is a positive constant, depending only on the distribution $F_Y(y)$. ∎

The proof of Theorem 1 is given in Appendix 7-B. It implies both that the random variable t_j can be replaced by its upper support r in any computation of the asymptotic complexity and that the mean complexity of A^* retains its $\exp[C\phi(N)]$ character in the presence of overestimation errors.

SUMMARY

In this section we were interested in establishing a necessary condition for node-expansion under overestimating errors. We have seen that the condition for expanding an OPEN node $n_{j,k}$:

$$f(n_{j,k}) \leqslant L_j = \max_{0 \leqslant i < j} f(n_i^s)$$

can be simplified substantially if the ϕ-normalized errors $Y = (h - h^*)/\phi(h^*)$ along the solution path share a common upper support $r \geqslant 0$. When this occurs, we can replace the condition of expanding an OPEN node by the inequality:

$$f(n_{j,k}) \leqslant N + \phi(j - 1)r \qquad (7.12)$$

or equivalently, (using $g(n_{j,k}) = N - j + k$, $h^*(n_{j,k}) = j + k$), we may approximate the probabilities of expanding OPEN nodes by

$$q_{j,k} \approx \hat{q}_{j,k} = P\left[Y(n_{j,k}) \leqslant \frac{\phi(j - 1)r - 2k}{\phi(j + k)}\right] \qquad (7.13)$$

Note that these relations only hold for $r \geqslant 0$. In case h is admissible, we have $L_j = N$ and zero should replace r in Eqs. (7.12) and (7.13).

Based on these results we can manipulate the expression for the mean number of nodes expanded in off-track tree T_j,

$$E(Z_j) = \frac{b-1}{b} \sum_{d=1}^{\infty} b^d \prod_{k=1}^{d} q_{j,k}$$

in the same manner as in Chapter 6; simply replacing $q_{j,k}$ by Eq. (7.13).

7.2 WHEN IS ONE HEURISTIC BETTER THAN ANOTHER IF OVERESTIMATIONS ARE POSSIBLE?

If h_1 and h_2 are both admissible, the inequality $h_1 < h_2$ also implies that h_2 is a closer approximation to h^* and would naturally lead to a more efficient search. This simple criterion of choosing the highest cost estimates breaks down when overestimations are encountered. Overestimations *reduce* the search complexity when they occur at off-track nodes and *increase* it when they take place along the solution path. The exact effect of overestimations on the mean run-time of A^* depends on a delicate balance between these two forces.

The following two theorems demonstrate that **precision rather than accuracy** now becomes the important factor in determining the merit of a given heuristic. That is, narrowing the variability of the estimates h about their maximal value $h^* + r\phi(h^*)$ is more important than forcing them to fall in the neighborhood of h^*; the latter may even produce harmful effects.

DEFINITION: *We say that h_1 is* ***more efficient*** *than h_2 if the mean complexity associated with using h_1 has an asymptotic growth-rate greater than that associated with the use of h_2 (i.e., if $\log E(Z_1) \geqslant \log E(Z_2)$ for large enough N).*

THEOREM 2. *Let h_1 and h_2 be two heuristic functions whose respective ϕ-normalized errors $Y_1 = (h_1 - h^*)/\phi(h^*)$ and $Y_2 = (h_2 - h^*)/\phi(h^*)$ are each independent and identically distributed over all nodes of the search tree with distributions F_{Y_1} and F_{Y_2}, respectively. If Y_1 and Y_2 have the same upper support r and h_2 is stochastically greater than h_1 (i.e., $F_{Y_1}(y) \geqslant F_{Y_2}(y)$), then h_2 is more efficient that h_1.*

Proof: Writing

$$\log E(Z_j) = \log \left[\frac{(b-1)}{b} \sum_{d=0}^{\infty} b^d \prod_{k=1}^{d} q_{j,k} \right]$$

where

$$q_{j,k} = P\left[g(n_{j,k}) + h(n_{j,k}) \leqslant L_j\right] \tag{7.14}$$

it is clear that if for each node $n_{j,k}$ one heuristic induces a higher q than another, then the latter is more efficient than the former. Moreover, invoking Theorem 1 we can approximate $q_{j,k}$ by

$$q_{j,k} \approx \hat{q}_{j,k} = P\left[g(n_{j,k}) + h(n_{j,k}) \leqslant N + \phi(j-1)r\right] \tag{7.15}$$

without altering $\log E(Z)$. Since the right-hand side of the inequality is a function of r only, not the entire spectrum of h, it is clear that the higher h will induce a lower \hat{q}. Thus,

$$F_{Y_1}(y) \geqslant F_{Y_2}(y) \Longrightarrow \hat{q}_{j,k}^{(1)} \geqslant \hat{q}_{j,k}^{(2)}$$

which proves Theorem 2. ■

Theorem 2 generalizes the "more-informedness" criterion of Chapter 3 (Theorem 7) to the nonadmissible case simply by stating that the heuristic whose density is more concentrated around its upper support is the one to be preferred. This criterion sounds fairly reasonable in the admissible case where such concentration also means increased accuracy. It is somewhat surprising, though, in the nonadmissible case where concentration around the upper support and accuracy may not go hand in hand. In Figure 7.2, for example, h_1 is a more accurate heuristic since it assigns a greater weight to the neighborhood of the correct estimate $h = h^*$ (or $Y = 0$). Still, Theorem 2 proclaims h_2 as the more efficient heuristic.

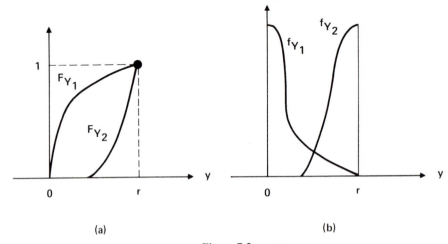

Figure 7.2
Error distributions (a) and densities (b) induced by two heuristic functions, having the same upper support r. h_2 is more efficient than h_1 even though h_1 is more accurate.

This apparent paradox can be explained by recalling that overestimation errors influence the search effort in two opposing directions, being a blessing when they occur at off-track nodes and a curse when they occur along the optimal solution path. Moreover, Theorem 1 points out that the latter effect is determined primarily by the *magnitude* of the error, not by the *frequency* of its occurrence. By contrast, the blissful effect of overestimating the cost of off-track nodes is sensitive to both frequency and magnitude. Now, once h_1 and h_2 are destined to have the same upper supports, the extreme obstacles they create along the solution path are of identical magnitudes even though h_1 creates them less often than h_2. However, the dikes that h_2 builds so as to confine the search alongside the solution path are more effective than those created by h_1 because h_2's construction is denser and more compact, whereas that of h_1 is full of gaps.

The next theorem establishes a preference between heuristics with *different* upper supports.

THEOREM 3. *If the ϕ-normalized errors induced by two heuristics h_1 and h_2 have distribution functions that differ only by a fixed translation (i.e., $F_{Y_2}(y) = F_{Y_1}(y - \beta)$, $\beta > 0$), then the heuristic with the higher support is more efficient.*

Proof: $F_{Y_2}(y) = F_{Y_1}(y - \beta)$ implies $r_2 = r_1 + \beta$, from which we have:

$$\hat{q}_{j,k}^{(1)} = F_{Y_1}\left[\frac{r_1\phi(j-1) - 2k}{\phi(j+k)}\right] \tag{7.16}$$

while

$$\hat{q}_{j,k}^{(2)} = F_{Y_2}\left[\frac{r_2\phi(j-1) - 2k}{\phi(j+k)}\right]$$

$$= F_{Y_1}\left[\frac{r_1\phi(j-1) - 2k}{\phi(j+k)} - \beta\left[\frac{1 - \phi(j-1)}{\phi(j-k)}\right]\right]$$

$$\leqslant \hat{q}_{j,k}^{(1)} \qquad \blacksquare$$

Like Theorem 2, this theorem advertises the superiority of the heuristic that is more likely to produce high overestimates, but now the superiority is proclaimed without sharpening the error distribution and despite of the dangers associated with increasing the upper support of the errors produced by h_1.

These results may tempt us to assume that overestimations are inherently beneficial and that we can always improve search efficiency by artificially boosting the estimates provided by a given heuristic model. Unfortunately, these temptations should be treated with caution; the improvements highlighted in Theorems 2 and 3 cannot be implemented by easy means. We know of no simple transformation $h' = \rho(h)$ that will render h' stochastically greater

than h and yet keep the upper supports of the two heuristics identical. Like-wise, we know of no way of guaranteeing that the ϕ-normalized errors pro-duced by $h' = \rho(h)$ will have distribution functions identical in shape to that of the errors produced by h, only shifted by β. The straightforward transforma-tion $h' = h + \beta$ will only produce a β-shift in the distribution of Y for $\phi = $ constant, a case ruled out from our discussion by the condition $\phi(N) \rightarrow \infty$ (Eq. 6.30). Alternatively, the more popular transformation $h' = \alpha h$, $\alpha > 1$, not only increases the upper support, but also distorts the shape of the error distri-bution. For example, if $\phi(N) = N$, the distribution will be *stretched*, not translated, by a factor α, and that may cause the search efficiency to deteriorate rather than improve.

The effect of multiplicative weighting of h is treated more specifically in the next section. The practical utility of Theorems 2 and 3 lies primarily in point-ing out under what condition it will be justified to replace a heuristic with given characteristics by another having a higher upper support. Combining Theorems 2 and 3 leads to a simple method of performing this test:

COROLLARY 1: *If $r_2 > r_1 \geqslant 0$ and, for all y:*

$$F_{Y_2}(y) \leqslant F_{Y_1}[y - (r_2 - r_1)]$$

then h_2 is more efficient that h_1.

In other words, we take the distribution F_{Y_1} with the lower support and shift it to the right until the two supports coincide. If F_{Y_2} lies entirely below the shift-ed distribution, h_2 is preferred to h_1. If it does not, then preference cannot be established by this method and more complete analysis is required. Figure 7.3 graphically illustrates this criterion.

7.3 HOW TO IMPROVE A GIVEN HEURISTIC

In the preceding section we pointed out that an indiscriminate amplification of the estimates produced by a given heuristic model may deteriorate the perfor-mance of A^*. In this section we will see that certain arithmetic operations on these estimates may, under the appropriate conditions, render them more desir-able in terms of improving search efficiency.

7.3.1 The Effect of Weighting g and h

In Chapter 3 (Section 3.2.1) we discussed the motivation for using Pohl's weighted evaluation function:

$$f_w(n) = (1 - w)g(n) + wh(n)$$

(a)

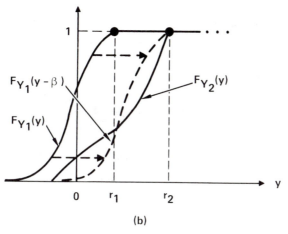

(b)

Figure 7.3

In part (a) h_2 is preferred to h_1 because $F_{Y_2}(y)$ lies below the right shift of $F_{Y_1}(y)$ that matches their upper supports. In part (b) no preference can be ascertained *a priori* since F_{Y_2} crosses over the matching translation of F_{Y_1}.

and showed that if h is admissible, then $0 \leqslant w \leqslant \frac{1}{2}$ will yield admissible search whereas $w > \frac{1}{2}$ may lead to suboptimal solution paths. In satisficing problems, where we are more concerned with minimizing search effort than with solution cost, the temptation of using $w > \frac{1}{2}$ to give A^* a higher depth-first component ought to be restrained only be considerations of computation efficiency. This temptation is even more compelling when the heuristic h in hand is known to underestimate h^* consistently such as when $r(Y) < 0$, and so the use of $w > \frac{1}{2}$ may be justified by the need to "debias" f and compensate for h's underestimation.

In this section we will study the effect of w on the computational complexity of A^* using the tree model of Figure 7-1 representing a satisficing task with one goal node. We will again assume that the ϕ-normalized errors $Y(n) = [h(n) - h^*(n)]/\phi[h(n)]$ are independent and identically distributed over all nodes of the tree.

Using Theorem 1, our first task is to explore whether multiplying h by a constant α may improve search efficiency. Recall that the use of $f = g + \alpha h$ is equivalent to that of $f_w = (1 - w)g + wh$ with

$$\alpha = \frac{w}{1 - w} \quad \text{or} \quad w = \frac{\alpha}{1 + \alpha} \tag{7.17}$$

THEOREM 4. *Let h_1 induce overestimation errors $Y_1(n)$ with upper support $r_1 > 0$, and let h_2 be an **amplification** of h_1,*

$$h_2 = \alpha h_1, \qquad \alpha > 1$$

*then h_2 is **less efficient** than h_1.*

Proof: For h_1 we have:

$$L_{j+1}^{(1)} = N + \phi(j)r_1$$

where

$$r_1 = r\left[Y_1(n_j^s)\right] = r\left[\frac{h_1(n_j^s) - j}{\phi(j)}\right]$$

For $h_2 = \alpha h_1$, the variable $L_{j+1}^{(2)}$ becomes:

$$L_{j+1}^{(2)} = N + \phi(j)r_2$$

where

$$r_2 = r\left[Y_2(n_j^s)\right] = r\left[\frac{\alpha h_1(n_j^s) - j}{\phi(j)}\right] = \alpha r_1 + \frac{j}{\phi(j)}(\alpha - 1) \tag{7.18}$$

The corresponding expansion probabilities for OPEN nodes are, respectively (using $g(n_{j,k}) = N - j + k$):

$$q_{j,k}^{(1)} \approx \hat{q}_{j,k}^{(1)} = P\left[h_1 \leqslant \phi(j - 1)r_1 + j - k\right]$$

and

$$q_{j,k}^{(2)} \approx \hat{q}_{j,k}^{(2)} = P\left[h_2 \leqslant \phi(j - 1)r_2 + j - k\right]$$

$$= P\left[\alpha h_1 \leqslant \phi(j - 1)\left[\alpha r_1 + \frac{(j - 1)(\alpha - 1)}{\phi(j - 1)}\right] + j - k\right]$$

$$= P\left[h_1 \leqslant \phi(j - 1)r_1 + (j - 1) - \frac{k - 1}{\alpha}\right] \tag{7.19}$$

Rewriting $\hat{q}^{(1)}$:

$$\hat{q}_{j,k}^{(1)} = P\left[h_1 \leqslant \phi(j-1)r_1 + (j-1) - (k-1)\right]$$

it is clear that for $k \geqslant 1$ and $\alpha \geqslant 1$

$$\hat{q}^{(2)} \geqslant \hat{q}^{(1)}$$

which proves the theorem. ■

Theorem 4 implies that, once a heuristic h is known to occasionally overestimate h^*, one should refrain from boosting its value any further; attempts to do so using $f = g + \alpha h$ and $\alpha > 1$ only degrade its search performance.

The mechanism of this performance degradation, however, is entirely different for the case $\phi(N) = N$ (i.e., proportional errors) than the case $\phi(N) = o(N)$ (i.e., subproportional errors). In the former case the transformation $h_2 = \alpha h_1$ retains the proportional character of the typical errors together with the exponential character of the mean complexity and will only alter the factor c in the exponent. In the latter case the transformation $h_2 = \alpha h_1$ renders the upper support of $Y_2(n)$ *unbounded*, either positively (if $\alpha > 1$) or negatively (if $\alpha < 1$), as can be seen from Eq. (7.18). In other words, this transformation may **change the order of the typical error from subproportional to proportional**, which in turn may cause a drastic increase in the mean complexity of A^* (see Theorem 2 of Chapter 6) from subexponential $\exp[c_1\phi(N)]$ to exponential $\exp[c_2 N]$. We will soon see, however, that only $\alpha < 1$ causes such a drastic performance degradation, whereas $\alpha > 1$ maintains the subexponential character of the mean complexity, only increasing the exponential factor from c_1 to $2\alpha c_1/(1 + \alpha)$.

Debiasing Proportional Errors. The case of proportional errors, $\phi(N) = N$, deserves special treatment because it offers an opportunity for improving efficiency through the transformation $h_2 = \alpha h_1$ or, equivalently, through $f_w = (1 - w)g + wh$. Naturally, when a heuristic h_1 is known to overestimate h^* consistently, that is, when $r_1 > 0$, then the use of $h_2 = \alpha h_1$ with $\alpha < 1$ may be justified in order to moderate the damage caused by overestimations or even to eliminate them altogether. Eq. (7.19) indeed reveals that $\hat{q}_{j,k}^{(2)}$ is a decreasing function of α, implying that the search efficiency can be improved by making α as small as possible as long as r_2 is kept nonnegative (i.e., $(1 + r_1)^{-1} < \alpha < 1$). Conversely, if h_1 is known to underestimate h^* consistently, that is, when $r_1 < 0$, then the use of $h_2 = \alpha h_1$ with $\alpha > 1$ will be beneficial as long as h_2 remains admissible, that is, as long as α remains below $(1 + r_1)^{-1}$ (see Eq. (7.18) with $r_2 = 0$).

These two arguments lead to an **optimal way of debiasing** proportional errors. They imply that multiplying h_1 by a constant factor α so as to make r_2 vanish is optimal. This can be restated as follows:

COROLLARY 2: *The optimal multiplier α for debiasing a heuristic with upper support r is*

$$\alpha_0 = \frac{1}{1+r}$$

or, equivalently, the optimal weight w is

$$w_0 = \frac{1}{2+r}$$

The quantity $1/(2+r)$, of course, is the highest value of w which renders f admissible and, clearly, maintaining w below that limit is necessary if we want to guarantee that $A*$ does not miss the optimal solution. However, the preceding results demonstrate that admissibility constraints are also beneficial in cases where only *one* solution exists and performance is judged solely by the effort required to discover it. This offers some vindication of the small-is-quick principle (Chapter 2) which directed us to employ an optimization procedure such as $A*$ in satisficing problems where just any solution will do.

Figure 7.4 demonstrates the effect of the weight w on the average complexity $E(Z_w)$ of $A*$ for three cases: $r = -\frac{1}{2}$ (h admissible with 50% underestimation bias), $r = 0$ (h admissible and unbiased), and $r = 1$ (h admissible with 100% overestimation bias). The ordinate represents the growth rate $\log_b [E(Z_w)]$ normalized by that of exhaustive search $w = 0$. The three curves were computed with the assumption that the relative errors are distributed by the truncated exponential distribution:

$$P\left[\frac{h(n) - h*(n)}{h*(n)} \leqslant x\right] = \begin{cases} 0 & x < -1 \\ e^{\beta(x-r)} & -1 \leqslant x \leqslant r \\ 1 & r \leqslant x \end{cases}$$

Variations in the underlying distribution only change the amplitudes of these curves but not their essential characteristics. The optimality of the admissibility limit $w_0 = 1/(2+r)$ is clearly demonstrated by the dips of the curves at this point. Note that when w is made too high the average complexity of $A*$ may exceed that of an exhaustive search and may become unbounded for $w = 1$. This is to be expected since the reliance on h alone may cause $A*$ to explore depths greater than N.

It is worth noting, again, that debiasing can only reduce the exponential growth rate of the mean search effort but cannot turn it into subexponential. The exponential complexity predicted by Theorem 2 of Chapter 6 also applies to nonadmissible heuristics as long as the condition

$$P[h(n) > h*(n)(r - \epsilon)] > 1/b \tag{7.20}$$

is satisfied by all nodes for some positive constant ϵ.

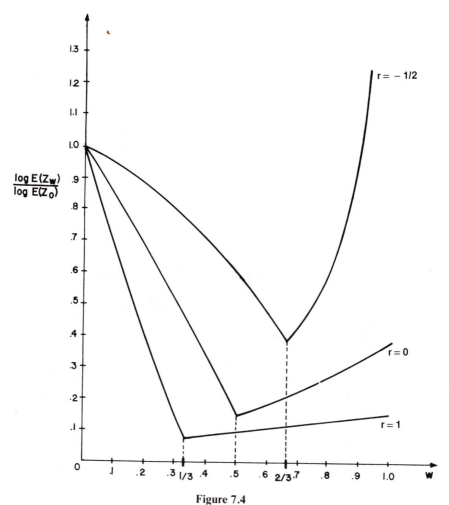

Figure 7.4

The effect of the weight w (in $f = (1-w)g + wh$) on the exponential growth-rate of A^*. The optimal w is the lowest weight which renders f admissible.

Weighting Heuristics with Subproportional Errors. We will show that debiasing using a constant multiplier is only appropriate for heuristics that induce proportional errors. If the typical error is subproportional, it is better to leave h biased rather than increase the exponential factor using $w > \frac{1}{2}$ or, even worse, raising the search time from subexponential to exponential using $w < \frac{1}{2}$.

THEOREM 5. *If the typical errors induced by h are subproportional, that is, $\phi(N) = o(N)$, then the mean complexity $E[Z(w,\phi)]$ associated with using*

$f_w = (1 - w)g + wh$ *has the growth rate:*

$$\log_b E[Z(w, \phi)] \sim \begin{cases} cw\phi(N) & w \geqslant \frac{1}{2} \\ (1 - 2w)N & w < \frac{1}{2} \end{cases} \qquad (7.21)$$

where c is a positive constant determined by the error distribution.

Proof of Part 1, $w \geqslant \frac{1}{2}$: Eq. (7.18) states that if $w > \frac{1}{2}$ ($\alpha > 1$) then, for all r_1, the upper support r_2 of the error induced by f_w is positive and unbounded as $j \to \infty$. Consequently, the appropriate formula for $\hat{q}_{j,k}(w)$ is given by Eq. (7.19) with $\alpha = w/(1 - w)$:

$$\hat{q}_{j,k}(w) = P\left[h \leqslant \phi(j - 1)r + (j - 1) - (k - 1)\frac{(1 - w)}{w} \right]$$

Using $h^* = j + k$ and $Y = \dfrac{h - (j + k)}{\phi(j + k)}$ we obtain:

$$\hat{q}_{j,k}(w) = F_Y\left[r\frac{\phi(j - 1)}{\phi(j + k)} - \frac{k}{w\phi(j + k)} \right] \qquad (7.22)$$

This is exactly the formula for $\hat{q}_{j,k}(\frac{1}{2})$ if instead of $\phi(N)$ we would write $2w\phi(N)$. Thus,

$$\log E[Z(w, \phi)] \sim \log E[Z(\frac{1}{2}, 2w\phi)]$$

The right-hand side of this equation corresponds to the performance of the unweighted evaluation function $f = g + h$ and is given, therefore, by Eq. (7.11):

$$\log E\left[Z_j(\frac{1}{2}, 2w\phi) \right] \sim c(r)2w\phi(j)$$

Since there are only N off-track trees stemming from levels $j = 1, 2, \ldots, N$, the overall complexity Z still satisfies:

$$\log E[Z(w, \phi)] \sim c(r)2w\phi(N)$$

which proves the first part of Theorem 5.

Proof of Part 2, $w < \frac{1}{2}$: Consulting Eq. (7.18) again, we see that if $w < \frac{1}{2}$ ($\alpha < 1$) then, for all r_1, the upper support r_2 of the error induced by f_w is negative and unbounded as $j \to \infty$. Consequently f_w is admissible and the appropriate formula for $q_{j,k}(w)$ is obtained from Eq. (7.2) by setting $L_j = (1 - w)N$ in Eq. (7.1), giving

$$q_{j,k}(w) = P\left[(1 - w)(N - j + k) + wh(n_{j,k}) \leqslant (1 - w)N \right]$$

$$= F_Y\left[\frac{j(1 - 2w) - k}{w\phi(j + k)} \right] \qquad (7.23)$$

Now, since the ϕ-normalized errors, $Y(n_{j,k})$, were assumed to be identically distributed, there exist two quantities r and y_b such that for all nodes in the tree we have:

$$P\left[Y(n_{j,k}) \leqslant r\right] = 1$$

and

$$P\left[Y(n_{j,k}) \leqslant y_b\right] < 1/b$$

Consequently, every node at depth

$$k < j(1 - 2w) - rw\phi(j + k)$$

will be expanded with probability $q_{j,k} = 1$, whereas every OPEN node at depth

$$k > j(1 - 2w) - y_b w\phi(j + k)$$

will be expanded with probability $q_{j,k} < 1/b$, implying an extinction thereafter. The difference between these two depths is $O[\phi(j)]$ whereas their absolute values is $j(1 - 2w) - O[\phi(j)]$. Hence the expected number of nodes expanded in any off-track tree T_j is

$$E(Z_j) = b^{(1 - 2w)j + O[\phi(j)]}$$

which proves the second part of Theorem 5. ■

In summary, we may state that attempting to use $f_w = (1 - w)g + wh$ while h possesses subproportional precision can only lead to performance degradation. However, the use of $w > \frac{1}{2}$ is relatively "safe" compared to $w < \frac{1}{2}$; the former can at worst ($w = 1$) increase the effective search depth by a factor of 2. Using $w < \frac{1}{2}$, on the other hand, endows the search with an exponentially complex breadth-first component and washes away the precision offered by h.

7.3.2 How to Combine Information from Several Heuristic Sources

If one admissible heuristic *dominates* another, that is, if $h^*(n) \geqslant h_2(n) \geqslant h_1(n)$ for every node in the graph, then h_1 cannot provide any useful information not already included in h_2 and so, one should simply use h_2 and ignore h_1. This is the case when h_1 is generated by a model more relaxed than that generating h_2 as is exemplified by the 8-Puzzle heuristics in Chapter 1 (e.g., $h_1 =$ number of misplaced tiles, $h_2 =$ sum of Manhattan distances). However, if the models inducing h_1 and h_2 represent two independent simplifications of the original problem, then h_1 may provide useful information even if it is stochastically smaller than h_2. Taking $h = \max(h_1, h_2)$ is the most natural way of exploiting the information provided by both models while still

maintaining admissibility. An example of such a case is the Traveling Sales-
man problem, where the heuristics obtained from the minimum spanning tree
and the optimal assignment problem represent two widely different aspects of
the problem domain. Therefore, solving both problems and using the solution
with the highest cost offers a definite advantage over using only one of these
heuristics.

This simple scheme of taking the maximum of the available heuristics may
not work as well in the nonadmissisble case. If either h_1 or h_2 is nonadmissible,
then the heuristic $h_m = \max(h_1, h_2)$ is not guaranteed to be superior to both
constituents. For example, if $r_1 > r_2$, then $r(h_m) = r_1$ and $h_m \gtrsim h_1$, so using
Theorem 2 h_m will be more efficient than h_1. However, there is no guarantee
that h_m will also be more efficient than h_2 unless, of course, we knew *a priori*
that h_1 was more efficient than h_2.

These difficulties disappear if the heuristics available are known to induce
proportional errors. In such a case, the availability of a debiasing technique
offers a very simple procedure of combining several heuristics, admissible as
well as nonadmissible. Given the set of estimates $h_1, h_2, ..., h_k$ for which the
upper supports of the relative errors are $r_1, r_2, ..., r_k$, the combination rule:

$$h = \max \left[\frac{h_1}{1 + r_1}, \frac{h_2}{1 + r_2}, ..., \frac{h_k}{1 + r_k} \right]$$

would yield a more efficient estimate than any of its constituents. The division
by $1 + r_i$ removes the bias from each constituent and renders it admissible and
optimal, with $r = 0$; the "max" operation further improves the estimate by
rendering it *larger* than each of its constituents, while also maintaining $r = 0$.

7.3.3 When Is It Safe to Use $f = h$ or, Who Is Afraid of $w = 1$?

In Chapter 2, we gave a heuristic explanation for the benefit of using g in
satisficing problems, where solution costs are of no concern. In Chapter 5 we
further demonstrated that, in the absence of the restoring force provided by g,
grossly misinformed heuristics may lead the search astray and result in catas-
trophic overcomputations. At the same time, the amazing success achieved by
$f = h$ in some problems (see Section 5.2) behooves us to give a more serious
consideration to the possibility of using $f = h$ and to attempt an analytical in-
vestigation of the conditions that make $w = 1$ successful or detrimental.

This task can easily be accomplished in the context of our search tree model
by simply observing the effect of letting α increase beyond bound ($\alpha \to \infty$ is
equivalent to $w \to 1$). Recalling Eqs. (7.19) and (7.20), it is clear that increasing
α beyond its admissibility limit $\alpha_o = 1/(1 + r)$ only deteriorates for propor-
tional errors (or above 1 for subproportional errors) and never improves the
search performance. Therefore our probabilistic model cannot predict a dras-
tic improvement in search efficiency such as that exhibited by the air-distance

heuristic in case (c) of Section 5.2 ($f = h$). This is to be expected since giving h a higher weight was devised to make A^* find *one of many* available solution paths quickly, however suboptimal. In our model, however, where only one solution path exists, the weight of h cannot exhibit its main power.

The main question to address in our model is: Under what conditions is the search guaranteed to terminate in a finite expected time when executed on an infinite tree? This question need only be addressed to proportional errors, since for subproportional errors Eq. (7.21) already implies "safety"; $E[Z(w = 1, \phi(N))]$ is finite and is also lower than $E[Z(w = 0, \phi(N)]$, which corresponds to breadth-first search.

Confining our discussion to proportional errors, we refer back to Eq. (7.22) with $w = 1$ and ask under what condition may

$$\hat{q}_{j,k}(w = 1) = F_Y\left[r\frac{j}{j + k} - \frac{k}{j + k}\right]$$

lead to infinitely long search. This is equivalent to asking under what conditions a node $n_{j,k}$ will maintain a nonzero probability of immortality, $q_{j,k} > 1/b$, regardless of how high k is. Since the argument of $F_Y(\cdot)$ converges to -1, it is clear that the condition we seek can be expressed as

$$F_Y(-1) > 1/b$$

or equivalently, since $P[Y < -1] = 0$ is guaranteed by $h \geqslant 0$,

$$P(h = 0) > 1/b$$

On the other hand if $F_Y(-1) < 1/b$ we can always find k sufficiently large that will render $q_{j,k} < 1/b$ thus entering an extinction phase with finite run-time. The equality $q_{j,k} = 1/b$ also guarantees extinction but is accompanied by an infinite mean run-time (see Appendix 5-A). We can summarize these arguments by the following theorem.

THEOREM 6. *If the relative errors $Y = (h - h^*)/h^*$ induced by h are independent and identically distributed, searching an infinite tree with $f = h$ will terminate in finite expected time iff*

$$F_Y(-1) < 1/b$$

or equivalently, iff

$$P[h = 0] < 1/b \qquad \blacksquare$$

This theorem can be generalized to include the case when the distribution of the relative errors varies along the node of the tree. The generalization reads:

COROLLARY 2: *If the relative errors induced by h are independent and if there exists a constant $\epsilon > 1$, such that for all nodes in the tree we have*

$$P[h > \epsilon h^*] < 1/b$$

then searching an infinite tree with $f = h$ is guaranteed to terminate in a finite expected time.

The divergence of the log $E(Z_w)$ curve in Figure 7.4 occurs only when the combination of the parameters β and r yields $F_Y(-1) \geqslant 1/b$, that is, when $\beta \leqslant \ln b /(1 + r)$. Note that such divergence can only occur at $w = 1$; for all $w < 1$ the argument of $F_Y(y)$ in Eqs. (7.22) or (7.23) will go below -1 when k exceeds some depth $k_o(j)$ given by

$$k_o(j) = \begin{cases} \dfrac{w}{1 - w}[j(r + 1) - r] & r > 1/w - 2 \\[2mm] j & r \leqslant 1/w - 2 \end{cases}$$

This implies that no node deeper than $k_o(j)$ will ever be expanded, limiting $\log_b E[Z(w)]$ to at most $N(r + 1)w/(1 - w)$ (if $r > 1/w - 2$) or to N (if $r \leqslant 1/w - 2$).

EXERCISES

7.1 Consider, again, the knight-move problem of exercise 6.1.
 a. What is the order of the typical error induced by the heuristic $h(x,y) = |m - x| + |n - y|$?
 b. How would you unbias this heuristic?
 c. What is the order of the typical error induced by the unbiased heuristic?
 d. Using the method of Section 5.2, estimate the average complexity of A^* guided by $f_w = (1 - w)g + wh$ for $w = 0, \frac{1}{2}, 1$, and the weight found in part (b).
 e. Explain the discrepancy between the results of part (d) and those predicted on the basis of Theorem 1.

7.2 Evaluate the effectiveness of Pohl's dynamic weighting scheme in light of the result of Chapter 7.
 a. Assuming that h is admissible and unbiased, i.e., $r(Y) = 0$, use the proof of Theorem 4 to show that the dynamic weighting scheme (Section 3.2.2)

$$ f = g + h + \epsilon \left[1 - \frac{d(n)}{N} \right] h, \qquad \epsilon > 0, $$

 is always less efficient than $f = g + h$.
 b. How would the conclusion of part (a) change if h induces negatively biased proportional errors, that is, $\phi(N) = N$, $r(Y) < 0$?
 c. Discuss the predictions of parts (a) and (b) in view of the empirical results shown in Figure 3.1.

7.3 Obtain analytical expressions for the three curves in Figure 7.4.

APPENDIX 7-A
PROOF OF LEMMA 2

LEMMA 2: *Let the ϕ-normalized overestimation errors $Y = (h - h^*)/\phi(h^*)$ along the solution path be independent random variables all having nonzero probabilities of exceeding some positive quantity y' (i.e., there exists a $y' > 0$ such that, for all i, $P(Y_i > y') > 0$). For sufficiently large j, the random variable $L_j = \max_{0 \leqslant i < j} f(n_i^s)$ is almost sure to exceed the quantity $N + y'\phi(j)$.*

Proof: For a node n_i^s along the solution path we have: $g(n_i^s) = N - i$, $h^*(n_i^s) = i$. Therefore:

$$f(n_i^s) = g(n_i^s) + h(n_i^s) = N - i + h(n_i^s)$$
$$= N + h(n_i^s) - h^*(n_i^s)$$
$$= N + Y_i \phi(i)$$

and

$$L_j = \max_{0 \leqslant i < j} [N + \phi(i) Y_i]$$

Define:

$$t_j = \frac{L_{j+1} - N}{\phi(j)} = \max_{0 \leqslant i \leqslant j} \frac{\phi(i)}{\phi(j)} Y_i \qquad (A.1)$$

Let us find the distribution $F_{t_j}(t)$ of t_j.

$$F_{t_j}(t) = P(t_j \leqslant t) = \prod_{i=0}^{j} P\left[\frac{\phi(i)}{\phi(j)} Y_i \leqslant t\right]$$
$$= \prod_{i=0}^{j} \left\{ 1 - P\left[Y_i > t \frac{\phi(j)}{\phi(i)}\right]\right\} \qquad (A.2)$$

In particular, for $t \leqslant y'$ we have

$$P(Y_i > t) > \alpha > 0 \qquad \forall(i)$$

and we can choose an arbitrary β $(0 < \beta < \alpha)$ such that, for some $\delta > 0$:

$$P(Y_i > t + \delta) > \beta > 0 \qquad \forall(i)$$

Therefore, $F_{t_j}(t)$ can be bounded by

$$F_{t_j}(t) \leqslant (1 - \beta)^{j - i_o(j)} \qquad t \leqslant y' \qquad (A.3)$$

Where $i_o(j)$ is the smallest integer i for which

$$t \frac{\phi(j)}{\phi(i)} \leqslant t + \delta$$

We will now show that, for sufficiently large j, $j - i_o(j)$ is proportional to j. More specifically, calling

$$\gamma(t) = \frac{1}{1 + \delta/t} < 1$$

we will show that for large j, $i > \gamma j$ implies

$$\phi(i) > \gamma \phi(j) \qquad\qquad (A.4)$$

which would render:

$$j - i_o(j) = (1 - \gamma)j \qquad\qquad (A.5)$$

The validity of Eq. (A.4) can be established from the following lemma.

LEMMA (Michon): *For every $\gamma > 0$, if $\phi(\gamma x)/\phi(x)$ has a limit then*

$$\frac{\phi(\gamma x)}{\phi(x)} \xrightarrow[x \to \infty]{} \gamma^m$$

where

$$m = \inf \left\{ \epsilon \in \mathcal{R} \,\middle|\, \phi(x) = O(x^\epsilon) \right\}$$

Proof: Given $\phi: \mathcal{R}^+ \to \mathcal{R}^+$ nondecreasing, consider the set

$$E = \left\{ \epsilon \in \mathcal{R} \,\middle|\, \phi(x) = O(x^\epsilon) \right\}$$

If ϕ is polynomially bounded (which is the case if $\phi(x) = O(x)$), then E is nonempty. Furthermore, since ϕ is nondecreasing, zero is a lower bound of E. Therefore E has a greatest lower bound $m \geqslant 0$. Let

$$g(x) = \frac{\phi(x)}{x^m}$$

The definition of m implies that

$$\forall \epsilon > 0 \qquad g(x) = O(x^\epsilon) \qquad\qquad (A.6)$$

$$\forall \epsilon > 0 \qquad g(x) = \Omega(x^{-\epsilon}) \qquad\qquad (A.7)$$

($g(x)$ could be something like: 1, $[\log(x)]^n$, $\log(\log(x))$, ..., etc., ...). Now, clearly:

$$\frac{\phi(\gamma x)}{\phi(x)} = \frac{\gamma^m x^m g(\gamma x)}{x^m g(x)} = \gamma^m \frac{g(\gamma x)}{g(x)}$$

Our problem, therefore, reduces to showing that if the ratio $g(\gamma x)/g(x)$ has a limit then

$$\lim_{x \to \infty} \frac{g(\gamma x)}{g(x)} = 1$$

knowing that, for all $\epsilon > 0$

$$g(x) = O(x^\epsilon)$$
$$= \Omega(x^{-\epsilon})$$

Now, let

$$\lim_{x \to \infty} \frac{g(\gamma x)}{g(x)} = q$$

Without loss of generality we assume $\gamma > 1$, then clearly

$$\lim_{x \to \infty} \frac{g(\gamma^n x)}{g(x)} = q^n$$

Let $X = \gamma^n x$ and x be a constant. Then

$$n = \frac{\log \dfrac{X}{x}}{\log \gamma}$$

and

$$q^n = \left[\frac{X}{x} \right]^{\frac{\log q}{\log \gamma}}$$

Therefore, the preceding implies

$$g(X) \sim X^{\frac{\log q}{\log \gamma}}$$

which contradicts (A.6) or (A.7) unless $\log q = 0$, i.e., $q = 1$ which proves the lemma. A similar argument holds for $\gamma \leqslant 1$. ∎

In our case, since $\lim \phi(x)/x < \infty$, m may not exceed 1 and so $\gamma^m > \gamma\,(\gamma \leqslant 1)$, which establishes the validity of Eq. (A.4).

Combining Eqs. (A.3) and (A.5) gives

$$F_{t_j}(t) \leqslant (1 - \beta)^{(1 - \gamma)j} = \rho(t)^j \qquad t \leqslant y' \tag{A.8}$$

where

$$\rho(t) = (1 - \beta)^{(1 - \gamma(t))} < 1 \tag{A.9}$$

Thus, as j increases, the distribution of t_j decreases to zero at a geometrical rate, for all $t \leqslant y'$. In terms of L_j this implies:

$$P[L_j > N + \phi(j)y'] = 1 - F_{t_{j-1}}\left[y' \frac{\phi(j - 1)}{\phi(j)} \right]$$

$$\geqslant 1 - \rho(y')^{j-1} \underset{j \to \infty}{\to} 1$$

which completes the proof of Lemma 2. ∎

APPENDIX 7-B
PROOF OF THEOREM 1
(THE PESSIMISTIC SUBSTITUTION PRINCIPLES)

Theorem 1. *Let $Z_j(t)$ denote the conditional expected number of nodes expanded in an off-track tree T_j given that $t_{j-1} = t$, and let the ϕ-normalized errors*

$Y = (h - h^*)/\phi(h^*)$ *at every node in the search tree be independent identically distributed random variables, with distribution function* $F_Y(y)$ *and upper support* $r > 0$. *Then:*

$$\log E_t\left[Z_j(t)\right] \sim \log\left[Z_j(r)\right] \sim C_F\phi(j) \qquad \text{as } j \to \infty \qquad (B.1)$$

where C_F *is a positive constant, depending on the shape of* F.

Proof: Recall:

$$t_j \triangleq \frac{L_{j+1} - N}{\phi(j)} \qquad L_j \triangleq \max_{0 \leqslant i < j} f(n_i^s) \qquad (B.2)$$

t_j is a bounded random variable $0 \leqslant t_j \leqslant r$ having a distribution:

$$F_{t_j} = P\left[t_j \leqslant t\right] \leqslant \rho^j(t) \qquad (B.3)$$

where $\rho(t) < 1$ for $t < r$. Also:

$$Z_j(t) = \frac{(b - 1)}{b} \sum_{d=1}^{\infty} b^d \prod_{k=1}^{d} q_{j,k}(t) \qquad (B.4)$$

where:

$$q_{j,k}(t) = F_Y\left[\frac{t\phi(j - 1) - 2k}{\phi(j + k)}\right] \qquad (B.5)$$

Since $Z_j(t)$ is nondecreasing in t, we have $E_t[Z_j(t)] \leqslant Z_j(r)$ and it is enough to prove that $Z_j(t)$ satisfies:

$$\log E_t\left[Z_j^{(t)}\right] \geqslant f(j, r) \sim \log Z_j(r) \qquad (B.6)$$

We plan to prove this by manipulating Eq. (B.4) in a way similar to that used in Chapter 6, and obtain:

$$Z_j(t) = e^{\phi(j)g_j(t)} \qquad (B.7)$$

where $g_j(t)$ is a continuous, positive, and increasing function of t. More specifically, Eq. (B.7) will be established by exhibiting an upper bound $Z_j^U(t)$ and a lower bound $Z_j^L(t)$ to $Z_j(t)$, both having the form of Eq. (B.7).

A convenient lower bound to $Z_j(t)$ can be established by taking only one term $d = d_o(j, t, \alpha)$ from the summation in Eq. (B.4), where $d_o(j, t, \alpha)$ is chosen as the highest integer k for which

$$q_{j,k}(t) > \alpha/b$$

for some arbitrary α in the range $b > \alpha > 1$, thus yielding:

$$Z_j(t) \geqslant (b - 1) \alpha^{d_o(j, t, \alpha)} \qquad (B.8)$$

From the form of the argument of $F_Y(\cdot)$ in Eq. (B.5) we can easily verify that

$$d_o(j, t, \alpha) = \begin{cases} j \cdot \dfrac{t - F_Y^{-1}(\alpha/b)}{2 + F_Y^{-1}(\alpha/b)}\left[1 + O(1/j)\right] & \text{for } \phi(N) = N \\[4mm] \dfrac{\phi(j)}{2}\left[t - F_Y^{-1}(\alpha/b)\right]\left[1 + O\left[\dfrac{\phi(\phi(j))}{\phi(j)}\right]\right] & \text{for } \phi(N) = o(N) \end{cases}$$

and so, the lower bound

$$Z_j^L(t) = (b - 1)\alpha^{d_o(j,t,a)}$$

complies with the form of Eq. (B.7).

The upper bound $Z_j^U(t)$ is established by substituting

$$q_{j,k}'(t) = \begin{cases} 1 & k \leqslant d_o(j, t, 1) \\ q_{j,d_o(j, t, 1)} & k > d_o(j, t, 1) \end{cases}$$

instead of $q_{j,k}(t)$ in Eq. (B.4). Now, since $q_{j,d_o}' < 1/b$, the summation over $d > d_o$ yields a converging geometric series and the overall summation is given by a constant times $b^{d_o(j,t,1)}$. Thus,

$$Z_j^U(t) = b^{d_o(j,t,1)+C}$$

which also conforms to the form in Eq. (B.7).

The fact that $g_j(t)$ must be increasing is apparent from Eq. (B.5) and its continuity is guaranteed by the continuity of $F_Y(y)$.

We now need to show that Eq. (B.6) is satisfied, given that the distribution of t_j is bounded by Eq. (B.3). The continuity of $g(t)$ near r implies that for every $\epsilon > 0$ we can choose a $\delta > 0$ such that

$$t \in (r - \delta, r) \implies g_j(t) > g_j(r) - \epsilon$$

and write

$$\lim_{j \to \infty} \frac{1}{\phi(j)} \log E_t\left[Z_j^L(t)\right] = \lim_{j \to \infty} \frac{1}{\phi(j)} \log \int_{t=0}^{r} F_{t_j}'(t) Z_j(t) dt$$

$$\geqslant \lim_{j \to \infty} \frac{1}{\phi(j)} \log \int_{t=r-\delta}^{r} F_{t_j}'(t) e^{\phi(j)[g(r) - \epsilon]} dt$$

$$= \lim_{j \to \infty} \frac{1}{\phi(j)} \log \left\{ e^{\phi(j)[g(r) - \epsilon]} \left[F_{t_j}(r) - F_{t_j}(r - \delta) \right] \right\}$$

$$= g(r) - \epsilon + \lim_{j \to \infty} \frac{1}{\phi(j)} \log \left[1 - F_{t_j}(r - \delta) \right]$$

$$\geqslant g(r) - \epsilon + \lim_{j \to \infty} \frac{1}{\phi(j)} \log \left[1 - \rho^j(r - \delta) \right]$$

$$= g(r) - \epsilon$$

$$= \lim_{j \to \infty} \frac{1}{\phi(j)} \log Z_j(r - \epsilon)$$

Since ϵ can be chosen arbitrarily small, the validity of Eq. (B.6) is established and Theorem 1 is proven. ∎

PART
III

Game-Playing Programs

And Abner said to Joab, "Let the young men come forward and play before us." Joab answered "Yes, let them." So they came up one by one, and took their places, twelve for Benjamin and Ishbosheth and twelve from David's men. Each man seized his opponent by the head and thrust his sword into his side; and thus they fell together.

(SAMUEL 2, 2, 14-16)

Chapter 8

Strategies and Models for Game-Playing Programs

The skill of playing games such as chess, checkers, or GO has long been regarded as a distinctive mark of human intelligence. It is natural, therefore, that the general public continues to monitor the success of game-playing programs as a measure of progress in artificial intelligence. This fact has helped elevate the status of such programs from merely an expensive amusement to a level worthy of scientific pursuit. Game-playing research is today a thriving activity at many prestigious research institutes and universities.

Games, like the puzzles discussed in Chapter 1, offer a perfect laboratory for studying complex problem-solving methodologies. With a few parsimonious rules, one can create complex situations that require no less insight, creativity, and expertise than problems actually encountered in areas such as business, government, scientific, legal, and others. Moreover, unlike these applied areas, games offer an arena in which computerized decisions can be evaluated by absolute standards of performance and in which proven human experts are both available and willing to work toward the goal of seeing their expertise emulated by a machine. Last, but not least, games possess addictive entertaining qualities of a very general appeal. That helps maintain a steady influx of research talents into the field and renders games a convenient media for communicating powerful ideas about general methods of strategic planning.

We will not attempt to cover all the intricate subtleties that enter the technology of game-playing programs. Rather, our aim is to give a unified treatment of the various control strategies used in game searching and to quantify their performances using synthetic game models.

8.1 SOLVING AND EVALUATING GAMES

8.1.1 Game Trees and Game-Playing Strategies

Most games played by computer programs, including chess, checkers, and GO, are **two-player, perfect-information** games. There are two adversary players who alternate in making moves, each viewing the opponent's failure as his own success. At each turn, the rules of the game define both what moves are legal and what effect each possible move will have, leaving no room for chance. In contrast to card games in which the players' hands are hidden, or to the game of backgammon where the outcome of a die determines the available moves, each player has complete information about his opponent's position and about the choices available to him. The game begins from a specified initial state and ends in a position that, using a simple criterion, can be declared a win for one player and a loss for the other, or possibly as a draw.

A **game tree** is an explicit representation of all possible plays of the game. The root node is the initial position of the game, its successors are the positions that the first player can reach in one move, their successors are the positions resulting from the second player's replies, and so on. Terminal or leaf nodes are those representing WIN, LOSS, or DRAW. Each path from the root to a terminal node represents a different complete play of the game.

The correspondence between game trees and AND/OR trees is obvious. The moves available to one player from a given position can be represented by OR links, whereas the moves available to his opponent are AND links since a response must be contemplated to each one of them. Another way of obtaining this correspondence is to view each game position J as a problem statement: "find a winning strategy (for player 1) from J" or equivalently "show that player 1 can force a win from J." Clearly, if J admits the first player's moves, this problem is solved if a winning strategy can be found from *any one* of J's successors, hence the OR links. Similarly, if it is the opponent's turn to move from J, then J is solved if player 1 can force a win from *each and every one* of J's successors, hence the AND links. Thus, in games the process of problem reduction is completely dictated by the rules of the game; each legal move available to the opponent defines a subproblem or a subgoal and all these subproblems must be solved before the parent problem is declared solved.

For reasons that will become clear later, we call the first player MAX and his opponent MIN. Correspondingly we refer to game positions where it is MAX's or MIN's turn to move as MAX or MIN positions, respectively. The trees representing our games contain two types of nodes: MAX nodes (at even levels from the root) and MIN nodes (at odd levels from the root). Instead of using curved arcs, as in the AND/OR graphs of Chapter 2, we distinguish between MAX and MIN positions using a different node shape; the former is represented by squares and the latter by circles (see Figure 8.1). The leaf nodes in a game tree are labeled WIN, LOSS, or DRAW, depending on whether they represent a win, loss, or draw position from MAX's viewpoint.

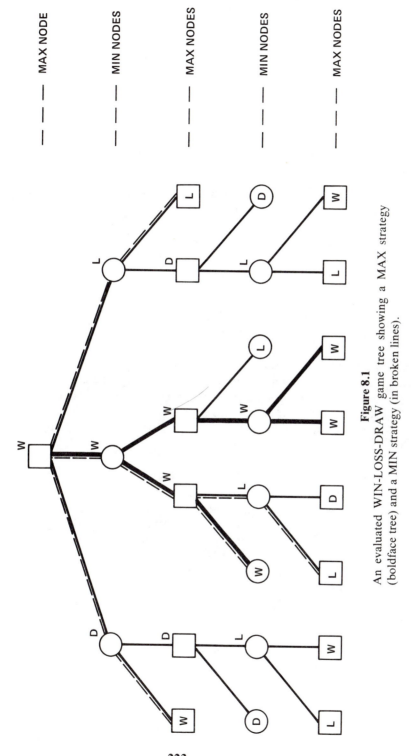

MAX NODE

MIN NODES

MAX NODES

MIN NODES

MAX NODES

Figure 8.1

An evaluated WIN-LOSS-DRAW game tree showing a MAX strategy
(boldface tree) and a MIN strategy (in broken lines).

223

Once the leaf nodes are assigned their WIN-LOSS-DRAW **status**, each node in the game tree can be labeled WIN, LOSS, or DRAW by a bottom-up process similar to the "solve" labeling procedure discussed in Chapter 1.

Status labeling procedure:

 If J is a nonterminal MAX node, then:

$$\text{STATUS}(J) = \begin{cases} WIN & \textit{if any of J's successors is a WIN} \\ LOSS & \textit{if all J's successors are LOSS} \\ DRAW & \textit{if any of J's successors is a DRAW} \\ & \textit{and none is a WIN} \end{cases} \quad (8.1)$$

 If J is a nonterminal MIN node, then:

$$\text{STATUS}(J) = \begin{cases} WIN & \textit{if all J's successors are WIN} \\ LOSS & \textit{if any of J's successors is a LOSS} \\ DRAW & \textit{if any of J's successors is a DRAW} \\ & \textit{and none is a LOSS} \end{cases} \quad (8.2)$$

The function STATUS(J) should be interpreted as the best terminal status MAX can achieve from position J if he plays optimally against a perfect opponent. Figure 8.1 depicts a simple game tree together with the status of all nodes. The status of the leaf nodes is assigned by the rules of the game, whereas those of nonterminal nodes are determined by the preceding labeling procedure.

Solving a game tree T means labeling the root node s as WIN, LOSS, or DRAW. Associated with each root label there is an optimal playing strategy which prescribes how that label can be guaranteed regardless of how MIN plays. A **strategy** for MAX is a subtree T^+ of T called a **solution tree** which is rooted at s and contains one successor of every nonterminal MAX node in T^+ and all successors of every nonterminal MIN node in T^+. A game-playing strategy T^- for MIN will contain, of course, the opposite types of nodes; one successor of every nonterminal MIN node and all successors of every nonterminal MAX node included in T^-. Of particular interest to us are **winning strategies**, strategies that guarantee a WIN for MAX regardless of how MIN plays. Clearly, a winning strategy for MAX is a solution tree T^+ whose terminal nodes are all WIN. Figure 8.1 shows a winning strategy for MAX (in heavy lines) and one nonwinning strategy for MIN (following broken lines).

 Consider now an arbitrary pair of strategies; one for MAX, T^+, and one for MIN, T^-. It is easy to see that the two sets of terminal nodes associated with the two subtrees have exactly one leaf node in common. The intersection of the two strategies defines the unique play path that results if both players

adhere to their corresponding strategies and the one common leaf node is, in fact, the end position that results from this play.

Let (T^+, T^-) denote the leaf node common to strategies T^+ and T^-. Suppose MAX is forced to choose a strategy T^+ ahead of the play, to show it to the opponent, and then stick to it during the play. What T^+ would be his best choice? Being at such a disadvantage, MAX should reason as follows: If I choose T^+, then my opponent, knowing all my plans, would definitely respond so as to lead me toward the least favorable leaf in T^+ with label $\min_{T^-} \text{STATUS}(T^+, T^-)$. Now that I have the option of choosing T^+, I can guarantee myself $\max_{T^+} \min_{T^-} \text{STATUS}(T^+, T^-)$. On the other hand, suppose we reverse the roles and put MIN at the disadvantage of adhering to a predisclosed strategy T^-. By a similar argument MIN could guarantee that MAX would not achieve any status better than $\min_{T^-} \max_{T^+} \text{STATUS}(T^+, T^-)$.

An important consequence of our assumption of perfect information games is that these two guarantees are equal to each other and, moreover, they are given by the status of the root node as computed by Eqs. (8.1) and (8.2). Thus,

$$\text{STATUS}(s) = \max_{T^+} \min_{T^-} \text{STATUS}(T^+, T^-) \qquad (8.3)$$

or

$$\text{STATUS}(s) = \min_{T^-} \max_{T^+} \text{STATUS}(T^+, T^-) \qquad (8.4)$$

The validity of these two equalities can be easily proven using bottom-up induction on a general game tree (exercise 8.1). The interpretation of these alternate definitions, however, is rather profound; it implies that in perfect information games it does not matter if you choose a rigid plan ahead of time or make your decisions as the game goes along. Moreover, rather than conducting an optimization exercise over the enormous space of strategy pairs, one can find an optimal playing strategy using the status labeling procedure of Eqs. (8.1) and (8.2).

Although the significance of this result is mainly theoretical, we will find several occasions where it will be more convenient to view $\text{STATUS}(s)$ as a product of optimization over strategies rather than the value returned by a labeling procedure. For example, such an occasion arises when we wish to answer the following question: Suppose someone claims that the root node of a certain game tree evaluates to a DRAW, what kind of information must he furnish to substantiate this claim? Had the claim been that s is a WIN, clearly we would only need to exhibit one winning strategy. Similarly, to defend the assertion "s is a LOSS," we need only demonstrate the existence of one winning strategy for MIN, that is, a MIN strategy with all LOSS leaf nodes. However, now that the claim is "s is a DRAW," would a single strategy suffice?

Eqs. (8.3) and (8.4) imply that *two* strategies are now needed. From Eq. (8.3) we see that as soon as we find a MAX strategy T^+ containing no LOSS leaves,

we immediately know that, no matter what MIN does, MAX can guarantee at least a DRAW. Moreover, as soon as we find a MIN strategy T^- with no WIN nodes, Eq. (8.4) implies that, no matter what MAX does, MIN can prevent him from obtaining a WIN. Thus, **two adversary strategies with compatible values** are both necessary and sufficient to verify that the game is a DRAW.

This result establishes an absolute limit on the number of terminal nodes that must be examined before a game tree can be solved. All the leaf nodes of two compatible strategies T^+ and T^- must be examined in case the game is a DRAW, whereas a single strategy is sufficient in case of a WIN or a LOSS. Equivalently, the task of solving a game can be viewed as the task of finding at most one pair of compatible strategies. We will show later that a pair of strategies is all that is required to certify the value of a more general game tree, even when the leaf nodes can take on more than three possible values.

8.1.2 Bounded Look-Ahead and the Use of Evaluation Functions

Size Considerations. The status labeling procedure described in the preceding section requires that a complete game tree, or at least a sizable portion of it, be generated. For most games, however, the tree of possibilities is far too large to be generated and evaluated backward from the terminal nodes in order to determine the optimal first move. A complete game tree for checkers, for instance, has been estimated as having about 10^{40} nonterminal nodes (Samuel, 1959). Generating the whole tree would require around 10^{21} centuries even if 3 billion nodes could be generated each second. The size of the game tree for chess is even more astronomical, estimated at about 10^{120} nodes or 10^{101} centuries at the same generation rate.

These numbers clearly demonstrate the absurdity of trying to generate the game tree exhaustively or even of hoping to find a winning strategy by luck. For, even if someone hands us a winning strategy for checkers, we would not know how to use it. A strategy should contain a prescribed response to each possible move of the opponent. Branching out once in every *two* levels of the game, the number of moves contained in a typical strategy is about the square root of the number of nodes in the game tree. That still leaves about 10^{20} moves for a single certified checkers strategy which poses an insurmountable requirement on storage space. Thus we must abandon all attempts to either find or retain a strategy that offers absolute end game guarantees.

Using Evaluation Functions. Having no practical way of evaluating the exact status of successor game positions, one may naturally resorts to heuristic approximations. Experience teaches us that certain features in a game position contribute to its strength, whereas others tend to weaken it. Thus we may be able to select a reasonably "good" move if we can list a sufficient number of features for each one of the resulting positions, aggregate their contributions into a single **evaluation function** e, and then choose the move leading toward the game position of highest merit.

Such a simplistic decision would obviously lead to poor play unless the evaluation function were extremely accurate, that is, if it correlated very closely with the actual status of the nodes evaluated. However, since e is based only on the static characteristics of game positions, it is very hard to achieve high levels of accuracy even using sophisticated evaluation functions.

Bounded Look-Ahead. An obvious generalization is not to use the board evaluation immediately, but use it after the play has extended through several rounds of move and counter move. In other words, we first explicate a reasonable portion of the game tree, assess the merit of the nodes on the search frontier using a **static evaluation function**, use these values to estimate the potential strength of ancestor nodes up to the immediate successors of the positions at hand, and finally choose the move that leads toward the successor with the highest potential strength. The most popular method of calculating the **backed-up values** of the ancestor nodes is based on the **face-value principle** discussed in Chapter 2, namely, the static evaluation of nodes on the search frontier are taken at their face value, as if these were true terminal payoffs given to MAX upon reaching any of these nodes.

The Minimax Rule. This assumption dictates that the backed-up values of ancestor nodes should be calculated using the following **minimax rule**:

1. The value $V(J)$ of node J on the search frontier is equal to its static evaluation function $e(J)$; otherwise
2. If J is a MAX node, $V(J)$ is equal to the maximum value of any of its successors.
3. If J is a MIN node, $V(J)$ is equal to the minimum value of any of its successors.

The minimax decision procedure is founded on two heuristics; the first is employed in the computation of $e(J)$, estimating the strength of a game position from its static characteristics. The second is used to compute the backed-up values while pretending that the frontier nodes were true terminal nodes and their evaluations true payoffs. Note that if the first heuristic is correct (i.e., $e(J) = \text{STATUS}(J)$), the second propagates the values exactly. If, however, the static evaluations are only rough estimates, the minimax propagation rule only offers a crude approximation to the method by which these estimates should be combined.

It is normally presumed that "the backed-up evaluations give a more accurate estimate of the true values of MAX's possible moves than would be obtained by applying the static evaluation function directly to those moves and not looking ahead to their consequences" (Barr and Feigenbaum, 1981). The underlying presumption is the notion that "the merit of a situation clarifies as it is pursued and that the look-ahead process can extend far enough that even rough board-evaluation formulas may be satisfactory" (Winston, 1977). The

appropriateness of these presumptions is critically analyzed in Chapter 10, where alternatives to minimax are also proposed.

8.1.3 MIN-MAX versus NEG-MAX Notations

So far the notation used in the preceding section evaluated games from one player's viewpoint. Both the WIN-LOSS status of the nodes considered as well as their assessed strength were viewed with respect to the objectives of the first player, MAX. That necessitated that we distinguish between MAX and MIN nodes, and that we define separate propagation rules for each node type.

An alternative approach, which leads to a more uniform notation called **NEG-MAX,** always evaluates a node from the viewpoint of the player whose turn it is to move at that node. A terminal node may assume a status of WIN, LOSS, or DRAW if the player whose turn it is to move wins, loses, or ties at this node, respectively. We call this mover-oriented status **MSTATUS.** The MSTATUS of a nonterminal node is dictated by those of its successors as follows:

$$MSTATUS(J) = \begin{cases} WIN & \textit{if any of J's successors has } MSTATUS = LOSS \\ LOSS & \textit{if all J's successors have } MSTATUS = WIN \\ DRAW & \textit{none of the above} \end{cases}$$

Eq. (8.5) combines Eqs. (8.1) and (8.2) into one rule, common to both MAX and MIN nodes. Moreover, comparing Eqs. (8.5) and (8.1), we see that the two rules become identical if we only complement the values of the successors' status. Equivalently, adapting the code

$$WIN = +1 \qquad DRAW = 0 \qquad LOSS = -1$$

$MSTATUS(J)$ can be calculated by the formula

$$MSTATUS(J) = \max_{J'} \{ -MSTATUS(J') \mid J' \textit{is a son of } J \} \qquad (8.6)$$

hence the term NEG-MAX. The best move for either player is then to a node with the *minimum* MSTATUS value, because the minimum value to the player who moves from a successor of J means the highest value to the player moving from J.

The NEG-MAX notation also simplifies the description of the minimax rule. Instead of having a separate rule for MAX and MIN nodes, we now have a single rule for the NEG-MAX value, $MV(J)$ (connoting "mover-value") of J:

$$MV(J) = \begin{cases} Me(J) & \textit{if J has no successor} \\ \max_{J'}\{ -MV(J') \mid J' \textit{ is a son of } J \} \end{cases} \qquad (8.7)$$

The NEG-MAX notation is useful for obtaining concise descriptions of game-searching algorithms and recursive performance formulas. The MIN-MAX notation, on the other hand, is more useful in explaining the rationale behind such algorithms and formulas. People find it easier to view the world from a fixed reference point rather than shifting back and forth between two adversaries. We will use the MIN-MAX notation in Chapter 8 and shift to NEG-MAX notation in Chapters 9 and 10.

8.2 BASIC GAME-SEARCHING STRATEGIES

Almost all game-playing programs use variants of the look-ahead minimax heuristic: the game tree is searched to some search frontier, a static evaluation function is computed to assess the strength values of nodes at that frontier, and minimax roll back is used to compute approximations of the strength values of shallower nodes. This procedure involves two major computational efforts: generating the partial game tree and evaluating the frontier positions. Highly sophisticated evaluation functions may permit us to get by with shallow search, whereas deep search may make up for deficiencies in the evaluation function.

Once we agree on the type of static evaluation function to be used, the search effort is directly proportional to the number of frontier nodes that are generated, examined, and evaluated. That number has become a standard measure of the complexity of game-searching procedures and this section describes several search strategies developed to reduce this number.

8.2.1 Exhaustive Minimaxing and the Potential for Pruning

The status of a node J and its minimax value $V(J)$ are both defined by a bottom-up induction which can be easily translated into a recursive search procedure. For example, we can write:

Algorithm: **MINIMAX** (Depth-First Version)

To determine the minimax value $V(J)$, do the following:

1. If J is terminal, return $V(J) = e(J)$; otherwise
2. Generate J's successors J_1, J_2, \ldots, J_b.
3. Evaluate $V(J_1), V(J_2), \ldots, V(J_b)$ from left to right.
4. If J is a MAX node, return $V(J) = \max[V(J_1), \ldots, V(J_b)]$.
5. If J is a MIN node, return $V(J) = \min[V(J_1), \ldots, V(J_b)]$.

This search procedure amounts to systematically traversing the search tree from left to right in a depth-first fashion. There is no need, of course, to gen-

erate all successors at once and keep them in storage until all are evaluated. Instead, the search can be executed in a backtracking style; successors are generated and evaluated one at a time and the value of the parent node updated each time a son is evaluated. This is accomplished in the following version of MINIMAX:

Algorithm: MINIMAX (Backtracking Version)

To determine the minimax value $V(J)$ of node J, do the following:

1. If J is terminal, return $V(J) = e(J)$. Otherwise;
2. For $k = 1, 2, \ldots, b$, do:
 a. Generate J_k, the k^{th} successor of J.
 b. Evaluate $V(J_k)$.
 c. If $k = 1$, set $CV(J) \leftarrow V(J_1)$. Otherwise, for $k \geqslant 2$,
 set $CV(J) \leftarrow \max[CV(J), V(J_k)]$ if J is MAX or
 set $CV(J) \leftarrow \min[CV(J), V(J_k)]$ if J is MIN.
3. Return $V(J) = CV(J)$.

The variable $CV(J)$ represents the updated "current value" of node J. Step 2(b) is performed by calling MINIMAX recursively.

Note that in both versions of MINIMAX the evaluation of J is not completed until all its successors are evaluated. Consequently this procedure examines every node on the search frontier and evaluates every node in the search space.

To demonstrate that MINIMAX is wasteful and that exhaustive evaluation is not necessary, let us consider the case of bi-valued terminal nodes, that is $e(J) \in \{\text{WIN}, \text{LOSS}\}$. Calculating the minimax values of node J amounts to determining the WIN-LOSS status of J or to *solving* the game rooted at J. The following straightforward algorithm, which we call SOLVE, determines the status of J without evaluating every node in the tree.

Algorithm: SOLVE

To solve an arbitrary node J, do the following:

1. If J is a terminal node, return its WIN-LOSS status directly; otherwise
2. Start solving J's successors from left to right (calling SOLVE recursively).
3. If J is a MAX node, return a WIN as soon as one successor is found to be a WIN; return a LOSS if all successors of J are found to be a LOSS.
4. If J is a MIN node, return a LOSS as soon as one successor is found to be a LOSS; return a WIN if all successors of J are found to be a WIN.

Clearly SOLVE does not evaluate every node in the tree. It is a backtracking search that traverses the tree from left to right but skips all nodes that cannot provide useful information. For example, as soon as one successor of a MAX node is found to be a WIN, the father can be declared a WIN without

solving the rest of its children. The overall savings achieved by this method can be substantial and it depends, of course, on the order in which the successors are evaluated.

SOLVE is probably the simplest game-searching algorithm. It also lends itself readily to average case analysis (see Section 8.3) and can be shown to be optimal under rather general conditions (Tarsi, 1983). We therefore use SOLVE as a standard to gauge the performance of more intricate algorithms such as those that search game trees with multi-valued terminal nodes.

SOLVE draws its efficiency from two factors: the determination to examine only nodes that may influence the status of the top node being evaluated and our *a priori* knowledge that the terminal nodes are bi-valued. At first glance it may appear that the second is the dominant factor and that very little pruning can be achieved without knowing, for example, that the father node cannot obtain a status higher than WIN or lower than LOSS. It turns out, however, that although the bi-valued nature of the evaluation function is helpful, *it is not essential.* Comparable savings also can be achieved for multi-valued or continuous valued games, even when the range of values is not known in advance.

One way in which such savings can be realized is by the celebrated alpha-beta (α-β) pruning algorithm which is described in the next section.

8.2.2 The α-β Pruning Procedure: A Backtracking Strategy

Description of the α-β Procedure. The α-β pruning algorithm is the most commonly used procedure in game-playing applications, where it serves to speed up game searching without loss of information. The algorithm determines the minimax value of the root of a game tree by traversing the tree in a predetermined order, say from left to right, skipping all those nodes that no longer can influence the minimax value of the root.

The method is demonstrated in Figure 8.2, which shows a binary game tree of depth $d = 4$ with MAX and MIN nodes represented by squares and circles, respectively. The numbers inside the terminal squares represent evaluations of the game positions at the frontier of the search tree, whereas those at higher levels are the minimax values computed by the α-β procedure. The heavy branches represent the search tree actually generated by the α-β procedure as it traverses the game tree from left to right. Nodes not on that search tree are skipped ("or cut off") by α-β because they cannot provide useful information.

The rationale for node skipping can be explained by examining Figure 8.3(a), which depicts the traversal path reached by α-β while skipping the node labeled C of Figure 8.2. The purpose of exploring node B has been to find out if the value of A should be reduced below 10, which is the value established for A's leftmost son. However, the facts that one of B's sons has already attained the value 14 and that B is a MAX node imply that the value of B must be at least 14, regardless of any information that C may provide. Therefore, nothing can alter the fact that the value of A is exactly 10, and C can be cut off from the search.

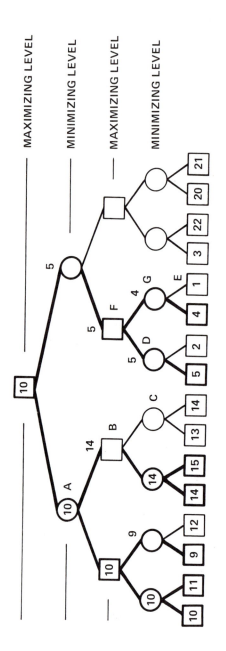

Figure 8.2
A game tree exhibiting alpha-beta (α-β) pruning.

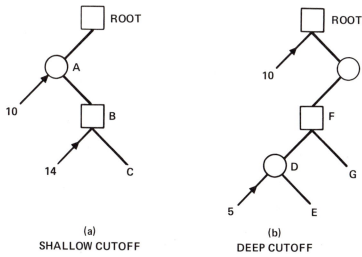

Figure 8.3
Shallow and deep cutoffs in alpha-beta search.

A similar argument can be used to justify cutting off the node labeled E in Figure 8.2. When this cutoff is decided, α-β has reached the path shown in Figure 8.3(b); the leftmost son of the root has delivered the value 10 and D is being explored to find out if it can increase the root value above 10. Clearly, as soon as one of D's sons reveals the value 5, D's value cannot exceed 5 and there is no way that D can cause the root value to rise above 10. Therefore E and D are discarded and the search moves to the next brother of D.

The example shown in Figure 8.3(a) demonstrates a **shallow cutoff** in the sense that the information responsible for cutting off node C came only from its siblings and uncles, but not from higher-level nodes. By contrast, the condition shown in Figure 8.3(b) demonstrates a **deep cutoff**; if it were not for the information received from its great-grandfather, the root node, E could not have been ignored.

In practice, these considerations translate into a very simple pruning scheme:

Perform the backtracking version of minimax search with one exception; if in the course of updating the minimax value of a given node this value crosses a certain bound, then no further exploration is needed beneath that node; its current-value CV can be transmitted to its father as if all of its sons have been evaluated.

The cutoff bounds are adjusted dynamically and are transmitted top-down as follows:

1. **α-bound**—The cutoff bound for a MIN node J is a lower bound called α, equal to the **highest current value of all MAX ancestors of J**. The explora-

tion of J can be terminated as soon as its current value CV equals or falls below α.

2. **β-bound**—The cutoff bound for a MAX node J is an upper bound called β, equal to the **lowest current value of all MIN ancestors of J.** The exploration of J can be terminated as soon as its current value CV equals or rises above β.

In Figure 8.3(a), for example, the exploration of node B begins with a β-bound of 10 which is received from A. As soon as the value 14 is received from its left son, B's current value (14) exceeds its β-bound (10) and all further explorations beneath B can be terminated. B now notifies its parent A to proceed with the other sons. In our example, since A has no more sons to the right of B, the evaluation of A is completed and it transmits its current value, 10, to its father.

The exploration of node D (Figure 8.3(b)) begins with an α-bound of 10 which propagates down from the root. The value of D drops below 10 as soon as it receives the value 5 from its left son. This causes the exploration of D to terminate and the search continues at the right brother of D.

This last example also permits us to demonstrate how the bounds are **updated** so as to comply with their given definitions. Consider node F which begins its exploration with an α-bound of 10. The α-bound that F should deliver to its right son G must equal the highest value over all MAX's ancestors of G, namely, the maximum of 10 and the value delivered by D. Since D delivers the value 5, G receives an α-bound of 10. Had the minimax value D been 15, F would deliver down to G the α-bound of 15.

These pruning and bound-updating operations are summarized by the following recursive procedure which we call $V(J; \alpha, \beta)$. It receives two parameters, $\alpha < \beta$, and evaluates $V(J)$, the minimax value of node J, if the latter lies between α and β. Otherwise, it returns either α (if $V(J) \leqslant \alpha$) or β (if $V(J) \geqslant \beta$). Clearly, if J is a root of a game tree, its minimax value will be obtained by $V(J; -\infty, +\infty)$.

α-β Procedure: $V(J; \alpha, \beta)$

1. If J is terminal, return $V(J) = e(J)$. Otherwise, let $J_1, \ldots, J_k, \ldots, J_b$ be the successors of J, set $k \leftarrow 1$ and, if J is a MAX node, go to step 2; else go to step 2'.

2. Set $\alpha \leftarrow \max[\alpha, V(J_k; \alpha, \beta)]$.

2'. Set $\beta \leftarrow \min[\beta, V(J_k; \alpha, \beta)]$.

3. If $\alpha \geqslant \beta$, return β; else continue.

3'. If $\beta \leqslant \alpha$, return α; else continue.

4. If $k = b$, return α; else proceed to J_{k+1}, i.e., set $k \leftarrow k + 1$ and go to step 2.

4'. If $k = b$, return β; else proceed to J_{k+1}, i.e., set $k \leftarrow k+1$ and go to step 2'.

A more concise definition of the α-β algorithm using NEG-MAX notation, and a proof that it returns the minimax value of the root node can be found in Knuth and Moore (1975).

Clearly, the efficiency of this search method depends on the order of the terminal values. For the values shown in Figure 8.2, only 7 terminal nodes are examined by a left-to-right search, whereas all 16 terminal nodes would be examined by a right-to-left search. In complex games, the difference between the best case and the worst case can be quite substantial, amounting to a factor of 2 in the depth of the look-ahead tree that a given computer system can afford to explore. This disparity warrants analysis of the *average* performance of α-β under the assumption that the terminal values are randomly ordered.

The analysis will be carried out in Chapter 9 and, strangely, it reveals that the pruning provided by α-β permits the search depth to extend roughly 33% deeper than that permitted by an exhaustive MINIMAX search, i.e., a third of the way between its worst case and best case values. However, before exposing this analysis, it is instructive to present α-β from a different perspective and to describe other algorithms that compete with α-β in game-searching applications.

Understanding α-β from an Influence Analysis Viewpoint.

The pruning action of α-β draws its legitimacy from the fact that the pruned nodes cannot **influence** the root node, no matter what their value turns out to be. Let us examine now what information must be gathered by the search so that we can decide that a particular node no longer has any influence on the value of the root. That information will lead to a simple criterion for determining whether a given node is generated by α-β and will play an important role in the analysis of α-β's expected performance.

Assuming that at a certain stage of the search the traversal path P_{s-J} has reached the situation described in Figure 8.4, all the terminal nodes to the left of this path have been explored, the minimax values of all subtrees stemming to the left of P_{s-J} are known, a decision must now be made whether node J should be explored or pruned. The information gathered by the search is summarized by the parameters $\alpha(K)$, $\beta(L)$, $\alpha(M)$, $\beta(N)$, ... where $\alpha(K)$ is the maximum of the values of the subtrees emanating from K to the left of P_{s-J}, $\beta(L)$ is the minimum of the values of the left subtrees emanating from L, and so on. For uniformity, we agree that, if a node Z on P_{s-J} has no sons to the left of P_{s-J}, its associated parameters will be $\alpha(Z) = -\infty$ or $\beta(Z) = +\infty$, depending on whether Z is MAX or MIN.

Our task now is to determine for what strings of parameters $\alpha(K)$, $\beta(L)$, ... we can declare J as having no influence on the root node value $V(s)$. We pretend that J is the last node to be evaluated before the root value is to be declared, and that $V(J)$ is a variable x, ranging from $-\infty$ to $+\infty$. The root value $V(s)$, if it is affected by $V(J)$, would correspondingly change its value along some curve $V(s) = F_J(x)$. If $F_J(x)$ is flat, J has no impact on s and can be pruned away; otherwise it must be explored lest $V(s)$ be determined erroneously. We call $F_J(x)$ the **influence function** of the root with respect to the node J.

The calculation of $F_J(x)$ is facilitated by the fact that, if J has any influence at all on s, that influence must be transmitted via the intervening nodes along

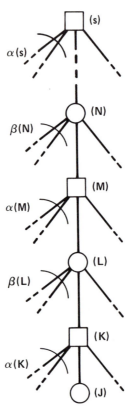

Figure 8.4
A traversal path in the midst of alpha-beta search.

P_{s-J}. In other words, in order for J to influence the root node, it must influence its father K, its grandfather L, and so on. Thus, instead of calculating $F_J(x)$ directly, we can compute it as a **cascade** of several influence functions in much the same way that we compute the output of a cascaded chain of electronic circuits, treating the output of one circuit as an input to its successor.

Let $f_{K,J}(x)$ characterize the direct influence of J on its father K, that is $V(K) = f_{K,J}[V(J)]$. If we know both $f_{K,J}(x)$ and $F_K(x)$, we can compute $F_J(x)$ using the composite function:

$$F_J(x) = F_K[f_{K,J}(x)] \tag{8.8}$$

Similarly, we may continue this process through all the intervening nodes between J and s, and obtain

$$F_J(x) = f_{s,\cdot}(\dots(f_{L,K}(f_{K,J}(x)))) \tag{8.9}$$

Let us now examine the direct influence function $f_{K,J}(x)$ between a son J and its father K. This is an elementary min or max function which depends only on

the parameter α or β available to the father node. If the father K is a MAX node with parameter α, then

$$f_{K,J}(x) = f_\alpha^+(x) \triangleq \max(\alpha, x) \tag{8.10}$$

If the father K is a MIN node with parameter β, then

$$f_{K,J}(x) = f_\beta^-(x) \triangleq \min(\beta, x) \tag{8.11}$$

Thus, $F_J(x)$ can be written

$$F_J(x) = \dots f_{\beta(N)}^-(f_{\alpha(M)}^+(f_{\beta(L)}^-(f_{\alpha(K)}^+(x)))) \tag{8.12}$$

The shape of the functions $f_\alpha^+(x)$, $f_\beta^-(x)$, and the pair cascade

$$L_{\alpha,\beta}(x) \triangleq f_\beta^-(f_\alpha^+(x)) = \begin{cases} x & \alpha \leqslant x \leqslant \beta \\ \alpha & x \leqslant \alpha \leqslant \beta \\ \beta & x \geqslant \alpha \geqslant \beta \\ \beta & \beta \leqslant \alpha \end{cases} \tag{8.13}$$

are shown in Figure 8.5. $L_{\alpha,\beta}(x)$ describes a linear 45° ramp truncated below α and above β. If $\beta \leqslant \alpha$, the ramp degenerates to a flat horizontal line at level β, a condition that we simply label FLAT. Note that the cascade $f_\beta^-(f_\alpha^+(x))$ is identical to $f_\alpha^+(f_\beta^-(x))$ if $\alpha \leqslant \beta$; the two only differ in the level of the horizontal line when $\alpha > \beta$. However, since for the purpose of influence analysis the level of a flat function is irrelevant, we may conclude that compositions of ramp functions are commutative:

$$f_\beta^-(f_\alpha^+(x)) = f_\alpha^+(f_\beta^-(x))$$

This allows us to group together all the f^+ functions in the expression for $F_J(x)$ in Eq. (8.12) and to write

$$F_J(x) = \dots f_{\beta(N)}^-(f_{\beta(L)}^-(\dots f_{\alpha(M)}^+(f_{\alpha(K)}^+(x))))$$

Note that the family of $f^+(\cdot)$ functions is **closed under composition**, that is, composing two functions $f_{\alpha_1}^+(x)$ and $f_{\alpha_2}^+(x)$ yields another member $f_{\alpha_3}^+(x)$ of the same family, where $\alpha_3 = \max(\alpha_1, \alpha_2)$. Similarly, the family of $f^-(\cdot)$ functions is also closed:

$$f_{\beta_1}^-(f_{\beta_2}^-(x)) = f_{\beta_3}^-(x) \qquad \beta_3 = \min(\beta_1, \beta_2)$$

That permits us to rewrite $F_J(x)$ as a single truncated ramp

$$F_J(x) = f_{B(J)}^-(f_{A(J)}^+(x)) = L_{A(J),B(J)}(x)$$

where

$$A(J) = \max[\alpha(K), \alpha(M), \dots]$$

$$B(J) = \min[\beta(L), \beta(N), \dots] \tag{8.14}$$

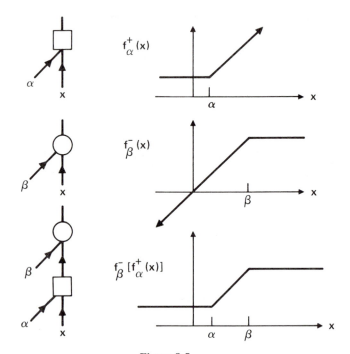

Figure 8.5
The influence functions $f_\alpha^+(x)$ and $f_\beta^-(x)$, and their composition $f_\beta^-(f_\alpha^+(x))$.

Thus the influence functions of all nodes are truncated 45° ramps each characterized by its own truncation points A and B. Obviously, $F_J(x)$ will be FLAT if $A(J) \geqslant B(J)$ in which case J can be pruned; otherwise J must be explored because its value may affect that of the root. This explains both the cutoff condition used by α-β and the process by which the bounds are updated; the α- and β-bounds that are passed down in the α-β search are exactly the parameters A and B above.

A Necessary and Sufficient Condition for Node Generation. The preceding discussion leads to a simple criterion for determining whether a given node is generated by the α-β algorithm:

For any node J, form the path leading from the root to J, and define the following quantities:

$A(J) =$ *the highest minimax value among all left-sons of MAX ancestors of J.*
$B(J) =$ *the lowest minimax value among all left-sons of MIN ancestors of J.*

J *will be generated by α-β if and only if:*

$$A(J) < B(J) \qquad (8.15)$$

The reader can easily verify that in Figure 8.2 all nodes generated satisfy the preceding criterion, whereas all those satisfying $A(J) \geqslant B(J)$ can provide no information beyond that which has already been gathered by the search and will be cut off. For example, for the right-most leaf node we have:

$$A(J) = \max\left[\min(3, 22), 10\right] = 10$$

$$B(J) = \min\{20, \max[\min(5, 2), \min(4, 1)]\} = 2$$

and since $A(J) > B(J)$, it is not generated by the α-β search.

At first glance, it may seem strange that the flatness criteria $A(J) \geqslant B(J)$ coincides with the pruning criterion of α-β; after all, the former relies on the actual minimax values of the subtrees emanating from the ancestors of J, whereas α-β, exploiting its pruning power, does not in fact evaluate the minimax values of all these subtrees. In Figure 8.2, for example, the minimax value of node F is 2, but the current value with which α-β abandons F is as high as 5.

On deeper thought, however, it becomes clear that the two criteria should coincide. We can demonstrate this fact by reasoning inductively. Assume that J is the first node that satisfies the flatness condition $A(J) \geqslant B(J)$, then $V(J)$ cannot affect $V(s)$ and, moreover, it also *cannot affect the influence function of any node J' to the right of J.* Therefore, we can pretend that $V(J)$ is equal to the minimax value of J's left brother. That would make the minimax value of J's father identical to the current value assigned to the father by α-β while pruning J. Because this substitution leaves the influence functions of all future nodes unaltered, we conclude that the next node pruned by α-β must also satisfy the flatness condition. We can now repeat that same argument from the second FLAT node and show that the fictitious value that α-β assigns to this node's father also leaves all future nodes with the same influence function, and so on. A formal proof of the statement in Eq. (8.15) can be found in Chapter 9 (Appendix 9-B) as a special case of the more elaborate condition of SSS*.

The criterion $A(J) \geqslant B(J)$, first derived by Fuller, Gaschnig, and Gillogly (1973), has a definite analytical advantage over the equivalent pruning criterion expressed by the operational statement "the current value of J's father exceeds its β-bound." The latter depends on two local variables of the search algorithm whose values fluctuate widely during the course of the computation in an unpredictable manner. The former, on the other hand, explicitly expresses the cutoff condition in terms of the values of the terminal nodes, whose variability can more easily be assessed. For that reason, the criterion in Eq. (8.15) is useful in computing the average number of terminal nodes examined by α-β. One need only compute the probability $P[A(J) < B(J)]$ for every node J, then sum these probabilities over all terminal nodes. This analysis is carried out in Chapter 9.

8.2.3 SSS*−A Best-First Search for an Optimal Playing Strategy†

SSS* (Stockman, 1979) is a game-searching algorithm that traverses subtrees of the game tree in a best-first fashion similar to $A*$ and $AO*$ (Chapter 2). SSS* has been shown to be superior to α-β in the sense that it never evaluates a node skipped by α-β, while occasionally examining fewer nodes than α-β.

Being a version of $AO*$, the aim of SSS* is the discovery of an optimal solution tree of the implicit game tree. A solution tree represents a strategy for MAX, specifying one response to each of the opponent's moves. Since the opponent is at liberty to choose any of the available moves, and since he is assumed to be both hostile and perfectly informed, the value of any strategy is equal to the minimum value of all terminal nodes in the solution tree representing that strategy (see Section 8.1.1). The minimax value of a game tree G reflects the maximal gain MAX can secure and is equal therefore to the value of the best solution tree embedded in G.

In accordance with the best-first split-and-prune paradigm, SSS* considers "clusters" of solution trees and splits (or refines) that cluster having the highest upper bound on the merit of its constituents. Every node in the game tree represents a **cluster** of solution trees defined by the set of all solution trees that share that node. However, unlike the clusters represented by the solution bases of Figure 2.9, the merit of a partially developed solution tree in a game is determined solely by the properties of the frontier nodes it contains, not by the cost of the paths leading to these nodes. The value of a frontier node is an upper bound on each solution tree in the cluster it represents. Thus, SSS* establishes upper bounds on the values of partially developed solution trees by sequentially (left to right) examining terminal nodes of these trees and taking the minimum value of those examined so far. These monotonically nonincreasing bounds are used to order the solution trees so that the tree of highest merit is chosen for development. The development process continues until one solution tree is fully developed, at which point that tree represents the optimal strategy and its value coincides with the minimax value of the root. We will demonstrate the operation of SSS* on the game tree of Figure 8.6, numbering nodes in the order they are generated.

An Informal Description of SSS*. We start by generating the two successors of the root, each successor represents a cluster of solution trees ready for further development. In the absence of any information about the merit of these clusters, the best we can do is to bound them from above by ∞ (see Figure 8.7(a)). Since SSS* always resolves ties in favor of the leftmost among the tied nodes, node 2 will be chosen for further development leading to the generation of the leftmost successor of 2, node 4 (see Figure 8.7(b)). Node 4' is not gen-

† The author thanks North Holland Publishing Company for permission to reprint the portion of the article "A Minimax Algorithm Better Than Alpha-Beta?: Yes and No" by Igor Roizen and Judea Pearl which first appeared in *Artificial Intelligence* 21(1–2), 199–220, March 1983.

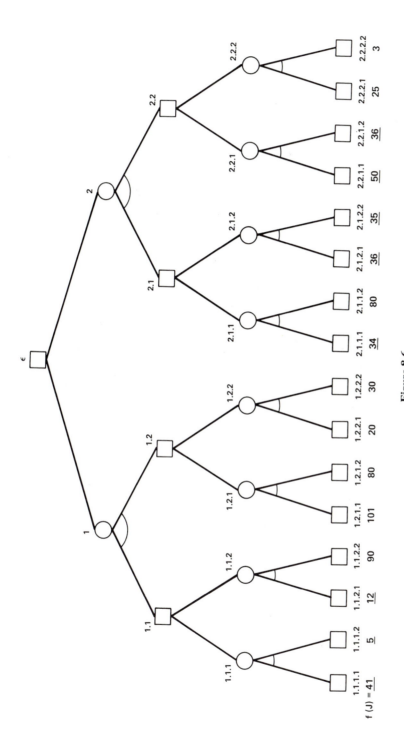

Figure 8.6

A game-tree to illustrate SSS*. Nodes are labeled in Dewey decimal notation, where the *j*th child of node *i* is labeled i.j. The leaf-nodes examined by SSS* are underlined.

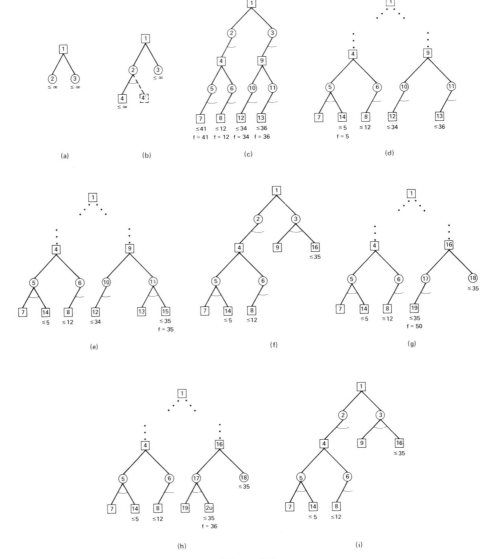

Figure 8.7

Various stages in the SSS* traversal of the game tree in Figure 8.6. Nodes are labeled in the order in which SSS* expands them. Upper bounds are listed below tip-nodes.

erated at this time because we want first to examine one tip node in each cluster before we can compare their merits for further development.

Such comparison is only feasible when all ∞'s are replaced by finite bounds taken from the values of the tip nodes as shown in Figure 8.7(c). At this point, the most promising cluster is that represented by node 7 with u.b. (upper

bound) 41—its value may decrease later, but so far it is the most meritorious candidate.

Further development of this cluster amounts to generating node 14 which reduces the u.b. to 5 (Figure 8.7(d)). This now renders the cluster containing node 13, having an u.b. of 36, the best candidate for the development. The latter bound is reduced to 35 after node 15 is generated (Figure 8.7(e)), thus maintaining the best candidate status for the cluster containing node 11.

At this point we can proclaim node 9 to be "solved" in the sense that no further development beneath 9 can boost the merit of its father, node 3, above its current value of 35. It so happened that in this case we also found the actual minimax value of node 9; but, as will be seen later, this is not always the case. Sometimes we can proclaim a node "solved," that is, to prune it from further considerations, prior to computing its actual minimax value.

The fact that the upper bound on node 3 is now 35 (Figure 8.7(f)) makes the cluster containing node 3 the best available candidate. Thus we continue the exploration of node 3 by generating node 16 (Figure 8.7(f)), carrying with us the u.b. 35 attributed to node 3. We now explore node 16 hoping to verify the proposition that the value of node 3 is still above the u.b.'s found for the other contending candidates (i.e., above 5 and 12). This verification proceeds in the same manner as the original expansion of the root node with one exception: we now have the u.b. 35 to guide us, whereas originally the root was expanded with ∞ as a bound. Consequently we may terminate the verification as soon as we conclude that node 16 roots a solution tree valued higher than or equal to 35. Indeed, generating the nodes in Figures 8.7(g) and 8.7(h), we conclude that node 16 roots such a solution, and so it can be assigned the final value 35.

Node 16 is now "solved" for the same reason we solved node 9 in Figure 8.7(e), which takes us to Figure 8.7(i). At this point one solution tree—that going through node 3—has been fully developed and all other candidate clusters were shown to be inferior to the one in hand. Therefore we may conclude that the value of the root is 35 with the best move being toward node 3.

*A Formal Definition of SSS * and an Example of a Complete Run.* We use *Dewey decimal notation* to represent nodes in a game tree. The root of the game tree will be denoted by ϵ, the empty sequence. If J stands for some internal node with b sons, then $J.j$ will denote the jth (from the left) son of node J, for $j = 1, ..., b$ (Figure 8.6). We define the state of processing as a triple (J, s, h), where J is a node of G, $s \in \{\text{LIVE, SOLVED}\}$ is the status of solution of J, and $h \in [-\infty, +\infty]$ is the merit of the state. LIVE status indicates that none of J's successors has been generated; SOLVED indicates that the algorithm has finished evaluating J and will never examine any of J's successors again. We define OPEN as a list of states (initially empty) kept in nonincreasing order of merit h.

Definition: The SSS* Algorithm.
1. Place the start state ($J = \epsilon, s = \text{LIVE}, h = +\infty$) on OPEN.

2. Remove the first (the highest merit) state $p = (J, s, h)$ from OPEN.
3. If $J = \epsilon$ (i.e., J is the root) and $s = $ SOLVED, then (one solution tree has been fully developed) terminate with h equal to the minimax value of the game tree. Otherwise continue.
4. Expand state p by applying state space operator Γ as defined in Table 8.1.
5. Go to step 2.

The tie-breaking rule of Case 3 in Table 8.1 is a revision of Stockman's original algorithm. This revision is necessary in order to maintain a strict superiority of SSS* over α-β. Otherwise, in a game tree such as the one in Figure 8.6, if the values of the third and fourth tip nodes (from the right) were both changed to 25, then the rightmost node 2.2.2.2 would be examined by Stockman's original SSS* and skipped by α-β.

Example

In Table 8.2 we give the complete OPEN list for each loop through the SSS* algorithm as applied to the game tree in Figure 8.6. LIVE and SOLVED are abbreviated as L and S, respectively.

TABLE 8.1 *State-Space Operator* Γ

Case of Γ	Conditions satisfied by input state (J, s, h)	Action of Γ
1	$s = $ LIVE type $(J) = $ MAX J is nonterminal	Add states $(J.j, s, h)$, where $j = 1, 2, ..., b$, in front of OPEN in increasing order of j.
2	$s = $ LIVE type $(J) = $ MIN J is nonterminal	Add $(J. 1, s, h)$ in front of OPEN.
3	$s = $ LIVE J is a terminal node	Place $(J, $ SOLVED, $\min\{h, v(J)\})$ on OPEN in front of all states of lesser merit h, where v is a real valued static evaluation function. Ties are resolved in favor of nodes with lesser lexicographic value (i.e., in favor of the nodes that are leftmost in the tree).
4	$s = $ SOLVED type $(J) = $ MAX $J = J'.j, j = b$	Add $(J'.j + 1, $ LIVE, $h)$ in front of OPEN.
5	$s = $ SOLVED type $(J) = $ MAX $J = J'.j, \ j = b$	Add (J', s, h) in front of OPEN.
6	$s = $ SOLVED type $(J) = $ MIN $J = J'.j$	Add (J', s, h) in front of OPEN. Then purge OPEN of all states corresponding to successors of J'.

TABLE 8.2. *SSS* Executed on the Tree of Figure 8.6*

Loop No.	Case of Γ	OPEN			
1	-	(ε ,L,+∞)			
2	1	(1 ,L,+∞)	(2 ,L,+∞)		
3	2	(1.1 ,L,+∞)	(2 ,L,+∞)		
4	1	(1.1.1 ,L,+∞)	(1.1.2 ,L,+∞)	(2 ,L,+∞)	
5	2	(1.1.1.1,L,+∞)	(1.1.2 ,L,+∞)	(2 ,L,+∞)	
6	3	(1.1.2 ,L,+∞)	(2 ,L,+∞)	(1.1.1.1,S,41)	
7	2	(1.1.2.1,L,+∞)	(2 ,L,+∞)	(1.1.1.1,S,41)	
8	3	(2 ,L,+∞)	(1.1.1.1,S,41)	(1.1.2.1,S,12)	
9	2	(2.1 ,L,+∞)	(1.1.1.1,S,41)	(1.1.2.1,S,12)	
10	1	(2.1.1 ,L,+∞)	(2.1.2 ,L,+∞)	(1.1.1.1,S,41)	(1.1.2.1,S,12)
11	2	(2.1.1.1,L,+∞)	(2.1.2 ,L,+∞)	(1.1.1.1,S,41)	(1.1.2.1,S,12)
12	3	(2.1.2 ,L,+∞)	(1.1.1.1,S,41)	(2.1.1.1,S,34)	(1.1.2.1,S,12)
13	2	(2.1.2.1,L,+∞)	(1.1.1.1,S,41)	(2.1.1.1,S,34)	(1.1.2.1,S,12)
14	3	(1.1.1.1,S,41)	(2.1.2.1,S,36)	(2.1.1.1,S,34)	(1.1.2.1,S,12)
15	4	(1.1.1.2,L,41)	(2.1.2.1,S,36)	(2.1.1.1,S,34)	(1.1.2.1,S,12)
16	3	(2.1.2.1,S,36)	(2.1.1.1,S,34)	(1.1.2.1,S,12)	(1.1.1.2,S,5)
17	4	(2.1.2.2,L,36)	(2.1.1.1,S,34)	(1.1.2.1,S,12)	(1.1.1.2,S,5)
18	3	(2.1.2.2,S,35)	(2.1.1.1,S,34)	(1.1.2.1,S,12)	(1.1.1.2,S,5)
19	5	(2.1.2 ,S,35)	(2.1.1.1,S,34)	(1.1.2.1,S,12)	(1.1.1.2,S,5)
20	6	(2.1 ,S,35)	(1.1.2.1,S,12)	(1.1.1.2,S,5)	
21	4	(2.2 ,L,35)	(1.1.2.1,S,12)	(1.1.1.2,S,5)	
22	1	(2.2.1 ,L,35)	(2.2.2 ,L,35)	(1.1.2.1,S,12)	(1.1.1.2,S,5)
23	2	(2.2.1.1,L,35)	(2.2.2 ,L,35)	(1.1.2.1,S,12)	(1.1.1.2,S,5)
24	3	(2.2.1.1,S,35)	(2.2.2 ,L,35)	(1.1.2.1,S,12)	(1.1.1.2,S,5)
25	4	(2.2.1.2,L,35)	(2.2.2 ,L,35)	(1.1.2.1,S,12)	(1.1.1.2,S,5)
26	3	(2.2.1.2,S,35)	(2.2.2 ,L,35)	(1.1.2.1,S,12)	(1.1.1.2,S,5)
27	5	(2.2.1 ,S,35)	(2.2.2 ,L,35)	(1.1.2.1,S,12)	(1.1.1.2,S,5)
28	6	(2.2 ,S,35)	(1.1.2.1,S,12)	(1.1.1.2,S,5)	
29	5	(2 ,S,35)	(1.1.2.1,S,12)	(1.1.1.2,S,5)	
30	6	(ε ,S,35)			

Only 8 out of the 16 frontier nodes in Figure 8.6 are examined by SSS*. By contrast, α-β would examine, in addition to these nodes, also those labeled 1.1.2.2, 1.2.1.1, 1.2.1.2, 2.1.1.2, bringing the total number of nodes examined to 12. In Section 9.3.1 we will show that every node examined by SSS* must also be examined by α-β.

The disadvantage of SSS* lies in the need to keep in storage a record of all contending candidate clusters, which may require large storage space, growing exponentially with search depth. This large storage space requirement is shared by all best-first search strategies (Section 2.5), and whether it is offset by a substantial increase in pruning power is considered in Chapter 9.

8.2.4 SCOUT–A Cautious Test-Before-Evaluate Strategy

SCOUT, the algorithm discussed in this section, is a newcomer to the family of game-searching strategies (Pearl, 1980). It has evolved as a theoretical tool for showing the existence of a strategy that achieves an optimal asymptotic performance (see Section 9.1) and only later has been found to also possess practical merits.

SCOUT is motivated by the observation that a substantial amount of search effort could be avoided if we had a quick way of **testing inequalities**. In Figure 8.8, for example, suppose the leftmost son J_1 of a MAX node evaluates to v; if we had a quick way of telling that the value $V(J_2)$ of the second son J_2 is lower than v, then J_2 could be permanently purged from further explorations.

While α-β pursues the *evaluation* of J_2 and stops the evaluation upon receiving evidence that $V(J_2) \leqslant v$, SCOUT focuses all its initial effort on *testing* whether the inequality $V(J_2) > v$ holds true, and proceeds to evaluate J_2 *only* upon receiving an affirmative answer.

Testing Game Trees. The task of verifying inequalities such as $V(J) > v$, where v is some fixed reference chosen for the test, is equivalent to **solving** the game rooted at J, and can be accomplished using a depth-first algorithm such as SOLVE. We simply interpret any terminal node t for which $e(t) > v$ as a WIN position (otherwise it is a LOSS), and apply SOLVE directly. If it issues a WIN, the proposition "$V(J) > v$" is proven, otherwise we deduce "$V(J) \leqslant v$." This procedure, which we call TEST$(J, v, >)$, is described as follows.

Procedure: TEST $(J, v, >)$
To test whether J satisfies the inequality $V(J) > v$ do the following:
 1. If J is a terminal node, return TRUE if $e(J) > v$, return FALSE if $e(J) \leqslant v$; otherwise
 2. Start testing J's successors from left to right.

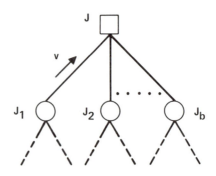

Figure 8.8
A portion of a game tree to illustrate SCOUT.

3. If J is MAX, return TRUE as soon as one successor is found to be larger than v; return FALSE if all successors are smaller than or equal to v.
4. If J is MIN, return FALSE as soon as one successor is found to be smaller than or equal to v; return TRUE if all successors are larger than v.

An identical procedure, called TEST(J, v, \geqslant), can be used to verify the inequality $V(J) \geqslant v$, with the obvious revisions induced by the equality sign.

Description of SCOUT. SCOUT invokes two recursive procedures called EVAL and TEST. The main procedure EVAL(J) returns $V(J)$, the minimax value of position J, whereas the function of TEST(J, v, $>$) is to validate (or refute) the truth of the inequality $V(J) > v$ where v is some given reference value.

Procedure: EVAL (J)
EVAL(J) computes the minimax value of a MAX positions J by first evaluating its left most successor J_1 (calling EVAL(J_1)), then "scouting" the remaining successors, from left to right, to determine (calling TEST) if any meets the conditions $V(J_k) > V(J_1)$. If the inequality is found to hold for J_k, this node is then evaluated exactly (calling EVAL(J_k)) and its value $V(J_k)$ is used for subsequent "scoutings" tests. Otherwise J_k is exempted from evaluation and J_{k+1} selected for a test. When all successors have been either evaluated or tested and found unworthy of evaluation, the last value obtained is issued as $V(J)$.

An identical procedure is used for evaluating a MIN position J, save for the fact that the event $V(J_k) \geqslant V(J_1)$ now constitutes grounds for exempting J_k from evaluation. The flowchart of Figure 8.9 describes SCOUT in algorithmic details.

At first glance it appears that SCOUT is very wasteful; any node J_k that is found to fail an exemption test is submitted back for evaluation. The terminal nodes inspected during such a test may (and in general will) be revisited during the evaluation phase. An exact mathematical analysis, however, reveals that the amount of waste is not substantial and that SCOUT, despite some duplicated effort, still achieves an optimal performance for deep trees.

Two factors work in favor of SCOUT:

1. Most tests would result in exempting the tested node (and all its descendants) from any further evaluation.
2. Testing inequalities using the TEST (J, v) procedure is relatively speedy in view of the fact that TEST induces many cutoffs not necessarily permitted by EVAL or any other evaluation scheme. As soon as *one* successor J_k of a MAX node meets the criterion $V(J_k) > v$, all other successors can be ignored. EVAL, by contrast, would necessitate a further examination of the remaining successors to determine if any possess a value higher than $V(J_k)$.

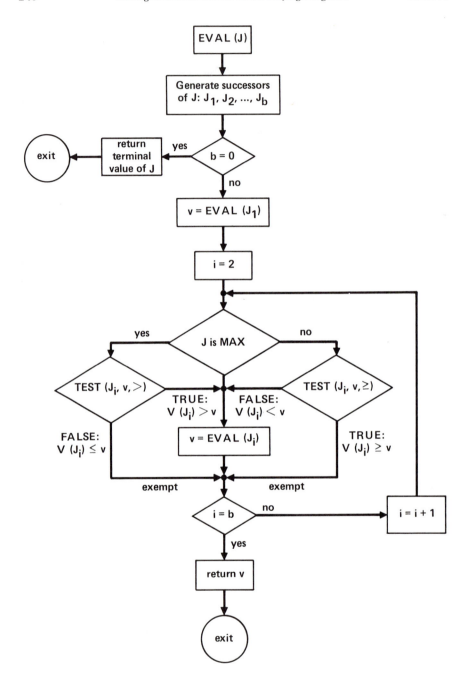

Figure 8.9
A flowchart for EVAL, the heart of SCOUT.

Several improvements could be applied to the SCOUT algorithm to render it more efficient. For example, when a TEST procedure issues a nonexempt verdict, it could also return a new reference value and some information regarding how the decision was obtained in order to minimize the number of nodes to be inspected by EVAL. Such improvements, however, will tarnish the conceptual and analytical simplicity of SCOUT which were the main reasons behind its inception. It is remarkable, though, that analytical and simulation studies have shown that, even in its unpolished version, SCOUT achieves an optimal asymptotic performance and that in some games it proved more efficient than α-β (Noe, 1980).

The analysis of the performance of SCOUT is generally easier than that of α-β (see Chapter 9). In fact, SCOUT was contrived under the false assumption that it is dominated by α-β, hoping that by showing that SCOUT achieves an optimal performance, we would be establishing the optimality of α-β. However, after futile attempts to prove the superiority of α-β over SCOUT, counterexamples were found demonstrating that SCOUT's extra caution in testing prior to evaluating may sometimes pay off, causing it to skip nodes that would be visited by α-β. In Figure 8.10 the node marked t_1 is examined by the α-β procedure but ignored by SCOUT. When J is submitted to TEST($J, 5, >$), the zero value assigned to node t_2 causes the test to fail, whereas during the TEST($K, 5, >$) phase, t_1 is skipped by virtue of its elder sibling having the value 10. α-β, on the other hand, has no way of finding out the low value of t_2 before t_1 is examined.

The converse situation can, of course, also be demonstrated. Figure 8.11 shows how a node (t_1) that is visited by SCOUT is cut off by α-β. Table 8.3 compares the number of node inspections spent by α-β and SCOUT in searching the game of Kalah (one-in-a-hole version) (Noe, 1980).

It shows that as the search depth increases, SCOUT offers some advantage over α-β. However, experiments with a higher number of stones in each hole

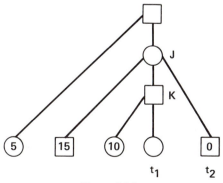

Figure 8.10
An example showing that alpha-beta is not always superior to SCOUT.

TABLE **8.3.** *Comparing SCOUT and α-β on the Game of Kalah*

Search	No. of Inspections		Percentage
Depth	SCOUT	α-β	Improvement
2	82	70	− 17.0
3	394	380	− 3.7
4	1173	1322	+11.3
5	2514	4198	+40.1
6	5111	6944	+26.4

(a version of Kalah that offers a higher number of moves from each position) indicate that this advantage disappears, suggesting that SCOUT may be found useful in searching "skinny" games, that is, games with high depth-to-width ratios. This suggestion, however, is not confirmed by the analytical results of Chapter 9 (see Figure 9.4) for random uniform game trees. The latter predict a slight advantage for α-β which disappears when *either* the search depth *or* the branching degree increase. Additionally, on nonuniform random game trees such as the one in Figure 8.31(*b*), SCOUT was found to outperform α-β by a factor *b* /log *b*. Thus, what structural characteristics of game trees are decisive in rendering α-β or SCOUT more effective remains an open question.

It is important to note that, unlike the SSS* algorithm which requires an enormous storage space for keeping a large number of potential strategies, SCOUT has storage requirements similar to those of α-β. At any point in time it only maintains pointers along one single path connecting the root to the currently generated node.

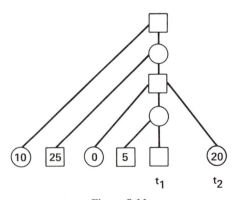

Figure 8.11
An example showing that SCOUT is not always superior to alpha-beta.

8.3 A STANDARD PROBABILISTIC MODEL FOR STUDYING THE PERFORMANCE OF GAME-SEARCHING STRATEGIES

In the preceding section we described three game-searching strategies and showed that in all three cases the search effort is sensitive to the ordering of nodes at the search frontier. In the worst case, the search strategies must examine all nodes at the search frontier, whereas in the best case the value of the game tree can be determined after examining only those nodes that belong to the first two adversary strategies encountered. The question now arises, how the performances of these search strategies **compare on an average basis**.

To answer such questions we must construct probabilistic models of games that are both analytically tractable and, at the same time, capture the essential features of game-playing environments. Our standard model consists of a uniform game tree of degree b and depth d where the terminal nodes are **randomly ordered**. We will study two special cases of this model; the first has bi-valued (e.g., WIN-LOSS) terminal nodes, and in the second the terminal nodes are assigned random and distinct values. Our plan in this chapter is to study some of the statistical properties of these models and to derive expressions for the average complexity of SOLVE and TEST. In Chapter 9 we use these properties to analyze the average performance of SCOUT, α-β, and SSS*. Later on we extend the standard models by assuming that successors are ordered informedly (Section 9.4), and that the game tree may have a random number of branches and shallow terminal positions (Section 9.5).

8.3.1 The Probability of Winning a Standard Game with Random Win Positions †

We consider a class of two-person perfect information games represented by the tree of Figure 8.12. Two players, called MAX and MIN, take alternate turns. In each turn a player may choose one out of b legal moves. The game lasts exactly d moves (d even), at which point a terminal position is reached. Each terminal position constitutes either a WIN or a LOSS for the first player. We assume that the assignment of labels to the b^d terminal positions is done at random, prior to the beginning of the game, and that each terminal position may receive a WIN with probability P_0 (and a LOSS with probability $1 - P_0$) independently of other assignments. Thus, our sample space $T(d, b, P_0)$ consists of bi-valued uniform game trees of depth d and degree b, and the probability that a tree with a specified WIN-LOSS assignment is drawn from $T(d, b, P_0)$ is given by $P_0^{N_1} (1 - P_0)^{N_0}$, where N_1 and N_0 are respectively the

† The author thanks North Holland Publishing Company for permission to reprint the portion of the article "Asymptotic Properties of Minimax Trees and Game-Searching Procedures" by Judea Pearl which first appeared in *Artificial Intelligence* 14–2: 113–138, September 1980.

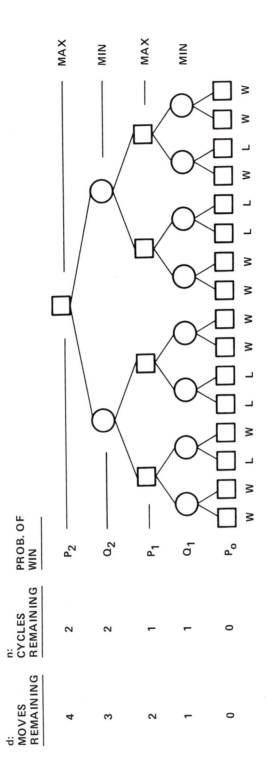

Figure 8.12

A complete binary tree with leaf nodes randomly assigned WIN with probability P_0, else LOSS.

252

number of WIN and LOSS leaf nodes ($N_1 + N_0 = b^d$). We will refer to a game tree drawn from such an ensemble as a (d, b, P_0)-tree.

The first quantity we wish to compute is P_n, the probability that MAX can force a WIN from a typical game position given that it is his turn to move and that exactly n move-cycles are left in the game. Similarly, we denote by Q_n the probability that MAX can force a WIN given that it is MIN's turn to move and that there are a total of $2n - 1$ individual moves left in the game. Clearly, P_n and Q_n are calculated prior to examining the terminal positions. Once the WIN-LOSS assignment is known, each node of the tree can, of course, be unequivocally labeled either a WIN or a LOSS.

For a MAX node to be a WIN, at least one of its b successors must be a WIN; therefore

$$1 - P_n = (1 - Q_n)^b \qquad (8.16)$$

Also, for a MIN position to be a WIN, all of its b successors must be a WIN; thus

$$Q_n = P_{n-1}^b \qquad (8.17)$$

Combining Eqs. (8.16) and (8.17) we obtain the recursive relationship:

$$P_n = 1 - (1 - P_{n-1}^b)^b \qquad (8.18)$$

The asymptotic behavior of P_n for large n can be inferred from the staircase construction of Figure 8.13.

The curve $y(x) = 1 - (1 - x^b)^b$ intersects the line $y = x$ in three points: two stable points $x = 0$ and $x = 1$, and one unstable point at $x = \xi_b$. ξ_b is the unique solution of the equation: $(1 - x^b)^b - (1 - x) = 0$ in the range $0 < x < 1$ or, more conveniently, the positive root of the equation $x^b + x - 1 = 0$. It can be easily ascertained that every root of the latter equation is also a root of the former.

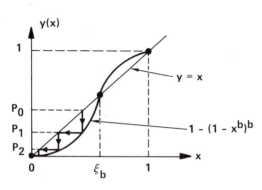

Figure 8.13
A staircase construction showing the effect of iterated composition of the function $y(x) = 1 - (1 - x^b)^b$.

The significance of the quantity ξ_b lies in the fact that if the terminal positions are assigned a WIN with probability $P_0 = \xi_b$, then, prior to examining any of these positions, MAX is assured a probability ξ_b of finding a winning strategy, regardless of the height of the tree.

More significantly, if P_0 is different from ξ_b, we have:

$$\lim_{n \to \infty} P_n(P_0) = \begin{cases} 1 & \text{if } P_0 > \xi_b \\ 0 & \text{if } P_0 < \xi_b \end{cases} \tag{8.19}$$

This means that when $P_0 > \xi_b$, MAX is almost assured a WIN if n is large enough, whereas he faces an almost sure LOSS in the case where $P_0 < \xi_b$.

To illustrate this phenomenon, consider a binary game ($b = 2$) with five move-cycles ($n = 5$). ξ_b is the solution to $x^2 + x - 1 = 0$, also known as the "golden ratio" (Gardner, 1961) $\xi_2 = (\sqrt{5} - 1)/2 = .6180339$. If all we know about the terminal positions is that 61.80 % of them are WIN's, then we also know that the first player to move has a 61.80% chance of being able to force a WIN. However, if only 50% of the terminal positions are winning, his chances to force a WIN drop to 1.95%, whereas when $P_0 = 70\%$, his chances increase to 98.5%. These numbers become much more dramatic in higher trees, as shown in Figure 8.14.

It is simple to show that the slope at the transition region increases exponentially with n:

$$P_n'(P_0) \big|_{P_0 = \xi_b} = \left[\frac{b(1 - \xi_b)}{\xi_b} \right]^{2n} \quad \text{and} \quad \frac{b(1 - \xi_b)}{\xi_b} > 1 \quad \text{for } b > 1 \tag{8.20}$$

Also, a more detailed analysis shows that, for sufficiently large n, P_n converges toward its asymptotic values at a super-exponential rate, that is, for every $0 < \delta < 1$, we can find two integers n_1 and n_2, such that:

$$\begin{aligned} P_n &\leqslant (\delta)^{b^{(n-n_1)}} & \text{for all } n > n_1 \text{ and } P_0 < \xi_b \\ 1 - P_n &\leqslant (\delta)^{b^{(n-n_2)}} & \text{for all } n > n_2 \text{ and } P_0 > \xi_b \end{aligned} \tag{8.21}$$

where n_1 and n_2 are functions of δ and $\xi_b - P_0$. It is, thus, safe to conclude that for sufficiently large n, the function $P_n(P_0)$ resembles a **step function** with an extremely narrow transition region around ξ_b.

8.3.2 Game Trees with an Arbitrary Distribution of Terminal Values

Consider a uniform b-ary game tree with depth d where each terminal node t is assigned a numerical value $V_0 = e(t)$ and assume the latter to be independent identically distributed random variables, drawn from a common distribution function $F_{V_0}(v) = P(V_0 \leqslant v)$. We will refer to a tree drawn from such an ensemble as a (d, b, F)-tree, and our first task is to calculate the distribution of the minimax value of the root node.

Figure 8.14
A graph showing P_n as a function of P_0 for $b = 2$.

Denoting the minimax values of nodes at the n^{th} cycle above the leaves by $V_n(J)$ for MAX nodes and by $U_n(J)$ for MIN nodes, we have:

$$V_n(J) = \max [U_n(J_1), U_n(J_2), \ldots, U_n(J_b)]$$

$$U_n(J) = \min [V_{n-1}(J_1), V_{n-1}(J_2), \ldots, V_{n-1}(J_b)] \tag{8.22}$$

where J_1, J_2, \ldots, J_b denote the b successors of J. The distribution of $V_n(J)$ is obtained by writing:

$$F_{V_n}(v) \triangleq P[V_n(J) \leqslant v] = \prod_{i=1}^{b} P[U_n(J_i) \leqslant v] = [F_{U_n}(v)]^b \tag{8.23}$$

$$1 - F_{U_n}(v) \triangleq P[U_n(J) > v] = \prod_{i=1}^{b} P[V_{n-1}(J_i) > v]$$

$$= [1 - F_{V_{n-1}}(v)]^b \tag{8.24}$$

yielding the recursive relation:

$$F_{V_n}(v) = \left\{ 1 - \left[1 - F_{V_{n-1}}(v) \right]^b \right\}^b \qquad (8.25)$$

Note that Eqs. (8.23), (8.24), and (8.25) are identical to Eqs. (8.16), (8.17), and (8.18), respectively, if one identifies $1 - F_{V_n}(v)$ with P_n and $1 - F_{U_n}(v)$ with Q_n. This is not surprising since for any fixed v, the propositions "$V(J_i) > v$" propagate by the same logic as the propositions "J_i is a WIN"; MAX nodes function as OR gates and MIN nodes perform an AND logic.

From the fact that P_n converges to a step-function as $n \to \infty$ (see Eq. (8.19)), we must conclude that $F_{V_n}(v)$, likewise, satisfies:

$$\lim_{n \to \infty} F_{V_n}(v) = \begin{cases} 0 & F_{V_0}(v) < 1 - \xi_b \\ 1 - \xi_b & F_{V_0}(v) = 1 - \xi_b \\ 1 & F_{V_0}(v) > 1 - \xi_b \end{cases} \qquad (8.26)$$

Assume, for the moment, that the terminal values V_0 are continuous random variables and that the distribution $F_{V_0}(v)$ is strictly increasing in the range $0 < F_{V_0} < 1$. In this case $F_{V_0}(v)$ has a unique inverse and the condition $F_{V_0}(v) = 1 - \xi_b$ is satisfied by one unique value of v which we call v^*:

$$v^* = F_{V_0}^{-1}(1 - \xi_b) \qquad (8.27)$$

Eq. (8.26) then implies that when the game tree is sufficiently tall, the cumulative distribution of the root-node value approaches a step function in v, and that the transition occurs at a unique value v^* which is called the $(1 - \xi_b)$-*quantile* of the terminal distribution $F_{V_0}(v)$. That implies that the density of $V_n(J)$, $F'_{V_n}(v)$, becomes highly concentrated around v^* or, in other words, that the **root-node value is almost certain to fall in the very close neighborhood of** v^*. It appears that the repeated application of alternating MIN-MAX operations on the terminal values has the effect of filtering out their uncertainties until the result emerges at the high levels of the tree as an almost certain, predetermined quantity. This is a rather remarkable phenomenon which deserves to be decorated by a theorem.

THEOREM 1 (Minimax Convergence). *The root value of a (d, b, F)-tree with continuous strictly increasing terminal distribution F converges, as $d \to \infty$ (in probability) to the $(1 - \xi_b)$-quantile of F, where ξ_b is the solution of $x^b + x - 1 = 0$.*

If the terminal values are discrete: $v_1 < v_2 < \cdots < v_M$, *then the root value converges to a definite limit if* $1 - \xi_b \neq F_{V_0}(v_i)$ *for all i, in which case the limit is the smallest* v_i *satisfying:*

$$F_{V_0}(v_{i-1}) < 1 - \xi_b < F_{V_0}(v_i)$$ ∎

The second part of Theorem 1 becomes evident by writing:

$$P[V_n(J) = v_i] = F_{V_n}(v_i) - F_{V_n}(v_{i-1})$$

If $1 - \xi_b$ can be "sandwiched" between two successive levels of F is such a way that $F_{V_0}(v_{i-1}) < 1 - \xi_b < F_{V_0}(v_i)$, then according to (8.26), $F_{V_n}(v_i) \to 1$, $F_{V_n}(v_{i-1}) \to 0$, and consequently $P[V_n(J) = v_i] \to 1$.

The remarkable feature of this phenomenon is that Theorem 1 holds for any arbitrary distribution of the terminal values. Thus, for example, the root value of a binary tree ($b = 2$) with terminal values uniformly distributed between 0 and 1 would converge to the value $1 - (\sqrt{5}-1)/2 = .382\ldots$. If the terminal values are integers, uniformly distributed between 1 and 100, then $F_{V_0}(38) < 1 - \xi_b = .382 < F_{V_0}(39)$, and so the root value converges to the integer 39.

Exceptions to the theorem would occur only in rare pathological cases where $1 - \xi_b$ coincides exactly with one of the plateaus of $F_{V_0}(v)$, as shown in Figure 8.15. In such a case, the asymptotic distribution of the root node would go from 0 to 1 in two steps, one at v_1 and the other at v_2, as is shown in Figure 8.16. This implies that $V_n(J)$ does not converge to a single limit but may assume two possible values; in a fraction ξ_b of the instances it will be assigned the value v_2 and in the remaining instances the value v_1. In fact, Section 8.3.1 already dealt with such a case where, if $P_0 = \xi_b$, the status of the root node remains undetermined between WIN ($V_n = 1$) and LOSS ($V_n = 0$). Some amusing applications of Theorem 1 will be described in Section 8.4.

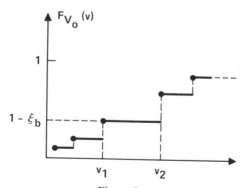

Figure 8.15
A pathological distribution function F_{V_0} which agrees exactly with $1 - \xi_b$ over some interval.

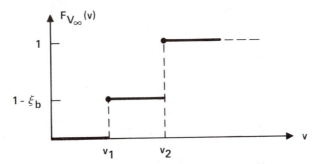

Figure 8.16

The limiting distribution function $F_{V_\infty} = \lim\limits_{n \to \infty} F_{V_n}$ for the pathological case of Fig. 8.15 takes on v_1 with probability $1 - \xi_b$, else v_2.

At this point a natural question to ask is how fast the density of the root value contracts to its final value v^*. The answer is that the width of the density function decreases exponentially with n. More precisely, it can be shown (Pearl, 1981a) that the sequence of random variables

$$y_n = \frac{V_n - v^*}{a^n} \qquad n = 0, 1, \ldots$$

possesses a limiting distribution $\phi(y) = \lim\limits_{n \to \infty} P(y_n \leqslant y)$, where

$$a = \left[\frac{\xi_b}{b(1 - \xi_b)} \right]^2 < 1$$

and $\phi(y)$ is the solution of Poincaré equation (Kuczma, 1968):

$$\phi(y) = g[\phi(ay)]$$

with

$$g(x) = [1 - (1 - x)^b]^b$$

Thus, for large n, the distributions of V_n become identical in shape save for a scale factor a^n. The density of these minimax values *contracts* by a factor $a < 1$ with each additional minimax cycle.

This finding raises some interesting questions regarding the advisability of searching deep uniform game trees. If the top level values of these trees can be predetermined with virtual certainty, why spend the exponentially growing effort demanded by an exact evaluation? Instead of insisting on selecting the *best* first move, we might as well select just any move at random. Even assuming that the terminal values represent exact payoffs, the expected loss of opportunity induced by such random selection is guaranteed not to exceed some predetermined limit that diminishes exponentially with the height of the remaining tree. It makes more sense to reserve one's computational powers for

the end-game where the shallowness of the trees is accompanied by more wide-ly varying node values.

These arguments touch on the more general questions of how the reliability of the backed-up minimax value compares with the reliability of the static evaluation of frontier nodes and how the willingness to act somewhat subop-timally can be converted into computational savings. The former is analyzed in Chapter 10, and the latter deserves serious studies. At this point, it suffices to state that the uniform tree model with independent and identically distributed terminal values was not devised as a practical game-playing tool but rather as a test bed for comparing the efficiencies of various exact-search methods. We will pursue this plan in the remaining part of this chapter.

8.3.3 The Mean Complexity of Solving a Standard (d, b, P_0)-game

Solving a game tree means deciding whether the root node is a WIN or a LOSS. An absolute lower bound on the number of terminal node examina-tions needed for establishing the status of the root node is given by the decision argument mentioned in Section 8.1.1. If the root node is a WIN, there exists a subtree called a solution tree consisting of one branch emanating from each MAX node and all branches emanating from each MIN node, terminating at a set of WIN terminal positions. Similarly, if the game is a LOSS, such a solu-tion tree exists for the opponent, terminating at all LOSS nodes. In either case, the number of terminal positions in a solution tree is b^n (representing a branching factor b in each move-cycle) or $b^{d/2}$ where d is the number of indi-vidual moves. The number of terminal node examinations required to solve the game must be at least $b^{d/2}$ since, regardless of how the solution tree was discovered, one must still certify that all of its $b^{d/2}$ terminal nodes are WIN in order to defend the proposition "root is a WIN." Thus, $b^{d/2}$ represents the number of terminal nodes inspected by a nondeterministic algorithm that solves the (d, b, P_0)-game and is therefore a lower bound for all deterministic algorithms.

It is possible to show that any algorithm solving the (d, b, P_0)-game would, in the worst case, inspect all b^d terminal positions. This can be done by clever-ly arranging the terminal assignments in such a way that a decision could not be reached until the last node is inspected. Since the difference between $b^{d/2}$ and b^d may be quite substantial, it is interesting to evaluate the expected number of terminal examinations where the expectation is taken with respect to all possible WIN-LOSS assignments to the terminal nodes.

DEFINITION: *Let A be a deterministic algorithm that solves the (d, b, P_0)-game and let $I_A(d, b, P_0)$ denote the expected number of terminal positions examined by A. The quantity:*

$$R_A(b, P_0) = \lim_{d \to \infty} \left[I_A(d, b, P_0) \right]^{1/d}$$

*is called the **branching factor** corresponding to the algorithm A.*

For deep trees, the branching factor measures the relative increase of I_A due to extending the search depth by one extra move. Equivalently, R_A measures the average number of moves explored by A from a typical node of the game tree.

DEFINITION: *Let C be a class of algorithms capable of solving a general (d, b, P_0)-game. An algorithm A is said to be **optimal over C** if for all $P_0, b,$ and d:*

$$I_A(d, b, P_0) \leqslant I_B(d, b, P_0) \qquad \forall \, B \in C$$

*Similarly, an algorithm A is said to be **asymptotically optimal over C** if for all P_0 and all b:*

$$R_A(b, P_0) \leqslant R_B(b, P_0) \qquad \forall \, B \in C$$

DEFINITION: *An algorithm A is said to be **directional** if for some linear arrangement of the terminal nodes it never selects for examination a node situated to the left of a previously examined node.*

Simply stated, an algorithm is directional if it always examines nodes from left to right, regardless of the content of the nodes examined. Clearly, every depth-first algorithm is directional and, vice versa, every directional algorithm must explore nodes in a depth-first fashion. This is so because once the subtree rooted at J is explored by a directional algorithm and is abandoned (to explore nodes at other subtrees), it can never be visited again thus yielding a depth-first search. The advantage of directional algorithms lies, of course, in their low storage requirement; they only maintain a single traversal path. We now compute the branching factor of the depth-first algorithm SOLVE described in Section 8.2.1.

We first compute $I_{\text{SOLVE}}(d, b, P_0)$ by considering the n^{th} cycle preceding the terminal positions. Let x_n stand for the expected number of terminal nodes inspected in solving an n-cycle tree rooted at J, and y_n the expected number of inspections used for solving any of the successors of J (see Figure 8.17). The probability of issuing a WIN after solving the k^{th} successor is $(1 - Q_n)^{k-1} Q_n$. Such an event requires an average of $(k - 1)y_n^- + y_n^+$ terminal inspections,

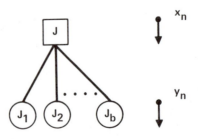

Figure 8.17
Notation used for a MAX-node in the analysis of SOLVE.

where y_n^- and y_n^+ stand for the mean number of inspections required for establishing a LOSS or a WIN, respectively, for a typical successor of J. Also, the event of issuing a LOSS for J occurs with probability $(1 - Q_n)^b$ and a mean expenditure of by_n^- inspections. Therefore:

$$x_n = \sum_{k=1}^{b} Q_n (1 - Q_n)^{k-1} [(k-1)y_n^- + y_n^+] + b(1 - Q_n)^b y_n^-$$

$$= y_n^+ Q_n \frac{1 - (1 - Q_n)^b}{Q_n} + y_n^-(1 - Q_n)\frac{1 - (1 - Q_n)^b}{Q_n}$$

$$= [y_n^+ Q_n + y_n^-(1 - Q_n)]\frac{[1 - (1 - Q_n)^b]}{Q_n}$$

and, using Eqs. (8.16) and (8.17),

$$x_n = y_n \frac{P_n}{P_{n-1}^b} \qquad (8.28)$$

Now examine the solution of any successor of J, say J_1, as in Figure 8.18. The event of issuing a LOSS after solving its k^{th} successor has a probability $P_{n-1}^{k-1}(1 - P_{n-1})$ and carries a mean expenditure of $(k-1)x_{n-1}^+ + x_n^-$ inspections. The event of exiting with a WIN involves solving all b successors and therefore occurs with probability P_{n-1}^b and costs an average of bx_{n-1}^+ inspections. Thus,

$$y_n = \sum_{k=1}^{b} P_{n-1}^{k-1}(1 - P_{n-1})[(k-1)x_{n-1}^+ + x_{n-1}^-] + bP_{n-1}^b x_{n-1}^+$$

$$= [x_{n-1}^+ P_{n-1} + x_{n-1}^-(1 - P_{n-1})]\frac{(1 - P_{n-1}^b)}{1 - P_{n-1}}$$

$$= x_{n-1}\frac{1 - P_{n-1}^b}{1 - P_{n-1}} \qquad (8.29)$$

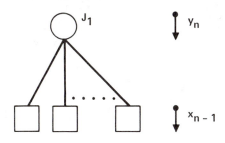

Figure 8.18
Notation used for a MIN-node in the analysis of SOLVE.

Combining Eqs. (8.28) and (8.29) we obtain:

$$\frac{x_n}{x_{n-1}} = \frac{1 - Q_n}{Q_n} \cdot \frac{P_n}{1 - P_{n-1}} = \frac{P_n\,(1 - P_{n-1}^b)}{P_{n-1}^b\,(1 - P_{n-1})} \tag{8.30}$$

Since x_n is equivalent to $I_{\text{SOLVE}}(2n, b, P_0)$ and $x_0 = 1$, we can state:

THEOREM 2. *The expected number of terminal positions in a (b, d, P_0)-tree examined by the SOLVE algorithm is given by:*

$$I_{\text{SOLVE}}(d, b, P_0) = \prod_{i=1}^{d/2} \frac{P_i(1 - P_{i-1}^b)}{P_{i-1}^b(1 - P_{i-1})} \tag{8.31}$$

where P_i, $i = 1, 2, \ldots, d/2$, is related to P_0 by Eq. (8.18).

A more elegant expression for I_{SOLVE} is obtained using the NEG-MAX notation. Let P_h' stand for the probability that a player, starting from a position with h moves remaining before termination, can force a WIN. We have:

$$I_{SOLVE}(d, b, P_0) = \prod_{d}^{h=1} \frac{P_h'}{1 - P'_{h-1}} \tag{8.32}$$

where

$$P_h' = 1 - (P'_{h-1})^b \quad \text{and} \quad P_0' = P_0 \tag{8.33}$$

Using Eqs. (8.21) and (8.31) we can also show that, if $P_0 \neq \xi_b$, the ratio between $I_{\text{SOLVE}}(d, b, P_0)$ and $b^{d/2}$ remains bounded as d tends to infinity, thus

$$I_{\text{SOLVE}}(d, b, P_0) \leqslant G(b, P_0)\, b^{d/2}, \qquad P_0 \neq \xi_b \tag{8.34}$$

where $G(b, P_0)$ is some function independent of d.

Theorem 2 permits an easy calculation of $I_{\text{SOLVE}}(d, b, P_0)$ for wide ranges of b and d, as shown in Figure 8.19.

In the special case where $P_0 = \xi_b$ all terms in the product of Eq. (8.16) are equal and, using $(\xi_b)^b = 1 - \xi_b$, Eq. (8.31) reduces to:

$$I_{\text{SOLVE}}(d, b, \xi_b) = \left[\frac{\xi_b}{1 - \xi_b}\right]^d \tag{8.35}$$

Note that $\displaystyle\lim_{P_{n-1} \to 0} \frac{x_n}{x_{n-1}} = \lim_{P_{n-1} \to 1} \frac{x_n}{x_{n-1}} = b$, which implies

$$\lim_{n \to \infty} \frac{x_n}{x_{n-1}} = \begin{cases} b & P_0 \neq \xi_b \\[2mm] \left[\dfrac{\xi_b}{1 - \xi_b}\right]^2 & P_0 = \xi_b \end{cases} \tag{8.36}$$

This limit, combined with the very rapid convergence of P_n (see Eq. (8.21)), leads directly to the asymptotic branching factor of SOLVE.

Figure 8.19(a)

The effective branching factor (the dth root of the expected number of leaves generated) of SOLVE as a function of the depth d and probability P_0 that a leaf node be a WIN. Part (a) is for $b = 5$ children/node; part (b) is for $b = 20$ children/node.

COROLLARY 1: *The branching factor of the SOLVE algorithm is given by:*

$$R_{\text{SOLVE}}(b, P_0) = \begin{cases} b^{1/2} & P_0 \neq \xi_b \\ R^*(b) & P_0 = \xi_b \end{cases} \tag{8.37a}$$

where ξ_b is the positive solution of $x^b + x - 1 = 0$, and $R^(b)$ is given by:*

$$R^*(b) = \frac{\xi_b}{1 - \xi_b} \tag{8.37b}$$

∎

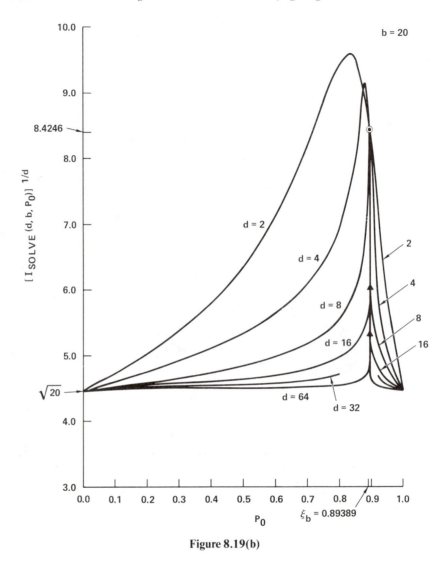

Figure 8.19(b)

Recalling that $b^{1/2}$ is an absolute lower bound for the branching factor of any game-solving algorithm, we conclude the following corollary.

COROLLARY 2: *SOLVE is asymptotically optimal for $P_0 \neq \xi_b$.* ■

The asymptotic behavior of SOLVE for $P_0 \neq \xi_b$ has a simple intuitive explanation. According to Eq. (8.19) as $n \to \infty$, almost all nodes at sufficiently high levels of the game tree are either WIN (if $P_0 > \xi_b$) or LOSS (if $P_0 < \xi_b$). In the first case SOLVE explores only the first successor of a MAX node and all b successors of a MIN node. The opposite occurs in the second

case. In both cases, I_{SOLVE} increases by a factor of b with the addition of each 2-move cycle, which is equivalent to a factor of $b^{1/2}$ with each single move. Hence, $R = b^{1/2}$.

The branching factor parameter only quantifies the rate of growth of I as d tends to infinity but gives no information regarding the absolute value of I for bounded depths. In fact, I can be multiplied by any polynomial of d without affecting its branching factor. However, a more detailed analysis of the product in Eq. (8.31) reveals (see Chapter 9, Theorem 1) that for all P_0 and all d, $I_{SOLVE}(d, b, P_0)$ can be bounded by

$$I_{SOLVE}(d, b, P_0) \leqslant L(b)R^*(b)^d \tag{8.38}$$

Hence,

$$I_{SOLVE}(d, b, P_0) = O\left[R^*(b)^d \right] \tag{8.39}$$

Any directional algorithm that is governed by a successor-ordering scheme identical to that of SOLVE must examine all the nodes examined by SOLVE. This is so because if some left-to-right algorithm B skips a node visited by SOLVE, a WIN-LOSS assignment can be found that would render the conclusion of SOLVE contrary to that of B. Thus B could not be a general algorithm for solving all (d, b, P_0)-trees. Now, since $I_{SOLVE}(d, b, P_0)$ is independent of the particular choice of ordering scheme, we may conclude that SOLVE is optimal over the class of directional game-solving algorithms.

COROLLARY 3: *The lowest expected number of terminal nodes examined by any directional algorithm that solves a general (d, b, P_0)-tree is given by Eq. (8.31) and its branching factor by Eq. (8.37).* ∎

This argument provides no guarantee that SOLVE is optimal over nondirectional algorithms for trees with limited search depths or for $P_0 = \xi_b$. The **optimality of SOLVE** under these added conditions and for all uniform game trees was established by Tarsi (1983) using a more elaborate analysis.

It is not hard to see that for some nonuniform game trees a nondirectional search outperforms any directional search. Consider, for example, the tree in Figure 8.20 and assume that P_0 is almost 1 for all leaf nodes. In this case, starting with J, it probably takes just one step to solve the whole tree, but if J_1 is found to be a LOSS, it is better to jump to K_1 rather than to proceed with J_2 and J_3. Since P_0 is almost 1, such a jump is likely to produce a solution in just one step, whereas proceeding with J_2 and J_3 would require at least two additional steps to a solution. Thus the optimal search algorithm for this game tree is not directional because it may leave the subtree rooted at J before solving J, and if K turns out to be a LOSS, J must be revisited, thus defying directionality.

The main result of Tarsi's analysis is that for trees where the degrees of all nodes at a given level are equal, there always exists a directional algorithm that is optimal for every value of P_0. This, together with Corollary 3, implies:

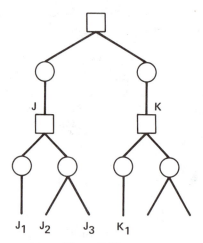

Figure 8.20

A game-tree demonstrating the limitations of purely directional algorithms.

COROLLARY 4 (Tarsi): *The optimal mean complexity of solving a standard (d, b, P_0)-game is given by Eq. (8.31), its branching factor by Eq. (8.37), and it is achieved by the depth-first algorithm SOLVE.* ∎

The case $P_0 = \xi_b$ deserves special attention as it causes SOLVE to exhibit its worst performance. Although this case is not very likely to occur in practical WIN-LOSS games, it plays an important role in the analysis of games with continuous values. We therefore conclude this section by examining the behavior of $R_{\text{SOLVE}}(b, \xi_b) = R^*(b)$ for large values of b. Writing:

$$q(b) = 1 - \xi_b \tag{8.40}$$

the defining equation for $q(b)$ becomes

$$q(b) = [1 - q(b)]^b \tag{8.41}$$

which can be satisfied only when

$$\lim_{b \to \infty} q(b) = 0 \tag{8.42}$$

Taking the log on both sides of Eq. (8.41), gives:

$$\log q(b) = b \log [1 - q(b)] = -b[q(b) + O(q^2)] \tag{8.43}$$

or

$$q(b) = (1/b) \log 1/q(b) + O(q^2) \tag{8.44}$$

Bootstrapping through repeated iterations, the solution of Eq. (8.44) can be written:

$$q(b) = 1/b[\log b - \log \log b + \log \log \log b - \cdots] \tag{8.45}$$

from which we see that for large b:

$$q(b) = \frac{\log b}{b} + O\left[\frac{\log \log b}{b}\right] \tag{8.46}$$

Substituting Eqs. (8.46) and (8.40) in Eq. (8.37b), the asymptotic behavior of $R^*(b)$ becomes

$$R^*(b) = \frac{b}{\log b}\left[1 + O\left[\frac{\log \log b}{\log b}\right]\right] \tag{8.47}$$

The log-log graph of Figure 8.21 depicts $R_{\text{SOLVE}}(b, \xi_b)$ for the range $2 \leqslant b \leqslant 10{,}000$. It is shown to be in remarkable agreement with the formula $(.925)b^{.747}$, while the asymptotic expression $b / \log b$ becomes a better approximation only for $b > 2000$. Since the number of moves considered in common games is usually below 100, we are justified in using the approximation $R^*(b) \approx (.925)b^{.747}$ or, more conveniently, $R^*(b) \approx b^{\frac{3}{4}}$.

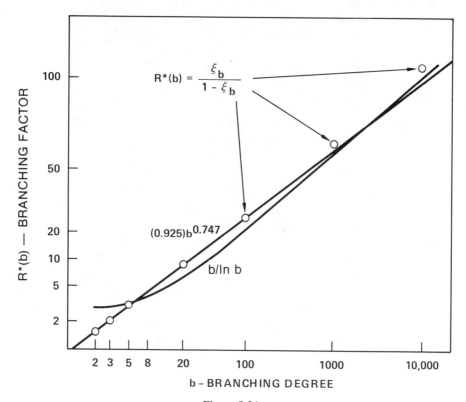

Figure 8.21
The branching factor $R^*(b)$ (shown as small circles) as a function of b on a log-log graph, along with its asymptotic estimate $b / \ln(b)$ and the approximation $0.925(b)^{0.747}$.

8.3.4 The Mean Complexity of Testing and Evaluating Multivalued Game Trees

When the terminal positions are assigned real values, the root node must be *evaluated* rather than *solved*, and our analysis of the SOLVE algorithm is no longer applicable. It is still applicable, however, to the task of *testing* whether the minimax value of the root node exceeds some reference value v.

From the structural identity of SOLVE and TEST, it is clear that the expected number of nodes inspected by TEST, $I_{TEST}(d, b, F_{V_0}, v)$, is equal to that inspected by SOLVE if the terminal nodes are assigned WIN labels with probability $P_0 = P[V_0(t) > v] = 1 - F_{V_0}(v)$. Therefore:

$$I_{TEST}(d, b, F_{V_0}, v) = I_{SOLVE}(d, b, 1 - F_{V_0}(v)) \qquad (8.48)$$

Eq. (8.48), combined with Eq. (8.37), yields the following,

THEOREM 3. *The expected number of terminal positions examined by the TEST algorithm in testing the proposition "$V(s) > v$" for the root of a (d, b, F_{V_0})-tree has a branching factor*

$$R_{TEST}(b, F_{V_0}, v) = \begin{cases} b^{1/2} & \text{if } v \neq v^* \\ R^*(b) & \text{if } v = v^* \end{cases} \qquad (8.49)$$

where v^ satisfies $F_{V_0}(v^*) = 1 - \xi_b$.* ∎

From the fact that SOLVE is optimal we can also conclude:

COROLLARY 5: *The optimal mean complexity of any algorithm which tests whether the root node of a (d, b, F_{V_0})-tree exceeds a specified reference v is given by $I_{SOLVE}(d, b, 1 - F_{V_0}(v))$ in Eq. (8.31), its branching factor by Eq. (8.49), and is achieved by the depth-first algorithm TEST.* ∎

Note that when the terminal values are continuous (and $F_{V_0}(v)$ strictly increasing) Theorem 1 states that $V(s)$ converges to v^* for very large d. Thus, although testing the proposition "$V(s) > v$" is easier for $v \neq v^*$, the outcomes of such tests are almost trivial. The most informative test is that which verifies whether $V(s) > v^*$, and such a test, according to Eq. (8.49) is indeed the hardest.

When the terminal positions are assigned discrete values, unless $1 - \xi_b$ coincides with one of the plateaus of F_{V_0}, the equation $F_{V_0}(v^*) = 1 - \xi_b$ would not have a solution and the limiting root value would converge to the smallest v' satisfying $F_{V_0}(v') > 1 - \xi_b$. Thus all inequality propositions could be tested with a branching factor $b^{1/2}$.

Consider now the minimum number of terminal node examinations required to **evaluate** a game tree. At the best possible case, even if someone hands us the

true value v of s, any evaluation algorithm should be able to defend the proposition "$V(s) = v$", that is, to defend the pair of propositions "$V(s) \geqslant v$" and "$V(s) \leqslant v$." Both propositions must be proven true from the game tree itself, except in the rare case where v is known to equal an extreme point of the range of V_0. Now, since the solution tree required for the verification of an inequality proposition contains $b^{d/2}$ terminal positions and since the sets of terminal positions participating in the defense of each of these inequalities are mutually exclusive, save for the one position satisfying $V_0(t) = V(s)$, we have the following corollary.

COROLLARY 6: *Any procedure that evaluates a (d, b, F_{V_0})-tree must examine at least $2b^{d/2} - 1$ nodes.* ∎

We assumed, of course, that d is even. If d is odd, one solution tree will contain $b^{(d+1)/2}$ leaf nodes and the other $b^{(d-1)/2}$ nodes, giving a total of $b^{(d-1)/2} + b^{(d+1)/2} - 1$ terminal nodes. This result was also proven by Knuth and Moore (1975), using a more elaborate proof. Earlier, Slagle and Dixon (1969) proved that the α-β procedure achieves this optimistic bound if the successor positions are perfectly ordered.

Let us consider now the more interesting question of estimating $I(d, b, F_{V_0})$, the **expected** number of terminal examinations required for evaluating (d, b, F_{V_0})-game trees. Let $I_0(d, b)$ be the minimal value of $I(d, b, F_{V_0})$ achieved by any algorithm under the worst-case F_{V_0}.

$$I_0(d, b) \triangleq \min_A \ \max_F I_A(d, b, F) \tag{8.50}$$

Every algorithm that evaluates a game tree must examine at least as many nodes as that required for testing whether the root value is greater than some reference v. This is so because an evaluation procedure produces a more informative outcome than any inequality test, and moreover one can always use the value $V(s)$ to deduce all inequality propositions regarding $V(s)$. This fact combined with the optimality of TEST over inequality-testing algorithms (see Corollary 5) leads to:

$$I_0(d, b) \geqslant R^*(b)^d \approx (b)^{\frac{3}{4}d} \tag{8.51}$$

The right-hand side of (8.51) is obtained when the terminal positions are assigned continuous values and TEST is given the task of verifying "$V(s) > v^*$." This leads directly to the following theorem.

THEOREM 4. *The expected number of terminal positions examined by any algorithm that evaluates a (d, b)-game tree with continuous terminal values must be greater than or equal to $R^*(b)^d$.* ∎

The quantity $R^*(b)$ was shown by Baudet (1978) to be a lower bound for the branching factor of the α-β procedure. Theorem 4 now extends the bound to

all game-evaluating algorithms. In Chapter 9 we will show that all three algorithms, α-β, SSS*, and SCOUT, actually achieve this branching factor, a fact that renders all three **asymptotically optimal**. Moreover, we will also show that the expected costs I of these algorithms are not too far from the lower bound $R^*(b)^d$.

However, before engaging in these intricate analyses, the reader may wish to enjoy a moment of relaxation. We, therefore, take a short excursion to explore some recreational aspects of game-searching, especially those associated with Theorem 1.

8.4 RECREATIONAL DIVERSIONS

8.4.1 The Board-Splitting Game—A Physical Embodiment of the Standard Game Tree

The model we chose as a standard test bed for game playing strategies has many artificial properties. The facts that there are exactly b moves from every nonterminal position, that the game ends after exactly d moves, and that the WIN-LOSS status of the terminal positions is assigned at random certainly do not materialize in common games such as chess or checkers. Some readers may suspect therefore that the class of trees we chose to analyze does not represent even a single case having game-like challenge and appeal. The purpose of this section is to pacify such suspicions. We will present a simple board-game that possesses the structure of (d, b, P_0)-trees and that enables us to demonstrate in an entertaining visual manner both the issues confronted by game-playing machines and the mathematical results obtained in the preceding sections.

The game consists of an $N \times N$ board (N is a power of 2) where each cell contains either a 1 or a 0. Two players, called MAX and MIN take turns in splitting the board in two and removing (or covering) the unwanted half. MAX splits the board along a vertical cut and chooses the right or left half. MIN splits the board horizontally, choosing the upper or lower half. After $n = \log_2 N$ move-cycles, there remains a single cell that can no longer be split. MAX wins the game if the last remaining cell contains a 1, he loses if it contains a 0. Figure 8.22 shows a possible sequence of moves on a 4×4 board.

Clearly, since the board configuration is available to both players, MAX may inspect the initial position to determine whether it offers a winning strategy, then decide if he wishes to play the game. However, when the board is very large (say 1024 × 1024), such an inspection may not be a simple matter, and our main concern should be whether there exists a simple procedure for deciding if a board position is a WIN or a LOSS.

For certain board configurations the game can be solved at first glance. For example, if the initial position contains a column with all 1's, MAX is

INITIAL MAX MIN MAX MIN MAX
POSITION MOVES MOVES MOVES MOVES WINS
 (LEFT) (DOWN) (RIGHT) (UP)

Figure 8.22
An illustrative play of the board-splitting game.

guaranteed a WIN. Similarly, if it contains an all 0 row, MIN can force a LOSS. However, these are rare special cases and the following question arises: how hard is it to solve a typical case when the initial configuration is chosen at random, say by flipping a coin on each square?

Figure 8.23, for example, was produced by a random device; each cell had a probability 1/3 of receiving a dot and a probability 2/3 of remaining empty. Would the reader prefer to be the first player or the second player? Does he wish to win on an empty cell or a full cell? Try it!

To further appreciate the concept of search effort, we can imagine that the board is initially covered and that MAX must pay a token for the privilege of inspecting the content of each cell he selects to uncover. How many tokens would MAX have to pay on the average in order to answer the preceding questions?

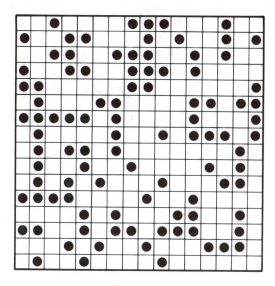

Figure 8.23
An initial configuration for the board-splitting game illustrating the difficulty of determining by eye whom the game favors.

Strangely, as a result of the phase-transition of Eq. (8.19), it is easier to answer these and many similar problems when the board size becomes very large. If we ask for the probability that a loaded p-coin (favoring 1 to 0 by $p/(1-p)$ odds) would generate a winning position for MAX, the answer is three-fold. Let ξ_2 stand for the golden ratio $\xi_2 = (\sqrt{5} - 1)/2 \approx 61.8\%$; then

1. If $p > \xi_2$, MAX is almost sure to start with a winning position;
2. If $p < \xi_2$, MAX is almost sure to lose; and
3. If $p = \xi_2$, MAX's chances of winning the game remain equal to ξ_2 regardless of the board size.

Thus, a fair coin ($p = \frac{1}{2}$) would put MAX at a tremendous disadvantage, whereas a loaded ξ_2-coin would give MAX a 61.8% advantage for all board sizes.

If $p = \xi_2$, we can easily determine the average number of cells that MAX must uncover before determining if he can win. Making the correspondence $b = 2$, $d = 2\log_2 N$, $P_0 = p$, that number is clearly given by

$$I_{\text{SOLVE}}(2\log_2 N, 2, \xi_2) = \left[\frac{\xi_2}{1 - \xi_2}\right]^{2\log_2 N} = N^{2\log_2 R^*(2)} \approx N^{1.388}$$

Thus, only a small fraction ($\approx 1/N^{.612}$) of the N^2 board cells need be uncovered. This fraction becomes even smaller when $p \neq \xi_2$, because in this case the branching factor of I_{SOLVE} is $b^{\frac{1}{2}}$, and so the average number of cells uncovered is proportional to $b^{d/2} = N$ rather than $N^{1.388}$.

A more interesting situation arises when the squares are assigned integer values (e.g., by rolling a die) and MIN promises to pay MAX as many dollars as the number indicated on the last remaining square. MAX's best move, as well as the value of the game, can be determined by the minimax method as shown in Figure 8.24. However, when the board is initially covered, how many squares would MAX need to inspect before deciding the value of the game and which board half to select on the first move?

The minimax convergence phenomenon (Theorem 1) implies that if the squares are assigned real values from some distribution F, then MAX can predict with almost certainty what value he can secure. It is equal to the $(1 - \xi_2)$-quantile of F, that is, that value above which there lies a fraction ξ_2 of

(MAX CAN ACHIEVE 3 BY SELECTING THE RIGHT HALF)

Figure 8.24
Minimax analysis of the board-splitting game with real-valued squares.

the area under the density curve. For instance, if the cell's content is deter-
mined by spinning a roulette wheel with integers $1, 2, \ldots, 10$, and both players
play optimally, one can almost guarantee that the last cell would contain the
number 4 since 4 is the $(1 - \xi_2)$-quantile of F (i.e., the lowest integer that
remains below the roulette outcome no more than $1 - \xi_2 = 38.1\%$ of the
time). The larger the board, the higher the certainty that MAX would be able
to realize a gain of exactly 4. The reader who tries to actually play the game
may be amazed with the accuracy of this prediction even on an 8×8 board.

We can now invoke the minimax convergence theorem to estimate the
number of cells that must be uncovered before the board can be evaluated with
certitude. Knowing *a priori* that the value of the game is almost surely 4, all we
need is to uncover enough cells with $V \geqslant 4$ to guarantee that MAX can
achieve at least 4, then uncover enough cells with $V \leqslant 4$ to demonstrate that
MIN can prevent MAX from getting more than 4. Each of these tasks is
equivalent to finding a winning strategy in a bi-valued game and can be exe-
cuted by examining an average $O(b^{d/2})$ terminal positions (see Eq. (8.34)).
Hence, MAX can find the best first move by uncovering an average of $O(N)$
cells.

The situation becomes more involved when the squares obtain random *con-
tinuous* values. From Theorem 4 we know that an average of at least
$[R^*(b)]^{2\log_2 N} \approx N^{1.388}$ cells must be uncovered. But how much more?

The answer is given in Chapter 9 where we analyze and compute the expect-
ed number of terminal nodes examined by SCOUT, α-β, and SSS*. The
reader may do well to study the cell-uncovering strategy dictated by each of
these three algorithms. It may sharpen the reader's insight into the anatomy of
the three game-searching algorithms and may evoke a discovery of new ones.
After mastering the information gathering policies corresponding to α-β and
SSS*, the reader may find it surprising that it took 6 years to invent the α-β
pruning algorithm (from Shannon, 1950, to McCarthy in 1956) and an addi-
tional 23 years (Stockman, 1979) to invent the SSS* algorithm.

As a pastime puzzle, the game has an interesting variation where the players
are allowed to cover only one column (for MAX) or row (for MIN) in each
move (exercise 8.6). Can you find the optimal playing strategies for MAX and
MIN? Can you determine the average number of cells that must be inspected
before deciding on the first move?

8.4.2 Other Applications of the Minimax Convergence Theorem

How To Make a Perfect Fuse. Consider a large collection of unreliable
electrical components (e.g., light bulbs, fuses) whose failure times are identical-
ly distributed random variables. If we connect two of them in series as in Fig-
ure 8.25(a), then the failure time T' of this series connection is given by
$\min(T_1, T_2)$. If we now connect two such circuits in parallel (Figure 8.25(b)),
the failure time of the parallel circuit is equal to that of the longest surviving

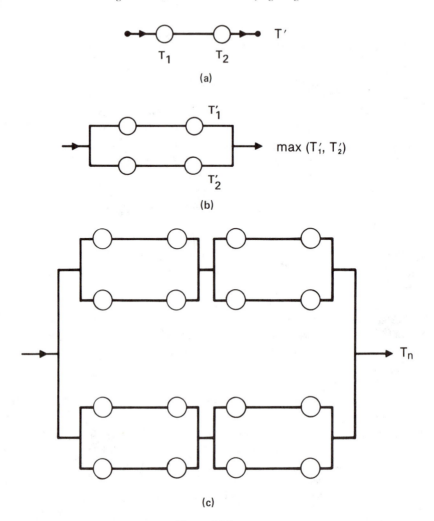

Figure 8.25
The construction of a series-parallel circuit of fuses, which, if repeated
long enough, will fail at a predictable time.

branch, i.e., $\max(T_1', T_2')$. Continuing the process, alternatingly connecting
duplicate circuits in series and in parallel for n cycles, a network such as that in
Figure 8.25(c) can be constructed. What can be said about the limiting distri-
bution of the failure time T_n of the entire circuit?

Clearly, T_n is equal to the minimax value of the root-node in an n-cycle
binary tree with terminal values determined by the failure times of the indivi-
dual components. According to Theorem 1, T_n converges to a definite value
given by the $(1 - \xi_2)$-fractile of the terminal distribution. Thus, assuming that
n is sufficiently large, the entire circuit should fail at a predictable, precise time,

which is quite remarkable considering the fact that the circuit is assembled from a host of independent, unreliable, and unpredictable components.

The convergence of the failure time to a predetermined value is not restricted to series-parallel circuits but occurs in most **recursive** networks. We take a "seed" circuit, replace each component by the seed circuit itself, and repeat the process. Figure 8.26, for example, shows a circuit constructed by two iterations on the Wheatstone bridge as a seed.

The convergence properties of recursive circuits can be determined by a simple analysis. The failure probability of the seed circuit is a polynomial $g(p)$ in p, where p is the failure probability of each component. Clearly, $g(p)$ has two trivial fixed points $g(0) = 0$ and $g(1) = 1$ and may have only one additional fixed point at the interior of the unit interval. However, exactly one of these fixed points is unstable, that is, satisfying both $g(q) = q$ and $g'(q) > 1$ (Moore and Shannon, 1956). If the unstable fixed point q of $g(p)$ is interior (as in Figure 8.13), the failure time of the recursive circuit converges (in probability) to the q-quantile of F, the distribution of the components failure time, and its variance vanishes geometrically like $[g'(q)]^{-n}$. In the second possibility, where q occurs at an end-point $p = 1$ or $p = 0$, the other end-point, $p = 0$ or $p = 1$, is stable and the convergence is toward the lowest or highest support of F, respectively.

Logic Circuits for Switching-Time Stabilization. Suppose we have a collection of $N = 2^n$ timing devices that are designed to fire an output signal at a specified time t_o. Due to variations in the operating conditions of these devices, the firing time of each device does not occur exactly at t_o but fluctuates randomly about some neighborhood of t_o. We now wish to use the fact that we

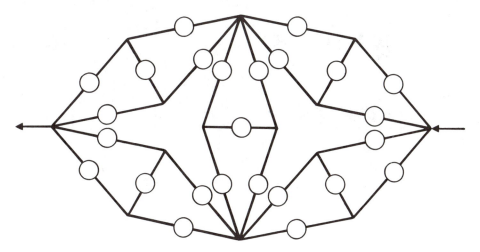

Figure 8.26
A recursive network built from a 5-component Wheatstone bridge.

have a multitude of devices in order to cut down the uncertainty in the firing time. How can this be accomplished?

We can, of course, construct a majority-logic circuit that fires only when the majority of its inputs are ON, and feed the outputs of our firing devices as inputs to this circuit. However, majority-logic circuits are quite complex and nonmodular. As an alternative, the logical circuit of Figure 8.27 accomplishes the stabilization in a relatively simple way. It consists of a binary tree of NOR gates which is equivalent to the series-parallel circuit of Figure 8.25(c). The output of a NOR gate is ON if both its inputs are OFF, and therefore two levels of NOR logic are equivalent to a level of OR followed by a level of AND. Again, the switching time of this circuit's output is equal to the minimax value of the root-node in a binary game tree, where the terminal values are determined by the switching times of the individual inputs. Theorem 1 guarantees a

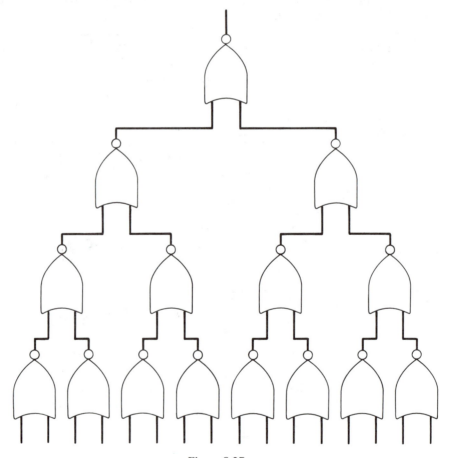

Figure 8.27
A tree of NOR gates for which the output fires more predictably than the signals arriving at the inputs.

reduction in the variance of the output switching time with each extra layer of the tree, and assures us, that the output will fire more predictably than the individual inputs. The rate of stabilization, however, is slower than that achievable via majority logic. The output variance for N-input circuit is reduced by a factor $1/N$ using majority logic and only by a factor $(1/N)^{.503}$ using the NOR tree of Figure 8.27.

On-Line Computation of Quantile Estimates. An obvious application of Theorem 1 is in the computation of the quantiles of an unknown distribution function F (Pearl, 1981a). Normally, when we need to estimate the q-quantile, z_q, of F (i.e., z_q is the solution of $F(x) = q$), we draw N random samples from F and compute the q-quantile of the sample. That is, we select the sample that ranks $\lfloor Nq \rfloor + 1$ from the bottom. This method encounters computational difficulties when N is large because it requires that all the samples reside in memory when z_q is computed. Theorem 1 permits us to use game-searching techniques such as α-β to compute z_q *on line*; by recursively updating the estimates each time a new sample arrives. We simply *pretend* that the arriving samples are the terminal nodes encountered by α-β as it traverses a game tree from left to right. The highest (even-level) node evaluated can, at any time, be taken as an estimate of the $(1 - \xi_b)$-quantile of F; when N is large, the estimates become accurate. Different quantiles can be estimated by pretending that the tree has a different degree b.

Clearly, since α-β only maintains a single path from the root to the currently examined node, this method requires the retention in storage of at most $\log_b N$ representative data points, where N is the number of samples observed in the past. Moreover, due to the pruning power of α-β, the estimation accuracy provided by the minimax method compares very favorably with that of the sample-quantile method. The standard deviation of the minimax estimates decreases approximately like $O(N^{-3/7})$ instead of the traditional $O(N^{-1/2})$ reduction for the sample-quantile estimates.

8.4.3 Games as Mazes with Hidden Paths: A Useful Metaphor

The analogy between games and path-seeking problems is clearly demonstrated by the circuit of Figure 8.25(c), which represents a standard (d, b)-game tree such as that of Figure 8.2. Each component (or edge) in the circuit stands for one terminal node of the game, and the component failure time represents the value assigned to the corresponding node. The minimax value of the game equals the time to failure of the entire circuit, that is, it equals the operating time of *the longest surviving source-to-sink path* in the circuit. Thus, the task of winning a bi-valued game corresponds to that of finding a well-functioning, source-to-sink path in the circuit. The task of selecting the best strategy in a multi-valued game corresponds to that of finding the longest surviving source-to-sink path in the circuit.

In the same way that the value of any game-playing strategy for MAX is equal to the lowest value leaf node in the subtree representing that strategy, so also the value of each path in the circuit is equal to the lowest value component (or edge) along that path. Each MIN strategy in the game maps into a **cut** in the circuit, that is, a set of edges that separates the source from the sink. Indeed, the existence of a cut consisting of only malfunctioning components precludes the existence of a functioning source-to-sink path in the circuit. The former corresponds to the existence of a MIN strategy forcing a LOSS on MAX, which should, of course, prevent MAX from finding a winning strategy. In multi-valued games, the value of a MIN strategy is equal to the highest value leaf in the subtree representing the strategy, hence, the value of a cut is correspondingly equal to the highest value component in that cut. Thus, the task of evaluating a game tree translates to that of **finding one path and one cut both having the same value**.

The game-circuit analogy is not confined to uniform game trees but is quite general. Given an arbitrary game tree, one can always construct a series-parallel circuit to represent the game using the following procedure.

1. Map each interior MAX node to a parallel connection.
2. Map each interior MIN node to a series connection.
3. Map each terminal node to a component or an edge in the circuit.

The inverse mapping, from a series-parallel circuit to a game tree, is also straightforward.

Circuits, such as that in Figure 8.26, that cannot be represented by series-parallel connections, can also be mapped into game trees, but now the terminal nodes may not always be distinct. If we further cluster together all those terminal node that have the same identity, the result is a *game graph*. Figure 8.28 shows the conversion of a five-edge bridge circuit into a game tree and later into a game graph.

Game graphs, likewise, can be converted into equivalent series-parallel circuits containing some edges with identical values. It is not always possible, however, to convert an arbitrary game graph in such a way that the number of edges in the circuit does not exceed the number of terminal positions in the game.

Is the analogy useful? Like any other analogy, the usefulness of the game-circuit duality lies in its ability to *evoke expertise*. Visually, a circuit diagram is a more convenient representation than a game tree. The human eye is quicker in finding paths in a maze than finding solution trees in a game tree. The up-and-down eye movements connected with game-tree traversals are avoided in circuit layouts simply because all the interior nodes of the game have been eliminated and replaced by wire connections which, at least on paper, occupy minimal space.

To demonstrate the effectiveness of the path-finding representation, we return to the board splitting game of Figure 8.23 which, the reader should agree,

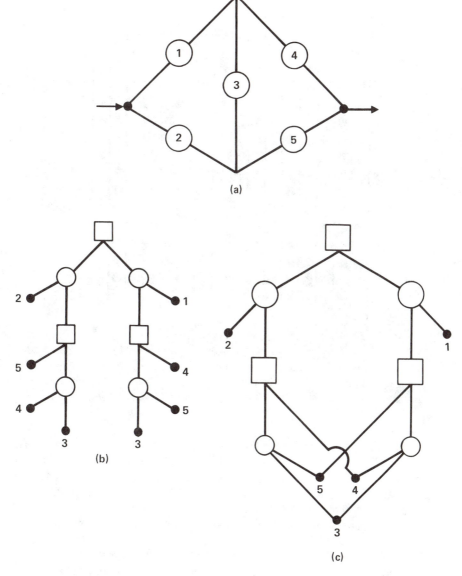

Figure 8.28
A Wheatstone bridge circuit (*a*) and its game tree (*b*) and game graph (*c*)
equivalents. The value of the game corresponds to the failure time of the
last-surviving path in the circuit.

is not easily solved by the bare eye. Figure 8.29 represents the same matrix of
cells with an added network of *partitions,* which turns the game into a circuit or
a maze. A strategy for MAX is represented in the maze by a top-to-bottom
path that does not cross any of the partitions. To find a winning strategy for

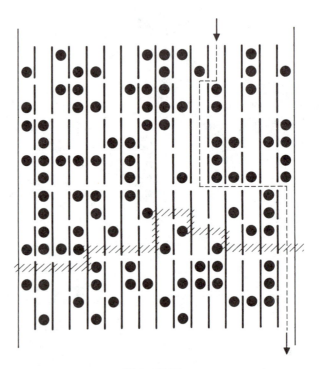

Figure 8.29

A system of partitions turns the board configuration of Figure 8.23 into a maze. The broken line corresponds to a MAX strategy guaranteeing an empty square. The shaded path corresponds to a MIN strategy (or a cut) demonstrating that MAX cannot win on a full square.

MAX, we only need to find a top-to-bottom path containing no empty cell (if MAX wins on a full cell) or containing all empty cells (if MAX wins on an empty cell). The reader should agree that the tasks of verifying the nonexistence of the former and the existence of the latter are now far easier and more challenging than in the original representation of Figure 8.23.

But solving games by visual skills would not in itself justify pursuing the analogy any further. After all, our main objective is to improve the problem-solving power of *machines* and those are not normally equipped with the highly sophisticated vision machinery possessed by man. The more important aspects of the game-maze duality are that it encourages the exchange of strategies and the transfer of expertise between the two task domains: game-searching and path-seeking.

The game-maze analogy reduces the problem of searching game trees to that of finding a maximum-capacity source-to-sink path in an edge weighted graph where the capacity of a path is defined as the lowest weight along its edges. This path-seeking problem is similar in many respects to the problem of finding the shortest (or the cheapest) path in a graph for which many algorithms have

been developed, tested, and analyzed. The two most popular methods of search for either the minimum sum-cost or the maximum-capacity path are: best-first (or uniform-cost in the absence of heuristic information) and backtracking. In Chapter 2 (Figures 2.4 and 2.6) we illustrated the search for a cheapest path conducted by these two strategies when the cost measure was additive. The extension to capacity-like or max-cost is straightforward. Figure 8.30 shows the sequence of cell inspections taken by both strategies, while seeking the maximum capacity path in a 4×4 maze. This maze is an exact representation of the game tree in Figure 8.6.

(a) (b)

Figure 8.30

The game-tree of Figure 8.6 depicted as a search for a maximum-capacity path in a maze. Part (a) represents best-first search; part (b) represents backtracking. Numbers in the lower-right corner of squares indicate the order of their evaluation.

Note how the best-first maze-searching strategy duplicates exactly the steps taken by SSS*. Similarly, the left-to-right top-down backtracking strategy mirrors the steps that would have been taken by α-β on the same game tree. Every path-optimization search strategy for graphs should have an image search strategy for evaluating game trees. For example, each of the hybrid strategies mentioned in Section 2.5, and especially those involving a component of irrevocable pruning, may point the way toward more effective game-searching techniques.

We will now show how ideas originally developed for analyzing game-searching can be used to elucidate path optimization tasks.

Searching for a Maximum Capacity Path in a Tree with Random Edge Capacities. Given a uniform b-ary flow tree of height N where each edge is assigned a capacity value X_1, X_2, \ldots, find the maximum capacity path from the root to

any of the leaves. What is the expected time of searching for a maximum capacity path if the capacities X_1, X_2, \ldots are drawn independently from a common continuous distribution $F_X(x)$?

A section of a binary flow tree and its corresponding game tree are shown in Figure 8.31. Obviously, the problem can be solved in the flow tree representation by a variety of path search algorithms, such as those mentioned in Chapter 2. However, the average case analysis of these algorithms may be rather involved. By applying the SCOUT algorithm on the corresponding game tree, we can easily show that, for any F and for all b, the problem can be solved in quadratic expected time.

Let $C(J)$ denote the capacity of an arbitrary node J in the flow tree, that is, $C(J)$ is the maximum capacity over all paths emanating from J to some leaf nodes. If J has b successors $J_1, J_2, \ldots, J_k, \ldots, J_b$ and X_k is the capacity of the edge from J to J_k, then $C(J)$ is defined recursively by

$$C(J) = \max_{1 \leqslant k \leqslant b} \{\min [X_k, C(J_k)]\} \qquad (8.52)$$

where $C(J)$ is understood to be ∞ if J is a terminal node.

The SCOUT algorithm, when viewed from the flow-tree formulation, evaluates C(J) as follows:

Procedure: EVAL $C(J)$

1. If J is terminal, return $C(J) = \infty$; else set $v \leftarrow 0$ and $k \leftarrow 0$ and continue.
2. Set $k \leftarrow k + 1$.
3. If $k = b + 1$, return $C(J) = v$, else continue.
4. Examine X_k; if $X_k \leqslant v$, go to step 2, else continue.
5. TEST[$C(J_k) \leqslant v$]; if TRUE, go to step 2, else continue.
6. TEST[$C(J_k) \geqslant X_k$]; if TRUE, set $v \leftarrow X_k$ and go to step 2, else continue.
7. EVAL $C(J_k)$; set $v \leftarrow C(J_k)$; go to step 2.

At the end of the k^{th} iteration of the loop the updated variable v stands for the maximal capacity of the k leftmost subtrees emanating from J. The inequality tests of step 5 and 6 are performed depth-first using the flow-tree correlate of the TEST algorithm for games (Section 8.2.4).

Let J be situated n levels above the leaves, let Z_n stand for the expected number of edges examined in the evaluation of $C(J)$, and let $y_{n-1}(k)$ and $y'_{n-1}(k)$ denote the expected number of edges examined in testing the inequalities $C(J_k) \leqslant v$ (step 5) and $C(J_k) \geqslant X_k$ (step 6), respectively. A successor node J_k may be tested once (step 5), twice (steps 5 and 6) or may be tested twice and evaluated (steps 5, 6, and 7). Let the probabilities associated with the events that J_k reaches steps 5, 6, and 7 be denoted by $P_5(k), P_6(k)$, and $P_7(k)$, respectively. Z_n can be related to Z_{n-1} via the recursion

$$Z_n = b + \sum_{k=1}^{b} P_5(k) y_{n-1}(k) + \sum_{k=1}^{b} P_6(k) y'_{n-1}(k) + Z_{n-1} \sum_{k=1}^{b} P_7(k) \qquad (8.53)$$

(a)

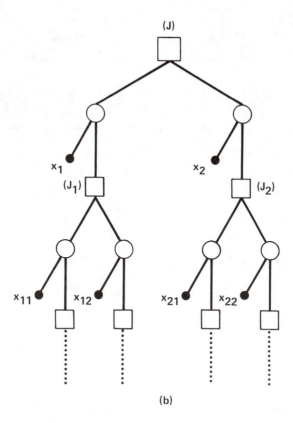

(b)

Figure 8.31
The problem of finding a maximum-capacity path in the flow tree of (a) is
equivalent to solving the game tree in (b).

where

$$P_5(k) = P[X_k > v_k]$$

$$P_6(k) = P[X_k > v_k, \text{ and } C(J_k) > v_k]$$

$$P_7(k) = P[v_k < C(J_k) < X_k]$$

and where v_k is the value of v upon the k^{th} entry into the loop of step 4, that is,

$$v_k = \begin{cases} \max_{1 \leqslant j < k} \{\min[X_j, C(J_j)]\} & k = 2, \ldots, b \\ 0 & k = 1 \end{cases} \qquad (8.54)$$

Testing inequalities of the type $C(J) > v$ amounts to searching for a path of length n after deleting from the flow tree every edge whose capacity does not exceed v. Since the paths remaining after such deletions can be thought of as **family lines in a branching process**, we know from Lemma 2 of Chapter 5 that the search can be accomplished in linear expected time, that is, $y_n(k) = O(n)$ and $y'_n(k) = O(n)$. Therefore, the asymptotic behavior of Z_n hinges on the last term in Eq. (8.53); it will be linear if $\sum_{k=1}^{b} P_7(k) < 1$, exponential if $\sum_{k=1}^{b} P_7(k) > 1$, and quadratic if $\sum_{k=1}^{b} P_7(k) = 1$. We will next show that as $n \to \infty$ strict equality holds, that is, $\sum_{k=1}^{b} P_7(k) \to 1$, and so $Z_n = O(n^2)$.

Letting $F_{v_k}(y)$, $F_C(y)$, and $F_X(y)$ stand for the distributions of v_k, $C(J_k)$, and X_k, respectively, and using the fact that these three variables are continuous and independent, we can write

$$\begin{aligned} P_7(k) &= P[v_k < C(J_k) < X_k] \\ &= \int P(v_k < y) P(y < X_k) \, dF_C(y) \\ &= \int [1 - F_X(y)] F_{v_k}(y) \, dF_C(y) \end{aligned} \qquad (8.55)$$

As $n \to \infty$, the relations between F_X, F_{v_k}, and F_C assume rather simple forms; from Eqs. (8.54) and (8.52) we obtain

$$F_{v_k} = [1 - (1 - F_X)(1 - F_C)]^{k-1}$$

and

$$F_C = [1 - (1 - F_X)(1 - F_C)]^b$$

where we assumed that $C(J_k)$ and $C(J)$ become identically distributed at high levels of the flow tree. These relations lead to

$$F_{v_k} = F_C^{(k-1)/b}$$

and

$$1 - F_X = \frac{1 - F_C^{1/b}}{1 - F_C}$$

and, when substituted in Eq. (8.55), give

$$P_7(k) = \int_0^1 \frac{1 - F_C^{1/b}}{1 - F_C} F_C^{(k-1)/b} dF_C$$

We can now perform the summation over k inside the integral and, using the formula for geometric series:

$$\sum_{k=1}^{b} F_C^{(k-1)/b} = \frac{1 - F_C}{1 - F_C^{1/b}}$$

we obtain directly

$$\sum_{k=1}^{b} P_7(k) = \int_0^1 dF_C = 1$$

This, together with Eq. (8.53), renders $Z_n = O(n^2)$. Thus, in a uniform flow tree with random edge capacities, **the SCOUT algorithm finds a maximum capacity path in quadratic expected time.**

The features that render SCOUT so amenable to analysis stem from its structural uniformity:

1. SCOUT begins the execution of each EVAL $C(J)$ phase afresh, unburdened by variables computed in previous phases.
2. The decision of whether to enter each EVAL $C(J)$ phase depends only on data gathered from nodes at the same level as J.

These features permit a simple recursive analysis of the performance of SCOUT (see Chapter 9) and help explain why it was SCOUT, and not α-β, that made possible the first demonstration that randomly ordered game trees can be evaluated with a branching factor of $R^*(b) = \xi_b / (1 - \xi_b)$.

The reader may find it instructive to explore how the flow tree will be searched when we apply α-β or SSS* to its game-tree image (exercises 8.7 and 8.8). The uniformity of SCOUT will be more appreciated once we try to analyze the average performance of these two algorithms.

8.5 BIBLIOGRAPHICAL AND HISTORICAL REMARKS

A survey of the chronology of computer chess and its literature can be found in Berliner (1978) and a fuller description, using sample games, in Newborn (1975). A comprehensive summary of the various heuristic strategies used in practical game-

searching programs is given in *The Handbook of Artificial Intelligence* (Barr and Feigen-baum, 1981).

The scheme of using bounded look-ahead followed by minimaxing was first suggested by Shannon (1950). It was implemented in early chess programs which conducted an exhaustive minimax search (Kister et al., 1957), and still serves as the basic paradigm in almost all game-playing programs.

John McCarthy was the first to recognize the potential for alpha-beta-type pruning in 1956, and is also responsible for coining the name "alpha-beta." The first written description of the alpha-beta method (with deep cutoffs) is contained in a memorandum by Hart and Edwards (1961), and the first published account appeared in the Russian literature (Brudno, 1963). The implementation of alpha-beta took longer to get entrenched; shallow cutoffs were used in an early chess program of Newell, Shaw, and Simon (1958) and perhaps even in Samuel's (1959) celebrated Checker-Playing Program. A full implementation of the method (with deep cutoffs) was described by Slagle and Dixon (1969). An excellent review of the historical development of the technique, including a proof of its correctness and an analysis of its performance, appears in Knuth and Moore (1975).

The best-first strategy SSS* was introduced by Stockman (1979), who developed it to solve problems of wave-form analysis. The roots of this method, however, go back to Nilsson (1969) and Slagle and Dixon (1969). Nilsson describes a best-first strategy (later called AO^*) for searching game trees which is very similar to SSS*. However, not taking full advantage of the potential for pruning candidate subtrees (step 8 of AO^*, Section 2.4.4) makes this search somewhat less efficient than SSS*. Slagle and Dixon's method of *dynamic ordering* offers another perspective of viewing SSS*. If, in the execution of alpha-beta, one reorders successors each time new information is obtained from nodes at the search frontier (an extreme case of dynamic ordering), then SSS* ensues. Another formulation of SSS*, based on a branch-and-bound paradigm, is given by Kumar and Kanal (1983).

The SCOUT strategy was introduced as a theoretical tool by Pearl (1980) and the rationale for its development is described in Section 8.2.4. The basic approach of using forward checking (or scouting) in optimization problems has also been found beneficial in several applications outside game-searching. For example, in the problem of finding the maximum capacity path (Section 8.4.3) SCOUT was found to outperform depth-search strategies (e.g., alpha-beta) by a factor of $(b - 1)/\ln b$ (exercise 9.4).

Our probabilistic treatment of the standard model for game trees is tailored after Pearl (1980). The history of analytical studies of game-searching performances is given in Section 9.2.1.

The use of recursive circuits to obtain a reliable performance from less reliable elements was first recognized by Moore and Shannon (1956), aiming to synthesize reliable relay networks. They proved that the polynomial $g(x)$ can cross the line $y = x$ only once and also mentioned the application to time stabilization. Pearl (1980) arrived at these applications the opposite way, seeking practical applications for the minimax convergence theorem which he encountered in game trees. Other methods of performing quantile estimation on-line are described in Weide (1978).

EXERCISES

8.1 Prove, by induction, the validity of Eqs. (8.3) and (8.4), namely, that in perfect information games a perfect player does not lose a thing by being forced to follow a prescribed strategy, open to his opponent, as long as he is given the option to choose that strategy.

8.2 a. (Knuth and Moore, 1975) Prove that it is always possible to reorder the successors of each node in a game tree in such a way that α-β will examine only critical nodes defined by $B - A = \infty$.

b. Find such a local reordering scheme for the game tree in Figure 8.6.

8.3 Suppose we know in advance that the terminal values lie in the range $[L, U]$. Modify α-β and SSS* so as to take advantage of this information and show that, if the terminal values are binary, $V \in \{0, 1\}$, then the modified algorithms both reduce to SOLVE.

8.4 Suggest improvements in SCOUT by letting EVAL use some of the information gatherable by TEST. Avoid improvements that require exponential storage space.

8.5 a. Prove that the function $y(x) = 1 - (1 - x^b)^b$ has a unique fixed point ξ_b in the interval $0 < x < 1$ given by the solution to $x^b + x - 1 = 0$.

b. Prove that $y'(\xi_b) > 1$ for all integers b.

c. Prove the validity of Eq. (8.21).

8.6 Find the optimal strategy for the board-covering game described at the end of Section 8.4.1. Calculate the distribution of the value of the game and the average number of inspections required for deciding the optimal first move.

8.7 Write an algorithm similar to EVAL $C(J)$ of Section 8.4.3 which computes the capacity $C(J)$ the α-β way, that is, by tracing the steps of α-β on the equivalent game-tree. Find a necessary and sufficient condition for an edge to be examined by the preceding algorithm. (*Hint*: You may use the flow-tree equivalent of the condition in Eq. (8.15)).

8.8 Repeat exercise 8.7 using SSS* instead of α-β. Which of the algorithms shown in Figure 2.10 will fit the one you wrote?

Chapter 9

Performance Analysis for Game-Searching Strategies

In this chapter we use the probabilistic model developed in Chapter 8 to quantify and compare the expected performances of SCOUT, α-β, and SSS*. We derive formulas for the expected number of frontier nodes examined by these three algorithms and then show that all three achieve the optimal branching factor $R^*(b)$ and, moreover, that even for moderate values of search depths the expected performances of the three are relatively close to one another.

At the end of the chapter we introduce two extensions to the standard model. First, we consider the effect of successor ordering assuming that the more meritorious successors have a higher likelihood of being among the first to be explored. Second, we consider nonuniform game trees where the number of legal moves available may vary at random from position to position, including the case of zero-moves termination (e.g., an early check-mate).

The expected performance of the SOLVE algorithm (Section 8.3.3) plays a major role in the analysis of SCOUT, α-β, and SSS*. It turns out that all three algorithms tacitly perform tests of inequalities, and so the expression for $I_{\text{TEST}}(d, b)$ appears as a dominant factor in the performance formulas of the three algorithms. To simplify the treatments of the formulas, we now introduce a **bound on** $I_{\text{SOLVE}}(d, b, P_o)$.

THEOREM 1. *For all* $0 \leqslant P_o \leqslant 1$ *and all* $d = 1, 2, ...,$ *the expected number of terminal nodes inspected by SOLVE while solving a standard* (d, b, P_o)-*game is bounded by:*

$$I_{SOLVE}(d, b, P_o) \leqslant L(b) \, R^*(b)^d$$

where $L(b)$ *is a constant depending on* b *only and* $R^*(b)$ *is the optimal branching factor* $\xi_b / (1 - \xi_b)$.

288

The proof of Theorem 1 is presented in Appendix 9-A. The reader is encouraged to follow this proof as it contains a useful technique for estimating complex functions of multiple iterations of some seed function $g(x)$. It makes use of a **characteristic distribution function $\phi(x)$** such that if the terminal values of a uniform game tree are distributed by $\phi(x)$, then the distribution of the minimax values j levels above the frontier will be given by $\phi(x/a^j)$. In other words, the distributions of all nodes in the tree will have identical shapes differing only by a scale factor.

9.1 THE EXPECTED PERFORMANCE OF SCOUT

9.1.1 Games with Continuous Terminal Values

Let J be a MAX node rooting a $(2n, b, F)$-tree with continuous terminal values independently drawn from a distribution F. Let z_n denote the expected number of terminal examinations undertaken by SCOUT. These examinations consist of those performed during the EVAL(J_k) phases ($k = 1, \ldots, b$) plus those performed during the TEST($J_k, v, >$) phases ($k = 2, \ldots, b$). Since the subtrees emanating from the successors of J all have identically distributed terminal values, the number of positions examined in each EVAL(J_k) phase have identical expectations, called z_n'. Let v_k be the test criterion during the TEST($J_k, v, >$) phase, and let $y_n(k)$ be the expected number of terminal examinations conducted in this phase (see Figure 9.1).

J_1 is always evaluated without being tested, thus consuming z_n' inspections. Each of the other successors is first tested, using $y_n(k)$ inspections, and then, if

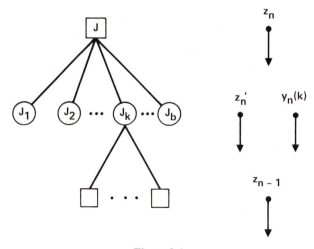

Figure 9.1
Notation used in the analysis of SCOUT.

found to satisfy $V(J_k) > v_k$, it is evaluated by an average of z_n' inspections. Thus, if q_k stands for the probability that successor J_k would require an evaluation we have:

$$z_n = z_n' + \sum_{k=2}^{b} [y_n(k) + q_k z_n']$$

$$= z_n' \left[1 + \sum_{k=2}^{b} q_k \right] + \sum_{k=2}^{b} y_n(k) \qquad (9.1)$$

Moreover, since J_k would require an evaluation if and only if $V(J_k) > \max[V(J_1), V(J_2), \ldots, V(J_{k-1})]$ and all the node-values at any given level are independent, identically distributed and continuous random variables, we have:

$$q_k = \frac{1}{k} \qquad k = 2, \ldots, b \qquad (9.2)$$

In general, the reference value v_k would vary throughout the search, and so $y_n(k)$ has to be calculated by averaging $I_{TEST}(2n - 1, b, F, v)$ over v using the distribution of v_k (see exercise 9.1). However, in order to get a simple conservative estimate of z_n each $y_n(k)$ can be replaced by its likely worst-case value. For large n, this occurs when $v_k = v^*$, in which case $y_n(k)$ is given by $R^*(b)^{2n-1}$ and we can write:

$$z_n = z_n' H_b + R^*(b)^{2n-1}(b - 1) \qquad (9.3)$$

where:

$$H_b = \sum_{k=1}^{b} \frac{1}{k} \qquad (9.4)$$

Note that this approximation is not too pessimistic in light of the fact that for large n the values of all nodes converge rapidly toward the limiting value v^* and, therefore, most tests would employ a reference level v_k from the neighborhood of v^*. Strictly speaking, it is also possible that, for some n and k, $y_n(k)$ would actually exceed $R^*(b)^{2n-1}$, but in view of Theorem 1 it cannot exceed it by more than a constant factor $L(b)$ and that would only alter our final result for z_n by at most this factor.

To compute the solution of Eq. (9.3) we note that we made no use of the assumption that the number of tree levels below J is even. Consequently the same relation should hold between z_n' and z_{n-1}, and denoting the level of a node by l, we can write:

$$z_l = z_{l-1} H_b + R^*(b)^{l-1}(b - 1) \qquad l = 1, 2, \ldots, d \qquad (9.5)$$

Eq. (9.5) is a linear difference equation of the form:

$$z_l = \alpha z_{l-1} + K \beta^l \qquad (9.6)$$

with:

$$z_0 = 1$$
$$K = (b - 1)/R^*(b)$$
$$\beta = R^*(b)$$
$$\alpha = H_b \qquad (9.7)$$

Its solution is given by:

$$z_d = \alpha^d + K\beta \frac{\beta^d - \alpha^d}{\beta - \alpha} \qquad (9.8)$$

Clearly it is the relative size of α and β that governs the asymptotic behavior of z_d for large values of d. However, since for all $b \geqslant 2$ we have:

$$R^*(b) > H_b$$

(see Section 8.3.3) β would become the dominant factor, and we can write:

$$z_d \sim \frac{K}{\beta - \alpha} \beta^{d+1} \qquad (9.9)$$

More precisely, incorporating the coefficient $L(b)$ from Theorem 1, and identifying α, β, and K from Eq. (9.8), we obtain (for large d):

$$I_{\text{SCOUT}}(d, b, F) \leqslant \frac{L(b)(b - 1)}{R^*(b) - H_b} R^*(b)^d \qquad (9.10)$$

The actual value of I_{SCOUT} for moderate depths is calculated in Section 9.3.5 (see Figure 9.4), using the exact expressions for $y_n(k)$ as in exercise 9.1.

THEOREM 2. *The expected number of terminal examinations performed by SCOUT in the evaluation of (d, b)-game trees with continuous terminal values has the branching factor:*

$$R_{\text{SCOUT}} = R^*(b) \qquad (9.11)$$

∎

Moreover, in view of the fact that $R^*(b)$ is the lowest possible branching factor achievable by any algorithm evaluating continuous-valued game trees (see Theorem 4, Chapter 8), we can also state:

COROLLARY 1: *SCOUT is asymptotically optimal for continuous-valued trees.*

Note that the bottle neck in the execution of SCOUT is the run-time of SOLVE (or TEST). Any extra information about the game that will speed up SOLVE can also be incorporated into SCOUT and help speed up SCOUT by approximately the same proportion. One such information is available from

the static evaluation of nonterminal positions, which can be used to order successors prior to expansion. The analysis of the savings induced by such ordering is provided in Section 9.4.

9.1.2 Games with Discrete Terminal Values

So far, our analysis has been based on the assumption that the terminal nodes may be assigned continuous values. We now demonstrate that I_{SCOUT} is substantially reduced if the terminal nodes are assigned only discrete values.

Let us ignore the rare case where $1-\xi_b$ coincides exactly with one of the plateaus of F. When coincidence does not occur, we showed in Section 8.3.2 that the values of all nodes at sufficiently high levels converge to the same limit, given by the lowest terminal value v' satisfying $F_{V_0}(v') > 1 - \xi_b$. This convergence has two effects on the complexity of SCOUT as analyzed in Eq. (9.1). First, q_k is no longer equal to $1/k$, but rather converges to zero at high n for all $k > 1$. The reason for this is that in order for $V(J_k)$ to be greater than $V(J_1)$ (which is most probably equal to v') it must exceed $V(J_1)$ by a fixed positive quantity. However, finite differences between any two nodes become extremely rare at high levels of the tree. Second, the threshold levels v_k against which the TEST $(J_k, v, >)$ procedures are performed are no longer close to v^* but differ from it by finite amounts. Under such conditions the proposition "$V(J_k) > v_k$" can be tested more efficiently since $R_{\text{TEST}} = b^{\frac{1}{2}}$.

Applying these considerations to the analysis of z_n in Eq. (9.1) gives:

$$R_{\text{SCOUT}} = b^{\frac{1}{2}} \tag{9.12}$$

and we obtain the following theorem.

THEOREM 3. *The expected number of terminal positions examined by the SCOUT procedure in evaluating a (d, b, F_{V_0})-game with discrete terminal values has a branching factor:*

$$R_{\text{SCOUT}} = b^{\frac{1}{2}} \tag{9.13}$$

with exceptions only when one of the discrete values, v^, satisfies $F_{V_0}(v^*) = 1 - \xi_b$.* ∎

COROLLARY 2: *For games with discrete terminal values satisfying the conditions of Theorem 3, the SCOUT procedure is asymptotically optimal over all evaluation algorithms.* ∎

Of course, the transition from $R_{\text{SCOUT}} = R^*(b)$ in the continuous case to $R_{\text{SCOUT}} = b^{\frac{1}{2}}$ in the discrete case does not occur abruptly. When the quantization levels are very close to each other, it takes many more levels before SCOUT begins to acquire the lower branching factor of $b^{\frac{1}{2}}$. In fact, using the

discussion of Section 8.3, it is possible to compute at what height SCOUT begins to act more efficiently. For example, if the terminal values are integers, uniformly distributed from 1 to M, we know that at very high levels of the tree the values of all nodes will converge to j^*, where j^* is the lowest integer satisfying $F_{V_0}(j^*) > 1 - \xi_b$. The probability that a node n cycles away from the bottom would acquire this value is:

$$P[V_n(J) = j^*] = F_{V_n}(j^*) - F_{V_n}(j^* - 1) \tag{9.14}$$

If $F_{V_n}(j^*)$ and $F_{V_v}(j^* - 1)$ are very close to each other, $P[V_n(J) = j^*]$ will be governed by the linear regions of the curves in Figure 8.14 where $F_{V_n}(n)$ can be approximated by

$$F_{V_n}(v) \approx F_{V_0}(v^*) + \left[\frac{b(1 - \xi_b)}{\xi_b} \right]^{2n} \left[F_{V_0}(v) - F_{V_0}(v^*) \right]$$

Therefore, we can write:

$$P\left[V_n(J) = j^* \right] \approx \left[\frac{b(1 - \xi_b)}{\xi_b} \right]^{2n} \left[F_{V_0}(j^*) - F_{V_0}(j^* - 1) \right]$$

$$= \left[\frac{b(1 - \xi_b)}{\xi_b} \right]^{2n} 1/M \tag{9.15}$$

In order for the TEST procedures nested in SCOUT to achieve a branching factor of $b^{\frac{1}{2}}$ the parameter $P[V_n(J) = j^*]$ must approach unity, that is, d must satisfy:

$$d \geqslant \frac{\log M}{\log \dfrac{b(1 - \xi_b)}{\xi_b}} \triangleq d_0(M, b) \tag{9.16}$$

Thus, above the critical level $d_0(M, b)$ it becomes fairly sure that every node has a minimax value j^* and, consequently, the SCOUT procedure would have to explore only $b^{\frac{1}{2}}$ nodes per level. Note that the critical depth increases logarithmically with the number of quantization levels M. Thus, in games such as chess where M is around 1000 and b is approximately 50, this improvement in performance will only be realized for searches looking more than seven moves ahead.

9.2 THE EXPECTED PERFORMANCE OF α-β

9.2.1 Historical Background

Although the α-β algorithm has dominated the practice of game-playing programs since the late fifties and experiments show that the exponential growth of

game tree searching is slowed significantly by the α-β pruning, quantitative analyses of its effectiveness have been frustrated for over a decade. One concern has been to determine if under random ordering of successor nodes α-β would not lose much of its pruning power. Another has been to determine whether the average performance of the α-β algorithm is optimal over that of other game-searching procedures.

Slagle and Dixon (1969) showed that the number of terminal nodes examined by α-β must be at least $b^{\lfloor d/2 \rfloor} + b^{\lceil d/2 \rceil} - 1$ but may, in the worst case, reach the entire set of b^d terminal nodes. Knuth and Moore (1975) have shown that there is always a way to arrange the terminal nodes such that α-β will not examine more nodes than the bare minimum of $b^{\lfloor d/2 \rfloor} + b^{\lceil d/2 \rceil} - 1$. In view of our discussion of Sections 8.1.1 and 8.3.1, it should be easy to find such a perfect ordering. One need only make sure that the leftmost MAX strategy and the leftmost MIN strategy have compatible values. (That is how the values in Figure 8.7 were contrived.)

The analysis of *expected* performance using uniform trees with random terminal values had begun with Fuller, Gaschnig, and Gillogly (1973), who obtained formulas by which the average number of terminal examinations $I_{\alpha\text{-}\beta}(d,b)$ can be computed. Unfortunately, the formula would not facilitate asymptotic analysis; simulation studies led to the estimate $R_{\alpha\text{-}\beta} \approx (b)^{.72}$.

Knuth and Moore (1975) analyzed a less powerful but simpler version of the α-β procedure by ignoring deep cutoffs. They showed that the branching factor of this simplified model is $O(b/\log b)$ and speculated that the inclusion of deep cutoffs would not alter this behavior substantially. A later study by Baudet (1978) confirmed this conjecture by deriving an integral formula for $I(d,b)$ (deep cutoffs included), from which the branching factor can be estimated. In particular, Baudet shows that $R_{\alpha\text{-}\beta}$ is bounded by

$$\xi_b / (1 - \xi_b) \leqslant R_{\alpha\text{-}\beta} \leqslant M_b^{\frac{1}{2}}$$

where ξ_b is the positive root of $x^b + x - 1 = 0$ and M_b is the maximal value of the polynomial

$$H(x) = \frac{1 - x^b}{1 - x} \cdot \frac{1 - [1 - x^b]^b}{x^b}$$

in the range $0 \leqslant x \leqslant 1$. Pearl (1980) has shown that $\xi_b / (1 - \xi_b)$ lower bounds the branching factor of every directional game-searching algorithm and that an algorithm exists (i.e., SCOUT) that actually achieves this bound. Tarsi (1983) has later shown that $\xi_b / (1 - \xi_b)$ also lower bounds the branching factor of nondirectional algorithms and so the enigma of whether α-β is optimal became contingent upon determining the exact magnitude of $R_{\alpha\text{-}\beta}$ within the range $[R^*(b), M_b^{\frac{1}{2}}]$ delineated by Baudet.

The next section shows that the branching factor of α-β indeed coincides with the lower bound $\xi_b / (1 - \xi_b)$, thus establishing the asymptotic optimality of α-β over the class of all game-searching algorithms (Pearl, 1982b).

9.2.2 An Integral Formula for $I_{\alpha\text{-}\beta}(d,b)$

Our starting point will be the condition under which an arbitrary node J in a (d,b,F)-tree is generated by the α-β algorithm. In Section 8.2.2, we saw that a necessary and sufficient condition for generating J is given by the inequality (Eq. 8.16):

$$A(J) < B(J) \qquad (9.17)$$

where $A(J)$ = the highest minimax value among all left-sons of MAX ancestors of J

$B(J)$ = the lowest minimax value among all left-sons of MIN ancestors of J.

To find $I_{\alpha\text{-}\beta}(d,b)$, the average number of terminal nodes examined by α-β, we need to compute the probability $P[A(J) < B(J)]$ and sum these probabilities over all terminal nodes.

$$I_{\alpha\text{-}\beta}(d,b) = \sum_{J \text{ terminal}} P[A(J) < B(J)]$$

This procedure may seem like a major undertaking. Fortunately, when the terminal values are drawn independently from a common distribution function $F_0(x) = P[V_0 \leqslant x]$, the distributions of the minimax values at higher levels of the tree can be computed by the simple propagation rules of Section 8.3.2. If V_k stands for the minimax value of a MIN node at level k of the tree, its distribution F_k is related to that of its direct descendants by:

$$F_k(x) = 1 - [1 - F_{k-1}(x)]^b$$

and to that of its grandsons by:

$$F_k(x) = 1 - \{1 - [F_{k-2}(x)]^b\}^b$$

From these recursions, one can compute the distributions $F_{A(J)}(x)$ and $F_{B(J)}(x)$ of the random variables $A(J)$ and $B(J)$ for any terminal node J. Moreover, since for noncritical nodes $A(J)$ and $B(J)$ are independent and continuous, we have:

$$P[A(J) < B(J)] = \int_{x=-\infty}^{\infty} F_{A(J)}(x)\, F'_{B(J)}(x)\, dx$$

and $I_{\alpha\text{-}\beta}(d,b)$ becomes:

$$I_{\alpha\text{-}\beta}(d,b) = \int_{x=-\infty}^{\infty} [\sum_{\substack{J \text{ terminal} \\ \text{noncritical}}} F_{A(J)}(x)\, F'_{B(J)}(x)\,]dx$$

$$+ b^{\lfloor d/2 \rfloor} + b^{\lceil d/2 \rceil} - 1$$

where the terms added to the integral represent the number of critical nodes, all of which are examined.

The **critical nodes** are the leaf nodes of the two leftmost adversary strategies, the one for MAX and the one for MIN. All these nodes must be examined because, being a directional algorithm, α-β cannot afford to skip any strategy until it is proven inferior to one that was traversed previously. Another way to see this is to recall that each critical node has either $A(J) = -\infty$ or $B(J) = +\infty$, and so it can never qualify for the cutoff condition, $A(J) \geqslant B(J)$.

The summation inside the integral can be performed using the preceding recursion relations (see Roizen, 1981) and leads to the following theorem:

THEOREM 4. *Let $f_0(x) = x$, and, for $i = 1, 2, ...,$ define:*

$$f_i(x) = 1 - \{1 - [f_{i-1}(x)]^b\}^{b},$$

$$r_i(x) = \frac{1 - [f_{i-1}(x)]^b}{1 - f_{i-1}(x)}$$

$$s_i(x) = \frac{f_i(x)}{[f_{i-1}(x)]^b}$$

$$R_i(x) = r_1(x) \times \cdots \times r_{\lceil i/2 \rceil}(x)$$

$$S_i(x) = s_1(x) \times \cdots \times s_{\lceil i/2 \rceil}(x)$$

The average number of terminal nodes examined by the α-β pruning algorithm in a uniform game tree of degree b and depth d for which the bottom values are drawn from an arbitrary continuous distribution, is given by:

$$I_{\alpha\text{-}\beta}(d, b) = b^{\lceil d/2 \rceil} + \int_0^1 R_d'(x)\, S_d(x)\, dx \qquad (9.18)$$

An identical expression for $I_{\alpha\text{-}\beta}$ was first derived by Baudet (1978) starting with discrete terminal values and progressively refining their quantization levels.

9.2.3 The Branching Factor of α-β and Its Optimality

The difficulty in estimating the integral in Eq. (9.18) stems from the recursive nature of $f_i(x)$ which tends to obscure the behavior of the integrand. One way of circumventing this difficulty is to substitute for $f_0(x)$ another function $\phi(x)$, which makes the regularity associated with each successive iteration more transparent.

The value of the integral in Eq. (9.18) does not depend on the shape of $F_0(x)$, reflecting the fact that the search procedure depends only on the *relative order* of the b^d terminal values, not on their magnitudes. Since any continuous distribution of the terminal value generates all ranking permutations with

equal probabilities, $I_{\alpha\text{-}\beta}$ will not be affected by the *shape* of that distribution. Consequently, $f_0(x)$, which in Theorem 4 represents a uniform terminal values' distribution, may assume an arbitrary form, subject to the usual constraints imposed on continuous distributions.

A convenient choice for the distribution $f_0(x)$ would be a characteristic function $\phi(x)$ which would render the distributions of the minimax value of every node in the tree identical in shape as shown in Appendix 9-A. This approach was pursued in the first derivation of $R_{\alpha\text{-}\beta}$ (Pearl, 1982b) and will not be repeated here since now, with the help of Theorem 1, the derivation can be obtained more directly from Eq. (9.18).

Assuming an even search depth, $d = 2h$, and writing Eq. (9.18) explicitly we obtain:

$$I_{\alpha\text{-}\beta} = b^h + \int_0^1 \prod_{i=1}^h \frac{f_i(x)}{f_{i-1}^b(x)} \left[\prod_{i=1}^h \frac{1-f_{i-1}^b(x)}{1-f_{i-1}(x)} \right]' dx$$

$$= b^h + \int_0^1 \sum_{i=0}^{h-1} \frac{r'_{i+1}(x)}{r_{i+1}(x)} \cdot \prod_{i=0}^{h-1} \frac{1-[1-f_i^b(x)]^b}{f_i^b(x)} \cdot \frac{1-f_i^b(x)}{1-f_i(x)} dx$$

$$(9.19)$$

where

$$r_{i+1} = \frac{1-f_i^b(x)}{1-f_i(x)} = 1 + f_i(x) + f_i^2(x) + \cdots + f_i^{b-1}(x) \quad (9.20)$$

The product term in the integrand of Eq. (9.19) is recognized as $I_{SOLVE}(2h, b, f_0(x))$ and, using Theorem 1, it can be bounded from above by $L(b) R^*(b)^{2h}$. The term $r'_{i+1}(x)/r_{i+1}(x)$ is the derivative of $\ln r_{i+1}(x)$, so Eq. (9.19) integrates to:

$$I_{\alpha\text{-}\beta} \leqslant b^h + L(b) R^*(b)^{2h} \sum_{i=0}^{h-1} \ln \frac{r_{i+1}(1)}{r_{i+1}(0)}$$

Finally, since for all i we have $f_i(1) = 1$ and $f_i(0) = 0$, Eq. (9.20) gives:

$$r_{i+1}(1) = b \qquad r_{i+1}(0) = 1$$

and we obtain:

$$I_{\alpha\text{-}\beta} \leqslant b^h + L(b) h \ln b \, R^*(b)^{2h} \tag{9.21}$$

This bound together with $b < R^*(b)^2$ gives

$$R_{\alpha\text{-}\beta} = \lim_{h \to \infty} I_{\alpha\text{-}\beta}(2h, b)^{1/2h} \leqslant R^*(b) \tag{9.22}$$

However, from the lower bound $R_{\alpha\text{-}\beta} \geqslant R^*(b)$ (see Section 8.3.4) we must conclude the following theorem.

THEOREM 5. *The expected number of terminal positions examined by the α-β algorithm in the evaluation of (d, b)-game trees having continuous terminal values has the branching factor*

$$R_{\alpha\text{-}\beta} = R^*(b) \qquad\qquad (9.23)$$

■

COROLLARY 3: *The α-β algorithm is asymptotically optimal over all game-searching algorithms.*

Proof: The proof follows directly from Theorem 4, Chapter 8, stating that $R^*(b)$ lower bounds the branching factors of all game-searching algorithms. ■

COROLLARY 4: *The branching factor of α-β for a uniform tree of degree b with distinct valued, randomly ordered terminal nodes is given by $R^*(b)$.*

Proof: The set of nodes examined by α-β depends only on their rank order, not their absolute magnitudes. Every continuous distribution produces randomly ordered nodes with zero probability of equalities. Thus, the corollary is implied by Theorem 5. ■

9.2.4 How Powerful Is the α-β Pruning?

The asymptotic behavior of $R_{\alpha\text{-}\beta}$ is $\sim (b/\log b)$, as predicted by Knuth and Moore (1975). However, for moderate values of b ($b \leqslant 1000$) $\xi_b/(1 - \xi_b)$ is fitted much better by the formula $(.925)b^{.747}$ (see Figure 8.21, Chapter 8), which vindicates the simulation results of Fuller, et al. (1973) from which they concluded that $R_{\alpha\text{-}\beta} \approx b^{.720}$.

This approximation offers a more meaningful appreciation of the pruning power of the α-β algorithm. Roughly speaking, a fraction of only $(.925)b^{.747}/b \approx b^{-\frac{1}{4}}$ of the b legal moves available from each game position will be explored by α-β. Alternatively, for a given search time allotment, the α-β pruning allows the search depth to be increased by a factor $\log b/\log R_{\alpha\text{-}\beta} \approx 4/3$ over that of an exhaustive minimax search.

These results are valid for continuous-valued games or, equivalently, for games having distinct and randomly ordered terminal values. Allowing equalities among the terminal values would cause a dramatic decrease in the branching factor as it did for SCOUT. The reason is that the condition for node generation $A(J) < B(J)$ excludes equality and when the terminal values are discrete, the probability that both $A(J)$ and $B(J)$ are equal to their asymptotic value v^* approaches unity at deep nodes, leading to the branching factor $R = b^{\frac{1}{2}}$ (Pearl, 1980). The depth at which this reduction takes effect is the same as the critical depth $d_0(M, b)$ of SCOUT (Section 9.1.2),

$$d_0(M, b) = \frac{\log M}{\log(b/R^*(b))}$$

where M is the number of discrete values allowable. (More precisely, $1/M$ is the probability of each quantization level in the neighborhood of $V_o = v^*$.)

The bound in Eq. (9.21) leaves much to be desired; in addition to the term $R^*(b)^d$, it also contains the coefficient $d/2L(b) \ln b$ which may be sizable for deep searches. In Section 9.3.3 we will present an exact numerical evaluation of the formula for $I_{\alpha\text{-}\beta}$ and show that the ratio $I_{\alpha\text{-}\beta}/R^*(b)^d$ is in fact fairly small; it remains below 4.2 over a wide range of b and d ($b \leqslant 20, d \leqslant 20$). This renders α-β remarkably powerful; it takes α-β only four times longer to completely evaluate a game than it would take the best possible algorithm just to certify that the actual value for the game is indeed achievable.

But, perhaps the most practical implication of the analysis of α-β under random ordering conditions is to provide an assessment for the relative improvement one can expect from **informed ordering**. A straightforward way of obtaining ordering information is to compute the static evaluation functions of contending successors, and use these values to determine which should be explored first. Such informed ordering requires that whenever we generate a node, some evaluation be applied to all its siblings, even to those that would eventually be cut off by the search. The question now arises whether this extra ordering computation will pay off, knowing that even under random ordering α-β is already fairly efficient.

If the order is ideal, then all noncritical nodes are pruned away and the number of nodes examined at depth d is only $2b^{d/2} - 1$. With random ordering we examine an average of roughly $5(R^*)^d \approx 5b^{(3/4)d}$ (5 is roughly the coefficient in $I_{\alpha\text{-}\beta}$ corresponding to $b = 35$ as in chess). For example, Shannon's estimated 10^9 chess positions at depth $d = 6$ would be reduced to around 65,000 by a perfect ordering and to 3×10^6 positions by random ordering. However, in order to also account for the evaluations of nonterminal positions required for informed ordering, we should multiply the $2b^{d/2}$ terminal positions by $2b^2/(b - 1)$, thus bringing the total number of evaluations required under informed ordering to about 4×10^6 evaluations, above that of random ordering. It appears, therefore, that in chess informed ordering produces a net advantage only if the search depth exceeds 6. However, for $d \geqslant 7$, the quantization effect due to equalities begins to take place, which provides a further improvement in the pruning power of α-β under random ordering. Thus, the choice between random or informed ordering of successors seems to be a tossup.

This analysis helps explain why *move* ordering is practiced more often than *successor* ordering. The former obtains a crude evaluation of a move without actually generating a full description of the resultant board position, using merely features of the move itself (e.g., recapturing a lost piece or attacking the opponent's queen). Evidently, even such crude information can induce a large fraction of the cutoffs missed by random ordering. This is further confirmed in Section 9.4, where we analyze the relationship between the accuracy of the ordering evaluation and the branching factor that it induces.

9.3 THE EXPECTED PERFORMANCE OF SSS*

Our analysis of the performance of SSS* will follow the same steps used in the analysis of α-β (Sections 8.2.2. and 9.2.2). We begin by establishing a necessary and sufficient condition for a terminal node to be examined by SSS* (Section 9.3.1) and determining the probability that a given terminal node satisfies this condition (Section 9.3.2). In Sections 9.3.3 and 9.3.4 we use these probabilities to derive an integral formula for I_{SSS^*}, analyze the behavior of I_{SSS^*} for large d, and present an explicit demonstration of the equality $R_{SSS^*} = R^*(b)$. In Section 9.3.5 we present a comparison between I_{SSS^*} and $I_{\alpha\text{-}\beta}$ for practical values of b and d ($2 \leqslant b \leqslant 20$, $2 \leqslant d \leqslant 20$) and assess the relative improvement in pruning power due to the best-first policy employed by SSS*.

9.3.1 A Necessary and Sufficient Condition for Node Examination[†]

Let $f(J)$ be the minimax value of an arbitrary node J in a uniform (d,b)-game tree. For any MIN node $J.j$ we define

$$g_L(J.j) = \begin{cases} \max\{f(J.i) \mid 1 \leqslant i \leqslant j-1\} & \text{if } j > 1 \\ -\infty & \text{if } j = 1 \end{cases} \qquad (9.24)$$

$$g_R(J.j) = \begin{cases} \max\{f(J.i) \mid j+1 \leqslant i \leqslant b\} & \text{if } j < b \\ -\infty & \text{if } j = b \end{cases} \qquad (9.25)$$

Similarly, for any MAX node $J.j$

$$v(J.j) = \begin{cases} \min\{f(J.i) \mid 1 \leqslant i \leqslant j-1\} & \text{if } j > 1 \\ +\infty & \text{if } j = 1 \end{cases} \qquad (9.26)$$

$g_L(J.j)$ and $v(J.j)$ are identical to the terms $\alpha(J)$ and $\beta(J)$ used in the description of the α-β procedure (Section 8.2.2). $g_R(J.j)$ serves in a role identical to that of $\alpha(J)$ but applies to subtrees stemming to the *right* of the path from the root to J (see Figure 8.4).

Paralleling the terms $A(J)$ and $B(J)$ used in the description of α-β (Eq. (8.15)), we now define three terms: $A_L^k(J)$, $A_R^k(J)$, and $B(J)$. For any terminal MAX node $J = j_1 \cdot \ldots \cdot j_d$, $d \geqslant 1$, with ancestors $J_i = j_1 \cdot \ldots \cdot j_{d-i}$ where $i = 0, \ldots, d-1$, let

$$A_L^k(J) = \max\{g_L(J_i) \mid i \text{ is odd}, k \leqslant i \leqslant d-1\} \qquad (9.27)$$

$$A_R^k(J) = \max\{g_R(J_i) \mid i \text{ is odd}, k \leqslant i \leqslant d-1\} \qquad (9.28)$$

$$B(J) = \min\{v(J_i) \mid i \text{ is even}, 0 \leqslant i \leqslant d-1\} \qquad (9.29)$$

† The author thanks North Holland Publishing Company for permission to reprint the portion of the article "A Minimax Algorithm Better Than Alpha-Beta?: Yes and No" by Igor Roizen and Judea Pearl which first appeared in *Artificial Intelligence* 21(1–2), 199–220, March 1983.

$B(J)$ is identical to that used in Eq. (8.15), that is, it stands for the lowest minimax value among all left-sons of MIN ancestors of J. $A_L^k(J)$ and $A_R^k(J)$ are similar to the $A(J)$ term used in Eq. (8.15) save for the fact that they now stand for the highest minimax value among all left-sons (right-sons for $A_R^k(J)$) of MAX ancestors of J, *positioned $k + 1$ or more levels above J*.

THEOREM 6. *A terminal MAX node J of a game tree, with ancestors J_i, will be examined by SSS* if and only if*

$$B(J) > A_L^0(J) \quad \text{and} \quad B(J) \geqslant A_R^{k'}(J) \qquad (9.30)$$

where k' is the level where $v(J_i)$ attains its minimal value (the highest such level in case of multiple minima); that is, k' is the highest integer k satisfying:

$$v(J_k) = \min_{\substack{0 \leqslant i \leqslant d-1 \\ i \text{ even}}} v(J_i) \qquad (9.31)$$

Proof: See Appendix 9-B.

COROLLARY 5: *SSS* dominates α-β, that is, every terminal node examined by SSS* is also examined by α-β.*

Proof: The condition in Eq. (9.30) for examining J is more restrictive than (i.e., is subsumed by) that established for α-β (Eq. 8.15); the latter is satisfied by the inequality $B(J) > A_L^0(J)$, whereas Eq. (9.30) also requires that $B(J) \geqslant A_R^{k'}(J)$ holds true before SSS* examines J. ∎

Theorem 6 clearly identifies the reason for SSS*'s superiority over α-β. Whereas α-β can justify skipping a node J only by information gathered to the left of J ($B(J) \leqslant A_L^0(J)$), SSS* also invokes information gathered from the right of J, that is, $A_R^k(J)$.

9.3.2 The Probability of Examining a Terminal Node

Let $\pi(J)$ stand for the probability that a terminal node J is examined by SSS*, that is:

$$\pi(J) = P[B(J) > A_L^0(J), \quad B(J) \geqslant A_R^{k'}(J)]$$

where the random variables $A_L^0(J)$, $A_R^{k'}(J)$, and $B(J)$ are defined by Eqs. (9.27), (9.28), and (9.29). The computation of $\pi(J)$ is facilitated by the fact that in a tree drawn from the ensemble of (d, b)-games these three random variables are independent of each other for any fixed k'. Consequently $\pi(J)$ can be computed from the distribution functions of the variables $A_L^0(J)$, $A_R^{k'}(J)$, and $B(J)$ by conditioning the inequality $B(J) \geqslant A_R^{k'}(J)$ on the event $k' = 0, 1, \ldots, d - 1$.

In what follows we will assume that d is even, $d = 2h$, that the terminal values are *continuous* random variables, drawn from a common distribution function $F_0(x)$, and will use A_L instead of A_L^0.

LEMMA 1: *The probability that an arbitrary terminal node J is examined by SSS* is given by:*

$$\pi(J) = \begin{cases} 1 \text{ if } J \text{ is a critical node*; otherwise} \\ \sum_{k=0}^{h-1} \int_{-\infty}^{\infty} \prod_{\substack{i=0 \\ i \neq k}}^{h-1} [1 - F_{v_i}(x)] \cdot F_{A_L}(x) \cdot F_{A_R^{k+1}}(x) \cdot F_{v_k}'(x)\, dx \end{cases} \tag{9.32}$$

Proof: If J is critical, then by Eqs. (9.26) and (9.29) $B(J) = +\infty$. Since $A_L(J)$ and $A_R^{k'}(J)$ never reach ∞ (see Eqs. (9.24), (9.25), (9.27), and (9.28)), we have $B(J) > A_L(J)$ and $B(J) > A_R^{k'}(J)$, and from Theorem 6 we conclude that node J will be examined by SSS*.

Otherwise, $B(J)$, $A_L(J)$, and $A_R^{k'}(J)$ have continuous probability distributions. Eq. (9.32) follows from Theorem 6 and the fact that $B(J)$, $A_L(J)$, and $A_R^{k'}(J)$ are independent random variables. Thus, letting J_i^+ denote the MAX ancestor of J situated $2i$ moves above J, we have:

$$\pi(J) = \sum_{k=0}^{h-1} P[v(J_k^+) < v(J_i^+) \quad \text{for } k+1 \leqslant i \leqslant h-1$$

$$v(J_k^+) \leqslant v(J_i^+) \quad \text{for } 0 \leqslant i \leqslant k-1$$

$$v(J_k^+) > A_L(J), v(J_k^+) \geqslant A_R^{k+1}(J)]$$

Since the random variables $v(J_i^+)$, $0 \leqslant i \leqslant h-1$, are independent and continuously distributed, we can write:

$$\pi(J) = \sum_{k=0}^{h-1} P[v(J_k^+) < v(J_i^+) \quad \text{for } 0 \leqslant i \leqslant h-1 \text{ and } i \neq k,$$

$$v(J_k^+) > A_L(J), v(J_k^+) \geqslant A_R^{k+1}(J)]$$

$$= \sum_{k=0}^{h-1} \int_{-\infty}^{\infty} \prod_{\substack{i=0 \\ i \neq k}}^{h-1} [1 - F_{v_i}(x)] F_{A_L}(x) F_{A_R^{k+1}}(x) F_{v_k}'(x)\, dx$$

which is identical to Eq. (9.32). ∎

The critical nodes relative to SSS are the leaves of the leftmost MIN strategy.

9.3.3 The Expected Number of Terminal Nodes Examined by SSS*

THEOREM 7. *Let $f_0(x) = x$, and:*

$$f_i(x) = 1 - \{1 - [f_{i-1}(x)]^b\}^b \qquad \text{for } i = 1, ..., h - 1 \qquad (9.33)$$

The average number $I_{\text{SSS}}(d, b)$ of terminal nodes examined by the SSS* algorithm in a uniform tree of degree b and even depth $d = 2h$ for which the bottom values are drawn from a continuous distribution is given by:*

$$I_{\text{SSS}*}(d, b) = b^h + \sum_{k=0}^{h-1} b(h - k) \int_0^1 \prod_{\substack{i=0 \\ i \neq k}}^{h-1} \frac{1 - [f_i(x)]^b}{1 - f_i(x)} \prod_{i=1}^{k} \frac{f_i(x)}{[f_{i-1}(x)]^b}$$

$$\prod_{i=k+1}^{h} \left\{ 1 - [f_{i-1}(x)]^b \right\}^{b-1} \left[\frac{1 - [f_k(x)]^b}{1 - f_k(x)} \right]' dx \qquad (9.34)$$

Proof: The expectation of the sum of random variables is equal to the sum of expectations. Thus,

$$I_{\text{SSS}*}(d, b) = \sum_{J} \pi(J)$$

where the sum extends over all terminal nodes J and $\pi(J)$ is given in Eq. (9.32). Eq. (9.34) is obtained by substituting in Eq. (9.32) the expressions for the distributions $F_{A_L}(x)$, $F_{A_R^k}(x)$ and $F_{v_i}(x)$ and performing the summation over J inside the integral. ∎

The details of this derivation are given in Roizen and Pearl (1983a) and will not be repeated here. We should only mention that this derivation, like the one for $I_{\alpha-\beta}$ (Eq. (9.18)), is facilitated by the fact that the distributions $F_{A_L}(x)$, $F_{A_R^k}(x)$, and $F_{v_i}(x)$ are simple polynomial functions of the terminal distribution $F_0(x)$, such as that in Eq. (9.33) and so the summation over J involves sums of geometric series that yield closed-form expressions.

It is worth noting that the value of the integral in Eq. (9.34) does not depend on the shape of the distribution function $F_0(x)$ as long as it is continuous. This reflects the fact that the set of nodes examined by SSS*, like those examined by α-β, depends only on the rank order of the terminal values, not their absolute magnitudes.

The integral in Eq. (9.34) is computable in closed form since the integrand is a polynomial in x, but the number of terms in the resulting expression explodes combinatorially. On the other hand, numerical evaluations can be easily carried out on electronic computers for all practical values of b and d. Results of such computations and a comparison to the performance of α-β are given in Section 9.3.5.

9.3.4 The Branching Factor of SSS*

The fact that the branching factor of SSS* must be equal to $R^*(b) = \xi_b /(1 - \xi_b)$ can be established from SSS*'s superiority over α-β (Corollary 5) together with our previous result that α-β is asymptotically optimal (Eq. 9.23 and Corollary 3). There are benefits, however, in demonstrating explicitly that the equality $R_{SSS^*} = R^*(b)$ follows from the integral in Eq. (9.34). In doing so, we establish a lower bound for I_{SSS^*} and also introduce a transformation useful in the numerical computation of (9.34).

The behavior of the integral in Eq. (9.34), like that of $I_{\alpha\text{-}\beta}$ (Eq. 9.18)), is made more transparent by the substitution $x = \phi(t)$, where $\phi(t)$ is the **characteristic distribution of b-ary games** (see Appendix 9-A) satisfying the functional equation:

$$\phi(t) = 1 - \{1 - [\phi(at)]^b \}^b \tag{9.35}$$

with

$$a = \left[\frac{\xi_b}{b(1 - \xi_b)} \right]^2 < 1 \tag{9.36}$$

This change of variable yields:

$$f_i(x) = \phi(t/a^i), \qquad i = 0, 1, 2, \ldots,$$

thus rendering functions $f_i(x)$ identical in shape, save for a scale factor. Additional properties of $\phi(t)$ are listed in Appendix 9-A.

We now wish to bound $I_{SSS^*}(d, b)$ in Eq. (9.34) from below by concentrating on the $k = h - 1$ term of the sum. Thus, making the change of variable as discussed earlier, we get:

$$I_{SSS^*}(b, d) > b^h + b \int_{-\infty}^{\infty} \pi_h(t)\{1 - [\phi(t/a^{h-1})]^b \}^{b-1} \left[\frac{1 - [\phi(t/a^{h-1})]^b}{1 - \phi(t/a^{h-1})} \right]' dt \tag{9.37}$$

where

$$\pi_h(t) = \prod_{i=1}^{h-1} H[\phi(t/a^{i-1})] \tag{9.38}$$

and

$$H(y) = \frac{1 - y^b}{1 - y} \cdot \frac{1 - (1 - y^b)^b}{y^b} \tag{9.39}$$

An examination of $H[\phi(t)]$ in Eq. (9.39) reveals that it is unimodal in t, lies above the asymptotes $H[\phi(-\infty)] = H[\phi(+\infty)] = b$, and that $H[\phi(0)] = [R^*(b)]^2$, as shown in Figure 9.2.

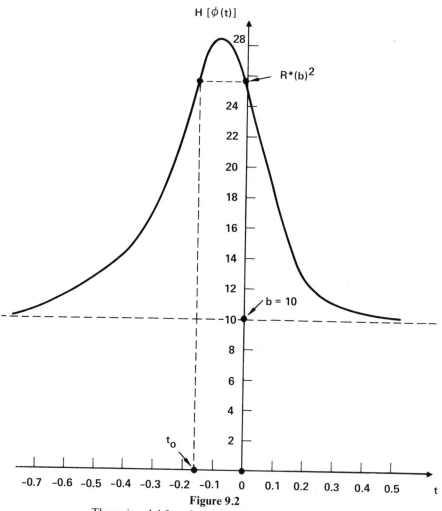

Figure 9.2
The unimodal function $H[\phi(t)]$ shown for $b = 10$.

THEOREM 8. *The branching factor of the SSS* algorithm for a uniform tree of degree b with continuously distributed values of terminal nodes is identical to that of α-β, and is given by:*

$$R_{SSS^*} = \frac{\xi_b}{1 - \xi_b}$$

where ξ_b is the positive root of the equation $x^b + x - 1 = 0$.

Proof: We first bound from below the first and second factors of the integrand in Eq. (9.37). For the first factor, an analysis of $H[\phi(t)]$ (see Figure 9.2) leads to:

$$\pi_h(t) \geqslant R^*(b)^{2(h-1)} \qquad \text{for } a^{h-2}t_0 \leqslant t \leqslant 0 \qquad (9.40)$$

where $t_0 < 0$ is the unique negative solution of $H(\phi(t)) = H(\phi(0))$. For the second factor we have

$$\{1 - [\phi(t)]^p\}^{b-1} \geqslant \frac{1}{R^*(b)} \qquad \text{for all } t \leqslant 0 \qquad (9.41)$$

because this expression is a decreasing function of t attaining the value $1/R^*(b)$ at $t = 0$.

Substituting these two bounds into Eq. (9.37) and reducing the interval of integration to $[a^{h-2}t_0, 0]$ yields:

$$I_{SSS^*}(b, d) > b^h + b \int_{a^{h-2}t_0}^{0} [R^*(b)]^{2(h-1)} \frac{1}{R^*(b)} \left[\frac{1 - [\phi(t/a^{h-1})]^p}{1 - \phi(t/a^{h-1})} \right]' dt$$

$$= b^h + L'(b)R^*(b)^{2h} \qquad (9.42)$$

where

$$L'(b) = b[R^*(b)]^{-3} \left[R^*(b) - \frac{1 - [\phi(t_0/a)]^p}{1 - \phi(t_0/a)} \right]$$

and hence,

$$R_{SSS^*} \triangleq \lim_{d \to \infty} \left[I_{SSS^*}(d, b) \right]^{1/d} \geqslant R^*(b)$$

Since SSS* dominates α-β on a node-per-node basis (Corollary 5) and the branching factor of α-β satisfies $R_{\alpha\text{-}\beta} = R^*(b)$, we conclude that

$$R_{SSS^*} = R_{\alpha\text{-}\beta} = \frac{\xi_b}{1 - \xi_b} \qquad \blacksquare$$

COROLLARY 6: *The branching factor of the SSS* algorithm for a uniform tree of degree b with distinct valued, randomly ordered terminal nodes is identical to that of α-β, and is given by:*

$$R_{SSS^*} = \frac{\xi_b}{1 - \xi_b}$$

Proof: similar to that of Corollary 4. $\qquad \blacksquare$

9.3.5 Numerical Comparison of the Performances of α-β, SSS*, and SCOUT

In this section we present numerical evaluation of the analytical expressions for I_{SSS^*} and I_{SCOUT} established in Eqs. (9.34) and (9.1), and compare their behavior to that of $I_{\alpha\text{-}\beta}$, Eq. (9.18).

Figure 9.3(a) gives the normalized expected complexity of α-β and SSS* as a function of d (the search depth) for various values of b (the branching degree). In both cases, the normalization is done by dividing $I(d, b)$ by $[R^*(b)]^d$, the asymptotic growth for both algorithms. From Figure 9.3(a) we conclude that $I_{\alpha\text{-}\beta}$ can be represented by the equation

$$I_{\alpha\text{-}\beta}(d, b) = A(d, b)[R^*(b)]^d$$

where $1.4 \leqslant A(d, b) \leqslant 4.2$ over the entire spectrum of practical values of b and d ($b = 2, ..., 20$, $d = 2, ..., 20$). For every value of b, $A(d, b)$ seems to approach an asymptote as d increases, becoming virtually a constant (e.g., case $b = 20$).

A similar behavior is exhibited by SSS* (Figure 9.3(a)) where

$$I_{\text{SSS*}}(d, b) = S(d, b)[R^*(b)]^d$$

and $1.2 \leqslant S(d, b) \leqslant 2$ for $b = 2, ..., 20$, $d = 2, ..., 20$. Figure 9.3(a) corroborates the bound established in Eq. (9.42), and shows a rapid convergence of both algorithms to the asymptotic behavior characterized by $R^*(b)$. The upper bound established for $I_{\alpha\text{-}\beta}$ in Eq. (9.21) appears to be rather loose, as it predicts the ratio $I_{\alpha\text{-}\beta}/R^*(b)^d$ to grow linearly with d.

The speed-up factor offered by SSS* relative to α-β is depicted in Figure 9.3(b), showing that:

1. For each $b \geqslant 5$, the superiority of SSS* relative to α-β increases only up to a certain depth, becoming almost constant for $d \geqslant 8$.
2. $1.1 \leqslant I_{\alpha\text{-}\beta}/I_{\text{SSS*}} \leqslant 3$ for $b = 2, ..., 20$, $d = 2, ..., 20$.
3. The superiority of SSS* is getting less and less appreciable as b increases, becoming merely 2.1 times better than α-β for $b = 20$.

The average performances of SCOUT and α-β are compared in Figure 9.4, showing that:

1. α-β offers a slight advantage over SCOUT at small depths and small branching degrees, but, on the whole, the two algorithms have strikingly close performances.
2. The ratio $I_{\text{SCOUT}}/I_{\alpha\text{-}\beta}$ remains below 1.275 over the range $b = 2, ..., 20$, $d = 2, ..., 20$, and tends to unity with increasing search depths.

In games like chess, where the number of moves is typically over 30, there ought to be only insignificant performance difference between SCOUT and α-β. However, recalling that most common games do not have uniform tree structures, that the values of frontier nodes are normally not independent, and that SCOUT can still undergo improvements to minimize duplicate node examinations (see exercise 8.4), the choice between these two algorithms must be done with care (see Table 8.3). Exercise 9.4, for example, exhibits a game

Figure 9.3(a)

The expected complexity (normalized) of α-β and SSS* as a function of d
(the search depth) and b (the branching degree).

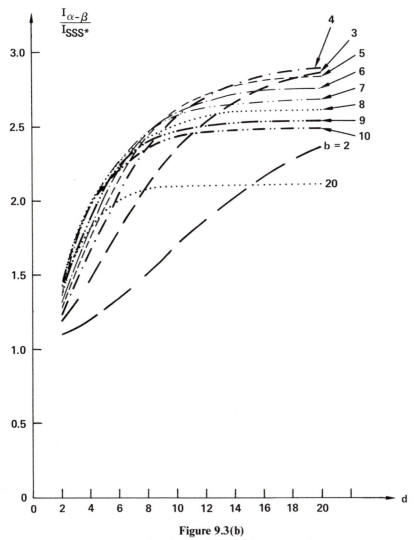

Figure 9.3(b)
The speedup factor of SSS* relative to α-β.

structure where SCOUT outperforms α-β by a factor $(b-1)/\ln b$, even in its unpolished version.

It is worth noting that numerical evaluations of $I_{\alpha\text{-}\beta}$, I_{SCOUT}, and $I_{\text{SSS*}}$ based on their exact formulas, unlike estimates based on simulation studies, can be carried out to any desired accuracy in reasonable computation time. For example, the curves presented in Figures 9.3 and 9.4 were computed to an accuracy of six significant decimal places. By contrast, for $b = 8$ and $d = 6$ simulation results (Campbell and Marsland, 1983) estimated $I_{\alpha\text{-}\beta}$ and $I_{\text{SSS*}}$ to be 35% and 40% lower than their respective actual values; for $b = 3$ and $d = 6$ $I_{\text{SSS*}}$ was estimated 30% above its actual value (Stockman, 1979). For higher

Figure 9.4
The ratio between the expected complexities of SCOUT and α-β.

search depths (e.g., $d \geqslant 10$), reliable performance evaluations are, of course, *only* feasible through analytical methods.

In conclusion, we may state that SSS*, α-β, and SCOUT exhibit very similar performance characteristics in terms of the average number of node examinations in uniform game trees. They have the same growth rate $[R^*(b)]^d$ for randomly ordered terminal nodes and their expected complexities differ by a factor smaller than 3 over the range $d \leqslant 20$, $b \leqslant 20$. The meager improvement in the pruning power of SSS* is more than offset by the increased storage space and bookkeeping (e.g., sorting OPEN) that it requires. One can safely speculate therefore that α-β will continue to monopolize the practice of computerized game playing, and SCOUT will occasionally prove useful in games with unique characteristics and perhaps in other applications of minimax search.

9.4 THE BENEFIT OF SUCCESSOR ORDERING

The analyses presented in the preceding sections assumed that the order in which the search algorithms select nodes for expansion is completely arbitrary, say from left to right. In most practical applications of the α-β procedure the successors of each expanded node are first ordered according to some static evaluation function that rates either the moves or the resulting game positions. Successors of MAX nodes are then explored in descending order of their

evaluation function (i.e., highest first) and those of MIN nodes in ascending order (i.e., lowest first). An identical scheme can be employed in SCOUT and in SSS*, though the latter can only apply order information to successors of MIN nodes.

It is normally assumed and empirically verified that such preordering increases substantially the number of cutoffs induced and results in a lower branching factor. Clearly, when the ordering evaluation function is well informed (i.e., closely correlates with the actual node value), preordering induces all possible cutoffs yielding $R = b^{\frac{1}{2}}$. On the other hand, when the ordering evaluation is uninformed, the ordering is superfluous and yields $R = \xi_b /(1-\xi_b)$ like random ordering. The analysis of this section quantifies the relation between the informedness of the ordering evaluation function and the branching factor of the resulting search.

Our analyses so far have shown that the branching factors of three search algorithms for continuously valued games follow that of $I_{SOLVE}(d,b,\xi_b)$, i.e., a depth-first search applied to a bi-valued game tree having probability $P_o = \xi_b$ that a terminal node be a WIN. Therefore we focus our investigation on the effect of preordering on the branching factor of SOLVE under the condition $p_0 = \xi_b$, and conjecture that searching multi-valued games would exhibit identical behavior.

The information quality of the ordering evaluation function e can be characterized by two distribution functions:

$$\begin{cases} F_W(x) = P[e \leqslant x & \text{given that a node is actually a WIN}] \\ F_L(x) = P[e \leqslant x & \text{given that a node is actually a LOSS}] \end{cases} \quad (9.43)$$

Normally, if the evaluation e is informative, we should expect to obtain high values for WIN nodes and low values for LOSS nodes as shown in Figure 9.5. The range of values where the two density functions overlap represents a region where errors may occur; a WIN node may be judged to have a lower value than a sibling LOSS node. Such errors produce imperfect node ordering, slow down the search, but do not affect the WIN-LOSS status calculated for the root node since the latter is determined by the status of the tip nodes and these are assumed to be perfectly observable.

Subsequent calculations show that, in fact, only one function suffices to characterize the information quality of the pair $[F_W(x), F_L(x)]$. This function, $g(z)$, is defined as follows. If in Eq. (9.43) we treat x as a variable parameter, F_W can be regarded as a function of F_L, that is, $F_W = g(F_L)$, where $g(z)$ is a monotonic nondecreasing function of z between the points $(0, 0)$ and $(1, 1)$ as in Figure 9.5(b). Totally uninformed e will be represented by $g(z) = z$, whereas "noiseless" e will be characterized by

$$g(z) = \begin{cases} 0 & z < 1 \\ 1 & z = 1 \end{cases}$$

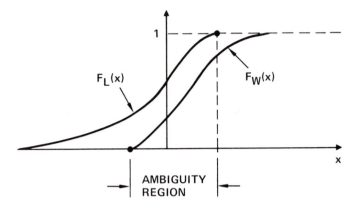

Figure 9.5(a)

Typical distributions of the ordering evaluation function for WIN nodes $(F_W(x))$ and LOSS nodes $(F_L(x))$.

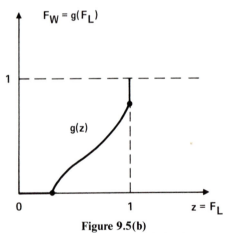

Figure 9.5(b)

The function g which characterizes the discriminating power of the ordering function.

Let us now consider a typical MAX node J, n cycles above termination, and assume that its successors, J_1, J_2, \ldots, J_b are ordered from left to right in descending order of e, that is, $e(J_1) \geqslant e(J_2) \geqslant \ldots \geqslant e(J_b)$. Following the notation of Section 8.3.3 (Figure 8.17), we let x_n stand for the expected number of terminal nodes examined by SOLVE in the tree rooted at J and y_n^+ (or y_n^-) stand for the expected number of terminal nodes examined under a WIN (or LOSS) successor of J. y_n^+ and y_n^- are the same for each successor of J, regardless of its rank order, because the ordering valuation $e(J_k)$ was assumed to be dependent only on the WIN-LOSS status of J_k and hence, once we know that J_k is a WIN (or LOSS), the probabilistic properties of the tree rooted at J_k are the same regardless of its rank order.

If the leftmost WIN successor is found after exactly k LOSSes, the average number of nodes examined is $ky_n^- + y_n^+$. Therefore, the relation between x_n, y_n^+, and y_n^- is given by:

$$x_n = \sum_{k=0}^{b-1} p_k \, (ky_n^- + y_n^+) + p_b \, by_n^- \tag{9.44}$$

where p_k stands for the probability that the sequence J_1, J_2, \ldots, J_b starts with a run of exactly k straight LOSSes, $k = 0, 1, \ldots, b$. Moreover, since for (d, b, ξ_b)-games we have $P(J \text{ is } LOSS) = 1 - \xi_b = p_b$, we can write

$$x_n = y_n^- \, E^- + \xi_b \, y_n^+ \tag{9.45}$$

where

$$E^-_. = \sum_{k=0}^{b} kp_k \tag{9.46}$$

is the **expected number of LOSSes preceding the first WIN** (if any) in the sequence J_1, J_2, \ldots, J_b.

Repeating the same argument for a MIN node, we obtain:

$$y_n = x_{n-1}^+ \, E^+ + \xi_b \, x_{n-1}^- \tag{9.47}$$

where E^+ stands for the expected number of WIN's preceding the first LOSS (if any) in an ordered sequence of MIN successors. Eqs. (9.45) and (9.47) can be combined to get a recursion for x_n^+ and x_n^-. Writing

$$x_n = \xi_b \, x_n^+ + (1 - \xi_b)x_n^- \qquad x_n^- = by_n^-$$
$$y_n = (1 - \xi_b)y_n^+ + \xi_b \, y_n^- \qquad y_n^+ = bx_{n-1}^+ \tag{9.48}$$

Eqs. (9.45) and (9.47) become

$$x_n^+ = (b + D^+D^-)x_{n-1}^+ + D^-x_{n-1}^- \tag{9.49}$$

$$x_n^- = bD^+ \, x_{n-1}^+ + bx_{n-1}^- \tag{9.50}$$

where

$$D^\pm = \frac{1}{\xi_b} \cdot [E^\pm - (1 - \xi_b)b]$$

The branching factor R of x_n is given by $\lambda^{\frac{1}{2}}$, where λ is the largest eigenvalue of the matrix

$$\begin{bmatrix} b + D^+D^- & D^- \\ bD^+ & b \end{bmatrix}$$

which evaluates to

$$\lambda = b + \frac{D^+D^-}{2} (1 + \sqrt{1 + 4b/D^+D^-}) \tag{9.51}$$

Note that for perfect ordering we have $E^+ = E^- = (1 - \xi_b)b$, giving $R = \lambda^{1/2} = b^{1/2}$, whereas for random ordering we have

$$P_k = \xi_b^k(1 - \xi_b) \quad k < b, \qquad p_b = 1 - \xi_b, \qquad E^- = E^+ = \frac{\xi_b^2}{1 - \xi_b}$$

giving

$$R = \lambda^{1/2} = \frac{\xi_b}{1 - \xi_b} = R^*(b)$$

as expected.

We now need to find how E^- and E^+ are influenced by the pair $[F_W(x), F_L(x)]$ which characterizes the informedness of the ordering function. This calculation is best carried out by conditioning the event of traversing k straight LOSSes upon the event of having exactly w WIN successors, $w = 0, ..., b$. This event amounts to finding exactly k LOSS nodes having e greater than that of the highest of the w WIN nodes, and exactly $b - w - k$ LOSS nodes that evaluate lower than the latter. The probability of this event is

$$P_{k \mid w} = \int \binom{b - w}{k} [1 - F_L(x)]^k \, F_L^{(b - w - k)}(x) \, d[F_W^w(x)]$$

At the same time the number of WIN nodes is binomially distributed:

$$P(\text{number of WIN successors} = w) = \binom{b}{w}(1 - \xi_b)^w \xi_b^{b - w} \qquad (9.52)$$

and hence:

$$E^- = \sum_{k=0}^{b} P_{k \mid w} \binom{w}{b}(1 - \xi_b)^w \xi_b^{b - w} \qquad (9.53)$$

After some arithmetic manipulations, Eq. (9.53) obtains the form

$$E^- = b\xi_b \int [1 - (1 - \xi_b)(1 - F_W(x))]^{b - 1} d[F_L(x)] \qquad (9.54)$$

and similarly:

$$E^+ = b\xi_b \int [1 - (1 - \xi_b)F_L(x)]^{b - 1} dF_W(x) \qquad (9.55)$$

Using the notation $F_W = g(F_L)$, E^- is given by the integral

$$E^- = b\,\xi_b \int_0^1 [\xi_b + (1 - \xi_b)g(z)]^{b - 1} dz \qquad (9.56)$$

and E^+ by:

$$E^+ = b\,\xi_b \int_0^1 [1 - (1 - \xi_b)g^{-1}(z)]^{b - 1} dz \qquad (9.57)$$

Note that the symmetry $g(z) = 1 - g^{-1}(1 - z)$ yields $E^- = E^+$.

An Example

To examine how the uncertainty in the ordering function affects the branching factor of the search, let us consider a simple case where $F_W(x)$ and $F_L(x)$ represent **uniformly distributed** random variables overlapping in a fraction t of their corresponding ranges (see Figure 9.6(a)). The parameter t represents the uncertainty in the ordering function since in a fraction t of the time it is impossible to tell whether a node is a WIN or a LOSS. $t = 0$ represents perfect discrimination, whereas $t = 1$ represents totally uninformed evaluation func-

(a)

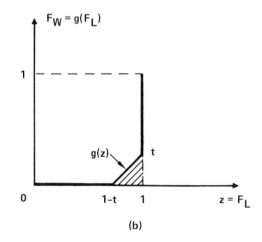

(b)

Figure 9.6
Uniformly distributed ordering functions with ambiguity factor t.

tion which leads to random ordering of successors. The $g(z)$ function corresponding to this case is shown in Figure 9.6(b) and is given by:

$$g(z) = \begin{cases} 0 & z \leqslant t \\ z - t & 1 > z \geqslant t \\ 1 & z = 1 \end{cases} \qquad (9.58)$$

The dependence of E^- and E^+ on t is obtained from Eq. (9.56), and reads

$$E^- = E^+ = b(1 - t)(1 - \xi_b) - \xi_b + \frac{\xi_b}{1 - \xi_b} [\xi_b + (1 - \xi_b)t]^b \qquad (9.59)$$

Finally, substituting Eq. (9.59) in Eq. (9.51) yields the branching factor $\lambda^{1/2}(t)$, as displayed in Figure 9.7. The vertical axis represents the normalized branching factor

$$r(t) = \frac{\lambda^{1/2}(t) - b^{1/2}}{R^*(b) - b^{1/2}} \qquad (9.60)$$

which attains the value 1 under random ordering and the value 0 under perfect ordering.

The steepness of the curves near $t = 1$ means that substantial improvement in speed can be obtained even with "sloppy" ordering heuristics. For instance, even when the uncertainty region occupies as much as 90% of the total area under the density of e, the reduction of the branching factor is already 30% of the overall reduction available with perfect ordering. More significant, perhaps, is the flatness of the curves near $t = 0$. In this region, the branching factor is quadratic in t

$$r(t) \approx \frac{1}{2} \frac{b(b - 1)}{R^*(R^{*2} - b)} t^2$$

which means that once a reasonably informative ordering heuristic has been found, attempts to further sharpen its accuracy will only produce marginal improvements in search speeds. Moreover, the higher the b, the easier it is to get by with "sloppy" ordering information.

The preceding analysis concerned only the branching factor of SOLVE for bi-valued game trees with $P_0 = \xi_b$. In the case of continuously valued games, a full characterization of the reliability of the ordering function would require a function of two variables:

$$F(x \mid y) = P[e(J) \leqslant x \mid V(J) = y]$$

However, since most comparison tests are performed against values from the neighborhood of v^*, the pair of distributions

$$F_{HIGH}(x) = P[e(J) \leqslant x \mid V(J) > v^*]$$
$$F_{LOW}(x) = P[e(J) \leqslant x \mid V(J) \leqslant v^*]$$

should be sufficient.

$$r = \frac{\lambda^{\frac{1}{2}} - b^{\frac{1}{2}}}{R^*(b) - b^{\frac{1}{2}}}$$

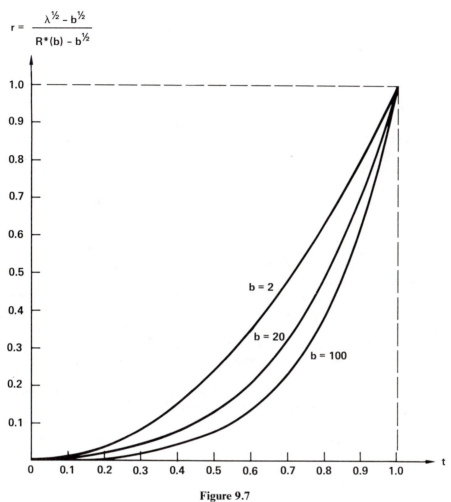

Figure 9.7

Normalized branching factor of SOLVE versus the ambiguity factor t of the ordering function.

The branching factor of SCOUT under informed ordering conditions will be identical to that of SOLVE (Eq. (9.60)) if one substitutes $F_{HIGH}(x)$ for $F_W(x)$ and $F_{LOW}(x)$ for $F_L(x)$. The reason is that the complexity of SCOUT is tied directly to that of TEST (or, equivalently, to SOLVE), and any reduction in the branching factor of the latter translates into an identical reduction in the branching factor of SCOUT. The suggestion that the branching factor of α-β will follow a similar suit is currently only a conjecture based on the fact that the formulas of I_{TEST} and $I_{\alpha\text{-}\beta}$ (Eq. (9.19)) appear strongly connected.

9.5　GAMES WITH RANDOM NUMBER OF MOVES

The inquisitive reader may suspect that the bulk of the results obtained so far in this book are merely artifacts of the structural regularity of our workbench model, the uniform (d, b, P_0)-game tree, but will not apply when this regularity is disturbed. A similar discomfort has also haunted the author and has motivated the following study where we no longer insist that the game tree have a uniform depth or a constant branching degree. Instead we assume that the number of options b available at each game position is a *random variable* which may take on any integer value k, $k = 0, 1, 2, ...$, with probability p_k. We still assume, though, that the set of probabilities $\{p_k\}$ remains the same for each node in the tree, and that the number of branches emanating from any one node is independent of the number of branches stemming from its neighbors.

To complete the game model we still need to specify how the WIN-LOSS status of each node is determined. Like in the uniform tree model, here too we assume that at depth d the game must terminate and that a WIN-LOSS status is assigned at random to nodes at that level. In the present model, however, we also have to determine the status of terminal nodes ($b = 0$) at depths lower than d, which are likely to occur if $p_0 \neq 0$. For simplicity we will decide that every terminal node at depth smaller than d represents a WIN for the last player to move. Thus, our model consists of two random processes:

1. A structural process $\{p_k\}$ which determines the number of branches emanating from each node at depth lower than d.
2. An assignment process where each node at depth d independently receives a WIN or a LOSS with probability P_0 and $1 - P_0$, respectively.

9.5.1　The Distribution of the Value of the Game

Following both the notation and objectives of Section 8.3, the first quantity we wish to calculate is P_n, the probability that a MAX node J situated n move-cycles above the search frontier is a WIN for MAX. If J had exactly b successors and each successor had a probability Q_n of being a WIN (for MAX), then

$$P_n(J) = 1 - (1 - Q_n)^b$$

Now that b is a random variable we have to take the expected value of $P_n(J)$ over all possible values of b, hence;

$$P_n = \sum_k [1 - (1 - Q_n)^k] p_k = 1 - G(1 - Q_n)$$

where

$$G(z) = \sum_k p_k z^k$$

is the generating function of $\{p_k\}$.

Similarly, we find for Q_n :

$$Q_n = \sum_k p_k P_{n-1}^k = G(P_{n-1})$$

and so we can write the recursion

$$P_n = 1 - G[1 - G(P_{n-1})]$$

or

$$P_n = F[F(P_{n-1})] \tag{9.61}$$

where

$$F(z) = 1 - G(z) \tag{9.62}$$

Thus, P_n is given by the $(2n)^{th}$ iteration of $F(P_0)$:

$$P_n = F_{(2n)}(P_0) \tag{9.63}$$

The asymptotic behavior of P_n as $n \to \infty$ is determined by the shape of $G(z)$ (or $F(z)$). The function $F(z)$ is monotonic decreasing from $[0, 1]$ onto $[0, 1 - p_0]$ and therefore always has a unique fixed point z^* satisfying:

$$F(z^*) = z^*$$

This is similar to the case of uniform b-ary trees where we had $p_b = 1$, $F(z) = 1 - z^b$ and the fixed point ξ_b satisfied $1 - z^b = z$. However, whereas in uniform trees the fixed point was always unstable, i.e., $|F'(\xi_b)| > 1$, in the random branching model it may also be stable, which requires a distinction between two separate cases as shown in Figures 9.8 and 9.9.

Case 1: $|F'(z^*)| < 1$, i.e., z^* is a stable fixed point of $F(z)$. In this case the n^{th} iterate of $F(z)$, $F_{(n)}(z)$, converges to z^* from any interior initial point z, as shown by the spiral of Figure 9.8. Consequently, if $p_0 > 0$, the WIN probability P_n will likewise converge to z^* regardless of what the assignment probability P_0 is, while if $p_0 = 0$, the boundary points $P_0 = 1$ and $P_0 = 0$ are themselves (unstable) fixed points. In summary, we have:

$$\lim_{n \to \infty} P_n = \begin{cases} 1 & \text{if } P_0 = 1 \text{ and } p_0 = 0 \\ 0 & \text{if } P_0 = 0 \text{ and } p_0 = 0 \\ z^* & \text{in all other cases} \end{cases} \tag{9.64}$$

The invariance of P_n with respect to P_0 may at first seem paradoxical; it appears as though the value of the root node becomes independent of the values of the leaf nodes. The paradox is partially resolved by recalling that unlike uniform game trees, we now have two types of leaf nodes:

1. **Deep leaves** at depth $d = 2n$.
2. **Shallow leaves** caused by the event $b = 0$.

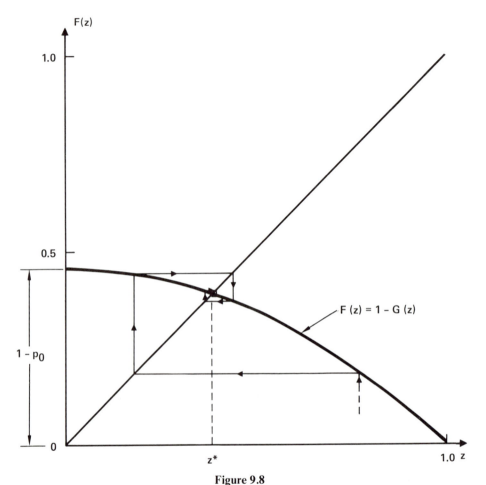

Figure 9.8

A generating function $G(z)$ with a stable fixed point of $1-G(z)$. The
probability of WIN converges to a unique value.

When n becomes very large it may very well happen that the *WIN-LOSS*
status of the shallow leaves is sufficient to dictate the status of the root so that
deep leaves no longer have any influence. This condition occurs when the
game has a finite solution tree and, therefore, we should expect invariance to
prevail whenever the process $\{p_k\}$ assures the existence of a finite solution tree
with probability approaching 1.

Strangely, however, the independence of P_n on P_0 may persist even where
shallow leaves are nonexisting. Take for instance the case:

$$p_1 = \frac{1}{2}, \qquad p_9 = \frac{1}{2}, \qquad \text{or} \qquad F(z) = 1 - \frac{z}{2} - \frac{z^9}{2}$$

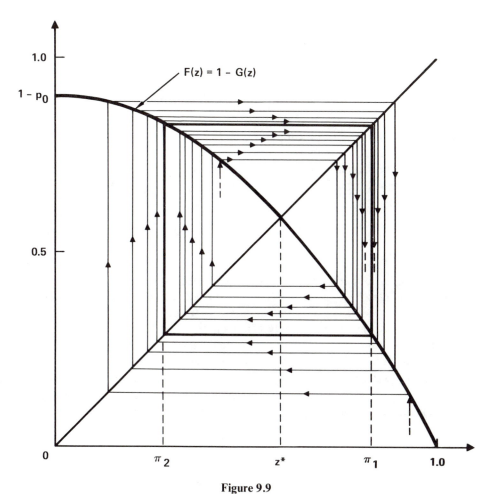

Figure 9.9
A generating function $G(z)$ with an unstable fixed point of $1 - G(z)$ giving
rise to a stable 2-cycle attractor.

Clearly $p_0 = 0$ excludes the formation of shallow leaf nodes and yet calcula-
tions show that $z^* = .66$ and $|F'(z^*)| = .492 < 1$, hence $P_n \to .66$ regard-
less of P_0. This phenomenon is caused by random fluctuations in the tree
structure itself; evidently the fluctuations in the number of branches at shallow
levels of the tree tend to "scramble" or "wash away" the influence of deep node
values as it propagates through many alternating MIN and MAX layers until
the win probability at the root becomes totally insensitive to that at the frontier.
A more detailed discussion of this phenomenon is given by Michon (1983).

Case 2: $|F'(z^*)| > 1$, i.e., z^* is an unstable fixed point of F. In this case
$F[F(z)]$ also has an unstable fixed point at z^* and two stable fixed points at

π_1 and π_2 as shown in Figure 9.9. These two points represent what became known as a *stable 2-cycle attractor* (Hofstadter, 1981), satisfying

$$F(\pi_1) = \pi_2, \qquad F(\pi_2) = \pi_1$$

$$\left| F'(\pi_1)\, F'(\pi_2) \right| < 1$$

A stable attractor (π_1, π_2) has the property that if we iterate the function F an even number of times from some initial argument z, then if $z > z^*$, the end result converges to π_1 whereas if $z < z^*$, the result converges to π_2. This behavior is represented by the spiral trajectories of Figure 9.9.

The asymptotic behavior of the WIN probability P_n is, therefore, given by:

$$\lim_{n \to \infty} P_n = \begin{cases} \pi_1 & \text{if } P_0 > z^* \\ z^* & \text{if } P_0 = z^* \\ \pi_2 & \text{if } P_0 < z^* \end{cases} \tag{9.65}$$

which is similar to that found in our standard uniform-tree model (Section 8.3). The latter is merely a special case of a two-cycle attractor, where the stable points π_1 and π_2 coincided with the boundaries 1 and 0.

We can now generalize this analysis to include games with **continuous terminal values**. We again assume that the terminal values are drawn independently from a distribution $F_{V_0}(x)$, and that deep leaf values represent payoffs given to MAX whereas shallow leaf values represent payoffs given to the last player to move. Going through the argument of Section 8.3.2, we can easily verify that the root value converges to a ternary random variable:

$$\lim_{n \to \infty} V_n = \begin{cases} V_{\min} & \text{with probability } 1 - \pi_1 \\ v^* & \text{with probability } \pi_1 - \pi_2 \\ V_{\max} & \text{with probability } \pi_2 \end{cases} \tag{9.66}$$

where v^* satisfies $1 - F_{V_0}(v^*) = z^*$ and V_{\min} and V_{\max} are the lowest and highest supports of the terminal values, respectively. Case 1 is represented by the condition $\pi_1 = \pi_2 = z^*$ under which V_n converges only to the limits V_{\min} and V_{\max} but not to v^*. Uniform games are represented by the condition $\pi_2 = 0, \pi_1 = 1$ under which V_n converges to a unique value v^*.

9.5.2 Performance Analysis

Assume that $G(z)$ yields a two-cycle attractor at (π_1, π_2), and that $P_0 > z^*$, that is, $P_n \to \pi_1$, $Q_n \to 1 - \pi_2$. We wish to compute the branching factor of SOLVE when executed on such games.

Let x_n and y_n stand for the expected number of leaf nodes examined by SOLVE in searching the tree rooted at a MAX node J and any of its succes-

sors, respectively. For the event that J has exactly k successors (i.e., $b(J) = k$) we obtained in Section 8.3.4, Eq. (8.28):

$$x_n(k) = \frac{y_n}{Q_n}[1-(1-Q_n)^k]$$

where y_n and Q_n do not depend on $b(J)$. Averaging over k we get

$$x_n = \frac{y_n}{Q_n}\sum_k p_k[1-(1-Q_n)^k] = y_n\frac{P_n}{Q_n}$$

A similar operation on y_n yields

$$y_n = x_{n-1}\frac{1-Q_n}{1-P_{n-1}}$$

which leads to a relation identical to that of Eq. (8.30)

$$\frac{x_n}{x_{n-1}} = \frac{P_n}{Q_n}\frac{1-Q_n}{1-P_{n-1}}$$

Consequently, letting $n = d/2$ and using Eq. (9.61), we obtain

$$I_{SOLVE}[d, F(z), P_0] = x_{d/2} = \prod_{i=0}^{d/2}\frac{F[F(P_i)]F(P_i)}{[1-F(P_i)](1-P_i)} \qquad (9.67)$$

For $n \to \infty$, $P_n \to \pi_1$ and $Q_n \to 1 - \pi_2$ and hence

$$\frac{x_n}{x_{n-1}} \to \frac{\pi_1}{1-\pi_1}\cdot\frac{\pi_2}{1-\pi_2}$$

Thus, the branching factor of SOLVE when applied to this model of games becomes:

$$R_{SOLVE} = \left[\frac{\pi_1}{1-\pi_1}\cdot\frac{\pi_2}{1-\pi_2}\right]^{\frac{1}{2}} \qquad (9.68)$$

In case 1, where $\pi_1 = \pi_2 = z^*$, Eq. (9.68) gives

$$R_{SOLVE} = \frac{z^*}{1-z^*} \qquad (9.69)$$

which is a generalization of our familiar expression

$$R_{SOLVE} = \frac{\xi_b}{1-\xi_b}$$

We again conjecture that searching continuously valued games using SCOUT, α-β, or SSS* will likewise have the same branching factor as in Eq. (9.68) — SCOUT because it actually uses SOLVE (or TEST), and α-β or SSS* because of the similarities in the mathematical forms of I_{SOLVE}, $I_{\alpha\text{-}\beta}$, and I_{SSS^*}.

The possibility of having $R < 1$ opens up an interesting set of questions. Clearly, if p_0 is sufficiently large so as to lower z^* below ½, then the branching

factor will be lower than 1, representing a **bounded search effort** with increasing d. Thus, the condition $z^* < \frac{1}{2}$ guarantees finding a finite solution tree, supported exclusively by shallow leaves, with probability approaching unity. However, suppose z^* is greater than $\frac{1}{2}$ and correspondingly $R > 1$, does it mean that no finite solution tree exists? Or is it possible that SOLVE simply cannot find that solution tree in a bounded average time because it gets stuck on some unbounded tree further to the left. Michon (1983) has shown that there is a range of $F'(z^*)$ where bounded solution trees almost certainly exist, but to find any one of them using a depth-first strategy would take exponential time.

9.5.3 Ordering Successors by Branching Degrees

If the number of branches emanating from the successors of a given node are known, it makes good sense to search these successors (using SOLVE) in increasing order of their branching degrees. We will show that this order of expansion is optimal in the sense that it yields the lowest possible expected search time.

Consider any two adjacent successors, J_k and J_{k+1}, of a MAX node J. Let p_k be the probability that J_k is a WIN and let y_k^+ and y_k^- be the expected times of solving J_k given that it is a WIN or LOSS, respectively. We will now calculate the effect of reversing the order at which SOLVE explores these two nodes while keeping the order of exploration of all other successors unaltered. Let $I(k, k+1)$ stand for the expected search time of solving J by exploring J_k prior to J_{k+1} and $I(k+1, k)$ that of exploring J_{k+1} first, immediately followed by J_k. If p_0 is the probability that the search terminates prior to exploring node J_k, and I_0 is the mean search time spent on the left siblings of J_k, then we can write:

$$I(k, k+1) = I_0 + (1 - p_0)\{p_k y_k^+ + (1 - p_k)[y_k^- + p_{k+1}y_{k+1}^-$$

$$+ (1 - p_{k+1})(y_{k+1}^- + I_R)]\} \qquad (9.70)$$

where I_R is the residual work remaining in the event that both J_k and J_{k+1} are found to be LOSS. Simplifying (9.70) we get:

$$I(k, k+1) = I_0 + (1-p_0)[y_k + (1-p_k)y_{k+1} + (1-p_k)(1-p_{k+1})I_R]$$

Likewise, exchanging J_k and J_{k+1}, gives

$$I(k+1, k) = I_0 + (1-p_0)[y_{k+1} + (1-p_{k+1})y_k + (1-p_{k+1})(1-p_k)I_R]$$

Now, taking the difference

$$\Delta_k = I(k, k+1) - I(k+1, k)$$

we find:

$$\Delta_k = (1-p_0)p_k p_{k+1} \left[\frac{y_k}{p_k} - \frac{y_{k+1}}{p_{k+1}} \right] \qquad (9.71)$$

The order $(k, k+1)$ is superior to $(k+1, k)$ if Δ_k is negative, that is, if $y_k/p_k < y_{k+1}/p_{k+1}$. That means that the ratio y_k/p_k should constitute the criterion for ordering the successors of any node J. Once the successors are searched in increasing order of this ratio, the mean search time is optimal since any disturbance of this order may only lead to an increase in search time.

This is a familiar result in statistical search theory (DeGroot, 1970) and was also used by Simon and Kadane (1975) to attack search problems in artificial intelligence. The interesting feature of our treatment here is that the ratio y_k/p_k remains the appropriate ordering criterion even when we assume that the search complexity depends on the WIN-LOSS status of the node explored (i.e., $y_k^+ \neq y_k^-$).

It is now easy to show that if the branching degrees $b(J_1), b(J_2), \ldots$ are the only information available to us regarding the subtrees rooted at J_1, J_2, \ldots, then choosing the successor with the lowest b is optimal. We need to show only that $b(J_k) < b(J_{k+1})$ implies $y_k/p_k < y_{k+1}/p_{k+1}$. But the game trees rooted at the grandsons of J all have the same statistical properties, and since all J_k's successors must be WIN in order for J_k to be a WIN, p_k decreases with $b(J_k)$ while y_k increases with $b(J_k)$. Hence

$$ b(J_k) < b(J_{k+1}) \Rightarrow \frac{y_k}{p_k} < \frac{y_{k+1}}{p_{k+1}} $$

thus confirming our conjecture that choosing the successor with the lowest b is optimal.

9.6 BIBLIOGRAPHICAL AND HISTORICAL REMARKS

The analysis of SCOUT (Section 9.1) is based on Pearl (1980). The historical background for the analysis of α-β is summarized in Section 9.2.1. The integral formula for $I_{\alpha\text{-}\beta}$ (Eq. (9.18)) was derived by Baudet (1978) using discrete values and by Roizen (1981) using continuous terminal values. The value of the branching factor of α-β was established by Pearl (1982b) using the method of characteristic distribution, as in Appendix 9-A.

The superiority of SSS* over α-β was proven by Stockman (1979) who also gives empirical comparison of their performances. The average case analysis of SSS* is due to Roizen and Pearl (1983a). T. Hopp began a similar analysis in 1980, but a false assumption regarding the conditions for node examination has led him to conclude $R_{\text{SSS*}} < R_{\alpha\text{-}\beta}$. The exact calculation of I_{SCOUT} (Figure 9.4) is due to Roizen and Pearl (1983b).

The results in Sections 9.4 and 9.5 are due to Pearl and have not been printed earlier. Additional properties of random games can be found in Michon (1983). Other applications of two-cycle attractors are surveyed in a *Scientific American* article by Hofstadter (1981).

EXERCISES

9.1 (After Roizen) Derive an exact expression for $y_n(k)$ in Eq. (9.1) by averaging over v_k and show that it is equal to:

$$y_n(k) = b^{2n-1}(k-1) \int_0^1 \frac{f_{n-1}^b(x)}{f_0(x)} \cdot \frac{[1 - f_{n-1}^b(x)]^{k-1}}{1 - f_0(x)} \, dx$$

where $f_0(x) = x$ and $f_{i+1}(x) = 1 - [1 - f_i^b(x)]^b$. Using the method of Appendix 9-A, derive an approximation to $y_n(k)$, as $n \to \infty$.

9.2 Consider the problem of finding a maximum-capacity path in a uniform flow tree with random edge capacities such as that analyzed in Section 8.4.3. Show that the backtracking algorithm of exercise 8.7 will find the maximum capacity path in quadratic expected time.

9.3 Find a necessary and sufficient condition for an edge to be examined by a best-first search for a maximum-capacity path (the equivalent of SSS* found in exercise 8.8). Using this condition, show that the best-first algorithm runs in $O(N \log N)$ expected time (N being the depth of the flow tree.) Estimate the average memory space required for a best-first search.

9.4 Use the results stated in exercise 5.4a to compare the expected performances of SCOUT and α-β in searching for the maximum capacity path in the flow tree of Figure 8.31(a). Show that SCOUT outperforms α-β by a factor of $(b-1)/\ln b$.

9.5 Generalize the results of Section 9.4 to the case where each shallow leaf node may be either a LOSS (with probability q) or a WIN (with probability $1 - q$) to the player whose turn it is to move.

9.6 Find the branching factor of SCOUT in a game where each node has 5% chance of being terminal, 10% of having one successor, and otherwise has two successors. Assume that the terminal values are distinct and randomly ordered.

9.7 Find the branching factor of SOLVE in the game of exercise 9.6 assuming that all leaf nodes represent WIN to the player who moves last. Calculate the improvement produced by exploring the successors in increasing order of their branching degrees.

9.8 (After Michon) Consider a random game in which the number of options b is geometrically distributed with mean m, i.e.,

$$p_k = \frac{(1 - 1/m)^k}{m - 1} \qquad k = 1, 2, \dots$$

 a. Show that all nodes at even depths of the game tree have the same win probability.

 b. What is the distribution of the root value if the tree is of odd depth d, and the terminal values are uniformly distributed over the unit interval?

 c. Show that $I_{SOLVE} = (m)^{d/2}$ for all P_0.

 d. Estimate I_{SCOUT} assuming that the terminal values are continous i.i.d random variables.

APPENDIX 9-A
PROOF OF THEOREM 1

THEOREM 1. *For all* $0 \leqslant P_0 \leqslant 1$, *the expected number of terminal nodes inspected by SOLVE in solving a* (d, b, P_o)-*game is bounded by* :

$$I_{\text{SOLVE}}(d, b, P_o) \leqslant L(b) R^*(b)^d$$

Proof: Let d be an even integer, $d = 2h$. We wish to prove:

$$I_{\text{SOLVE}}(2h, b, P_o) = \prod_{i=0}^{h-1} H(P_i) \leqslant L(b) R^*(b)^{2h} \tag{A.1}$$

where, from Eq. (8.31):

$$H(y) = \frac{1 - y^b}{1 - y} \frac{1 - (1 - y^b)^b}{y^b} \tag{A.2}$$

and

$$P_i = g(P_{i-1}) \triangleq 1 - (1 - P_{i-1}^b)^b \qquad i = 1, 2, ..., h - 1 \tag{A.3}$$

The difficulty in estimating the product in Eq. (A.1) stems from the fact that the dependence of its various components $H(P_o), H(P_1), ..., H(P_i) ...$ on P_o is not explicitly stated but, rather, must be obtained via the iteration of Eq. (A.3). To rectify this difficulty, we make the substitution

$$P_o = \phi(x)$$

where $\phi(x)$ is a monotonic function onto $[0, 1]$ conveniently chosen to make the iteration more manageable. Since $\phi(x)$ is monotonic and onto $[0, 1]$, we have

$$\max_{P_o} I_{\text{SOLVE}}(2h, b, P_o) = \max_{x} I_{\text{SOLVE}}(2h, b, \phi(x))$$

$$= \max_{x} \prod_{i=0}^{h-1} H[g^i(\phi(x))] \tag{A.4}$$

where g^i is the i^{th} iterate of g, and so, the bounding of I_{SOLVE} can be done in the x domain.

A convenient choice of ϕ would be a function that renders all the iterates $g^i[\phi(x)]$ identical in shape, save for a scale factor.[†] Thus, we choose ϕ to be the solution of the functional equation:

$$g[\phi(x)] = \phi(x/a) \tag{A.5}$$

where a is a real-valued parameter to be determined by the requirement that Eq. (A.5) possess a nontrivial solution for $\phi(x)$.

† Pearl, Judea, "The Solution for the Branching Factor of the Alpha-Beta Pruning Algorithm and Its Optimality," *CACM*, Vol. 25, No. 8, August 1982, pp. 559–564. Copyright 1982, Association for Computing Machinery, Inc., reprinted by permission.

Eq. (A.5) is known as the Poincaré Equation (Kuczma, 1968) and since $g(\phi)$ is one-to-one over $\phi \in [0, 1]$, it can be shown to have a nontrivial solution $\phi(x)$ with the following properties (Pearl, 1981a):

1. $\phi(0) = \xi_b$, where ξ_b is the root of $x^b + x - 1 = 0$.

2. $a = \dfrac{1}{g'(\xi_b)} = \left[\dfrac{\xi_b}{b(1-\xi_b)} \right]^2$.

3. $\phi'(0)$ can be chosen arbitrarily, e.g., $\phi'(0) = 1$.

4. $\phi(x)$ is monotonic in x over $x \in [-\infty, +\infty]$.

5. $x(\phi) = \lim\limits_{k \to \infty} a^k [g^{-k}(\phi) - \xi_b]$

6. $\phi(x) \underset{x \to \infty}{\approx} 1 - (b)^{-b/b-1} \exp[-(x)^{-\ln b/\ln a}]$

7. $\phi(x) \underset{x \to -\infty}{\approx} (b)^{-1/b-1} \exp[-|x|^{-\ln b/\ln a}]$

However, only properties 1, 2, and 4 will play a role in our analysis. Most significantly, the parameter a, which is an implicit function of b, remains lower than 1 for all b.

Equation (A.5) means that ϕ is in some sense a **characteristic function** of the transformation g; operating on $\phi(x)$ by g leaves its shape unaltered and only causes its scale to shrink by a factor of $1/a$. Consequently the factors $H[P_i(\phi(x))]$ in Eq. (A.4) will likewise only change scale to become $H[\phi(x/a^i)]$. Our task now is to bound from above a product term $\pi_h(x)$, where

$$\pi_h(x) = \prod_{i=0}^{h-1} \psi(x/a^i) \tag{A.8}$$

and

$$\psi(x) = H[\phi(x)] \tag{A.9}$$

An examination of the polynomial $H(\phi)$ and the function $\psi(x) = H[\phi(x)]$ (Eqs. (A.2) and (A.9)) reveals that $\psi(x)$ is unimodal in x,

$$\psi(0) = [\xi_b/(1 - \xi_b)]^2 = R^*(b)^2 \tag{A.10}$$

and that $\psi(x)$ lies above the asymptotes $\psi(-\infty) = \psi(+\infty) = b$. Moreover, the maximum of $H(\phi)$ occurs below $\phi = \xi_b$ and, consequently, $\psi(x)$ attains its maximum, M_b, below $x = 0$ (see Figure 9.2).

At this point, were we to use the bound $\psi(x) \leqslant M_b$ in Eq. (A.1), it would result in $I_{\text{SOLVE}}(d, h, P_o) \leqslant (M_b)^h$ which is much too loose because $M_b > R^*(b)^2$. Instead, a tighter bound can be established by exploiting the unique relationships between the factors of $\pi_h(x)$.

LEMMA 1: Let $x_0 < 0$ be the unique negative solution of $\psi(x_0) = \psi(0)$. $\pi_h(x)$ attains its maximal value in the range $a^{h-1}x_0 \leqslant x \leqslant 0$.

Proof: Since $\psi(x)$ is unimodal, we have $\psi(x) < \psi(0)$ and $\psi'(x) > 0$ for all $x < x_0$. Consequently, for all $x < x_0$, any decrease in the magnitude of $|x|$ would result in increasing $\psi(x)$, that is, $\psi(cx) > \psi(x)$ for all $0 \leqslant c \leqslant 1$. Now consider $\pi_h(ax)$:

$$\pi_h(ax) = \psi(x/a^{h-2}) \psi(x/a^{h-3}) \cdots \psi(x) \psi(ax)$$

$$= \pi_h(x) \psi(ax)/\psi(x/a^{h-1});$$

for all x' satisfying $x'/a^{h-1} < x_0$ we must have $\psi(ax') > \psi(x'/a^{h-1})$ (using $c = a^h < 1$) and so $\pi_h(x')$ could not be maximal. Consequently, for $\pi_h(x')$ to be maximal, x' must be in the range $x_0 a^{h-1} \leqslant x' \leqslant 0$. ∎

LEMMA 2: $\pi_h(x)$ can be bounded by:

$$\pi_h(x) \leqslant L(b) [\psi(0)]^h \tag{A.11}$$

where $L(b)$ is a constant factor, independent of h.

Proof: Since $\psi(x)$ is continuous, there exists a positive α such that $\psi(x) \leqslant \psi(0) - \alpha x$ for all $x \leqslant 0$. Consequently, using Lemma 1, we can write:

$$\max_x \pi_h(x) = \max_{a^{h-1}x_0 \leqslant x \leqslant 0} \pi_h(x) \leqslant \max_{a^{h-1}x_0 \leqslant x \leqslant 0} \prod_{i=0}^{h-1}(\psi(0) - \alpha x/a^i)$$

$$\leqslant [\psi(0)]^h \max_{a^{h-1}x_0 \leqslant x \leqslant 0} \exp\left[\sum_{i=0}^{h-1} - \frac{\alpha x}{a^i \psi(0)}\right]$$

$$\leqslant [\psi(0)]^h \exp\left[\frac{-\alpha x_0}{\psi(0)} a^{h-1} \prod_{i=0}^{h-1} 1/a^i\right]$$

$$\leqslant [\psi(0)]^h \exp\left[\frac{-\alpha x_0}{\psi(0)(1-a)}\right]$$

Selecting $L(b) = \exp\left[\dfrac{-\alpha x_0}{\psi(0)(1-a)}\right]$ proves Lemma 2. ∎

The proof of Theorem 1 now follows from Eqs. (A.4), (A.10), and (A.11), writing:

$$I_{\text{SOLVE}}(2h, b, P_o) \leqslant \max_x \pi_h(x)$$

$$\leqslant L(b)[\psi(0)]^h$$

$$\leqslant L(b)R^*(b)^{2h}$$ ∎

APPENDIX 9-B
PROOF OF THEOREM 6

1. *The "only if" part.*

Suppose a terminal MAX node **J**, with ancestors \mathbf{J}_i, is examined by SSS*. Then it appears on OPEN as part of the triple $(\mathbf{J}, L, h(\mathbf{J}))$ and:

$$B(\mathbf{J}) = \min\{v(\mathbf{J}_i) \mid i \text{ is even}, 0 \leqslant i \leqslant d - 1\}$$

$$= \min\{\min\{f(\lambda) \mid \lambda \text{ is left sibling of } \mathbf{J}_i\} \mid i \text{ is even},$$

$$0 \leqslant i \leqslant d - 1\}$$

$$= h(\mathbf{J})$$

because all of the nodes λ (the set of left siblings of ancestors of \mathbf{J}) are part of the solution tree which SSS* has traversed up to state $(\mathbf{J}, L, h(\mathbf{J}))$, and $h(\mathbf{J})$ is determined by the lowest value leaf in that solution tree. Also, it must be that

$$h(\mathbf{J}) > A_L^0(\mathbf{J}).$$

Suppose $h(\mathbf{J}) \leqslant A_L^0(\mathbf{J})$. Then, by Eq. (9.27), there exists a MIN ancestor \mathbf{J}_{i_1} of \mathbf{J} for which $h(\mathbf{J}) \leqslant g_L(\mathbf{J}_{i_1})$. Hence, by Eq. (9.24), there also exists on OPEN a left sibling J of \mathbf{J}_{i_1} for which $f(J) \geqslant h(\mathbf{J})$ and so it will compete for expansion with the left sibling of \mathbf{J} having merit $h(\mathbf{J})$. J as well as its successors appearing on OPEN will have merit

$$h_1 \geqslant \min\{h(father(\mathbf{J}_{i_1})), f(J)\} \geqslant \min\{h(\mathbf{J}), f(J)\} = h(\mathbf{J})$$

Since J and its successors have smaller lexicographic values than \mathbf{J}, case 3 of Γ (Table 8.1) will resolve ties ($h_1 = h(\mathbf{J})$) in favor of J and its progeny on OPEN. Thus \mathbf{J}'s left sibling will never be the first on OPEN, and consequently, \mathbf{J} will never be examined, a contradiction to our basic assumption that \mathbf{J} is examined. Therefore, $B(\mathbf{J}) = h(\mathbf{J}) > A_L^0(\mathbf{J})$.

Let us now prove that $v(\mathbf{J}_{k'}) = B(\mathbf{J}) \geqslant A_R^{k'}(\mathbf{J})$, where k' is defined by Eq. (9.31). First consider the OPEN list when node \mathbf{J} is about to be examined, that is, when the triple $(\mathbf{J}, L, h(\mathbf{J}))$ arrives to the top of OPEN. By the definition of Γ operator (Table 8.1), every right-hand-side MIN sibling J of each \mathbf{J}_i ancestor of \mathbf{J} is represented on OPEN by a set of triples $(J, S, h(J))$. Since $(\mathbf{J}, L, h(\mathbf{J}))$ is on the top of OPEN, it must be that

$$(\forall J)\, h(\mathbf{J}) \geqslant h(J) \geqslant f(J)$$

$$h(\mathbf{J}) \geqslant \max\{f(J) \mid J \text{ is a descendant of } \mathbf{J}_i, \mathbf{J}_i \text{ is an ancestor of } \mathbf{J}\}$$

$$h(\mathbf{J}) \geqslant A_R^k(\mathbf{J}), \text{ for all } k$$

In particular, choosing $k = k'$ from Eq. (9.31), and recalling that $B(\mathbf{J}) = h(\mathbf{J})$, we have

$$B(\mathbf{J}) = h(\mathbf{J}) \geqslant A_R^{k'}(\mathbf{J}).$$

2. *The "if" part* will be proved by induction on the lexicographic ordering of left siblings of the MAX ancestors of \mathbf{J} having the properties stated in the theorem, that is:

$$v(\mathbf{J}_{k'}) > A_L^0(\mathbf{J}), \qquad \text{and } v(\mathbf{J}_{k'}) \geqslant A_R^{k'}(\mathbf{J})$$

Assume $\mathbf{J} = j_1 . j_2 . \ldots . j_d$ satisfies Eq. (9.30). We prove by induction that every left sibling of the MAX ancestors of \mathbf{J}, including \mathbf{J}, must enter OPEN.

1. The leftmost sibling of $j_1 . j_2$ was on OPEN by virtue of being on the critical path (see case 1 of Γ-operator in Table 8.1).
2. Assuming that every node preceding some arbitrary node I in our lexicographic ordering was put on OPEN, we prove that I, too, must enter OPEN. Suppose I never entered OPEN. That implies that examination of the node preceding I lowered I's upper bound to a level $h(I)$ such that either or both of $h(I) \leqslant h(I_L)$, $h(I) < h(I_R)$ holds throughout the end of execution, where I_L and I_R are competing nodes to the left and right of I, respectively.

Since SSS* is an admissible minimax procedure, when it halts, $h(I_L)$ and $h(I_R)$ must satisfy $h(I_L) \leqslant A_L^0(\mathbf{J})$ and $h(I_R) \leqslant A_R^{k'}(\mathbf{J})$ because $A_L^0(\mathbf{J})$ and $A_R^{k'}(\mathbf{J})$ each constitute an upper bound to the final value of the game, whereas $h(I_L)$ (or $h(I_R)$) in turn, upper bounds the cluster of solution trees containing I_L (or I_R). Hence, if SSS* halts with $h(I_L) > A_L^0(I)$ (or $h(I_R) > A_R^{k'}(I)$), then the final solution tree discovered is not certified to be superior to every member of the cluster represented by I_L (or I_R), which is a contradiction to admissibility. Finally, from $B(\mathbf{J}) \leqslant h(I)$, $h(I) \leqslant h(I_L) \leqslant A_L^0(\mathbf{J})$, or $h(I) < h(I_R) \leqslant A_R^{k'}(\mathbf{J})$ would violate the condition of Eq. (9.30) assumed to hold true by the "*if*" part of our theorem. We, therefore, conclude that, contrary to our initial supposition, node I did enter OPEN. End of inductive proof. ∎

Chapter 10

Decision Quality in Game Searching[†]

All game-searching methodologies are founded on the belief that look-ahead followed by minimaxing improves the quality of decisions or, in other words, that the "backed-up" evaluation function discriminates between good and bad moves better than the unprocessed static evaluation function. Although no theoretical model has supported this belief, it has become entrenched in the practice of game-playing and its foundation is rarely challenged.

In fact it is surprising that the minimax method works at all. The static evaluation does not exactly evaluate the positions on the search frontier, but only provides estimates of their strengths. Minimaxing these estimates as if they were true payoffs amounts to committing one of the deadly sins of statistics: computing a *function of the estimates* instead of an *estimate of the function*. In the same way that the average of a product generally is not equal to the product of the averages, so also the estimate of the minimax differs from the minimax of the estimates.

Two heuristic arguments are usually advanced in support of look-ahead. The first invokes the notion of **visibility**, claiming that since the fate of the game is more apparent near its end, nodes at deeper levels of the game tree will be more accurately evaluated and choices based on such evaluations should be more reliable. The second alludes to the fact that whereas the static evaluation is computed on the basis of the properties of a single game position, the backed-up value integrates the features of all the nodes lying on the search frontier, and so should be more informed. This latter argument essentially takes after a **filtering** model; the more samples, the less noise.

The filtering argument, compelling as it seems, turns out to be utterly fallacious. True, obtaining more refined information from a large number of samples should only improve our decisions, provided this information is properly

† The author thanks North Holland Publishing Company for permission to reprint the portion of the article "On the Nature of Pathology in Game Searching" by Judea Pearl which first appeared in *Artificial Intelligence* 20(4), 427–453, July 1983.

integrated. However, passing this refined information through repetitive minimax operations does not guarantee that what was gained by refinement will not get lost by misaggregation. Indeed, Nau (1980) and Beal (1980) independently discovered that in some models of games **reaching deeper consistently degrades the quality of a decision**, a phenomenon that Nau termed **pathological**. In this chapter we use our standard probabilistic model to study the quality of the decisions that are produced by minimaxing, and to identify the conditions that give rise to pathological behavior.

Section 10.1 demonstrates that if one assumes a uniform game tree with random independent node values, the discriminating power of the backed-up evaluation function *decreases* appreciably with each level of minimaxing. If one further assumes that the accuracy of the static evaluation function does not improve with increasing depths (i.e., no improvement in visibility), search-depth pathology becomes inevitable; *the deeper we search, the worse we play*. This phenomenon, of course, is not observed in common game-playing; searching deeper has proven to be beneficial in most games of perfect information. This discrepancy raises the question: What is it about game trees that could account for the success of search in games such as chess or checkers?

To answer this question, we examine three modifications to the original model:

1. Evaluation functions with **improved visibility**
2. **Dependencies** among values of "close" nodes
3. Game trees with **"traps"** causing early termination

Section 10.2.1 shows that in order to suppress search-depth pathology, the accuracy of the static evaluation function must improve at a very high rate, unreasonable for most games. Section 10.2.2 discusses the noise abatement contribution of dependencies and argues that although strong dependencies undoubtedly quench pathology, it is too early to judge whether the dependencies actually found in ordinary games are of sufficient strength to be considered the prime benefactors of look-ahead search. In Section 10.2.3 we show that the introduction of even a small fraction of traps may dampen significantly the noise amplification due to minimaxing. An early detection of these traps is therefore postulated as the most important function served by deep search (Pearl, 1983b).

10.1　ERROR PROPAGATION THROUGH MINIMAXING

10.1.1　Error Propagation for Bi-Valued Estimates and Binary Trees

To illustrate the nature of search pathology, let us begin by considering a uniform binary game tree where the terminal nodes may assume WIN or LOSS status with a probability of p and $1 - p$, respectively. These terminal nodes do

not represent the terminal positions of the game, but rather the look-ahead positions at the frontier of a game-searching procedure. Hence, connected with each terminal node is a (static) evaluation function e which provides information on the strength of that position. For simplicity, let us begin by assuming that e is bi-valued, with $e = 1$ and $e = 0$ indicating a strong and weak position, respectively.

Naturally such an evaluation function, being imperfect, would lead to some erroneous decisions since it might assign the value $e = 1$ to a position that in fact is a LOSS and, vice versa, a value of $e = 0$ to a WIN position. The strengths of positions at higher levels of the search tree are estimated by the backed-up (also called roll-back) minimax value of e and, likewise, would constitute somewhat unreliable predictions of the true WIN-LOSS status of these positions. Our plan is to trace the prediction quality of the backed-up evaluation function as it is minimaxed through higher and higher levels.

For conciseness, we will use the symbol e_i to denote the backed-up evaluation of position i, and S_i to denote the WIN-LOSS status of position i. Moreover, e_i and S_i will be referred to the player whose turn it is to move from position i (i.e., NEG-MAX notation as in Section 8.1.3). For example, if player 2 can move and force a WIN from position i, we write $S_i = W$, and if we estimate that i is a weak position to player 1, we write $e_i = 1$, because to the mover, player 2, i appears strong.

Using this notation, the propagation rules for S and e are identical and remain invariant to the identity of the player. If node 3 has two sons 1 and 2, as shown in Figure 10.1, we can write:

$$S_3 = \begin{cases} L & \text{if } S_1 = W \text{ and } S_2 = W \\ W & \text{otherwise} \end{cases} \tag{10.1}$$

and

$$e_3 = \begin{cases} 0 & \text{if } e_1 = 1 \text{ and } e_2 = 1 \\ 1 & \text{otherwise} \end{cases} \tag{10.2}$$

The informedness of the evaluation function e is quantified probabilistically using two error parameters:

$$\alpha = P(e = 1 \mid S = L) \tag{10.3}$$

$$\beta = P(e = 0 \mid S = W) \tag{10.4}$$

α and β essentially measure the familiar statistical type I and type II errors, respectively, where a type I error amounts to rejecting the hypothesis H_0: "S is a LOSS" when it is true, and a type II error is committed if H_0 is accepted when in reality S is a WIN. To calculate how these errors propagate to higher levels of the tree, we also need to assume that the terminal positions are assigned random and independent WIN-LOSS status and that each node's

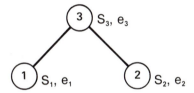

Figure 10.1

Notation used in analyzing error propagation. e_i denotes the backed-up evaluation function of position i, and S_i denotes its WIN-LOSS status.

evaluation depends only on the status of that node, not on the status or evaluation of its neighbors.

Assume that nodes 1 and 2 are both characterized by the parameters α, β, and p, where α and β are defined in Eqs.(10.3) and (10.4), and p stands for the probability that position 1 is a WIN. Let us now calculate the parameters α', β', and p' associated with node 3, their father. p' is obtained directly from Eq.(10.1):

$$p' = P(S_3 = W) = 1 - P(S_1 = W, S_2 = W) = 1 - p^2. \qquad (10.5)$$

Similarly, for α' we have:

$$\begin{aligned}
\alpha' = P(e_3 = 1 \mid S_3 = L) &= 1 - P(e_3 = 0 \mid S_3 = L) \\
&= 1 - P(e_1 = 1, e_2 = 1 \mid S_1 = W, S_2 = W) \\
&= 1 - [P(e_1 = 1 \mid S_1 = W)]^2 \\
&= 1 - (1 - \beta)^2 \qquad (10.6)
\end{aligned}$$

β' can best be obtained from the unconditional probability $P(e_3 = 0)$, which is easy to calculate. Writing:

$$\begin{aligned}
P(e_3 = 0) &= P(e_3 = 0 \mid S_3 = W)\, P(S_3 = W) + P(e_3 = 0 \mid S_3 = L)\, P(S_3 = L) \\
&= \beta'(1 - p^2) + (1 - \alpha')p^2 \\
&= \beta'(1 - p^2) + (1 - \beta)^2 p^2
\end{aligned}$$

we obtain for β':

$$\beta' = \frac{1}{1 - p^2} [P(e_3 = 0) - (1 - \beta)^2 p^2]$$

Substituting for $P(e_3 = 0)$:

$$\begin{aligned}
P(e_3 = 0) &= [P(e_1 = 1)]^2 \\
&= [P(e_1 = 1 \mid S_1 = W)\, P(S_1 = W) + P(e_1 = 1 \mid S_1 = L)\, P(S_1 = L)]^2 \\
&= [p(1 - \beta) + (1 - p)\alpha]^2
\end{aligned}$$

we finally have:

$$\beta' = \frac{\alpha}{1+p} [(1-p)\alpha + 2p(1-\beta)] \tag{10.7}$$

For any node in a binary game tree, Eqs.(10.5), (10.6), and (10.7) relate its α, β, and p parameters to those of its successors. Hence, if α_k, β_k and p_k characterize nodes at the k^{th} level of the tree, nodes at the $(k+1)^{th}$ level will be governed by α_{k+1}, β_{k+1}, and p_{k+1}, where

$$\alpha_{k+1} = 1 - (1-\beta_k)^2 \tag{10.8a}$$

$$\beta_{k+1} = \frac{\alpha_k}{1+p_k} [(1-p_k)\alpha_k + 2p_k(1-\beta_k)] \tag{10.8b}$$

$$p_{k+1} = 1 - p_k^2 \tag{10.8c}$$

These recursion equations completely describe the properties of the evaluation function as it is minimaxed up the tree. However, does such minimaxing procedure improve or deteriorate the reliability of the evaluation function? If the "filtering" argument is valid, we should expect α_k and β_k to diminish with increasing k, thus vindicating the benefits of deep look-ahead search. We will see that the opposite is true.

The most natural way of measuring the quality of the evaluation function is via P_e, the **probability of error** it induces. Given a game position with two successors, a LOSS and a WIN, an error is induced when the WIN position obtains a lower evaluation than its LOSS sibling. Likewise, if ties are broken arbitrarily, equal evaluations of WIN and LOSS positions carry a 50% chance of inducing a decision error. In summary:

$$P_e = P(e_1 > e_2 \mid S_2 = W, S_1 = L) + \tfrac{1}{2}P(e_1 = e_2 \mid S_2 = W, S_1 = L)$$

$$= P(e_1 = 1, e_2 = 0 \mid S_2 = W, S_1 = L) + \tfrac{1}{2}P(e_1 = 0, e_2 = 0 \mid S_2 = W, S_1 = L)$$

$$+ \tfrac{1}{2}P(e_1 = 1, e_2 = 1 \mid S_2 = W, S_1 = L)$$

$$= \alpha\beta + (1-\alpha)\beta/2 + \alpha(1-\beta)/2$$

$$= (\alpha + \beta)/2 \tag{10.9}$$

If one regards the pair (α, β) as a point in the plane, then P_e is given by the shaded area created by connecting (α, β) with $(0, 1)$ and $(1, 0)$ as shown in Figure 10.2. The quality of decisions induced by the evaluation function e improves as the point (α, β) comes closer to the origin. Also, any point on the line $\alpha + \beta = 1$ gives rise to a 50% error probability which amounts to a worthless evaluation function. In the following discussion we focus our attention on the region $\alpha + \beta \leqslant 1$; the area above this region represents evaluation functions that are not only misinformed but also misleading, as they induce more errors than one would obtain by flipping a random coin.

Eq.(10.8) can be regarded as a **transformation** which governs the trajectory of a two-dimensional vector (α_k, β_k) starting from the initial state (α_0, β_0).

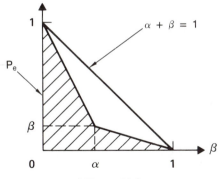

Figure 10.2

The shaded area measures the error probability P_e associated with the parameters (α, β).

Each initial probability p_0 gives rise to a different family of **trajectories** as is illustrated in Figures 10.3 and 10.4. The arrows along the trajectories represent the changes occurring in the vector (α, β) by two successive iterations of Eq.(10.8). It is apparent from these illustrations that, regardless of the initial conditions, all the interior trajectories migrate toward the line $\alpha + \beta = 1$, which represents a complete deterioration of the discrimination power of the backed-up evaluation function, accompanied by an error probability $P_e = .50$. The only trajectories possibly migrating toward the perfect information point $(0, 0)$ are those originating on the axes $\alpha = 0$ or $\beta = 0$; that is, where the initial static evaluation function is already free of error of one type. This assertion is proven in Section 10.1.3.

10.1.2 Extensions to Multivalued Estimates and b-ary Trees

At this point, prior to proving that the migration pattern of Figures 10.3 and 10.4 emerges from every initial condition, let us show that Eq.(10.8) also governs the error propagation in cases where the static evaluation function takes on a multiple of discrete, or even continuous, values. In this general case the connection between the magnitude of e and the actual WIN-LOSS status of any game position is characterized by the following pair of cumulative distribution functions:

$$F_L(x) = P(e \leqslant x \mid S = L) \qquad -\infty < x < \infty \qquad (10.10)$$

$$F_W(x) = P(e \leqslant x \mid S = W) \qquad -\infty < x < \infty \qquad (10.11)$$

Referring back to Figure 10.1 and following the NEG-MAX notations of Eq. (8.7), the event $e_3 \leqslant x$ depends on the magnitude of e_1 and e_2 via the relation:

$$\begin{cases} e_3 \leqslant x & \text{if } e_1 \geqslant -x \text{ and } e_2 \geqslant -x \\ e_3 > x & \text{otherwise} \end{cases} \qquad (10.12)$$

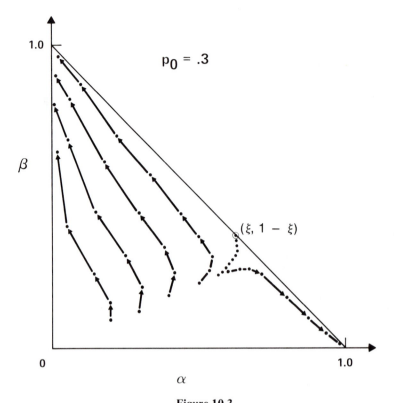

Figure 10.3

Trajectories showing how the vector (α, β) changes with each minimax cycle, starting with $P_0 = .3$.

Comparing Eqs.(10.12) and (10.2), it is evident that for any fixed x the events $e \leqslant x$ and $e > x$ propagate with the same logic as the events $e = 0$ and $e = 1$ in our initial, bi-valued model. Consequently, if we define the two functions:

$$\alpha(x) = 1 - F_L(x)$$
$$\beta(x) = F_W(x) \tag{10.13}$$

and compare Eqs.(10.10) and (10.11) to Eqs.(10.3) and (10.4), it becomes clear that with each minimax operation the pair $[\alpha(x), \beta(x)]$ undergoes the same transformation as the pair (α, β) in two iterations of Eq.(10.8).

If e is a continuous random variable, as x varies continuously over its entire domain, Eq.(10.13) traces a curve $\beta = g(\alpha)$, as shown in Figure 10.5. Minimaxing causes each point on this curve to shift along the trajectories illustrated in Figures 10.3 and 10.4, and so the entire g curve is shifted to form a new curve g', shown as the broken curve in Figure 10.5.

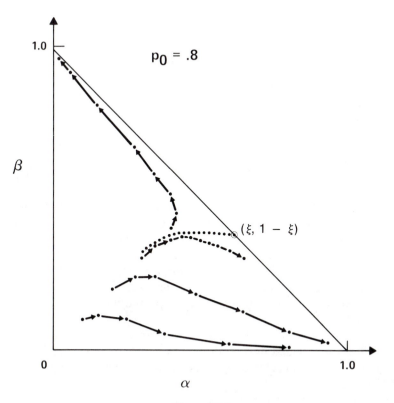

Figure 10.4
Same as 10.3 but starting with a WIN-probability of $P_0 = .8$ at the leaves.

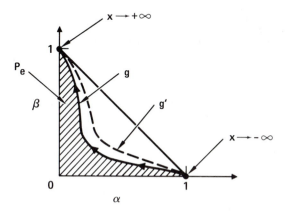

Figure 10.5
When e takes on continuous values, the vector (α, β) traces a continuous
function g. After one minimax cycle it shifts to form g', representing a
higher probability of error.

It is easy to show that the probability of error amounts to the area below the g curve. Indeed, paralleling Eq.(10.9) we obtain:

$$P_e = P[e_1 > e_2 \mid S_2 = W, S_1 = L]$$

$$= \int_x F_W(x) \, d[F_L(x)]$$

$$= \int_x \beta(x) \, d[\alpha(x)]$$

$$= \int_{\alpha=0}^{1} g(\alpha) \, d\alpha \tag{10.14}$$

Hence, if the initial g curve goes through the end-points $(0, 1)$ and $(1, 0)$ and if the trajectories governed by Eq.(10.8) propel every interior point to migrate toward the line $\alpha + \beta = 1$, the entire g curve eventually will coincide with that line and the error probability will reach 50%. If there are values of e that permit a perfect discrimination between a LOSS and a WIN, then g will intersect one of the axes at a distance shorter than 1. In such a case the final error probability will be either 50% or zero, depending on p_0 and the point of intersection (see exercise 10.1).

A similar picture prevails in the case of discrete multi-valued e. Here, Eq.(10.13) will be represented by a set of discrete points in the α-β plane, and P_e will amount to the area enclosed by the polygon connecting these points, as shown in Figure 10.6.

Finally, before returning to the analysis of Eq.(10.8), it is worth mentioning that a similar equation also governs uniform b-ary game trees. Assuming that each nonterminal node has b successors, and following a derivation similar to that in Eqs. (10.1)–(10.8), we obtain:

$$\alpha_{k+1} = 1 - (1 - \beta_k)^b$$

$$\beta_{k+1} = \frac{1}{1 - p_k^b} \left\{ [p_k(1 - \beta_k) + (1 - p_k)\alpha_k]^b - [p_k(1 - \beta_k)]^b \right\}$$

$$p_{k+1} = 1 - p_k^b \tag{10.8'}$$

This equation gives rise to a trajectory pattern very similar to that of Eq.(10.8). However, for the sake of maintaining clarity, we will only pursue the special case $b = 2$.

10.1.3 Limit-Points of (α_k, β_k)

Eq.(10.8c) is decoupled from the other two. It simply describes how the proportion of WIN positions changes from level to level and was thoroughly examined in our study of search complexity (Section 8.3). p_k exhibits the follow-

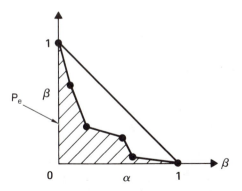

Figure 10.6
Discrete evaluation functions are characterized by a set of points in the
α-β plane.

ing limit behavior:

$$\lim_{k \to \infty} p_{2k} = \begin{cases} 1 & \text{if } p_0 > \xi \\ \xi & \text{if } p_0 = \xi \\ 0 & \text{if } p_0 < \xi \end{cases} \tag{10.15}$$

where ξ is the solution of $x^2 + x - 1 = 0$ ($\xi = .618034$). It is clear, therefore, that if (α_k, β_k) converges to a limit (α^*, β^*), that limit must be a fixed point of Eq.(10.8) under either one of the following three cases: $p_{2k} \to 0, p_{2k} \to 1$, or $p_k = \xi$.

Case 1: $p_{2k} \to 0$.
The complete cycle (two-iteration) version of Eq.(10.8) reduces to:

$$\alpha_{k+2} = 1 - (1 - \alpha_k^2)^2 \tag{10.16a}$$

$$\beta_{k+2} = [1 - (1 - \beta_k)^2](1 - \alpha_k^2) \tag{10.16b}$$

Eq.(10.16a) is essentially identical to Eq.(10.8c) and, hence, assumes the limits:

$$\lim_{k \to \infty} \alpha_{2k} = \begin{cases} 1 & \text{if } \alpha_0 > \xi \\ \xi & \text{if } \alpha_0 = \xi \\ 0 & \text{if } \alpha_0 < \xi \end{cases} \tag{10.17}$$

These three limits induce corresponding limits on β_k:

$$\lim_{k \to \infty} \beta_{2k} = \begin{cases} 0 & \text{if } \alpha_0 < \xi \\ 1 & \text{if } \alpha_0 > \xi, \beta_0 > 0 \\ 1 - \xi & \text{if } \alpha_0 = \xi, \beta_0 > 0 \\ 0 & \text{if } \beta_0 = 0 \end{cases} \tag{10.18}$$

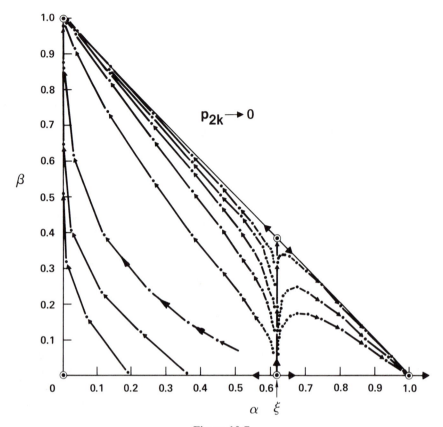

Figure 10.7
Limiting trajectories of (α, β) under the condition $p_0 < \xi$ which leads to
$p_{2k} \to 0$.

This behavior is illustrated in Figure 10.7, where the limit of every point in the
region $0 \leqslant \alpha + \beta \leqslant 1$ is given by the destination of the trajectory passing
through that point. Eqs.(10.17) and (10.18) imply the existence of five fixed
points, two stable limits $(1, 0)$ and $(0, 1)$ and three unstable limits $(0, 0)$, $(\xi, 0)$,
and $(\xi, 1-\xi)$. Note that unless $\beta_0 = 0$, all trajectories are destined to ter-
minate on the line $\alpha + \beta = 1$, where $P_e = \frac{1}{2}$.

Case 2: $p_{2k} \to 1$.
The complete cycle (two-iteration) version of Eq.(10.8) becomes:

$$\alpha_{k+2} = 1 - [1 - \alpha_k (1 - \beta_k)]^2 \tag{10.19a}$$

$$\beta_{k+2} = [1 - (1 - \beta_k)^2]^2 \tag{10.19b}$$

β_k assumes the limits:

$$\lim_{k \to \infty} \beta_{2k} = \begin{cases} 1 & \text{if } \beta_0 > 1-\xi \\ 1-\xi & \text{if } \beta_0 = 1-\xi \\ 0 & \text{if } \beta_0 < 1-\xi \end{cases} \qquad (10.20)$$

and these dictate:

$$\lim_{k \to \infty} \alpha_{2k} = \begin{cases} 0 & \text{if } \beta_0 > 1-\xi \\ 1 & \text{if } \beta_0 < 1-\xi, \alpha_0 > 0 \\ \xi & \text{if } \beta_0 = 1-\xi, \alpha_0 > 0 \\ 0 & \text{if } \alpha_0 = 0 \end{cases} \qquad (10.21)$$

The limit points are marked by circles in Figure 10.8. Again, all trajectories lead to the line $\alpha + \beta = 1$, except the one emanating from the segment $\alpha = 0$, $\beta \leqslant 1 - \xi$.

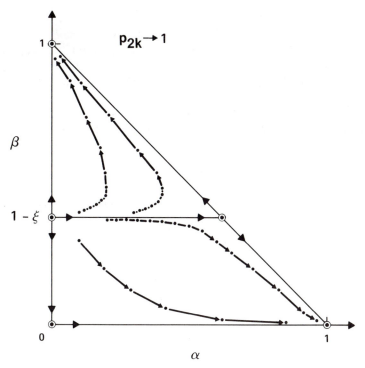

Figure 10.8
Limiting trajectories for the condition $p_{2k} \to 1$ which prevails if $p_0 > \xi$.

Case 3: $p_k = \xi$.

To decouple Eqs.(10.8a) and (10.8b), it is convenient to introduce the linear transformation:

$$\omega = 1 - (\alpha + \beta)$$
$$z = (1 - \xi)\alpha + \xi(1 - \beta) \tag{10.22a}$$

or

$$\alpha = z - \xi\omega$$
$$\beta = 1 - z - (1 - \xi)\omega \tag{10.22b}$$

In terms of the new variables ω and z, Eqs.(10.8a) and (10.8b) become

$$\omega_{k+1} = 2\xi z_k \omega_k + (2\xi - 1)\omega_k^2 \tag{10.23a}$$
$$z_{k+1} = 1 - z_k^2 \tag{10.23b}$$

which give rise to the familiar limits:

$$\lim_{k \to \infty} z_{2k} = \begin{cases} 1 & \text{if } z_0 > \xi \\ \xi & \text{if } z_0 = \xi \\ 0 & \text{if } z_0 < \xi \end{cases} \tag{10.24}$$

Note that the region $z > \xi$ stands for the area below the line $\beta = \alpha(1 - \xi)/\xi$, whereas the point $z = 1$ translates to $\pi_1 = 1$, $\beta = 0$. Eq.(10.24), therefore, implies that all trajectories emanating below the line $\beta = \alpha(1 - \xi)/\xi$ migrate toward $(1, 0)$ and, similarly, that those emanating above that line end up in $(0, 1)$, as shown in Figure 10.9.

 In this case ($p_k = \xi$) we may, in fact, derive a more informative equation for the deterioration of the evaluation function. Iterating Eq.(10.23) twice we obtain:

$$\omega_{k+2} = \omega_k I(z_k, \omega_k)$$

where $I(z_k, \omega_k)$ is a positive-coefficient third-order polynomial in ω_k. Hence, for $1 > \omega_k > 0$:

$$\frac{\omega_{k+2}}{\omega_k} < I(z_k, 1)$$

A separate calculation reveals that $I(z, 1)$ is at most 1 (at $z = \xi$), and so

$$\frac{\omega_{k+2}}{\omega_k} < 1 \tag{10.25}$$

implying that ω approaches zero monotonically. Moreover, since $\omega = 1 - 2P_e$ (see Eqs. (10.22a) and (10.9)), we conclude that the probability of error also approaches ½ monotonically.

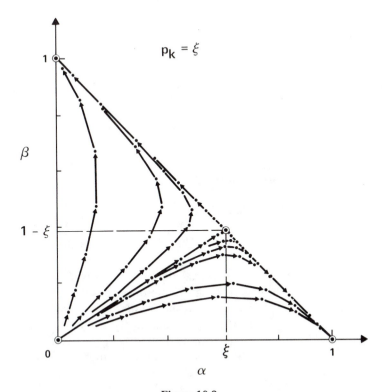

Figure 10.9
Trajectories produced when the WIN-probability remains invariant,
$p_k = p_0 = \xi$.

To obtain a feel for the growth rate of the error probability, we may use a
small-error approximation of Eqs.(10.8a) and (10.8b). Assuming $\alpha \ll 1$ and
$\beta \ll 1$, we obtain

$$\alpha_{k+2} \approx 4(1 - \xi)\alpha_k$$
$$\beta_{k+2} \approx 4(1 - \xi)\beta_k \qquad (10.26)$$

implying, using Eq. (10.9):

$$P_e(k + 2) \approx 4(1 - \xi)P_e(k) \approx 1.53\, P_e(k)$$

Thus, under small error conditions the error probability increases by more than
50% with each game cycle.

For a general b-ary tree ($b > 2$), the error amplification is even more pro-
nounced. Eq.(10.8') gives

$$P_e(k + 2) \approx b^2 \left[\frac{1-\xi_b}{\xi_b} \right]^2 P_e(k)$$

where ξ_b is the root of $x^b + x - 1 = 0$ and, using the approximation $(1 - \xi_b)/\xi_b \approx 1.081 b^{-3/4}$ (see Figure 8.21), we finally get

$$P_e(k + 2) \approx 1.169 \, b^{1/2} \, P_e(k)$$

Thus the rate of error amplification per game cycle increases as the square root of the number of alternative moves available to each player. For a game like chess, where the typical number of alternatives is estimated to be about 30, the error probability would increase by more than *fivefold* with each game cycle.

10.1.4 The Effect of Searching Deeper

Our discussion so far has demonstrated that the informedness of the evaluation function deteriorates as it is minimaxed *up* the game tree. We now examine how this phenomenon affects the quality of decisions as the search extends deeper *down* the tree.

Let the vector (α_k, β_k, p_k) characterize the backed-up evaluation function e_k obtained after passing through k levels of minimaxing. Let (α_0, β_0, p_0) characterize the static evaluation functions at the frontier of a d-ply search (i.e., d moves below the root), and $(\alpha'_0, \beta'_0, p'_0)$ that at the frontier of a $(d + 2)$-ply search. Our task is to evaluate the benefit of increasing the search depth by one additional move cycle. To that end we need to compare the quality of e_d, starting with (α_0, β_0, p_0) then backed up d levels to that of e'_{d+2}, starting with $(\alpha'_0, \beta'_0, p'_0)$ and backed up $d + 2$ levels.

If we write Eq.(10.8) in a concise vector notation:

$$(\alpha_{k+1}, \beta_{k+1}, p_{k+1}) = \psi(\alpha_k, \beta_k, p_k)$$

we get for e_d :

$$(\alpha_d, \beta_d, p_d) = \psi^d(\alpha_0, \beta_0, p_0) \tag{10.27}$$

and for e'_{d+2} :

$$(\alpha'_{d+2}, \beta'_{d+2}, p'_{d+2}) = \psi^{d+2}(\alpha'_0, \beta'_0, p'_0)$$

Since $p_0 = 1 - (1 - p_0'^2)^2$ (see Eq. (10.8c)), the last equation can also be written:

$$(\alpha'_{d+2}, \beta'_{d+2}, p'_{d+2}) = \psi^2[\psi^d(\alpha'_0, \beta'_0, \sqrt{1 - \sqrt{1 - p_0}})] \tag{10.28}$$

Note that $p'_{d+2} = p_d$ because they describe the probability of WIN for the same node, the root.

In comparing Eqs.(10.27) and (10.28), we first notice that if the static evaluation function is assumed to be equally informed at all levels of the game (i.e., ignoring improved visibility) and under the steady-state condition $p_d = p_0 = \xi$, then searching becomes utterly *harmful*. Writing $\alpha'_0 = \alpha_0$ and $\beta'_0 = \beta_0$, Eq.(10.28) becomes

$$(\alpha'_{d+2}, \beta'_{d+2}, \xi) = \psi^2(\alpha_d, \beta_d, \xi) \tag{10.29}$$

Thus, the effect of increasing the search depth by two extra levels is equivalent to that of passing the error parameters α_d, β_d through two successive iterations of Eq.(10.8). Such iterations, as is illustrated by Figure 10.9 and confirmed by Eq.(10.25), always cause an increase in the probability of errors (except when $P_e = 0$ or $P_e = \frac{1}{2}$).

Similar conclusions can be established for an arbitrary value of p_d, albeit for large d. Defining the function $q(x) = \sqrt{1 - x}$, Eqs. (10.27) and (10.28) can be written:

$$(\alpha_d, \beta_d, p_d) = \psi^d [\alpha_0, \beta_0, q^d (p_d)]$$

$$(\alpha'_{d+2}, \beta'_{d+2}, p_d) = \psi^{d+2}[\alpha_0, \beta_0, q^{d+2}(p_d)]$$

But since $\lim_{n \to \infty} q^{2n}(x) = \xi$, for large d we can write:

$$q^{d+2}(p_d) \approx q^d (p_d)$$

and hence:

$$(\alpha'_{d+2}, \beta'_{d+2}, p_d) \approx \psi^2(\alpha_d, \beta_d, p_d)$$

with a similar conclusion as that of Eq.(10.29).

10.2 WHEN IS LOOK-AHEAD BENEFICIAL?

The search-depth pathology, as just described, is not observed in common game-playing; typically, computer programs playing games such as chess and checkers improve their performances with increasing search-depth. Evidently, the assumed model failed to capture some essential characteristics of common games. Next, we examine our assumptions one by one, and find out which of them, if relaxed, may lead to the elimination of this pathology.

10.2.1 Improved Visibility

The argument of improved visibility has often been advanced in defense of the look-ahead scheme. Although it is rather doubtful that the evaluation functions currently used in chess playing give more accurate assessments of mid-game positions than opening positions, it is generally agreed that looking a few moves ahead may reveal threats and opportunities not easily recognizable at the initial game configuration. This feature was not included in the preceding analysis where we assumed $(\alpha_0, \beta_0) = (\alpha'_0, \beta'_0)$.

In some games, pathological behavior may occur despite an increase in evaluation function accuracy. Take, for instance, the board-splitting game described in Section 8.4.1 and use as an evaluation function the proportion of winning squares in the board evaluated, that is, the proportion of winning

leaves in the subtree rooted at each node. One can show that this evaluation has a greater discriminating power for small boards than for larger boards, and hence that it exhibits the feature of improved visibility. Yet simulation studies show that the search is pathological, causing the percentage of wrong decisions to grow with increasing depths (Nau, 1981); evidently the improved accuracy is insufficient to combat misaggregation.

In fact, from Eq.(10.27) we may determine the rate of improved accuracy necessary to combat pathology. Assuming $p_0 = \xi$, we may ask what relations should hold between (α'_0, β'_0) and (α_0, β_0) to make $(\alpha'_{d+2}, \beta'_{d+2})$ identical to (α_d, β_d). Since $\psi(\cdot)$ has a unique inverse, the answer is:

$$(\alpha'_0, \beta'_0, \xi) = \psi^{-2}(\alpha_0, \beta_0, \xi)$$

Thus, the required improvement in accuracy is obtained by passing (α_0, β_0) through two reversed iterations of Eq.(10.8). If the improvement in accuracy is greater than the accuracy lost in a single step along the trajectories of Figure 10.9, the net effect of searching one additional cycle further will be beneficial.

In the small-errors region, Eq.(10.26) dictates:

$$\alpha'_0 \approx \frac{\alpha_0}{4(1-\xi)} \approx \frac{\alpha_0}{1.53}$$

Thus, over 50% error reduction is necessary in order to combat pathology. Similarly, near the point $(0, 1)$ we obtain (by small perturbation analysis)

$$1 - \beta'_0 \approx \sqrt{(1 + p_0)(1 - \beta_0)/2}$$

and near $(1, 0)$:

$$1 - \alpha'_0 \approx \frac{1 + p_0}{2}\sqrt{1 - \alpha_0}$$

Such dramatic improvements in accuracy were not exhibited by the evaluation function in the board-splitting game simulated by Nau, and are also not likely to occur in games such as chess or checkers.

10.2.2 The Effect of Dependencies

Several authors have argued that the assumption of independence used in our preceding model may not fit common games such as chess and checkers (Knuth and Moore, 1975; Newborn, 1977). In such games, so the argument goes, the strength of a board position changes in an incremental manner so that closely related nodes such as sibling nodes have both closely related minimax values and WIN-LOSS status. In contrast, the estimated strengths of sibling nodes, as well as their status were assumed to be completely independent in our probabilistic model.

It is natural that the assumption of independence becomes suspect in searching for the causes of pathology. The reader may recall that the fundamental

source of degrading the quality of decisions lies not with look-ahead per se, but rather with the deployment of the minimax combination rule which treats estimates of game positions as if these were true terminal payoffs and so ignores their inaccuracies. Focusing, for instance, on a single maximum operation, it is clear that a substantial error is introduced when we replace the estimate of the maximum of several random variables by the maximum of their estimates. If the estimates are represented by the expected values, then the error introduced is equal to:

$$E[\max(x_1, x_2, \ldots, x_b)] - \max[E(x_1), E(x_2), \ldots, E(x_b)]$$

and this error, indeed, is at its highest when the random variables $x_1, x_2, ..., x_b$ fluctuate independently about their mean values. The error actually disappears when the fluctuations are tightly correlated and of equal magnitude. One may expect, therefore, that pathological effects are minimized in games where sibling nodes have closely related strengths.

A simulation study conducted by Nau (1981) shows that search-depth pathology may indeed disappear when dependencies are introduced. Nau used the board-splitting game with the same evaluation function as before, however, the initial assignment of WIN-LOSS status to the individual cells was governed by a process that maintained a strong correlation between neighboring cells. This caused the search-depth pathology to disappear.

This observation suggests that the incremental change in node strength in games such as chess and checkers is one of the reasons why such games are not pathological. However, the correlation used in Nau's simulation was extremely strong and very long-ranged. For example, knowing that a given leaf node is a WIN implied that every node in a neighborhood set as large as the square root of all the leaves has a probability greater than 2/3 of also being a WIN. Although some sibling correlation definitely exists in a game such as chess, it is still unclear whether this correlation by itself is sufficient to suppress pathology. This should be decided by analyzing multi-parameter game models where the range of correlation and its strength are governed separately. Such models, unfortunately are hard to construct and even harder to analyze (Acosta, 1982, Verstraete, 1982).

Another way of modeling node dependency, albeit an extreme one, is to assume that at any level of the game tree a certain fraction of the nodes **sprout subtrees containing only WIN nodes** for one of the players (Bratko and Gam, 1982). Clearly, if the static evaluation function is not grossly misinformed, performing minimax search under any such **seed node** will rapidly cause the backed-up value of that node to become perfect; all errors will eventually be filtered out (see exercise 10.1d). Consequently, if the probability of encountering such seed nodes is sufficiently high, then as the search depth increases the root node will eventually be evaluated perfectly (Bratko and Gam, 1982; Beal, 1982). Note that a seed node, representing an extreme case of perfectly correlated node clusters, acts similar to a terminal node in that it advertises its status with high reliability. Therefore, one can infer the impact of such clusters from

the analysis of the next section (10.2.3), where we will study the influence of 'traps' or shallow terminations.

It should be pointed out, though, that some chess phenomena normally brought up as evidence of correlation are also predicted by the the independence model of Section 10.1.1. For example, it is often argued that a strong chess position is usually accompanied by not just one, but *several* strong options and that the value of a successor position in chess does not vary substantially from the value of its father. The fact is that the model of Section 10.1.1 also predicts this behavior; having several strong siblings surely increases the probability that the father too is strong, and hence, by Bayes Theorem, the converse is also true. Likewise, the static evaluations of a father and a son are also correlated in our i.i.d. model because both depend on the strongly correlated WIN-LOSS status of their corresponding nodes. For example, knowing that a father is a WIN increases the probability that any given son is a WIN from p to $p/[1 - (1 - p)^b]$. At the same time the incremental nature of the evaluation function in chess is partly illusory; the values of successor positions appear tied down to the value of the father position mainly because we normally limit our consideration to the select set of successors that are reasonable to play and ignore those that are manifestly bad. With this limitation removed, it is hard to conceive of a chess position so strong that it cannot be spoiled abruptly if one really tries to make a stupid move.

The set of plausible next moves in chess normally falls into tightly correlated subsets where each subset represents a different tactical goal or strategic approach. Although the values of board positions in each such subset are correlated, much weaker correlation exists *across* subsets and, therefore, if we regard these subsets as macro-options, the analysis of Section 10.1 and its pessimistic predictions are not too unrealistic.

In summary, although the presence of dependencies among neighboring positions has a definite dampening effect on the noise amplification phenomena shown in Section 10.1, more analysis is needed to determine the nature of dependencies that actually exist in ordinary games and whether these dependencies can explain the advantage that search offers in game environments.

10.2.3 The Avoidance of Traps

A second simplifying assumption in the mathematical model of Section 10.1.3 is that of a *uniform* game tree with *identically* distributed node values. This assumption implies that the pair $F_L(x)$, $F_W(x)$ which quantifies the accuracy of the static evaluation function is the same for all nodes in a given level of the game tree (such as the model described in Section 9.4).

Common games clearly do not possess this property; blunders result in a quick termination, whereas careful playing leads to lengthy games. A careless chess player may even be beaten in as few as four moves from the opening. The danger of committing blunders exists in all stages of the game, and there-

fore a more realistic model should include terminal nodes at all levels of the game tree.

It is possible to argue both that the main role of look-ahead is the avoidance of these blunders, and that in models containing densely distributed traps the phenomenon of pathology should be minimal even using the imperfect minimax roll-back procedure. Since terminal nodes are perfectly identifiable by the static evaluation function, look-ahead will propagate reliable warnings to upper levels and will lead to the detection and avoidance of otherwise un-suspected traps. Another way of expressing this idea is to say that the accuracy of the static evaluation function is not the same for all nodes at a given level; for terminal nodes the static evaluation is perfect, whereas for nonterminal nodes it may be grossly misinformed. Thus, the mere presence of terminal po-sitions in the vicinity of the search frontier endows the static evaluation func-tion with improved visibility and results, as discussed previously, in weakening pathology. Note, however, that the significance of a terminal node in this model lies not in stopping the play per se, but rather, in permitting a highly re-liable estimate of the WIN-LOSS status of that node. Thus, nonterminal posi-tions that can be assessed reliably (such as the seed nodes discussed in Section 10.2.2) will produce equivalent results even though the end of the game may be many moves ahead.

These notions can be represented mathematically by modifying the model presented in Section 10.1 so that each node has a **nonzero probability q of being terminal**. For simplicity, we will also assume that a terminal node is always a LOSS to the player who has the move, and that every nonterminal node has exactly two successors. Obviously, every WIN node must be nonterminal.

Assuming that the evaluation function identifies the LOSS status of terminal nodes without error and following closely the derivation of Eqs.(10.5), (10.6), and (10.7), we obtain a modified version of the three parts of Eq.(10.8):

$$\alpha_{k+1} = \frac{(1-q)p_k^2}{1-(1-q)(1-p_k^2)}[1-(1-\beta_k)^2] \tag{10.30a}$$

$$\beta_{k+1} = \frac{\alpha_k}{1+p_k}[(1-p_k)\alpha_k + 2p_k(1-\beta_k)] \tag{10.30b}$$

$$p_{k+1} = (1-q)(1-p_k^2) \tag{10.30c}$$

Unlike Eq.(10.15), the asymptotic winning probability is now governed by the fixed points of the function $G(x) = (1-q)(1-x^2)$ shown in Figure 10.10. For $q < 1 - \sqrt{3}/2 \approx .134$, $G(x)$ has an unstable fixed point $\pi_0 = (\sqrt{1+4(1-q)^2}-1)/2(1-q)$ and a stable two-cycle between the points π_1 and π_2, so that:

$$G(\pi_0) = \pi_0 \qquad |G'(\pi_0)| > 1$$

$$G(\pi_1) = \pi_2 \qquad G(\pi_2) = \pi_1 \tag{10.31}$$

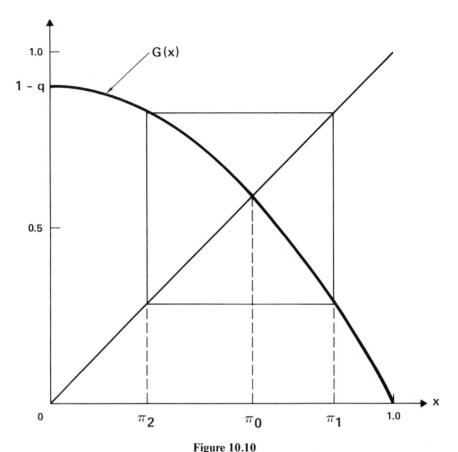

Figure 10.10
For small trap density q, the WIN-probability converges either to π_1 (if $p_0 > \pi_0$) or to π_2 (if $p_0 < \pi_0$).

For $q \geqslant .134$, the fixed point at π_0 becomes stable; π_1 and π_2 collapse into π_0. Consequently p_k exhibits the following asymptotic behavior:

$$\lim_{k \to \infty} p_{2k} = \begin{cases} \pi_1 & \text{if } \pi_0 < p_0 \leqslant 1, q < 1 - \sqrt{3}/2 \\ \pi_0 & \text{if } p_0 = \pi_0, q < 1 - \sqrt{3}/2 \\ \pi_2 & \text{if } 0 < p_0 < \pi_0, q < 1 - \sqrt{3}/2 \\ \pi_0 & \text{if } q \geqslant 1 - \sqrt{3}/2 \end{cases} \tag{10.32}$$

We now focus our attention on low values of q ($0 < q < 0.134$) where $\pi_1 > \pi_2$, and assume that at some even level k the winning probability p_k reached the stable value π_2. With each minimax cycle, the error parameters α_k and β_k undergo a transformation given by two successive iterations of Eq.(10.30). Figure 10.11 illustrates these transformations for $q = .05$ in the form of trajectories in the α, β plane.

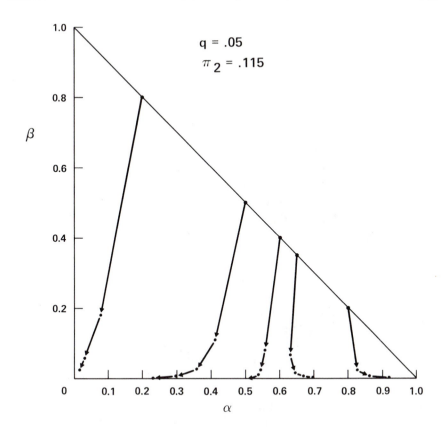

Figure 10.11

Introducing 5% of random traps while keeping $p_{2k} = \pi_2$ causes all trajectories to seek the zero error line $\beta = 0$.

Note the dramatic departure between Figures 10.7 ($q = 0, p_{2k} \to 0$) and 10.11 ($q = .05, p_{2k} \to .1152$). Whereas in Figure 10.7 the trajectories in the region $\pi_1 < \xi$ migrate toward the vertex $(0, 1)$, in Figure 10.11 they seek the perfect information point $(0, 0)$. While π_1 changes in roughly the same manner as in Figure 10.7, β now exhibits a very sharp drop after a single iteration. In the case of multi-valued evaluation functions, the curve g in Figure 10.5 or the polygon in Figure 10.6 collapses toward the coordinate axes after only a few cycles, resulting in the total elimination of decision errors. Thus, the presence of random traps in the game, even at the low density of 5%, completely eliminates search-depth pathology and renders look-ahead beneficial.

The reader who suspects that a 5% trap-density is unreasonably high for modeling common games will be in for a surprise. Contrary to intuition, the sharp drop in errors becomes *more pronounced* when q is made smaller until, for $q \to 0$, β drops to zero after only a single cycle. The reason for this is that when q approaches zero, the equilibrium winning probability π_2 also becomes

vanishingly small. If we analyze the small-q behavior of Eq.(10.30), using:

$$\pi_2(q) \approx 2q \tag{10.33}$$

$$\pi_1(q) \approx 1 - q \tag{10.34}$$

derived from Eq.(10.31), we obtain:

$$\beta_{k+2} \approx 4q[1 - (1 - \beta_k)^2](1 - \alpha_k^2) \leqslant 4q \tag{10.35}$$

Thus, no matter how misinformed the static evaluation function is initially, a single minimax cycle reduces β, the type II error, to zero if only the termination probability is made vanishingly small.

This phenomenon was not encountered in our previous analysis where, in Eq.(10.8) we literally set $q = 0$. On the contrary, in Eq.(10.16b), which represents the case $q = 0, p_{2k} \to 0$, we actually obtained:

$$\beta_{k+2} = [1 - (1 - \beta_k)^2](1 - \alpha_k^2)$$

describing an ever increasing β in the region $\alpha < \xi$, as illustrated in Figure 10.7. The disparity between Eqs.(10.35) and (10.16b) stems from the fact that the value of the right-hand expression of Eq.(10.30a) *at* $q = 0$ and $p_{2k} \to 0$, differs from its limit *along* $q \to 0$ and $p_{2k} = 2q$. This difference reflects two essentially different error mechanisms for the cases $q = 0$ and $q \to 0$. In both cases, $p_k \to 0$ implies that winning positions are very scarce at even levels of the game. When traps are nonexistent, these rare winning positions pass undetected by the minimax look-ahead method. However, in the presence of some traps, even at vanishingly small densities, the *majority of these winning positions are direct parents* of terminal nodes one move below. These types of winning nodes are perfectly detectable by the look-ahead method, which explains the drastic reduction of β in Figure 10.11.

To show that this reduction of β is an artifact of keeping p_k at the equilibrium point π_2, let us examine the effect of small q when p_0 is set equal to the fixed point π_0 ($\pi_0 \approx \xi - q\xi/(1 + 2\xi)$). Eq.(10.30) becomes:

$$\alpha_k \approx [1 - (1 - \beta_k)^2][1 - q/(1 - \xi)]$$

$$\beta_k \approx \frac{\alpha_k}{1 + \xi}[\alpha_k(1 - \xi) + 2\xi(1 - \beta_k)]$$

$$\left[1 + \frac{q\,\xi}{1 + 2\xi} \cdot \left[\frac{1}{1 + \xi} + \frac{\alpha_k - 2(1 - \beta_k)}{\alpha_k(1 - \xi) + 2\xi(1 - \beta_k)}\right]\right] \tag{10.36}$$

gradually converging to Eq.(10.8) as $q \to 0$. Figure 10.12 displays the trajectories generated by Eq.(10.30) for $q = .05$ and $p_0 = \pi_0 = .60373$. Although the trajectories no longer seek the perfect information point $(0, 0)$ they nevertheless represent a marked improvement over the pattern of Figure 10.9 where $q = 0$. Instead of the destination $(0, 1)$ and $(1, 0)$ in Figure 10.9, all trajectories in Figure 10.12 migrate toward the points $(0, .8089)$ and $(.842, 0)$,

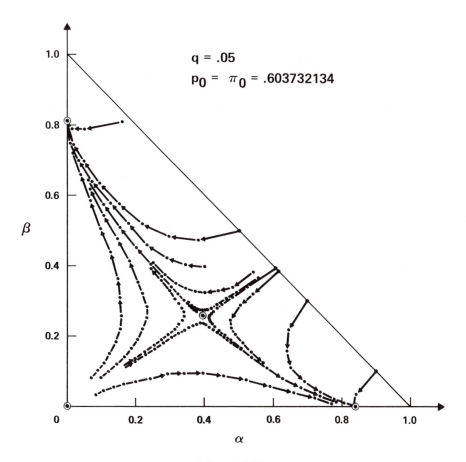

Figure 10.12

Introducing 5% of random traps while keeping p_{2k} at π_0 causes the trajectories to seek new limit points, away from the line $\alpha + \beta = 1$.

marked in circles. The asymptotic shape of the g curves for continuous evaluation functions is clearly visible by the trajectories connecting the unstable fixed point (.2577, .3925) to the two limit points just mentioned.

The significance of these limits is as follows. As $k \to \infty$, the probability that the status of the root node can be determined by a finite depth solution tree approaches a definite limit; $p^*(q)$. If a finite solution tree exists within the search frontier, the minimax procedure determines the root's status without error, because the evaluation function is errorless on terminal nodes. In cases where a finite solution tree does not exist, the root's status is dependent on the nodes at level $k = 0$, and, since the evaluations of these nodes are not perfect and since the errors are amplified by minimaxing these evaluations, a decision error will be committed at the root. The trajectory limits (0, .8089) and (.842, 0) represent the asymptotic errors averaged over these two cases.

Another case of special interest develops when the trap density exceeds the value $q = 1 - \sqrt{3}/2$, rendering π_0 a stable fixed point. The stability of π_0 means that the winning probability at the root becomes independent of p_0, the winning probability at the bottom level $k = 0$. Thus, as $k \to \infty$ the probability of a finite solution tree existing under the root node may approach 1, and since under such conditions the evaluation becomes perfect, we should expect the error parameters α and β to approach zero. This indeed is exhibited in Figure 10.13, representing the case $q = .25$. In general, the critical trap density q_c which guarantees both $\alpha \to 0$ and $\beta \to 0$ is given by

$$q_c = 1 - \frac{(1 + b)^{1 - 1/b}}{b}$$

(see exercise 10.4d), implying that games with a large number of moves require a lower density of traps to quench pathology. A general analysis of this transi-

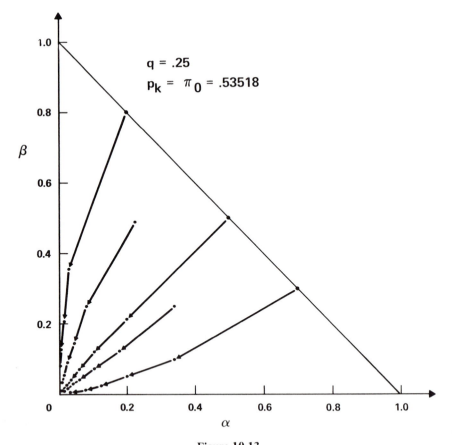

Figure 10.13
Increasing the trap density beyond $q = 1 - \sqrt{3}/2$ results in a quick reduction of error; all trajectories migrate toward the perfect information point $(0, 0)$.

tion point for games with random number of branches is given by Michon (1983).

The detection of terminal traps within the search domain could not, of course, be the sole role served by look-ahead. If this was the case, the strength of game-playing programs would depend only on the search-depth and not on the quality of the evaluation functions used. A more realistic model should incorporate the fact that each mid-game trap tends to make its presence felt even when it is situated a few levels beyond the search frontier. Parent nodes at the search frontier, whose WIN-LOSS status is determined by traps a few moves below them, normally carry more reliable evaluation functions than nodes located far above such traps. A deeper search exposes more nodes of the former, high reliability type, which tends to counterbalance the noise introduced with each additional minimax operation.

10.2.4 Playing to Win Versus Playing Correctly

So far our only criterion for judging the utility of searching has been the probability of making *correct* decisions, i.e., choosing a force WIN if such is available and avoiding a sure LOSS if such is threatened. In complex games such as chess or checkers, force WIN positions are rarely recognizable in mid game. Both players choose their moves using inaccurate assessments of board positions, and a player able to exploit his adversary's inaccuracy may *win* quicker by making *incorrect* moves, moving into sure LOSS positions if these are not recognizable as such by the adversary. The minimax look-ahead method reflects some of these considerations.

Assume that the terminal values in the game tree shown in Figure 10.14 are estimates of the probability that player 1 can force a WIN from these positions.

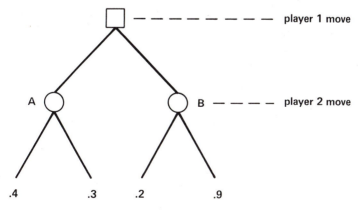

Figure 10.14

The minimax rule advises player-1 to move toward *A*, whereas probability theory recommends the opposite move, toward *B*, where the chances for winning are greater.

Which move should be selected, toward A or toward B? The minimax evaluation procedure assigns the values of .3 to node A and .2 to node B, leading player 1 to prefer A over B. On the other hand, if one computes the probabilities that nodes A or B are WIN (for player 1), one obtains:

$$P(A \text{ is WIN}) = P \text{ (all } A\text{'s successors are WIN)}$$

$$= (.3)(.4) = .12$$

$$P(B \text{ is WIN}) = P(\text{all } B\text{'s successors are WIN})$$

$$= (.9)(.2) = .18$$

Clearly, then, B is to be preferred. It is obvious from this example that if one wants to maximize the chances of choosing WIN positions, the minimax rule is inadequate and should be replaced by **product-propagation rules,** $\prod_i P_i$ for MIN nodes and $1 - \prod_i (1 - P_i)$ for MAX nodes. If these propagation rules are used, and if the estimates P_i are consistent with the maxims of probability theory, the phenomenon of pathology should be eliminated altogether.

However, this example also facilitates a line of defense in favor of the minimax rule if one is not concerned with winning regardless of what the opponent does, but simply with **beating a fallible opponent.** Such an opponent, if he shares our assessment of the terminal values, can be *predicted* to choose the left move from position B and the right move from position A. Therefore, on the basis of such a prediction, we have:

$$P(\text{player 1 wins from } A) = .3$$

$$P(\text{player 1 wins from } B) = .2$$

which agrees with the minimax calculation. In summary, although the minimax rule is inadequate when playing against an omnipotent opponent, tacitly it contains a realistic model of a fallible opponent who shares the knowledge and limitations of player 1, and therefore should be effective against such opponents. This may also contribute to the fact that pathology is not observed in practical game-playing programs; the quality of these programs is always judged by their score against human or man-made opponents. It is not entirely impossible that if judged against absolute standards of WIN-LOSS status today's programs may exhibit a less pronounced improvement with increasing search depths.

SUMMARY

This chapter demonstrated that in the game model of uniform trees with random terminal values, the discriminating power of the backed-up evaluation function decreases appreciably with each level of minimaxing. If the accuracy

of the static evaluation function remains the same at all levels of the game, a search depth pathology develops: the deeper we search, the worse we play. Moreover, to combat this pathology, the accuracy of the static evaluation function must improve with depth at an unreasonable high rate.

The most credible explanation for the absence of search-depth pathology in common game-playing programs is based on the fact that common games do not possess a uniform structure but are riddled with early terminal positions, colloquially named blunders, pitfalls, or traps. Close ancestors of such traps carry more reliable evaluation functions than the rest of the nodes, and when more of these ancestors are exposed by the search, the decisions become more valid.

The fact that deep search has proven beneficial in most popular games does not mean that game-playing practitioners can afford to ignore the pessimistic predictions issued by the probabilistic model of Section 10.1.1. Error amplification due to minimaxing is an established fact that may significantly degrade the quality of decisions in practical games. The absence of search-depth pathology in common games only means that the deterioration in decision quality due to minimaxing is masked by other processes and so is not sufficient to show up as a weakening ability with increasing search depth. At the same time, it is quite possible that substantial improvements in decision quality could be achieved if this deterioration is minimized by employing more appropriate aggregation rules to account for the inaccuracies in the evaluation function.

One such rule is represented in Berliner's B^* algorithm (Berliner, 1979) where each node is quantified by both an optimistic and a pessimistic estimate of its strength. A node is pruned when its optimistic estimate proves to be below the pessimistic estimates of all contending alternatives. Palay (1983) has developed improvements over the basic B^* algorithm using *distributions*, rather than *ranges*, to quantify the uncertainty of appraising the strength of game positions. The distributions of ancestor nodes are dictated by those of their descendants using the propagation rules of Eqs.(8.23) and (8.24) (i.e., independence is assumed) and the alternative selected for exploration is the one that exhibits the highest likelihood of turning out the best. This distribution-based search strategy proved significantly better than those based on point estimates in solving standard end-game chess problems.

An alternative approach to account for the uncertainty in evaluating the *strength* of game positions is to **translate** these evaluations into estimates of the *probability* of winning the game from these positions, then propagate these estimates by the **product rule,** as dictated by probability theory (Pearl, 1981b). In chess this translation can be based on statistical records. For example, a standard scale for scoring a chess position is the equivalent number-of-pawns lead that this position represents. It is possible, therefore, to actually *count* the fraction of times that positions with a given pawn score e have actually led to a WIN between players with experiences similar to those actually playing. In

cases where such records are not available, reasonable mapping functions such as

$$P = \frac{1}{2} + \frac{2}{\pi}\arctan(e/e_o) \qquad -\infty < e < \infty$$

may be adequate.

The success of these approaches may be hindered, of course, by inaccuracies in the mapping functions and by the inappropriateness of the product rule in cases where strong dependencies exist. However, these approximations offer a greater flexibility for improvement than those behind the minimax approach, which takes the estimates at face value. Whether programs based on these procedures will defeat programs using minimax remains an interesting experimental challenge (see Nau, 1983).

EXERCISES

10.1 Let e be a continuous evaluation function characterized by a curve $\beta = g(\alpha)$ which goes through the end-points $(0, \alpha^o), (\beta^o, 0)$.

 a. For each value of p_o $(0 \leqslant p_o \leqslant 1)$ determine the condition under which g will collapse (after repeated minimaxing on a b-ary game-tree) to the perfect information point $\alpha = 0, \beta = 0$.

 b. Let the conditional distributions of e be uniformly distributed with ambiguity factor t, as in Figure 9.6a. For each value of p_o and b there is a critical value t_c of the ambiguity factor, below which decisions improve with search depth and above which pathology sets in. Express t_c as a function of p_o and b and plot t_c versus p_o for $b = 2, 5, 10,$ and 25.

 c. Starting with $t = .1, b = 2, p_o = \xi$, plot the transformations of g as e passes through 10 minimax cycles. Repeat these from the starting points:

$$t = .3, \qquad p_o = .4, \qquad b = 2$$

$$t = .4, \qquad p_o = .4, \qquad b = 2$$

 d. Show that a minimax search conducted under a WIN seed node (a node whose descendants are all WIN to one player) returns an evaluation function that converges (with increasing search depths) to the node status if $\beta_o < \xi_b$. Similarly, for a LOSS seed node the condition is $\alpha_o < 1 - \xi_b$.

10.2 (After Nau, 1980) Consider a uniform game tree of degree b where every winning MAX node has exactly m winning sons (for the same player) and every losing MIN node has exactly n losing sons.

 a. Derive recursive equations describing the propagation of the error parameters α and β in this game tree.

 b. For $b = 2, m = 1$, and $n = 1$, determine the condition under which pathology will develop.

10.3 a. For a general b-ary tree, show that if $p_k = \xi_b$, every point on the line

$$\beta = \frac{1 - \xi_b}{\xi_b} \alpha$$

will remain on that line after an even number of iterations of Eq. 10.8.

 b. Prove that in the case $p_k = \xi_b$ the error probability increases with each minimax cycle.

10.4 a. Generalize the trajectory equations of Eq. (10.36) to the case where only a fraction r of the traps are LOSS (to the player who has the move) whereas a fraction $1 - r$ of them are WIN.

 b. Using a small-error analysis in part (a), plot the proportionality coefficient between α_{k+2} and α_k as a function of q and b, assuming $p_{k+1} = p_k = \pi_o$ and $r = 1 - \pi_o$.

 c. Determine the minimal value of q (as a function of r and b) for which the errors will converge to zero, under the condition $p_{k+1} = p_k = \pi_o$.

 d. Show that for $r = 1$ the minimal value of q becomes:

$$q_c = 1 - \frac{(1 + b)^{1 - 1/b}}{b}$$

Bibliography

Acosta, Anthony. 1982. Conditions for pathological search on MIN-MAX games. Master's thesis, Dept. of Engineering Systems, School of Engineering and Applied Science, University of California, Los Angeles.

Amarel, S. 1967. An approach to heuristic problem-solving and theorem proving in the propositional calculus. In *Systems and Computer Science*, ed J. Hart and S. Takasu. Toronto: University of Toronto Press.

Amarel, S. 1968. On representations of problems of reasoning about actions. *Machine Intelligence 3* pp. 131−71.

Amarel, S. 1982. Expert behavior and problem representations. Technical Report CBM-TR-126, Computer Science Dept., Rutgers University, New Brunswick, N.J.

Averbach, B., and Chein, O. 1980. *Mathematics—Problem solving through recreational mathematics.* San Francisco: W. H. Freeman.

Bagchi, A., and Mahanti, A. 1983. Search algorithms under different kinds of heuristics—A comparative study. *JACM* 30(1):1−21.

Bahl, L. R., Jelinek, F., and Mercer, R. L. 1983. A maximum likelihood approach to continuous speech recognition. *IEEE Trans. on Pattern Analysis and Machine Intelligence,* PAMI-5(2):179−90.

Banerji, R. B. 1980. *Artificial Intelligence: A Theoretical Approach.* Amsterdam: North Holland.

Barr, A., and Feigenbaum, E. A. 1981. *The Handbook of Artificial Intelligence,* vol. 1. Los Altos, Calif.: Wm. Kaufmann.

Baudet, G. M. 1978. On the branching factor of the alpha-beta pruning algorithm. *Artificial Intelligence* 10(2):173−99.

Beal, D. 1980. An analysis of minimax. In *Advances in Computer Chess 2,* ed. M. R. B. Clarke, pp. 103−9. Edinburgh: University Press.

Beal, D. 1982. Benefits of minimax search. In *Advances in Computer Chess 3,* ed. M. R. B. Clarke, pp. 17−24. Elmsford, N.Y.: Pergamon.

Bellman, R., and Dreyfus, S. 1962. *Applied Dynamic Programming.* Princeton, N.J.: Princeton University Press.

Bellmore, M., and Nemhauser, G. L. 1968. The traveling salesman problem: A survey. *Operations Research* 16:538−58.

363

Berlekamp, E. R., Conway, J. H., and Guy, R. K. 1982. *Winning Ways.* 2 vols. London: Academic Press.

Berliner, H. J. 1978. A chronology of computer chess and its literature. *Artificial Intelligence* 10(2):201‑14.

Berliner, H. J. 1979. The *B** tree search algorithm: A best-first proof procedure. *Artificial Intelligence* 12(1):23‑40.

Bramson, M. D. 1978. Minimal displacement of branching random walk. *Z. Wahrsch. Verw. Gebiete* 45:89‑108.

Bratko, I., and Gams, M. 1982. Error analysis of the minimax principle. In *Advances in Computer Chess 3*, ed. M. R. B. Clarke, pp. 1‑15. Elmsford, N.Y.: Pergamon.

Brudno, A. L. 1963. Bounds and valuations for shortening the scanning of variations (in Russian). *Problemy Kibernet.* 10:141‑50.

Campbell, M. S., and Marsland, T. A. 1983. A comparison of minimax tree search algorithms. *Artificial Intelligence* 20(4):347‑67.

Carbonell, J. G. 1983. Learning by analogy: Formulating and generating plans from past experience. In *Machine Learning*, ed. Michalski, Carbonell and Mitchell. Palo Alto, Calif.: Tioga Press.

Chang, C. L., and Slagle, J. R. 1971. An admissible and optimal algorithm for searching AND/OR graphs. *Artificial Intelligence* 2(2):117‑28.

Conway, J. 1976. *On Numbers and Games.* New York: Academic Press.

Darling, D. A. 1970. The Galton-Watson process with infinite mean. *J. Appl. Prob.* 1(7):455‑56.

de Champeaux, B., and Sint, L. 1977. An improved bi-directional heuristic search algorithm. *JACM* 24:177‑91.

Dechter, R., and Pearl, J. 1983. Generalized best-first strategies and the optimality of *A**. Technical Report UCLA-ENG-83-19. Cognitive Systems Laboratory, University of California, Los Angeles. Also: The optimality of *A** revisited. *Proc. of the 3d AAAI Natl. Conf. on AI,* Washington, D.C., pp. 59‑99.

DeGroot, M. H. 1970. *Optimal Statistical Decisions,* New York: McGraw-Hill.

Deo, N., and Pang, C. 1980. Shortest path algorithms: Taxonomy and annotation. CS-80-057, Computer Science Dept., Washington State University.

DeWitt, H. K. 1977. The theory of random graphs with applications to the probabilistic analysis of optimization algorithms. Ph.D. dissertation, Computer Science Dept., University of California, Los Angeles.

Dijkstra, E. W. 1959. A note on two problems in connection with graphs. *Numerische Mathematik* 1:269‑71.

Doran, J., and Michie, D. 1966. Experiments with the graph traverser program. *Proceedings of the Royal Society of London* 294(A):235‑59.

Dreyfus, S. E., and Law, A. M. 1977. *The Art and Theory of Dynamic Programming.* New York: Academic Press.

Durrett, R. 1981. An introduction to infinite particle systems. *Stochastic Processes and their Applications* 11:109‑50.

Eastman, W. L. 1958. Linear programming with pattern constraints, Ph.D. dissertation, Harvard University.

Edmonds, J., and Karp, R. M. 1972. Theoretical improvements in algorithmic efficiency for network flow problems. *JACM* 19(2):248‑64.

Ernst, G. W., and Newell, A. 1969. *GPS: A Case Study in Generality and Problem Solving.* New York: Academic Press.

Ernst, G. W., and Goldstein, M. M. 1982. Mechanical discovery of classes of problem-solving strategies. *JACM* 29(1):1 – 23.

Feller, W. 1968. *An Introduction to Probability Theory and its Applications.* Vol. 1, New York: Wiley.

Fikes, R. E. 1970. REF-ARF: A system for solving problems stated as procedures. *Artificial Intelligence* 1:27 – 120.

Fikes, R. E., and Nilsson, N. J. 1971. STRIPS: A new approach to the application of theorem proving to problem solving. *Artificial Intelligence* 2(3/4):189 – 208.

Fisher, M. L. 1981. The Lagrangian relaxation method for solving integer programming problems. *Management Science* 27(1):1 – 19.

Floyd, R. W. 1967. Nondeterministic algorithms. *JACM* 14:636 – 44.

Forney, G.D. 1973. The Viterbi algorithm. *Proceedings of IEEE* 61:268 – 278

Fuller, S. H., Gaschnig, J. G., and Gillogly, J. J. 1973. An analysis of the alpha-beta pruning algorithm. Dept. of Computer Science Report, Carnegie-Mellon University.

Funt, B. V. 1977. WHISPER: A problem-solving system utilizing diagrams and a parallel processing retina. *Proc. IJCAI* 5, pp. 459 – 64.

Galileo, G. 1638, *Discorsi e Dimostrazioni matematiche.* Leiden: Elsevirii.

Gardner, M. 1959. *The Scientific American Book of Mathematical Puzzles and Diversions.* New York: Simon and Schuster.

Gardner, M. 1961. *The Second Scientific American Book of Mathematical Puzzles and Diversions.* New York: Simon and Schuster.

Garey, M. R., and Johnson, D. S. 1979. *Computers and Intractibility.* San Francisco: W. H. Freeman.

Gaschnig, J. 1979a. Performance measurement and analysis of certain search algorithms. Ph.D. dissertation, Technical Report CMU-CS-79-124, Computer Science Dept., Carnegie-Mellon University.

Gaschnig, J. 1979b. A problem similarity approach to devising heuristics: First results. *Proc. IJCAI 6,* Tokyo, pp. 301 – 7.

Gelperin, D. 1977. On the optimality of A^*. *Artificial Intelligence* 8(1):69 – 76.

Geoffrion, A. M. 1974. Lagrangian relaxation and its uses in integer programming. *Math. Programming Study* 2:82 – 114.

Ghallab, M. 1982. Optimization de processus décisionnels pour la robotique. Thesis, L'Université Paul Sabatier de Toulouse, Toulouse, France.

Golden, B., and Ball, M. 1978. Shortest paths with Euclidean distances: An explanatory model. *Networks* 8:297 – 314.

Guida, G., and Somalvico, M. 1979. A method for computing heuristics in problem solving. *Information Sciences* 19:251 – 59.

Haralick, R. M., and Elliot, G. L. 1980. Increasing tree searching efficiency for constraint satisfaction problems. *Artificial Intelligence* 14:263 – 313.

Harris, L. R. 1974. The heuristic search under conditions of error. *Artificial Intelligence* 5(3):217 – 34.

Harris, T. 1963. *The Theory of Branching Processes.* Berlin: Springer.

Hart, P. E., Nilsson, N. J., and Raphael, B. 1968. A formal basis for the heuristic determination of minimum cost paths. *IEEE Trans. Systems Science and Cybernetics* SSC-4(2):100 – 7.

Hart, P. E., Nilsson, N. J., and Raphael, B. 1972. Correction to a formal basis for the heuristic determination of minimum cost paths. *SIGART Newsletter* 37:28 – 9.

Hart, T. P., and Edwards, D. J. 1961. The tree prune (TP) algorithm. M.I.T. Artificial Intelligence Project Memo #30, R.L.E. and Computation Center, Massachusetts Institute of Technology, Cambridge, Mass. (December 4). Reprinted in revised form as The alpha-beta heuristic, D. J. Edwards and T. P. Hart (October 28, 1963).

Held, M., and Karp, R. M. 1970. The traveling salesman problem and minimum spanning trees. *Operations Research* 18:1138–62.

Held, M., and Karp, R. M. 1971. The traveling salesman problem and minimum spanning trees—Part II. *Mathematical Prog.* 1:6–25.

Hillier, F. S., and Lieberman, G. J. 1974. *Introduction to Operations Research.* 2d ed. San Francisco: Holden-Day.

Hofstadter, D. R. 1981. Strange attractors. *Scientific Amer.* November, pp. 22–43.

Horowitz, E., and Sahni, S. 1978. *Fundamentals of Computer Algorithms.* Potomac, Md.: Computer Science Press.

Huyn, N., Dechter, R., and Pearl, J. 1980. Probabilistic analysis of the complexity of A*. *Artificial Intelligence* 15:241–54.

Ibaraki, T. 1977. The power of dominance relations in branch-and-bound algorithms. *JACM* 24(2):264–79.

Ibaraki, T. 1978a. Branch-and-bound procedure and state space representation of combinatorial optimization problems. *Information and Control* 36(1):1–27.

Ibaraki, T. 1978b. *m*-depth search in branch-and-bound algorithms. *Int. J. Comp. Inform. Sci.* 7(4):315–73.

Karp, R. 1976. The probabilistic analysis of some combinatorial search algorithms. In J.S. Traub (ed.), *Algorithms and Complexity,* pp. 1–9. New York: Academic Press

Karp, R. M., and Pearl, J. 1983. Searching for an optimal path in a tree with random costs. *Artificial Intelligence* 21(1-2):99–117.

Kibler, D. 1982. Natural generation of admissible heuristics. University of California at Irvine, Dept. of Computer Science.

Kister, J., Stein, P., Ulam, S., Walden, W., and Wells, M. 1957. Experiments in chess. *JACM* 4:174–77.

Kling, R. E. 1971. A paradigm for reasoning by analogy. *Artificial Intelligence* 2:147–78.

Knuth, D. E., and Moore, R. W. 1975. An analysis of alpha-beta pruning. *Artificial Intelligence* 6(4):293–326.

Knuth, D. E. 1975. Estimating the efficiency of backtrack programs. *Mathematics of Computation* 24(129):121–36.

Korf, R. E. 1982. A program that learns to solve Rubik's cube. *Proc. of the 2nd AAAI Conference,* Pittsburgh, Pa., pp. 164–7.

Kowalski, R. 1972. AND/OR graphs, theorem proving graphs, and bidirectional search. In *Machine Intelligence 7,* vol. 7, ed. B. Metzer and D. Michie. New York: American Elsevier, pp. 167–94.

Kuczma, M. 1968. *Functional Equations in a Single Variable.* Warsaw: Polish Scientific Publishers, p. 141.

Kumar, V., and Kanal, L. 1983. A general branch and bound formulation for understanding and synthesizing AND/OR tree search procedures. *Artificial Intelligence* 21(1-2):179–98.

Lawler, E. L., and Wood, D. E. 1966. Branch-and-bound methods: A survey. *Operations Research* 14(4):699–719.

Lea, W., ed. 1980. *Trends in Speech Recognition.* Englewood Cliffs, N.J.: Prentice-Hall.

Lenat, D. 1977. Discovery in mathematics as heuristic search. Ph.D. dissertation, Computer Science Dept., Stanford University.

Lenat, D. 1983. EURISKO: A program that learns new heuristics and domain concepts. *Artificial Intelligence* 21(1-2):61 – 98.

Lin, Shen. 1965. Computer solutions of the travelling salesman problem. *Bell Systems Tech. J.* 44(10):2245 – 69.

Linial, N., and Tarsi, M. 1981. The counterfeit coin problem revisited. Technical Report UCLA-81-44, Cognitive Systems Laboratory, University of California, Los Angeles.

Lowerre, B. T. 1976. *The HARPY speech recognition system.* Doctoral dissertation, Computer Science Dept., Carnegie-Mellon University.

Loyd, S. 1959. *Mathematical Puzzles of Sam Loyd,* New York: Dover.

Mackworth, A. K. 1977. Consistency in networks of relations. *Artificial Intelligence* 8(1):99 – 118.

Martelli, A. 1977. On the complexity of admissible search algorithms. *Artificial Intelligence* 8(1):1 – 13.

Martelli, A., and Montanari, U. 1973. Additive AND/OR graphs. *Proc. IJCAI 3,* Stanford, pp. 1 – 11.

Martelli, A., and Montanari, U. 1978. Optimizing decision trees through heuristically guided search. *CACM* 21(12):1025 – 39.

Massey, J. 1976. Topics in discrete information processing. Lecture notes.

Méro, L. 1981. Some remarks on heuristic search algorithms. *Proc. IJCAI 7,* Vancouver, August 24-28, pp. 572 – 4.

Michie, D., and Ross, R. 1970. Experiments with the adaptive graph traverser. *Machine Intelligence 5,* pp. 301 – 8.

Michon, G. 1983. Recursive random games. Doctoral dissertation, Computer Science Dept., University of California, Los Angeles.

Montanari, U. 1970. Heuristically guided search and chromosome matching. *Artificial Intelligence* 1(4):227 – 45.

Montanari, U. 1974. Networks of constraints: Fundamental properties and applications to picture processing. *Information Science* 7:95 – 132.

Moore, E. F., and Shannon, C. E. 1956. Reliable circuits using less reliable relays. *Journal of Franklyn Inst.* 262:191 – 208.

Moore, E. F. 1959. The shortest path through a maze. In *Proceedings of an International Symposium on the Theory of Switching, Part II.* Cambridge, Mass.: Harvard University Press, 285 – 92.

Moses, J. 1971. Symbolic integration: The stormy decade. *CACM* 14(8):548 – 60.

Munyer, J. 1976. Some results on the complexity of heuristic search in graphs. Technical Report HP-76-2, Information Sciences Dept., University of California, Santa Cruz.

Nau, D. S. 1980. Pathology on game trees: A summary of results. *Proc. 1st Nat. Conf. on Artificial Intelligence* pp. 102 – 4.

Nau, D. S. 1981. An investigation of the causes of pathology in games. Technical Report TR-999, Computer Science Dept., University of Maryland.

Nau, D. S. 1983. Pathology on game trees revisited and an alternative to minimaxing. *Artificial Intelligence* 21(1-2):221 – 44.

Nau, D. S., Kumar, V., and Kanal, L. 1982. A general paradigm for AI search procedures. *Proc. of the 2nd AAAI Conference,* Pittsburgh, Pa., pp. 120 – 3.

Newborn, M. 1975. *Computer Chess.* New York: Academic Press.

Newborn, M. 1977. The efficiency of the alpha-beta search on trees with branch-dependent terminal node scores. *Artificial Intelligence* 8(2):137−53.

Newell, A., Shaw, J. C., and Simon, H. A. 1957. Empirical explorations of the logic theory machine. *Proc. West Joint Computer Conf.* 15:218−39. Reprinted in *Computers and Thought*, ed. E. A. Feigenbaum and J. Feldman, New York: McGraw-Hill.

Newell, A., Shaw, J. C., and Simon, H. A. 1958. Chess-playing programs and the problem of complexity. *IBM J. Res. and Develop.* 2:320−55. Reprinted with minor corrections in *Computers and Thought,* ed. E. A. Feigenbaum and J. Feldman, New York: McGraw-Hill, pp. 109−33.

Newell, A., Shaw, J., and Simon, H. A. 1960. Report on a general problem-solving program for a computer. *Proc. of the Int. Conf. on Information Processing,* UNESCO, Paris, pp. 256−64.

Newell, A., and Simon H. A. 1963. GPS: A program that simulates human thought. In *Computers and Thought,* ed. E. A. Feigenbaum and J. Feldman, pp. 279−93. New York: McGraw-Hill.

Newell, A., and Simon, H. A. 1972. *Human Problem Solving.* Englewood Cliffs, N.J.: Prentice-Hall.

Newell, A. 1978. HARPY: Production systems and human cognition. Rep. CMU-CS-78-140, Dept. of Computer Science, Carnegie-Mellon University.

Nilsson, N. J. 1969. Searching problem-solving and game-playing trees for minimal cost solutions. In *Information Processing,* ed. A. J. H. Morrell, pp. 1556−62.

Nilsson, N. J. 1971. *Problem-Solving Methods in Artificial Intelligence.* New York: McGraw-Hill.

Nilsson, N. 1980. *Principles of Artificial Intelligence.* Palo Alto, Calif.: Tioga.

Noe, T. 1980. A comparision of the alpha-beta and SCOUT algorithms using the game of Kalah. Technical Report UCLA-ENG-80-17, Cognitive Systems Laboratory, University of California, Los Angeles.

Nudel, B. 1983. Consistent-lableing problems and their algorithms: Expected-complexities and theory-based heuristics. *Artificial Intelligence* 21(1-2):135−79.

Palay, A. 1983. Searching with probabilities. Ph.D. dissertation, Computer Science Dept., Carnegie-Mellon University.

Pearl, J. 1977a. A framework for processing value judgments. *IEEE Transactions on Systems, Man and Cybernetics* SMC-7(5):349−54.

Pearl, J. 1977b. Toward a computational model of visual thinking. Technical Report UCLA-ENG-77-88, Cognitive Systems Laboratory, University of California, Los Angeles.

Pearl, J. 1980. Asymptotic properties of minimax trees and game-searching procedures. *Artificial Intelligence* 14(2):113−38.

Pearl, J. 1981a. A space-efficient on-line method of computing quantile estimates, *Journal of Algorithms.* 2(2):164−77.

Pearl, J. 1981b. Heuristic search theory: A survey of recent results. *Proc. IJCAI 7,* Vancouver, British Columbia, Canada, pp. 24−28.

Pearl, J. 1982a. On the discovery and generation of certain heuristics. *The UCLA Computer Science Quarterly* 10(2):121−32. Reprinted in the *AI Magazine* Winter/Spring 1983, pp. 23−33.

Pearl, J. 1982b. The solution for the branching factor of the alpha-beta pruning algorithm and its optimality. *CACM* 25(8):559−64.

Pearl, J. 1983a. Knowledge versus search: A quantitative analysis using A^*. *Artificial Intelligence* 20:1−13.

Pearl, J. 1983b. On the nature of pathology in game searching. *Artificial Intelligence* 20(4):427−53.

Pearl, J., ed. 1983c. *Search and Heuristics*, Amsterdam: North-Holland.

Pearl, J., and Kim, J. H. 1982. Studies in semi-admissible heuristics. *IEEE Trans on Pattern Analysis and Machine Intelligence*, PAMI-4(4):392−99.

Pearl, J., Leal, A., and Saleh, J. 1982. GODDESS: A goal-directed decision structuring system. *IEEE Trans. on Pattern Analysis and Machine Intelligence*, PAMI-4(31):250−62.

Peterson, W. W. 1961. *Error Correcting Codes*. Cambridge: M.I.T. Press, New York: Wiley, Appendix A.

Pohl, I. 1970. First results on the effect of error in heuristic search. In *Machine Intelligence 5*, ed. B. Meltzer and D. Michie, pp. 219−36. New York: American Elsevier.

Pohl, I. 1971. Bi-directional search. In *Machine Intelligence 6*, ed. B. Meltzer and D. Michie, pp. 127−40. New York: American Elsevier.

Pohl, I. 1973. The avoidance of (relative) catastrophe, heuristic competence, genuine dynamic weighting and computational issues in heuristic problem solving. *Proc. IJCAI 3*, Stanford, pp. 20−23.

Pohl, I. 1977. Practical and theoretical considerations in heuristic search algorithms. In *Machine Intelligence 8*, ed. E. W. Elcock and D. Michie, pp. 55−72. New York: Wiley.

Rabin, M. 1976. Probabilistic Algorithms. In *Algorithms and Complexity*, ed. J. F. Traube, pp. 21−39. Academic Press, Inc.

Roizen, I. 1981. On the Average Number of Terminal Nodes Examined by Alpha-Beta. Technical Report UCLA-ENG-8101, Cognitive Systems Laboratory, University of California, Los Angeles.

Roizen, I., and Pearl, J. 1983a. A minimax algorithm better than alpha-beta? Yes and no. *Artificial Intelligence* 21(1-2):199−220.

Roizen, I., and Pearl, J. 1983b. The average performance of three game-searching algorithms. Technical Report UCLA-ENG-83, Cognitive Systems Laboratory, University of California, Los Angeles.

Rosenfeld, A., Hummel, R., and Zucker, S. 1976. Scene labeling by relaxation operations, *IEEE Trans. Systems, Man and Cybernetics* SMC-6:420−33.

Rubin, S. 1978. *The ARGOS image understanding system*. Doctoral dissertation, Department of Computer Science, Carnegie-Mellon University, November. (Also in *Proc. ARPA Image Understanding Workshop*, Carnegie-Mellon, November, pp. 159−62.

Sacerdoti, E. D. 1974. Planning in a hierarchy of abstraction spaces. *Artificial Intelligence* 5(2):115−35.

Samuel, A. L. 1959. Some studies in machine learning using the game of checkers. *IBM Journal of Research and Development* 3:211−29. Reprinted in *Computers and Thought*, ed. E. A. Feigenbaum and J. Feldman, pp. 71−105. New York: McGraw-Hill.

Samuel, A. L. 1967. Some studies in machine learning using the game of checkers II— Recent progress. *IBM Journal of Research and Development*, 11(6):601−17.

Shannon, C. E. 1950. Programming a computer for playing chess. *Philosophical Magazine* 41(7):256‒75.

Shapiro, J. F. 1979. *Mathematical Programming: Structures and Algorithms.* New York: Wiley.

Simon, H. 1956. Rational choice and the structure of the environment. *Psychological Review* 63:129.

Simon, H. A., and Kadane, J. B. 1975. Optimal problem-solving search: All-or-none solutions. *Artificial Intelligence* 6(3):235‒47.

Simon, H. A. 1983. Search and reasoning in problem-solving. *Artificial Intelligence* 21(1-2):7‒30.

Slagle, J. R. 1963. A heuristic program that solves symbolic integration problems in freshman calculus. In *Computers and Thought*, E. A. Feigenbaum and J. Feldman, pp. 191‒203. New York: McGraw-Hill. (Also, *JACM* 10:507‒20.)

Slagle, J. R., and Bursky, P. 1968. Experiments with a multipurpose theorem-proving heuristic program. *JACM* 15:85‒99.

Slagle, J. R., and Dixon, J. K. 1969. Experiments with some programs that search game trees. *JACM* 16(2):189‒207.

Slagle, J. R. 1971. *Artificial Intelligence: The heuristic programming approach.* New York: McGraw-Hill.

Stockman, G. 1979. A minimax algorithm better than alpha-beta? *Artificial Intelligence* 12(2):179‒96.

Tarsi, M. 1983. Optimal search on some game trees. *JACM* 30(3):389‒96.

Tversky, A., and Kahneman, D. 1973. Availability: A heuristic for judging frequency and probability. *Cognitive Psychology* 5:207‒32.

Tversky, A., and Kahneman, D. 1974. Judgment under uncertainty: Heuristics and biases. *Science* 185:1124‒31.

Uspensky, J. V. 1937. *Introduction to Mathematical Probability*, New York: McGraw-Hill, ch. 6.

Valtorta, M. 1981. A result on the computational complexity of heuristic estimates for the *A** algorithm. Dept. of Computer Science, Duke Univ., Durham, N.C.

vanderBrug, G. J., and Minker, J. 1975. State space, problem-reduction, and theorem-proving—Some relationships. *CACM* 18(2):107‒15.

vanderBrug, G. J. 1976. Problem representations and formal properties of heuristic search. *Information Sciences* 2:279‒307.

Verstraete, R. 1982. Models for game trees with dependent terminal values. Technical Report UCLA-ENG-82-48, Cognitive Systems Laboratory, University of California, Los Angeles.

Wagner, H. 1975. *Principles of Operations Research.* 2d ed. Englewood Cliffs, N.J.: Prentice-Hall.

Waltz, D. 1975. Understanding line drawing of scenes with shadows. In *The Psychology of Computer Vision*, ed. P. Winston, pp. 19‒91. New York: McGraw-Hill.

Weide, B. W. 1978. Statistical methods in algorithm design and analysis. Ph.D. dissertation, Computer Science Dept., Carnegie-Mellon University, Pittsburgh, Pa.

Winkler, R. L., and Hays, W. L. 1975. *Statistics.* 2d ed. New York: Holt, Rinehart and Winston.

Winston, P. H. 1977. *Artificial Intelligence.* Reading, Mass.: Addison-Wesley.

Glossary of Notation†

†In those few cases where a symbol has more than one meaning, the context (or the syntax) resolves the ambiguity.

371

Notation	*Definition*	*Typical Page Reference*
i.i.d.	Independent and identically distributed	326
inf $\{x \mid A\}$	Highest lower bound of elements x satisfying condition A	215
J	Typical node in a graph	260
$J.j$	The jth successor of game position J	244
$k(n,n')$	Cost of cheapest path from n to n'	74
M	Minimum of M_j	103
M_j	Maximum of f along jth solution path	103
m	Expected number of sons in a branching process	165
N	Problem-size parameter, e.g., the depth of the shallowest goal	150
n, n_i	Typical nodes in a graph	34
$\binom{n}{k}$	Binomial coefficient $= \dfrac{n!}{k!(n-k)!}$	156
$O(f(n)) = g(n)$	$g(n) \leqslant Cf(n)$ for some $C > 0$ and all $n \geqslant n_0$	153
$o(f(n)) = g(n)$	$\lim g(n)/f(n) = 0$ as $n \to \infty$	160
P	Path in a graph	34
$P(A)$	Probability of event A	128
$P(A \mid B)$	Probability of event A conditioned on event B	128
PP	Pointer path	34
P_0	Probability that a frontier node is a WIN	252
$P_{n_1-n_2}$	Path from n_1 to n_2	74
P^s	Solution path	103
p_k	Probability that an object in a branching process has exactly k sons	168
$Q_S(n)$	Quality of strategy S initiated at node n	58
q	Probability of extinction in a branching process	165
R_A	Branching factor of algorithm A	259
$R^*(b)$	$\xi_b/(1-\xi_b)$, the branching factor of SOLVE for $P_0 = \xi_b$	267
$r(X)$	Upper support of random variable X	197
s	Start node	74
s	Generating function variable	165
sup $\{x \mid A\}$	Lowest upper bound of elements x satisfying condition A	94
T^+, T^-	Strategies for players MAX $(+)$ and MIN $(-)$	225
t	Termination node	78
$V(J)$	Minimax value of game position J	227
$W_G(n)$	Weight of the subgraph of G consisting of descendants of n	57
w	Relative weight given to h	87
$x_n \to x$	$x = \lim x_n$, as $n \to \infty$	164
$Y(n)$	Normalized error at node n, Eq. (6.29)	184
Z	Number of nodes expanded by A^*	175
Γ	Set of goal nodes	74
γ	Typical goal node	74

Notation	Definition	Typical Page Reference
$\Omega(f(n)) = g(n)$	$g(n) \geq Cf(n)$ for some $C > 0$ and all $n \geqslant n_0$	181
$\phi(N)$	Error-normalization function, Eq. (6.29)	184
$\rho_X(x)$	Probability density function of X	94
$\Theta(f(n)) = g(n)$	$C_1 f(n) \leq g(n) \leq C_2 f(n)$ for $n > n_0$	149
ξ_b	Positive root of $x^b + x - 1 = 0$	253
\triangleq	Equals by definition	156
$\forall(x)$	For every x	77
\Rightarrow	Implies	62
\wedge	Logical "AND", conjuction of events	120
\approx	Almost equal	128
$\overset{\sim}{>}$	Stochastically greater	177
\sim	Tends to (see $f(n)) \sim g(n)$)	160
$\underset{i}{\cup} E_i$	Union of events E_1, E_2, \ldots	167
\in	Which is a member of	78
\notin	Which is not a member of	76
$SCS(n)$	Set of direct successors to node n	74

Author Index

Subject Index

*A** algorithm, 62–64, 71–85
 admissibility of, 77–78, 85, 106, 111, 164
 definition, 64
 expected performance, 140–150, 169–193
 optimality of, 85, 107, 111, 112, 206–207
 properties, 73–85
 references for, 70, 110
 variations to, 49, 65, 70, 85–99, 111, 112, 125, 145
ABSTRIPS, 29, 131
Accuracy of heuristic estimates, 53, 79, 87, 91, 145, 149, 169, 170, 334, 351
Add list, in STRIPS, 119
Admissibility, of search algorithms, 75, 86, 105, 162, 194, 331
 ϵ-admissibility, 88–91, 104–106, 111, 128, 164
 of *A**, 77–78, 106, 111, 164
 of *AO**, 62
 of *GBF**, 55, 78
 relaxation-based, 11
 risk admissibility, 94–99, 112
 set-splitting proof of, 55, 62, 78
 See also Optimality of solutions
Admissible heuristics, 77, 113, 169–193
Air-distance heuristic, 9, 114, 140, 145, 163
Alpha–Beta (α–β) procedure, for games, 231–239, 287
 branching factor, 269, 296–298
 for computing quantiles, 277
 definition, 234
 expected performance, 235, 293–299, 307–310
 history of, 273, 286, 293–294
 influence-analysis view of, 235–239
 pruning power of, 235, 298–299
 for searching flow trees, 281, 287
Alpha bound, 233, 238
Analogical models, 117–118
Ancestor nodes, 34
AND links, 22, 26–27, 222
AND nodes, 25

AND/OR graphs and trees, 19, 22–32
 best–first search of (*GBF, GBF**), 49–56, 63, 240–245
 cost of solutions, 50–54, 57–58
 cycles in, 46
 definition, 22
 examples, 23–24, 30, 47, 223, 279
 labeling procedures for, 51, 58–60
 node selection in, 53–54
 to represent games, 26, 32, 222–223, 279
 uninformed search of, 44–46
AO Algorithm, 62–63
*AO** Algorithm, 62–64, 70, 72, 240, 286
Approximate-optimization, 15, 90–99, 129, 154
Arcs, 33
Artificial intelligence (AI), 4, 19, 137
Assignment problem, 11, 31, 115, 176, 210
Asymptotic optimality, 260, 264, 270
Attractors, 322, 325, 352

Backed-up values, 58, 60, 227, 332
Backmarking, 40
Backtracking, 36, 40, 65, 71, 121, 190, 230
 analysis, 190–192
 in AND/OR graphs, 45–47
 definition, 40
 illustration, 42
 informed, 40, 42, 190
 references for, 69
 variations of, 40–42, 66, 69, 152, 162
Bernoulli theorem, 126–127
Best-first strategies, 46–56, 63, 65, 111, 112, 240, 326
 for AND/OR graphs, 49, 240
 generalized, 50–51, 99–110
 for OR graphs, 48–49, 72
 provisions for optimality, 54–55
 specialized, 61–65
β-bound, 234, 238, 239
BF algorithm, 74, 87
 definition, 48
 relation to *GBF*, 55, 63